MUSEUM OF FINE ARTS · HOUSTON
ABBEVILLE PRESS · PUBLISHERS · NEW YORK

JOHN BEARDSLEY
JANE LIVINGSTON
WITH AN ESSAY BY OCTAVIO PAZ

Hispanic
ART IN THE UNITED STATES

Hispanic Art in the United States: Thirty Contemporary Painters and Sculptors, organized by The Museum of Fine Arts, Houston, is made possible by grants from the Rockefeller Foundation and Atlantic Richfield Foundation. The national tour is sponsored by the AT&T Foundation.

Cover: Carlos Alfonzo. *Where Tears Can't Stop,* 1986, detail. Acrylic on canvas, 96 × 120". Collection of the artist.

Frontispiece: Arnaldo Roche. *Burning the Spirit of the Flesh*, 1980. Oil pastel on paper, 50 × 40". Collection of the artist.

Editor: Alan Axelrod
Designers: Alex and Caroline Castro, Hollowpress
Production supervisor: Hope Koturo

Published in the United States of America in 1987 by Abbeville Press, Inc.

Printed and bound in Japan.

Library of Congress Cataloging in Publication Data

Beardsley, John.
 Hispanic art in the United States.

 Issued in conjunction with an exhibition held at the Museum of Fine Arts, Houston, May-Sept. 1987, and other museums.
 "Artists' bibliography": p.
 Bibliography: p.
 Includes index.
 1. Hispanic American art—Exhibitions. 2. Art, Modern—20th century—United States—Exhibitions.
I. Livingston, Jane. II. Museum of Fine Arts, Houston.
III. Title.
N6538.H58B43 1987 704'.0368073'074013 86-28819
ISBN 0-89659-688-5 (Abbeville Press)
ISBN 0-89659-690-7 (Abbeville Press: pbk.)

CONTENTS

7 Preface and Acknowledgments

13 Art and Identity: Hispanics in the United States
 Octavio Paz

43 And/Or: Hispanic Art, American Culture
 John Beardsley

85 Recent Hispanic Art: Style and Influence
 Jane Livingston

137 Artists' Biographies

251 Artists' Bibliographies

255 General Bibliography

258 Index

Ibsen Espada. *Salsa para ti,* 1986. Oil and ink on rice paper, 37 × 72½″.
Mr. and Mrs. Irvin A. Levy.

PREFACE AND ACKNOWLEDGMENTS

Hispanic-American visual art is at once too familiar and utterly unknown. Largely overlooked by our major museums and art magazines, it is regularly championed only by smaller organizations with limited constituencies. Very few artists whose work is of an assertively Hispanic character, whose subject matter or style reveals an affinity for their Latin roots, have received a measure of recognition at least partially equivalent to their accomplishments. A few other Hispanic Americans, although unacknowledged as such, have come to the fore in a more mainstream style. At the same time, certain limited aspects of Hispanic visual culture have been seized upon—both by a majority of the art establishment and of the interested public—as the sum total and limit of Hispanic achievement in the fine arts. The Chicano mural movement, in particular—while it boasts a distinguished tradition and while it is still capable of summoning excellent work from a number of artists—has lately become something of a stereotype in the perception of Hispanic artistic expression. In all, the true depth and range of Hispanic art in the United States remains an uncelebrated phenomenon, an unacknowledged chapter in the history of recent American art.

Such were our intuitions in 1982 when this project originated in conversations among ourselves and Peter Marzio, then Director of the Corcoran Gallery of Art, Washington, D.C. Having worked together before on an exhibition of self-taught American artists, we had been particularly struck by Felipe Archuleta, Martín Ramírez, and the tradition of Hispanic religious carving in the Southwest. Jane Livingston had also been haunted by her experience in Los Angeles in 1973–74, working with the artists in "Los Four"—Carlos Almaraz, Gilbert Luján, Frank Romero, and Beto de la Rocha—on an exhibition that occurred at the Los Angeles County Museum of Art shortly before she left there to become Chief Curator at the Corcoran. That show became for her an issue of unfinished business. It was so good, so open-ended, and so prescient of what was to come

in mainstream art everywhere, that it seemed to call for resuscitation and elaboration. In addition, we had each independently followed the emergence of certain important artists on the American scene, such as Rafael Ferrer, Robert Graham, Luis Jimenez, and Manuel Neri, who, whether or not they were primarily identified with a Latino sensibility, were blazing a trail into the mainstream American art world for other Hispanic artists working—but working invisibly.

However, our suspicion of a larger and deeper phenomenon of contemporary Hispanic art in the United States wasn't sufficiently substantiated by 1983 to justify a firm commitment to a large exhibition based on it. We felt strongly impelled to explore the field, but were also firm in postponing any announcement of a show and book until we had consulted further with our colleagues, especially those in the various Hispanic art organizations. We were immensely fortunate at this time in obtaining a generous unconditional grant from the Rockefeller Foundation and the Atlantic Richfield Foundation to carry out a year-long study. Alberta Arthurs, Director for Arts and Humanities at the Rockefeller Foundation, and Anna Arrington, former Program Officer at Atlantic Richfield, were extraordinarily helpful to us in securing this planning grant. Our agreement was to visit a dozen of the major locales in the United States with significant Hispanic populations—among them New York, Texas, Florida, New Mexico, Northern and Southern California, and Arizona—to gather information and images, to meet artists, leaders of Hispanic and community arts organizations, curators, writers, collectors, and dealers knowledgeable in this area, and to compile a report based on what we found.

Planning for this project, we came to realize that there was a great richness and variety of visual art in the Hispanic worlds everywhere in the United States. Painting, sculpture, decorative arts, architecture, design, photography, film, and video were among the many areas we explored; literature, poetry, and theater were beyond our purview, but our increasing familiarity with their depth and vitality became important in our early research. Early on we felt the necessity to narrow our field of view. Somehow, to concentrate on painting and sculpture seemed to us the natural first step in revealing both the scope and the particularity of the achievements of Hispanic artists in the United States. Still photography, video, and performance might have been equally compelling fields to explore, but they would simply have opened up too much territory to survey in a single book and exhibition. We trust that these important areas of endeavor among Hispanic artists will be treated in due course.

In April 1985, based both on a series of extended trips and on the numerous responses to our systematic requests for local canvassing by colleagues, who sent slides and artists' names, we presented a formal report and proposal to the Rockefeller and Atlantic Richfield Foundations. In it, we showed images by some forty artists. Both potential sponsors responded to the report by committing substantial financial support for an exhibition and accompanying book. Again, Alberta Arthurs and Anna Arrington were instrumental in securing this support. Thus, with a self-imposed deadline of two years, we proceeded.

Although it was always understood that the show would open at the Museum of Fine Arts, Houston, there is an important sense in which the exhibition has

been a collaborative effort between the Museum of Fine Arts and the Corcoran Gallery of Art. It was as Director of the Corcoran that Peter Marzio had first expressed interest in the possibility of such an exhibition; it was as Director of the Museum of Fine Arts, Houston, that he committed the time and the resources to make it possible. We have remained based at the Corcoran, and the Corcoran's firm commitment to the project has continued under its present Director, Michael Botwinick.

As the tour beyond the Corcoran has developed, we have added to our sponsorship the generous commitment of the American Telephone and Telegraph Corporation Foundation, which has agreed to defray the expenses of touring the massive exhibition. The Louisa Moseley Charitable Income Trust, Los Angeles, through the efforts of Joseph Terrell, has provided additional financial support toward the realization of works made especially for the exhibition and book.

For the book, we thank our copublisher, Abbeville Press, and are grateful to Alan Axelrod, editor, and to Alex and Caroline Castro of Hollowpress, Baltimore, who designed the book as well as the exhibition installation.

While we have assumed the responsibility for curating the exhibition, we have been at every stage and in every place valuably assisted by many, many people in locating artists and in coming to understand the phenomenon of contemporary Hispanic art. Most often our best leads to undiscovered artists have come from artists themselves. In addition to a number of the painters and sculptors we ultimately selected for the book and exhibition, we have had unstinting help from such artists as Francisco Alvarado-Juárez in Washington and New York, Teresa Archuleta-Sagel in New Mexico, David Avalos in San Diego, Myrna Baez in Puerto Rico, Santa Barraza in Texas, Harry Gamboa in Los Angeles, Benito Huerta in Houston, Alejandro López in Washington and New Mexico, Santos Martínez in San Antonio, Amalia Mesa-Bains in San Francisco, José Montoya in Sacramento, Victor Ochoa in San Diego, Guillermo Pulido in Galveston, Juan Sánchez in New York, and César Trasobares in Miami, among many others.

We also learned a great deal from the curators and directors of museums and other nonprofit Hispanic arts organizations. Among the people who have been especially helpful are Nilda Peraza, Director, and Susana Torruella Leval, Chief Curator, the Museum of Contemporary Hispanic Art, New York; Jack Agüeros, former Executive Director, and Rafael Colón Morales, Curator, El Museo del Barrio, New York; Inverna Lockpez, Director, Intar Latin American Gallery, New York; René Yañez, Director, and the late Ralph Maradiaga of the Galería de la Raza, San Francisco; Judith Baca, Director, Social and Public Arts Resource Center, Los Angeles; Philip Brookman, Curator, Centro Cultural de la Raza, San Diego; Patricio Córdova, Director, Chicano Humanities and Arts Council, Denver; Carlos Luís, Director, Cuban Museum of Art and Culture, Miami; René Taylor, Director, and Haydée Venegas, Assistant Director, Museo de Arte de Ponce, Puerto Rico; and Ricardo Alegría, Director, Centro de Estudios Avanzados de Puerto Rico y el Caribe, San Juan. We have also benefitted considerably from following the activities over the last several years of Galería Posada, Sacramento; the Mexican Museum, San Francisco; the Mission Cultural Center,

San Francisco; Plaza de la Raza, Los Angeles; Self-Help Graphics, Los Angeles; MARS Gallery, Phoenix; the Fine Arts Latin Association, Houston; Mexic-Arte, Austin; Xochil Gallery, Mission, Texas; and Fondo del Sol, Washington, D.C.

Other individuals, particularly knowledgeable in the field of contemporary Hispanic art, who have been especially generous with their time and information include Jacinto Quirarte, Director, Research Center for the Arts and Humanities, University of Texas, San Antonio; Josine Ianco-Starrels, Director, Municipal Art Gallery at Barnsdall Park, Los Angeles; Al Nodal, Director, Exhibition Center, Otis Art Institute of Parsons School of Design, Los Angeles; Selma Holo, Director, Fisher Gallery, University of Southern California, Los Angeles; Fritz Frauchiger, former Director of the Arco Center for Visual Art, Los Angeles; Margarita Cano, Miami-Dade Public Library, Miami; Juan Espinosa, Director, Bacardi Gallery, Miami; Arthur Wolf, Director, Millicent Rogers Museum, Taos; Helen Lucero, Curator of New Mexican Hispanic Crafts and Textiles, Museum of International Folk Art, Santa Fe; Christine and Davis Mather, Santa Fe; Jim Dunlap and Barbara Sommer, Alla Gallery, Santa Fe; Marianne Stoller, Colorado College, Colorado Springs; Jon Batkin, Curator, Taylor Museum of the Colorado Springs Fine Arts Center; Irvine MacManus, New York; Thomas Sokolowski, Director, the Grey Art Gallery and Study Center, New York University; Geno Rodriguez, Director, Alternative Museum, New York; and John Stringer, Director of Visual Arts, Center for Inter-American Relations Art Gallery, New York.

We have likewise been helped by conversations and correspondence with Nicolás Kanellos, University of Houston; Rodolfo J. Cortina, Florida International University; Tomás Ybarra-Frausto, Stanford University; Francisco Arturo Rosales, Arizona State University; Gary D. Keller, Arizona State University; Victor A. Sorell, Chicago State University; Carla Stellweg, New York; Nohra Haime, Nohra Haime Gallery, New York; Luis Cancel, Director, and Philip Verre, Chief Curator, Bronx Museum of the Arts; Giulio V. Blanc, New York; Richard Duardo, Future Perfect Graphics, Los Angeles; Rolando Castellón, San Francisco; Ellen Landis, Curator of Art, Albuquerque Museum; David Turner, Associate Director of Fine Arts, Museum of New Mexico, Santa Fe; Elaine Dagen Bela, Dagen Bela Gallery, San Antonio; Dora Valdes-Fauli, Miami; and Ricardo Pau-Llosa, Miami.

The execution of this book and exhibition would not have been possible without the help of numerous staff members at the Museum of Fine Arts, Houston. Among those who have been most directly involved are Karen Bremer, Administrator for Collections and Exhibitions; Charles J. Carroll, Associate Registrar; Alison de Lima Greene, Assistant Curator of Twentieth Century Art; Margaret Skidmore, Development Director; Jack Eby, Chief Designer; Barbara Michels, Grants Coordinator; Amy Studer, Curatorial Assistant; and Ann Lewis, Public Relations. We are most grateful to them all. At the Corcoran Gallery of Art, we have been ably assisted throughout by Pamela Lawson.

In reviewing the sum and substance of what is here, we think it will be apparent to all but the most prejudiced observer that the predominating values in this book and exhibition are artistic, not sociological. What we have cared about above all else is the strength of an artist's work, not conformity to some preconceived notion of what constitutes a Hispanic "style" or "school." Such

generalizations as each of us draws follow from our observations of what is *good* about Hispanic art; the broader cultural implications we detect reflect artistic goals determined by the painters and sculptors themselves.

At the same time, certain issues have emerged, almost unconsciously, or at least in spite of our stated intentions. We did not set out to define a generation, and yet we see a fascinating generational gap. What we have included perforce is *mature work*—which means most of our artists are over thirty-five (one, Martín Ramírez, died long ago and serves as a special case). Were this book written and the exhibition mounted ten or fifteen years in the future, it would include a rather different roster and content. First, more women would be represented. Our overwhelming reaction to the many young women whose work we saw—from, among numerous others, Elsa Flores and Diane Gamboa in Los Angeles to Candida Alvarez and Marina Gutierrez in New York and Marta Sanchez in Philadelphia (still a student at Tyler School of Art when we saw her work)—was a sense of *promise,* a feeling that their work would fully flower soon. We have a strong conviction that in the near future the clear talent of these women will prevail over whatever particular cultural forces might still tend to limit them.

Second, a project of the year 2000 would certainly include much greater monumentality of execution. The impetus to large, public art is rife among Hispanic artists—but the economic means of supporting such art is for the present missing. Several of the large-scale pieces here would not exist were it not for the direct subsidy this undertaking provided, and others could have been added given yet more time and additional resources. In short, the Hispanic aesthetic we are addressing *thinks* monumentally. We associate this tendency with the long tradition of city murals, but it has many other potential outlets. Hispanic and Hispanic-derived art may well surround and define the American public landscape of the near future.

Third, in the next generation, Hispanic artists in the United States will be far more readily recognized as deeply influential for American mainstream art. We hope the present effort is only the first suggestive episode in a sequence of events that will stretch both backward and forward, helping us to understand some previously unappreciated realities about the development of American art—and to prepare the way for what is to come.

<div align="right">

John Beardsley
Jane Livingston

</div>

A Note on Spelling:

Throughout this book, the use of accents in proper names conforms to the artists' own practice, which is sometimes at variance with conventional Spanish.

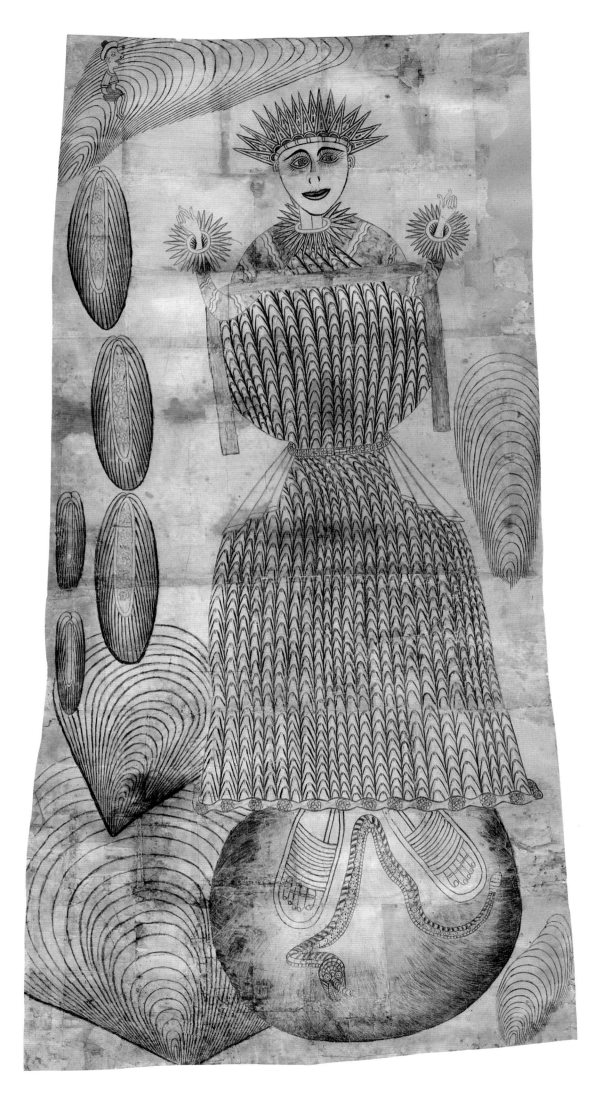

Martín Ramírez. *Madonna.* c. 1950s. Crayon and colored pencil on paper, 76½ × 37″. Mr. and Mrs. James Harithas.

ART AND IDENTITY: HISPANICS IN THE UNITED STATES

OCTAVIO PAZ

Names and Constitutions

Our earliest experience, in the darkness of the beginning, is a sensation of a sudden breaking away. Expelled from an *all* that envelops us, we open our eyes for the first time in strange, indifferent surroundings. Birth is a falling in the metaphysical as well as in the physiological sense; for this reason, psychologists consider birth a trauma, and for Christians it is a reenactment of the original Fall. The sensation of helplessness combines with a feeling of having been uprooted from a far greater reality. It is what the theologian Schleiermacher called the

Concerning the term *Hispanic*: What should we call the various Spanish-American communities living in the U.S.—the Chicanos, Puerto Ricans, Cubans, Central Americans, and so on? It seems to me that the most common term, Hispanics, covers all of them in their complex unity.

sense of original dependence, a basis for Christianity and perhaps all other religions. These two forces, dependence and fall—or, in terms less theologically charged, participation and separation—are present throughout our lives. They are born with us and die with us. One exists to serve the other, in permanent discord and in perpetual search of reconciliation. Every human life is a continual weaving and unweaving and reweaving of these threads of our beginnings. That first experience, separation and participation, appears in endless variation in all our acts.

We live within concentric, successive, widening circles: family, neighborhood, church, school, work, club, party, city, nation. The sense of belonging to this or that collective reality is older than names or ideas: first we *are* part of a family, later we *know* the name of that family, and still later we form an idea, however vague, of what a family is and means. The same occurs with the sense of separation and solitude. Growing up, we discover new names and realities; each name stands for communities, groups, and associations that become wider, increasingly evanescent: we can see our family, talk with it, but only in a figurative way can we see or talk with our nation or the congregations of the faithful of our church. All of the names of these various communities refer obscurely to the original sensation; all of them are extensions, prolongations, or reflections of the moment of beginning. Family, clan, tribe, and nation are metaphors for the name of that first day. What is its name? No one knows. Perhaps it is a reality that has no name. Silence cloaks the original reality, the moment when we opened our eyes in a strange world. At birth we lose the name of our true homeland. The names we say in the anxieties of possession and participation—*my* family, *my* country—attempt to fill the nameless empty space that is somehow involved with our birth.

That double sense of participation and separation appears in all societies and in all times. The love we profess for house and home, the loyalty to friends and those of the same religious beliefs, to party and to country, are affections that come from our beginnings, reiterations and variations of the primal situation. They are a code for our original condition, which was not simple, but rather composed of two antagonistic and inseparable terms: fusion and dismemberment. This is the essential principle of every human life and the nucleus of all of our passions, feelings, and actions. It is a principle older than consciousness or reason, and yet, at the same time, the origin of both. From feeling to knowing is a small step; we all take that step to reach the consciousness of ourselves. The name of the origin—unknown, hidden, perhaps nonexistent—becomes an individual name: I am Peter, Teresa, Juan, Elvira. Our names are the metaphor for the name lost at birth.

This process has been repeated in the lives of all societies, from the Paleolithic to our own times. First there is the collective feeling of belonging to this or that community, a feeling shared with greater or lesser fervor by all its members; then the sense of the difference between our group and the other human groups. Later, the sense of feeling different creates the consciousness of what we are; and that consciousness, finally, is expressed in the act of naming. The name of the group recapitulates the dual principle on which we are founded: it is the name of a collective identity composed of internal likenesses and the

Carmen Lomas Garza. *Self-Portrait*, 1980. Gouache on Arches paper, 8½ × 7½". Collection of the artist.

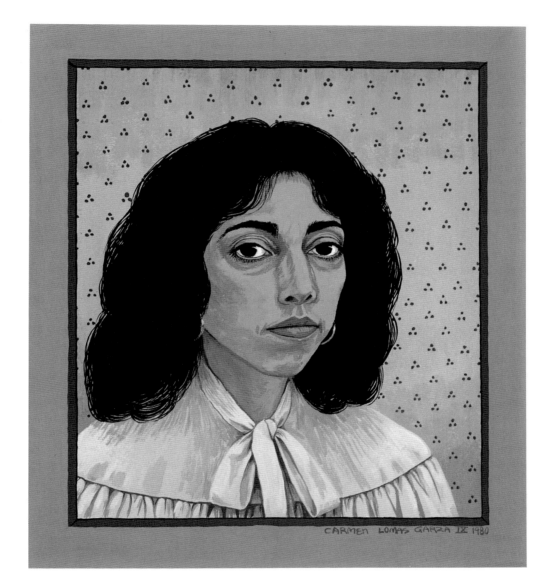

differences between us and the others. The enormous diversity of societies, their various histories, and the richness and plurality of cultures have not altered the universality of the process. Everywhere the phenomenon has been basically the same, whether in the Neolithic village, the Greek *polis*, the Renaissance republic, or among a tribe of headhunters in the jungle. The name reinforces the ties that bind us to the group and, at the same time, justifies the group's existence, asserts its worth. The name is a code for the fate of the group, simultaneously designating a reality, an idea, and a set of values.

To give a name to a community is not to invent it, but to recognize it. Modern societies tend to believe that constitutions found nations. It is a legacy of the political thought of the Greeks, who nearly always identified being with reason. But reason—that is to say, the constitution—does not constitute. Society comes first. Constitutions construct their principles on a given reality, the people. Of course, it is impossible to imagine a society without rules or laws, whatever they may be. Yet those rules are not principles older than the society; rather, they are ancestral customs, the society's common norms. Society *is* its customs, its rites, its rules. For that reason the invention of the constitution in ancient Greece—or more precisely, the invention of the *idea* of the constitution—was the beginning of history as well as liberty: the rupturing of unconscious custom and heritage by an act of the collective conscience.

The declaration of a constitution is simultaneously a fiction and the consecration of a pact. The former, because the constitution pretends to be the birth or baptismal certificate of a society—a fiction, for obviously the society existed before the announcement of its birth. At the same time, the fiction becomes a pact and thus ceases to be a fiction; the constitutional pact changes custom into norm. Through a constitution the traditional and unconscious ties—customs, rites, rules, taboos, exemptions, hierarchies—become voluntary and freely accepted laws. The original dual principle—the sensation of separation and participation—reappears in the constitutional pact, but it is transformed: it is no longer a fate but a freedom. The fatality of birth becomes an act of free will.

The history of modern societies, first in the West and later in the rest of the world, is to a great extent the history of the intimate association between the various constitutions and the idea of a nation. I say the *idea* of a nation because, as I have noted, it is evident that the reality we call a nation is older than its idea. It is nearly impossible to determine what a nation is, or how and when nations are born. It is still endlessly debated exactly when political philosophy appeared in Greece. But the reality named by the word *nation* needs no proof to be perceived. Before it is a political idea, the nation has been, and still is, a profound and elemental feeling: that of participation. Nature, said Herder, has created nations but not states. By that he no doubt meant that nations are the more or less involuntary creations of the complex processes that he called natural and that we call historical. The English, the French, and the other European peoples were nations before they knew what they were; when they learned it, and fused the idea of the nation with the idea of the state, the modern world began. In general, despite the natural differences of every case, the process has been similar in all the nations of Europe and, later on, the other continents.

Luis Cruz Azaceta. *Self-Portrait as a She-Wolf,* 1985. Acrylic on canvas, 72 × 120". Allan Frumkin Gallery, New York.

16

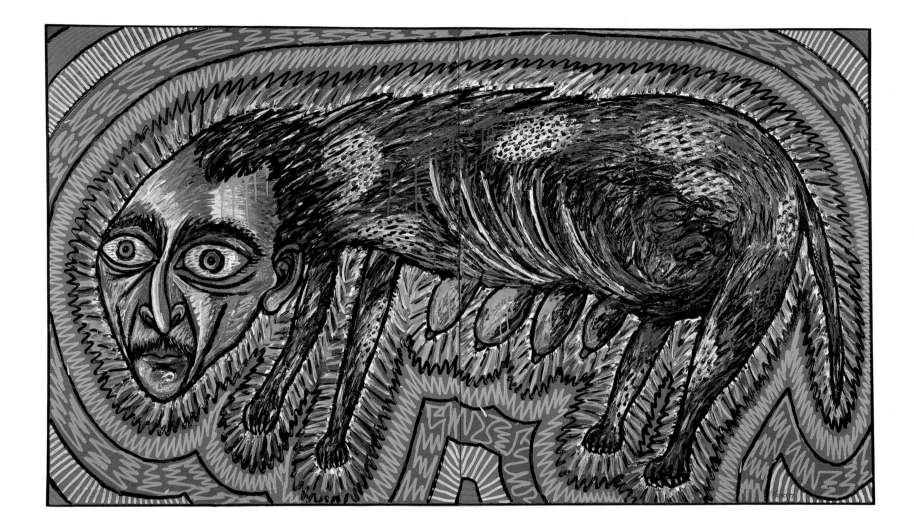

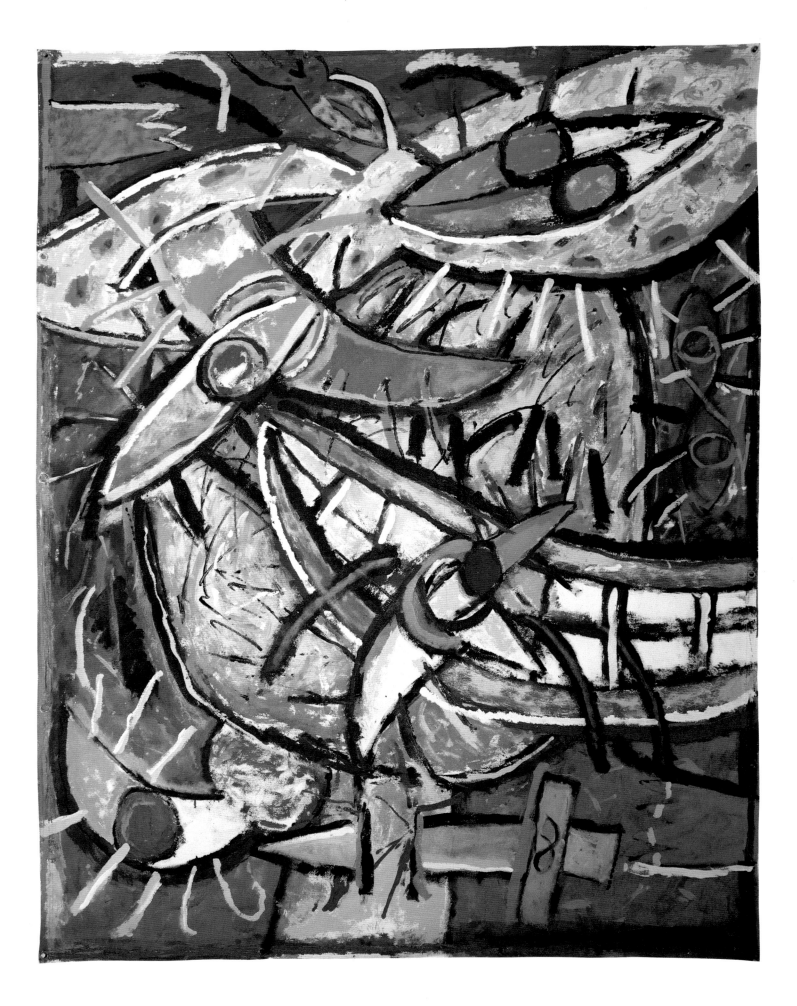

The idea of the nation, transformed into one of the ideologies of the modern era, has frequently replaced historical reality. Through a curious confusion, the Gallic chieftain Vercingetorix has been seen as a patriotic symbol for France, the cave paintings of Altamira as the beginning of the history of Spanish art, and the independence of Mexico in 1821 not as the birth but as the restoration of the nation. According to our official history, Mexico *recovered* in 1821 the independence it had *lost* in 1521 when Cortés conquered the Aztec city-state of Mexico Tenochtitlan. The examples I have almost randomly cited—there are many to choose from—illustrate the modern and dangerous confusion between reality and ideology. I should add that this confusion, though widespread and dangerous, is understandable. It was natural, for example, that the Mexican feeling of participation, exaggerated after the war for independence (separation) from Spain, should have been expressed in a distorted chronology tinged with ideological passion: the nation existed for many centuries, was kidnapped, and then the constitutional pact restored the original reality. For this romantic version of our history, shared by many, the independence of Mexico was not a beginning but a return to the beginning. In almost all the modern revolutions, one finds the same idea: revolutionary movements *restore* the ancient freedoms and the lost rights. Thus the ancient idea of the return to the original time fuses with the modern idea of an absolute beginning. An unholy marriage of myth and political philosophy.

Children of the Idea

The process has been universal: the nation is the child of history, not of the idea. And yet there are exceptions. The most notable among them has been the United States. The English or the French discovered one day that they were English or French, but the Americans decided to invent themselves. Their nation was not born from the play of impersonal historical forces but from a deliberate political act. They did not, one happy day, discover that they were American; they decided to become it. The past did not establish them; they established themselves. I exaggerate, of course, but not a great deal. It is obvious that the birth of the United States, as in all that happens in history, was a coincidence of circumstances. It ultimately produced American society. What seems to me astonishing, however, and worth thinking about is the central and prominent role played, amid all these circumstances, by the political will to create a new nation. One often hears the United States referred to as an enormous historical novelty. Yet nearly everything that is the United States began in Europe. Not only is it a country made of immigrants and their descendants, its ideas and institutions, its religion and democracy, language and science, capitalism and individualism also came from Europe. But in no other part of the world has a nation been born by a deliberate act of self-establishment. It was also a new country in a polemical sense; it wanted to be different from the others, different from the nations created by history. Its newness was radical, anti-historical. The independence of the United States was not a restoration of a more or less mythic past, but an authentic birth. Not a return to the origins, but a true beginning.

Carlos Alfonzo. *Self-Portrait #2*, 1984. Acrylic on canvas, 96 × 72". Collection of the artist.

19

The appearance of the United States was an inversion of the normal historical process: before it was a nation it was a proposal for a nation. Not a reality but an idea: the Constitution. The Americans were not children of a history: they were the beginning of *another* history. They did not define themselves by their origins, as others did, but rather by what they were going to be. The "genius of the people," that expression so loved by Romantic historians, was always conceived as the sum of inherited traits; in contrast, the primary characteristic of the United States was its lack of characteristics, and its uniqueness consisted in an absence of national traits. It was an act of violence against history, an attempt to create a nation *outside of* history. Its cornerstone was the future, a territory more unexplored and unknown than the land in which the Americans rooted themselves.

It was a total beginning in the face of and against a history personified by the European past with its particularisms, hierarchies, and old, stagnant institutions. Tocqueville's fascination for it is understandable; he was the first to realize that the appearance of the United States on the world scene represented a unique attempt to conquer historical destiny. Thus its negation of the past and its wager on the future. Of course, no one escapes history, and today the United States is not, as the "founding fathers" proposed, a nation outside of history, but one bound to it with iron chains, the chains of a world superpower. But what was decisive was the act of origin, the self-establishment. That act inaugurated *another* way of making history. All that the Americans have made, within and beyond their own borders, good and bad, has been a consequence, an effect, of that initial act.

I mentioned earlier the absence of national traits in the United States. I did not mean, of course, that such traits do not exist. Rather, I wanted to emphasize that the project of the founders of the United States did not consist, as in other countries, of the recognition of the genius of the people, the collective idio-syncrasy or the unique character of the national tradition, but in the proclama-tion of a set of universal rights and obligations. The United States was founded not on particularisms but on two universal ideas: the first, from Christianity, declared the sanctity of each individual, who was considered unique and irreplaceable; the second, from the Enlightenment, affirmed the primacy of reason. The subject of rights and duties is the individual person, in whose interior conscience debates itself and God: a Protestant legacy. In turn, those rights and obligations possess the universality and legitimacy of reason: a legacy of the eighteenth century. The emphasis on the future has the same root as the rational optimism of the Enlightenment. The past is the dominion of the individual, while the future is the kingdom of reason. Why? Because it is the unknown territory, a *no man's land* that progress will ultimately explore and colonize. And progress is nothing but the form by which reason manifests itself in history. Progress, for the nineteenth century, was reason in motion. American pragmatism and activism are inseparable from progressive optimism, and the basis of that attitude is the belief in reason. In sum, one can see the birth of the United States as a unique phenomenon and yet, at the same time and without contradiction, as a consequence of the two great movements that began the modern era: the Reformation and the Enlightenment.

The new universality was expressed by three emblems: a language, a book, and a set of laws. The language was English, the book the Bible, and the laws the Constitution. A strange universality: not false, but rather paradoxical and contradictory. It was a universality undermined by the three emblems that expressed it. English has become a universal language, but only because it embodies a particular version of Western culture. In the United States it was forced to respond to a double exigency, to remain faithful to the English tradition while still expressing the new American realities. The result has been a continual and stimulating tension; because of it, there is an American literature, one with its own unique character. The Bible, for its part, symbolizes the Protestant scission and represents a particular version of Christianity. None of the churches into which the reformist movement split has been able to reconstruct the original universality. The same can be said of the Constitution: the principles that inspired it are not timeless, like an axiom or a theorem, but rather are expressions of a certain moment in Western political philosophy. A triple contradiction: it was a universality that, in order to realize itself, had to face up to particularisms and, in the end, identify with them; it was a set of beliefs that could be seen as versions or interpretations of the central doctrines of the most widespread traditions of the West; and finally they were political and moral norms that expressed the beliefs and ideals of a single linguistically and culturally determined ethnic group, the white Anglo-Saxon Protestants.

In its clash with particularisms, the United States discovered history. These particularisms assumed many forms, but, in my opinion, two of them were especially significant: relations with the outside world, and the immigrants. Two manifestations of otherness. In other writings I have dealt with some of the ramifications of the former, the inability of the United States to find a foreign policy that can meet the contradictory demands of an imperial democracy. As for the latter, it is hardly necessary to recall that it is, and has been for two hundred years, one of the central themes of American history. Some of the immigrations were forced (such as those of the blacks taken from Africa); others were voluntary (the Europeans, Asians, and Latin Americans). For a long time an extraordinary plurality of ethnic and cultural groups has predominated in the United States. Other empires have known such heterogeneity—Rome, the Caliphate, Spain, Portugal, England—but it was one nearly always outside of the metropolitan areas, in the distant provinces or in the conquered territories. I know of no similar examples in history of such heterogeneity within a country. The situation can be reduced, in a succinct but not inexact way, to this alternative: if the United States had not built a multiracial democracy, its life and its integrity would have been subject to grave threats and terrible conflicts. Luckily—although not without errors and setbacks—the American people have met this goal. If they can hold on to it, they will have created a work without parallel in history.

In order to resolve the problem, the Americans have considered, at one time or another, nearly all of the other solutions attempted by other countries and empires. The repertoire is extensive and depressing. The oldest remedy—outside of plain extermination—is exclusion. It was Sparta's solution. It is inapplicable to the modern world. Not only is it in contradiction to our institu-

tions and ethical and political convictions, but it also implies an impossible demographic immobility. The example of England and the other modern empires is equally inapplicable. The foreign populations are not outside but rather within the national territory. It is equally impossible to imitate the policy of imperial China—homogenization. Another notable solution has been the caste system of India, which has lasted more than two thousand years; it, of course, is based on ideas foreign to our civilization. Spain and Portugal offered a model halfway between exclusion and absorption. The two empires were founded on the universality of the Catholic faith (participation) and on the hierarchies of blood and origin (separation). The Roman model is a worthy ancestor. Rome granted citizenship to the subjects of the empire. It was a great deal for its time, but today it is not enough. In fact, the only lasting and viable solution is the choice made by the United States: integration within a plurality, a universalism that neither denies nor ignores the singularities that comprise it, a society that reconciles the two contrary currents of that original sentiment: separation and participation.

Guadalupe, Coatlicue, Yemanyá

In size, the Hispanic minority is the second largest in the United States. In its ethnic and cultural composition, it is a world apart. What is most surprising is its ethnic diversity—Spanish, Indian, black, mestizo, mulatto—a marked and violent contrast to cultural homogeneity. This fact distinguishes it from the other large minority, the blacks. While the original culture is still very much alive among the Hispanics, the African roots of the black communities in the United States have almost entirely disappeared. Those cultures, of course, were never homogeneous, and one must speak of them in the plural. The differences between the Hispanic and Asian minorities are equally notable—language, religion, customs, histories. The Asian minority is composed of a great diversity of languages, cultures, religions, nations; the Hispanics are largely Catholic, Spanish is their original language, and their culture is not essentially different from that of other Spanish Americans. Culturally and historically, Catholic Hispanics are a continuation in America of that version of the West embodied by Spain and Portugal as, at the other extreme, Anglo-Americans are an English version. This fact has never been easily accepted, for the Europeans and the Americans have, since the eighteenth century, looked down on the Spanish and Portuguese and their descendents. Nevertheless, to accept the fact is not to ignore the differences. They are substantial and great.

Manuel Neri. *Indios Verdes No. 4*, 1980. Mixed media on paper, 42½ × 32½". The Mexican Museum, San Francisco.

For the United States, the Hispanic minority represents a variant of Western civilization, a variant that is no less eccentric than that of the Anglo-Americans. Both are eccentric because the founding nations—Spain, Portugal, and England—were frontier entities, almost peripheral, not only geographically but historically and perhaps culturally. They are singularities in the history of Europe. An island and a peninsula, lands at the end of the world. Latin Americans and Anglo-Americans are the heirs of two extreme and antagonistic movements that, in the sixteenth and seventeenth centuries, fought for supremacy not only of the sea and the continents but also of the human con-

science. Both communities were born in the Americas as European transplants, transplants composed of separate cultures with conflicting ideas and divergent interests. Two versions of Western civilization were established in this hemisphere. The English and Dutch version was full of the spirit of the Reformation, which began the modern age; the Spanish and Portuguese version identified with the Counter-Reformation. Historians still debate the meaning of that movement. For some it was an attempt to halt the rise of modernity; for others it was an attempt to create a model different from modernity. Whether it was one or the other, the Counter-Reformation was a failed enterprise. We, the Latin Americans, are the descendants of a petrified dream. The Hispanics of the United States are a piece of that dream that has fallen into the Anglo-American world. I don't know if they are the seeds of a resurrection scattered by storm winds, or the survivors of a great shipwreck of history. Whatever they are, they are alive. Their culture is ancient, but they are new. They are a beginning.

The eccentricity of Hispanic culture cannot be reduced to the Counter-Reformation and its negation of modernity. Spain is incomprehensible if one neglects two essential elements of its formation: the Arabs and the Jews. Without them we cannot understand many aspects of its history and culture, from its conquest of America to its mystical poetry. A culture is defined not only by its acts but by its omissions, lacunae, and repressions; among the last, in the case of Spain, is the expulsion of the Moors and the Jews. It was an act of self-mutilation that, like all such acts, engendered countless demons and obsessions. Our other heritage—black and Indian—is equally complex. It, too, contains terrible demons: the conquest, slavery, servitude, the myths, languages, and lost gods.

Besides this ethnic and cultural complex, the Hispanics in the United States also belong to various nations. At one extreme, the Mexicans: immigrants from a country in which the most immediate reality is the mountains and the great plateaus. A population that traditionally has lived with its back to the sea. At the other extreme, the Cubans and Puerto Ricans: islanders who have never known any other plain but the sea. Among the Mexicans—ceremonious, taciturn, introverted, religious, and violent—the Indian legacy is the determining factor; among the Cubans and Puerto Ricans—extroverted, boisterous, effusive, vivacious, and equally violent—the black influence is visible. Two temperaments, two visions, two societies within the same culture.

This ethnic, geographic, and psychological diversity extends to other domains. The majority of the Mexicans are of peasant stock. The oldest populations are descendants of the early settlers of the American Southwest, from the time when those lands were Mexican; the others, more numerous, have arrived in successive waves throughout the twentieth century. Mexico is an ancient country, and the most ancient part of Mexico is its peasants. They are contemporaries of the birth of the first American cultures, three thousand years ago; since then they have survived enormous upheavals, various gods, and political regimes. They are also the authors of a strange and fascinating creation, Mexican Catholicism, that imaginative synthesis of sixteenth-century Christianity and the pre-Columbian ritualistic religions. Deeply religious, traditional, stubborn, patient, suffering, communal, immersed in a slow-moving time made of rhyth-

mic repetitions—one can imagine their distress and their difficulties in adapting to the ways of life in the United States, with its frenetic individualism. A clash of two sensibilities, two visions of time—what will be the final result of this encounter?

The case of the Cubans is quite opposite. It is a new wave of immigrants expelled by the Castro regime, and one that is largely middle class: lawyers, doctors, businessmen, technicians, professors, engineers. They did not have to leap into modernity; they were already modern. That, and their immense vitality, alert intelligence, enterprise, and capacity for hard work help to explain their rapid and successful integration into American life. It is unfair to compare the Cubans to the Puerto Ricans; the Cuban immigrants had, from the start, an advantage that many of the Puerto Ricans lacked—a modern culture. Nevertheless, the achievements of the Puerto Ricans are hardly insignificant. One of them, in fact, is extraordinary and worthy of all our admiration: not only have they preserved their national character, but they have revitalized their culture.

The differences imposed by geography, blood, and class are also the differences of historical times. The peasant from Oaxaca who has immigrated to the United States does not come from the same century as the journalist from Havana or the worker from San Juan. But one thing unites them: they are outcasts of history. The Mexicans belong to a country in which various civilizations have raised pyramids, temples, palaces, and other magnificent constructions, yet it has not been able, in this century, to house all of its own children; the Cubans and the Puerto Ricans—fragments of a great dismembered empire, Spain—have been the object of American imperial expansion, and now, for the Cubans, of Russian. (The day when democracy and freedom truly prevail in the Americas will be when the division and atomization of the Antilles and Central America ceases to be.) The other groups of Hispanics who come from Central and South America are also fugitives from history. We Latin Americans are still unable to create stable, prosperous, and democratic societies.

No matter how terrible and powerful the reasons for leaving their countries, the Hispanics have not broken their ties with their places of origin. No sooner had Castro allowed the exiles to visit their parents and relatives in Cuba than the island was full of visitors from Miami and other places. The same has occurred with the Puerto Rican and Chicano communities. In the north of Mexico and in the south of the United States there is now a subculture that is a mixture of Mexican and American traits. This geographical proximity has fostered exchange and, at the same time, strengthened the bonds of the Hispanic communities with their native places. It is a fact that is full of future; communication between the Hispanic minority and the Latin American countries has existed and will continue to exist. It is inconceivable that it will ever be broken. It is a true community, neither ethnic nor political nor economic, but cultural.

In sum, what seems to me particularly notable is not the diversity of the Hispanic groups and the differences among them, but rather their extraordinary cohesion, a cohesion not expressed politically, but in collective acts and attitudes. North American society is founded on the individual. The origin of the preeminence of the individual as a central value is twofold, as I have noted; it comes from the Reformation and from the Enlightenment. Hispanic-Catholic

society is communal, and its nucleus is the family, that small solar system that revolves around a fixed star: the mother. The predominance of the maternal image in Latin American society is no accident; it is a confluence of ancient Mediterranean female divinities, Christian virgins, pre-Columbian and African goddesses: Isis and Mary, Coatlicue and Yemanyá (who is venerated in Cuba as the Copper Virgin and in Brazil as Saint Barbara). Axis of the world, wheel of time, center of motion, force of reconciliation, the mother is the fountain of life and the storehouse of religious beliefs and traditional values.

Hispanic-Catholic values express a vision of life quite different from what prevails in North American society, where religion is above all a private matter. The separation between public and private, family and individual, is less clear and emphatic among the Hispanics than among the North Americans. The ethical foundations are the same; both are part of the Christian heritage. Nevertheless, the differences are marked; in the two versions of the North American ethic, the Puritan and the neohedonist, the prohibitive and the permissive, the center is the individual; in Hispanic morals the true protagonist is the family. This primacy of the family is not entirely beneficial. The family is a priori hostile to the common good and general interest. Family morals have been and continue to be opposed to generous and disinterested actions (one need only recall various evangelical condemnations). The root of our apathy and passivity in political matters, as well as the patrimonialism of our leaders—with their nepotism and corruption—is the family's egotism and narrow vision. Moreover, precisely because the individual is confined to a more constricted space, individual action often becomes manifest in two equally pernicious ways: strict order and violent rupture. Cohesion and dispersion: the partriarch and the prodigal son, Abraham and Don Juan, the political boss and the lone sniper.

The continuity of these traditional models of living together is not, of course, entirely explained by loyalty to one's own culture and the influence of the family. Persecutions, inequalities, humiliations, and daily injustices have also been decisive factors in the strengthening of the cohesion of the Hispanic communities. This is especially apparent in the cases of the Puerto Rican and Mexican minorities, constant victims of discrimination and other indignities. To these circumstances one must add another, equally powerful one, with its economic ramifications: the difficulty in obtaining higher education. All of this—culture, tradition, and communal cohesion, as well as discrimination—has influenced the state of the intellectual and artistic achievements of these groups. The Hispanics have excelled in painting, music, and dance; on the other hand, they have not produced notable writers. It is not difficult to understand why. Language is the soul of a people; in order to write works of the imagination—poetry, fiction, plays—one must transform the language in which one wants to write. This is what Melville, Whitman, and the other great writers did with English: they planted themselves in America, and they transformed the language. The Spaniard George Santayana wrote in a prose that is admirable for its transparency and elegance—a prose that, at heart, had little to do with English—but he had to sacrifice his life as a poet. On the other hand, in the visual arts—painting and sculpture above all—the Hispanics have expressed themselves with energy and delight. Not because the genius of the community is visual

Arnaldo Roche. *The Source,* 1986. Oil on canvas, 72 × 60". Jose E. Rovira.

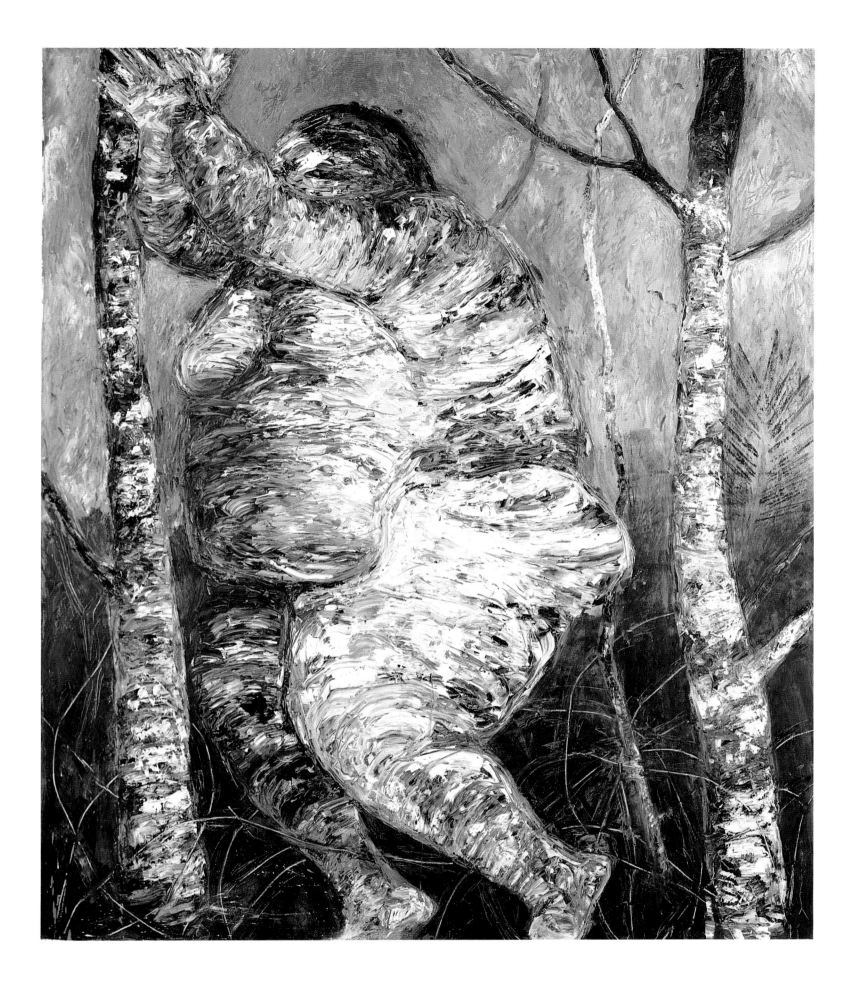

rather than verbal, but for the reasons I have outlined above. The visual image *speaks,* but what it says does not need to be translated into words. Painting is a language sufficient unto itself.

Art and Identity

This book and the exhibition of contemporary Hispanic art that it documents provide an excellent opportunity to *hear* what the Hispanic artists are saying. To hear them with our eyes and with our imagination. Gathered together here is the work of thirty artists. Some of them have already achieved renown, but most are little known, both to the critics and to the general public. In this sense, the book and exhibition constitute a true act of discovery. I do not propose to talk about the artists themselves: it is not the intention of these comments, nor have I the authority to do so. Moreover, I think it is impossible in an essay such as this to evalute thirty artists effectively. One need only read the chronicles of Baudelaire and Apollinaire on the "salons" of their time to realize that no one, not even the greatest, escapes the vices of that genre of writing: polite vagueness, flip generalization, smatterings of insipid praise, and peremptory dismissal. On the other hand, these two great poet-critics were nearly always on target when they were talking about the specific artists who corresponded to their own tastes. A good critic is born from sympathy and a wide exposure to the work.

Although I cannot and do not want to speak of the artists presented, I can venture an opinion on the selection of works represented here. That selection has been exacting but wise, resulting in a collection both rich and diverse, one that frequently startles. Here is a living, restless, changing reality. The majority of these artists—contrary to the general tendency in contemporary art—do not paint as a "career" but rather out of an inner necessity. More precisely, they paint out of an inner necessity to affirm and express themselves to an external reality that often ignores them. It is impossible to forget that many of these works were made far from the artistic centers of the country, in isolation, poverty, and distress. This is not an exhibition of people satisfied with what they have found, but rather of artists who are searching.

It is no coincidence that the exhibition opens with the colored drawings of Martín Ramírez. He is neither a precursor nor a predecessor: he is a symbol. While he lived he was completely unknown; he was discovered in 1970, ten years after his death. Ramírez was born in 1885 somewhere in the state of Jalisco, probably in a small village. He worked for a while in the fields and later in a laundry; at the beginning of the century, half dead from hunger and in the midst of the Mexican Revolution, he immigrated to the United States. Like many of his countrymen, he became an itinerant laborer on the railroads, but he had to stop working when he began to suffer from hallucinations and mental confusion. Although it is difficult to reconstruct his comings and goings, it is known that around 1915 he completely stopped speaking. He wandered aimlessly for a number of years, sometimes working and sometimes living off charity, until in 1930 the Los Angeles authorities picked him up in Pershing Square, among the vagabonds and beggars who congregated there. The medical report was

Martín Ramírez. *Untitled* (Jesus), c. 1950s. Crayon on paper, 33½ × 20″. Collection of A. Dennis Kyte and Seymour Surnow.

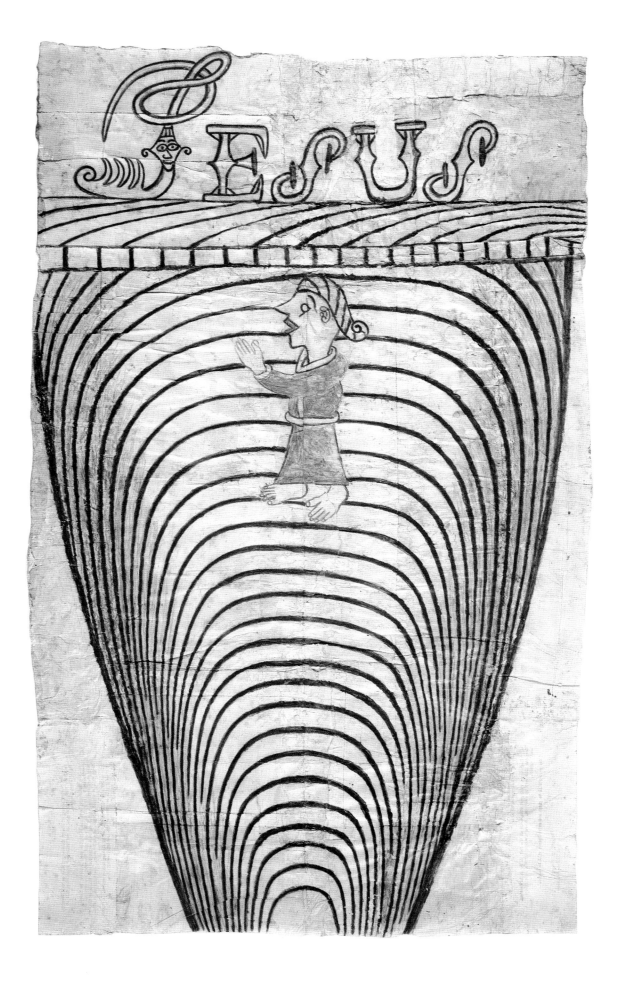

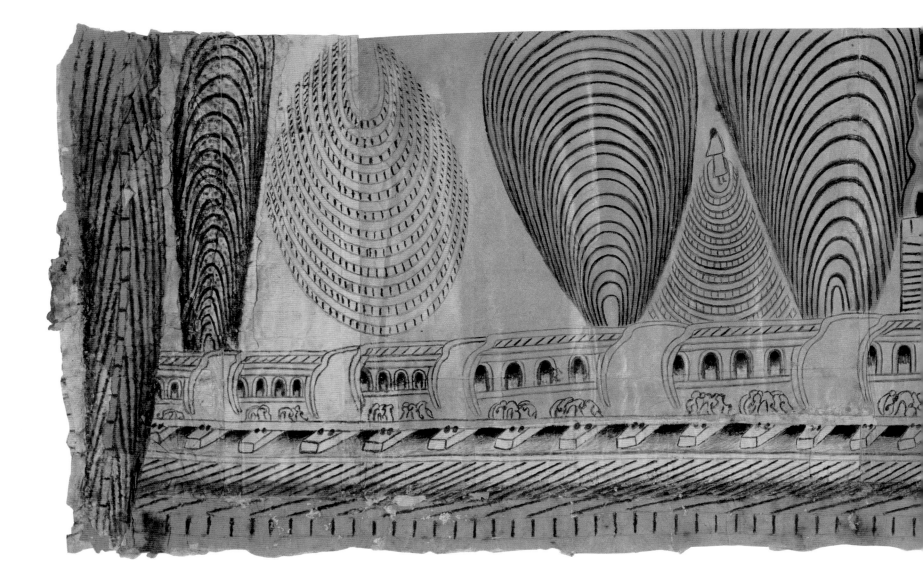

Martín Ramírez. *Untitled* (Tunnels and Trains), c. 1953. Pencil, tempera, crayon on collaged paper, 24½ × 79¼″. Jim Nutt and Gladys Nilsson.

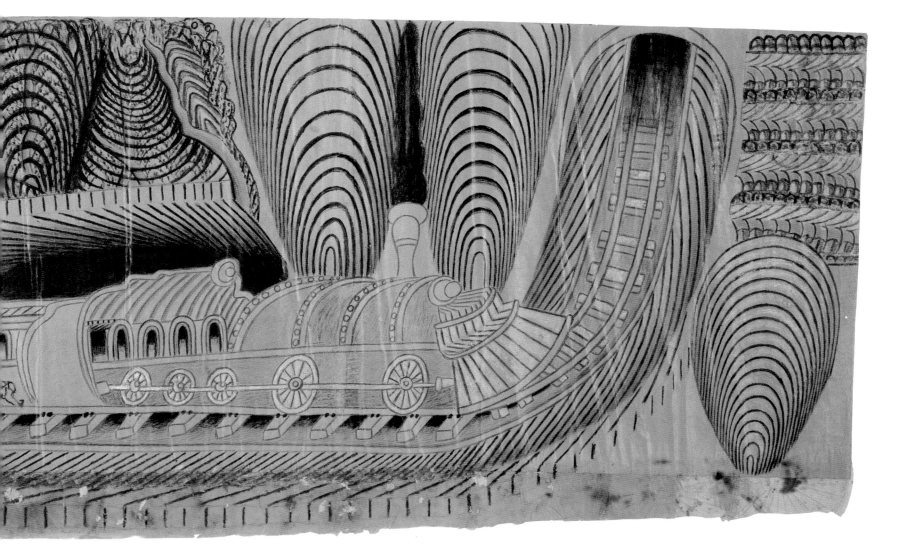

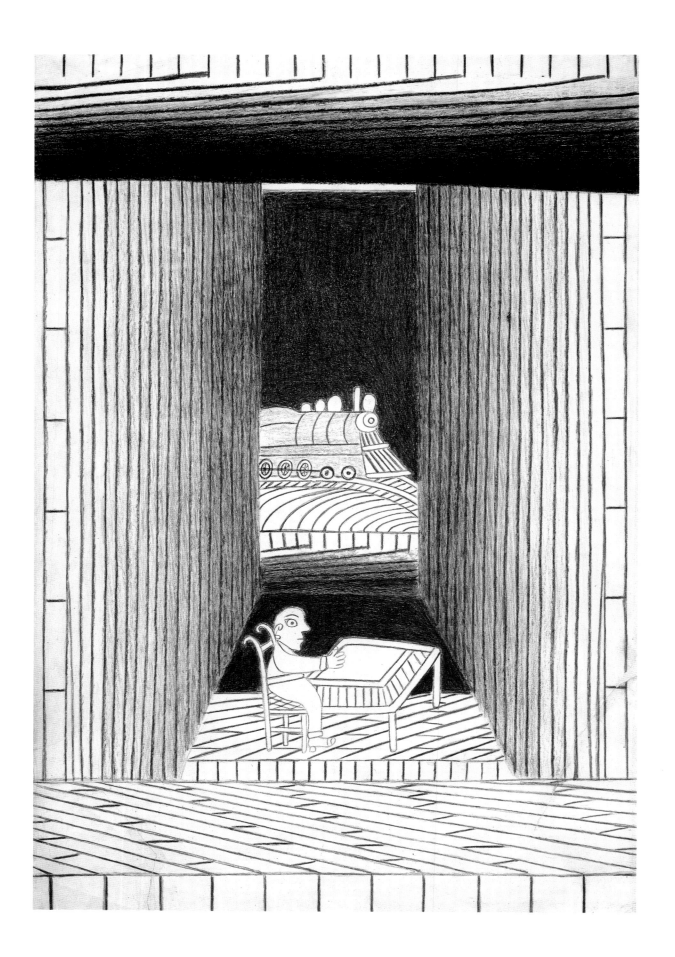

hopeless: incurable paranoid schizophrenia. He was placed in a state institution, DeWitt Hospital, where he lived for the thirty years until his death in 1960.

Ramírez never regained his speech, but around 1945 he began to draw with colored pencils, a decision that is a code to his situation and the key to his artistic personality. He renounced the word but not self-expression. He drew secretly; for the wardens, in order to keep the rooms tidy, destroyed the work of inmates. A few years before his death, he had the good fortune to be discovered by a psychiatrist, Dr. Tarmo Pasto, who became his guardian angel. One day, as the doctor was visiting the hospital with his students from the university in Sacramento, Ramírez approached him and handed him a roll of drawings that he was carrying hidden under his shirt. After that the doctor saw him often, giving him as much paper, colored pencils, and other supplies as he needed. He understood immediately, with rare insight and even rarer generosity, that this patient was an important artist. Pasto collected many of Ramírez's works and later showed them to various artists, among them Jim Nutt and his wife Gladys Nilsson. With another friend, the art dealer Phyllis Kind, they organized the first exhibition of Ramírez's work in Sacramento, which was followed by shows in Chicago, New York, London, and other cities.

The temptation to see Ramírez's work mainly as an example of "psychotic art" is easily resisted. In the first place, it is unclear—and will never be clear—what is meant by the term. Moreover, art transcends—or, more exactly, ignores—the fragile distinction between health and madness, as it ignores the differences between primitive and modern. In the case of Ramírez, without denying his psychic disorders, what interests us is the artistic value of his work. The English critic Roger Cardinal, who has written about Ramírez with acumen and sensitivity, emphasizes the purely visual and plastic (and also poetic) characteristics of his drawings and compositions (See *Vuelta* 112, March 1986). These qualities are not present in other artists who were also victims of mental disorders. The world of Ramírez—because his work *shows us a world*—is full of objects that are easy to recognize because they are versions, though somewhat distorted, of reality. We can imagine that these images were simultaneously both icons and talismans. They commemorated his life experiences and protected him against demons.

The compositions of Ramírez are evocations of what he lived and dreamed: a cowboy with cartridges across his chest mounted on a spirited horse (like so many of the bandits or guerillas he would have seen in his youth, during the Mexican Revolution), an endless aqueduct, a village church, a smoking locomotive crossing a stony landscape, bridges, cities, parks, women, and more women: the enigmatic figure of primordial reality, the feminine image of the origin in which the attributes of the Virgin of Guadalupe combine with others, more ancient, like the serpent of Isis and the crown of sun rays. These works do not make us think of the four walls that enclosed the schizophrenic, nor paranoia's hall of mirrors. They are resurrections of the lost world of his past, and the secret roads that led to another world. What was that other world? It is impossible to know. The road that took him is mysterious, a tunnel with its mouth of shadows, a sexual and prophetic mouth from which visions issued

Martín Ramírez. *Untitled* (Proscenium Image), c. 1953. Pencil, tempera, and crayon on paper, 36 × 24″. Jim Nutt and Gladys Nilsson.

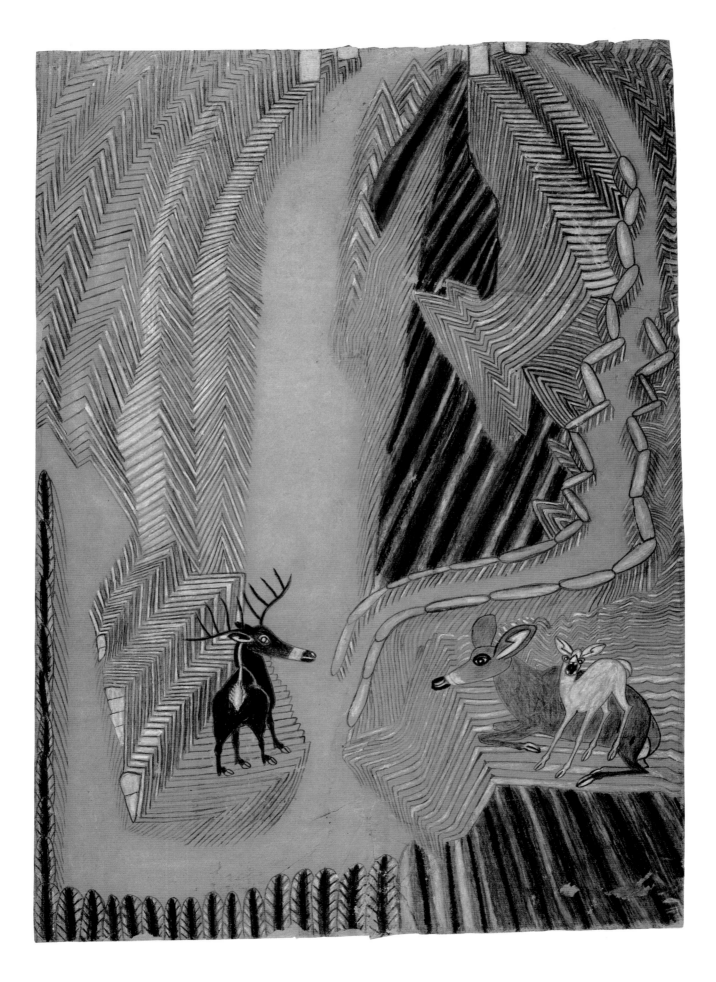

forth, and through which the artist descended in search of a way out. These works recount a pilgrimage.

Looking at Ramírez's work, I thought of another extraordinary artist, Richard Dadd. But the two cases are quite different. Dadd was an artist who became mad; Ramírez was a madman who became an artist. In the asylum, Dadd remembered that he was a painter and then created various memorable pictures, the best of his work; in the hospital, Ramírez discovered art, and it served him as an escape from his self. Cardinal points out correctly that his autism was not total. On a few occasions he came out of his isolation, as when he approached Dr. Pasto to show him his work, and when he allowed himself to be photographed in a room of the hospital, with the doctor and one of his compositions. The very fact of drawing and painting is a break from autism, a communication. But it is an encoded communication. In the compositions of Ramírez, the twofold demands of art are fulfilled: to be a force for the destruction of current communication and to be the creation of another communication.

Dr. Pasto stated that, at least in part, Ramírez's mental disorders were a reaction to a strange and incomprehensible culture. One must add that he left Mexico at a tumultuous and violent time. Thus his life embodies the twin currents that determined all of his activities. In his escape from Mexico there is the motion of flight that soon took on an extreme and delirious form—paranoia; in his silence and in his breaking of relations with the outside world, the contrary current triumphed—schizophrenia. But paranoia and schizophrenia are names, headings, classifications; psychic reality is always beyond names. One cannot forget, moreover, that Ramírez's art transcends these contradictory currents. It is a communication, but it is a symbolic communication, a code that we must decipher.

Ramírez is an emblem. The contradictory currents that animated his life—an immersion in the self and an escape toward the outside, toward an encounter with the world—dramatically portray the situation of the Hispanic communities. Of course, Ramírez is a case, an anomaly, but that anomaly is a metaphor for the condition of the Hispanic artist. Needless to say, although the condition is general, the responses to it are individual. Each artist confronts the situation in a different way, and each response, if it is authentic, is unique and unrepeatable. The responses of some of the artists have religious and traditional roots; they paint images of Hispanic-American popular syncretism, although their sensibility and their media are contemporary. For others, the religious is not in the forms and the figures they paint, but rather in their attitude to the human image: they almost never *describe* it, as North American artists do, but rather exalt it or mutilate it—in either case, transfiguring it. Other works are a violent response to the violence of modern urban life; still others are satires of street life or an attempt to capture everyday wonders, a great tradition in twentieth-century art. Some of the artists, finally, are searching for the marvelous not in urban landscapes but by returning to the origins, to the lands of the old Afro-Cuban myths and the saints and virgins of Mexican Catholicism. Satire, violence, blasphemy, veneration: forms, lines, volumes, and colors that express with a sort of exasperation the twin forces of separation and participation.

Martín Ramírez. *Untitled* (Family of Deer), c. 1950s. Pencil and crayon on brown paper, 33½ × 23¼". William H. Plummer.

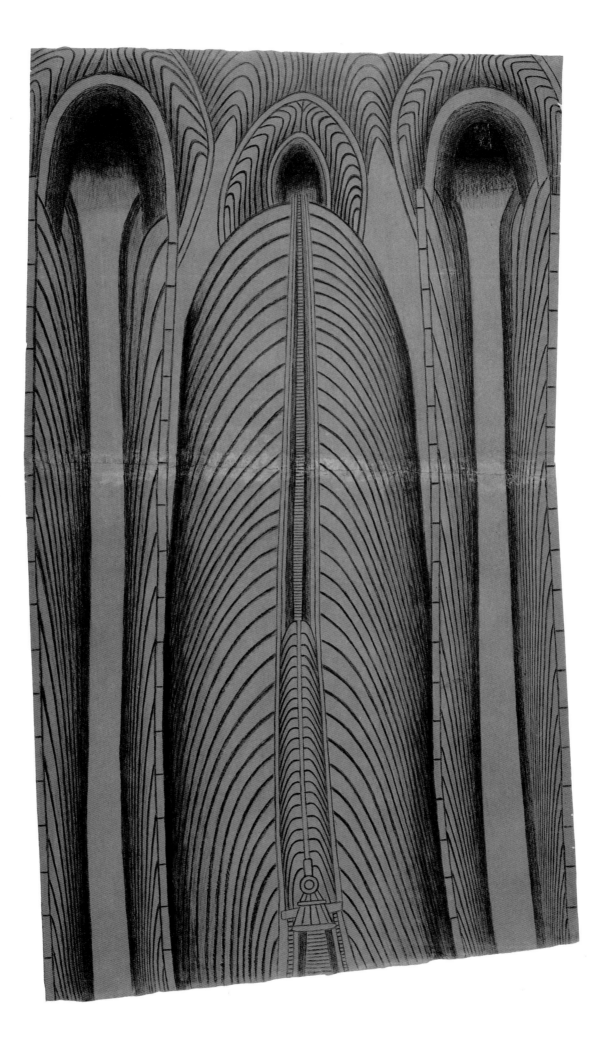

The image of the tunnel and its mouth is another emblem of Hispanic art. The mouth of the tunnel is the place of apparitions and disappearances. Consciousness descends the shadowy stairs toward the blind kingdom of the origin, the source of the beginning; and, in the opposite direction, the buried images climb in search of the sun. In the history of twentieth-century art, the obsession with the image that comes from the depths characterizes, above all, the Surrealists. Prominent among them are two Latin Americans, Matta and Wifredo Lam, as well as a painter with close ties to the group, Rufino Tamayo. The three are great thaumaturges, masters of the art of conjuring phantoms. The relation between the surrealist *image* and the *phantasma* of the Neoplatonic philosophers and artists of the Renaissance has not yet been fully elucidated. But it is obvious. Modern criticism has increasingly recognized a subterranean current in our tradition, one that was born in the Neoplatonism and hermeticism of Florence in the fifteenth century, nourished various spiritual and artistic movements such as Romanticism, and surfaced in the twentieth century as Symbolism, Surrealism, and other movements. Even a quick walk through this exhibition of Hispanic artists will reveal that their work has no deep affinities with photo-realism, Minimalism, Pop Art, Neo-Expressionism, and other tendencies of the last twenty years. They do, of course, have relations with various North American artists and with others who live in the United States, such as David Hockney, but their vision of the human figure possesses a more secret and profound kinship with the tradition represented in Latin America by a Matta or a Lam. Their images sprout from the shadow of the mouth of the tunnel.

For the ancients, the *phantasma* was the bridge between the soul, prisoner of the body, and the exterior world (worlds). For the surrealist poet and painter, the oneiric image is the messenger of the inner man. Poetry and art allow that prisoner, transfigured, to escape: to escape to desire, and to the imagination buried from the first day by prohibitions and institutions. The apparition of these images in the works of the Hispanic artists is disturbing. They are hieroglyphs of vengeance, but also of illumination, poundings on a closed door. Their paintings are neither metaphysics nor the knowledge of inner man nor poetic subversion, but rather something more ancient and more instinctual: icons, talismans, altars, amulets, effigies, travesties, fetishes—objects of adoration and abomination. The *phantasma* is, once again, the mediator between the world of *here* and the world of *there*. How can one not see in these works another face of North American art? A face still undrawn, but whose traces are now discernible. An art of the image not as a form in space but as an *irradiation*.

Translated by Eliot Weinberger

Martín Ramírez. *Untitled* (Tunnels and Trains), c. 1950s. Pencil and crayon on brown paper, 66 × 36". Private collection.

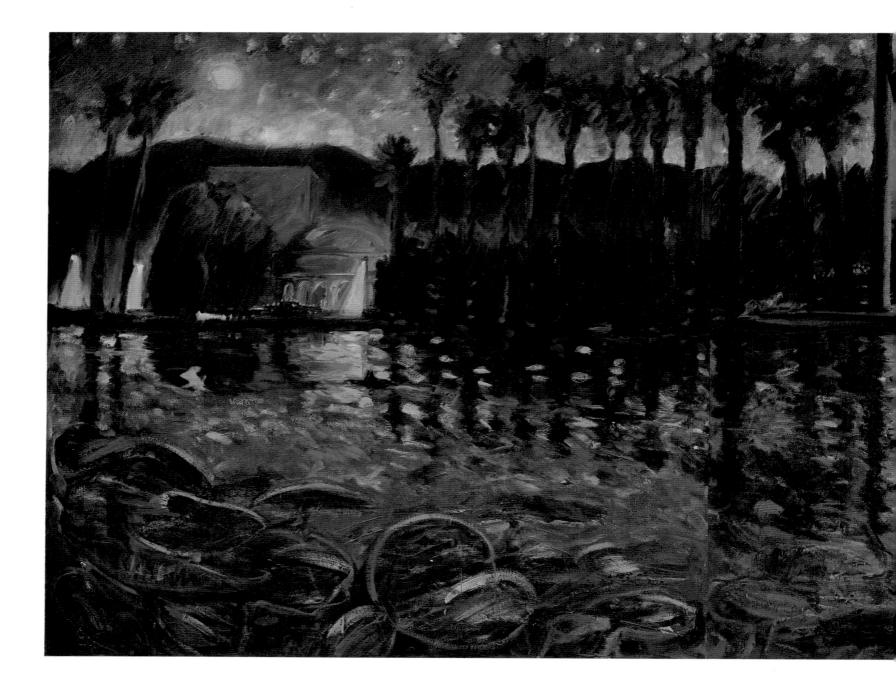

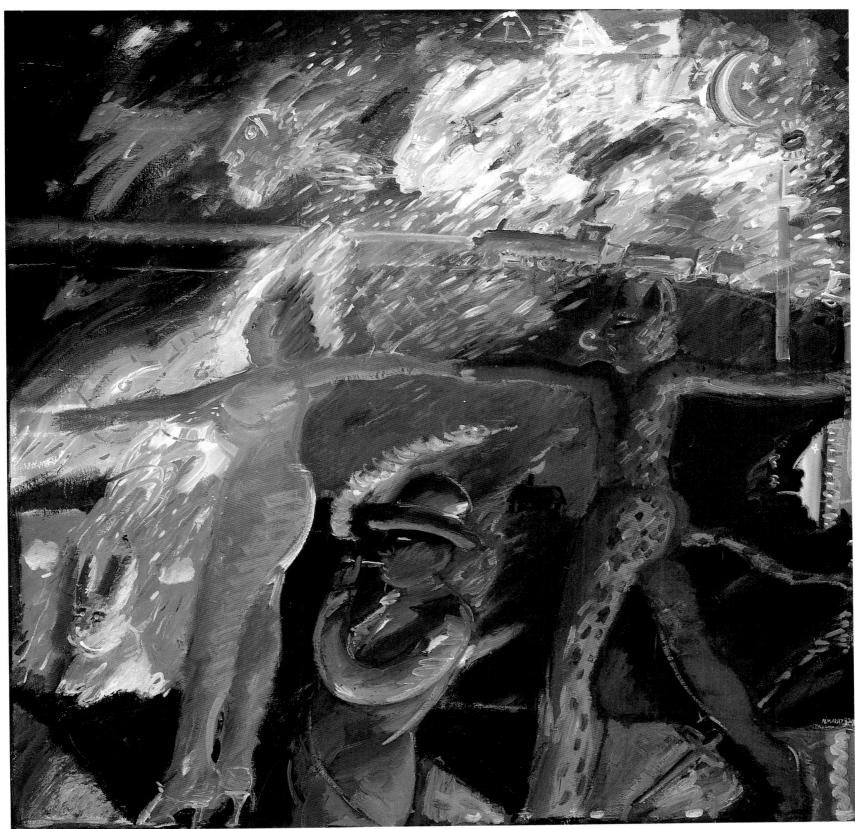

Carlos Almaraz. *Europe and the Jaguar.* 1982. Oil on canvas, 72 × 72". Courtesy of Locus Gallery. San Antonio.

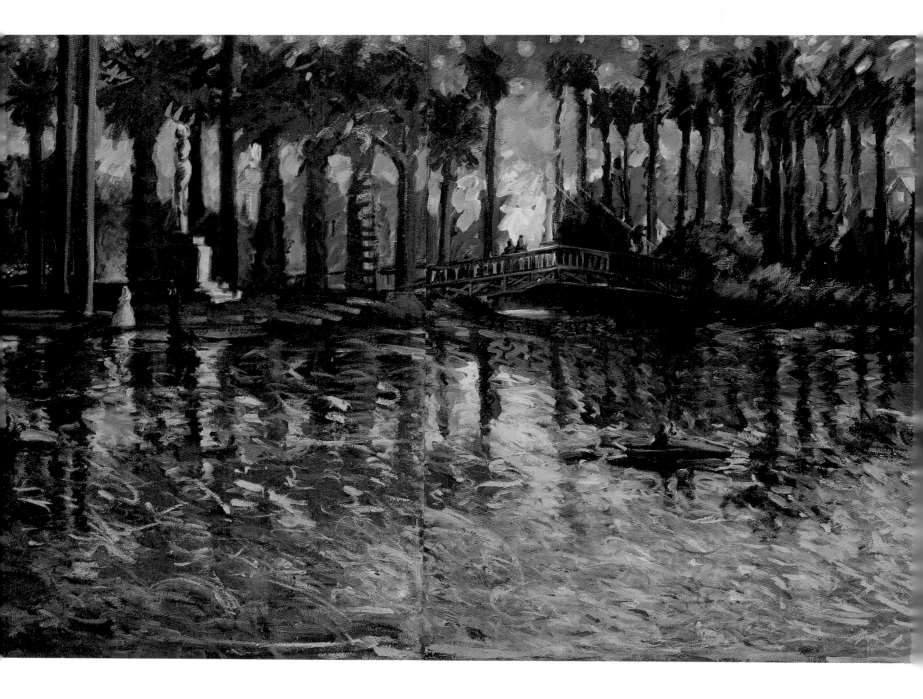

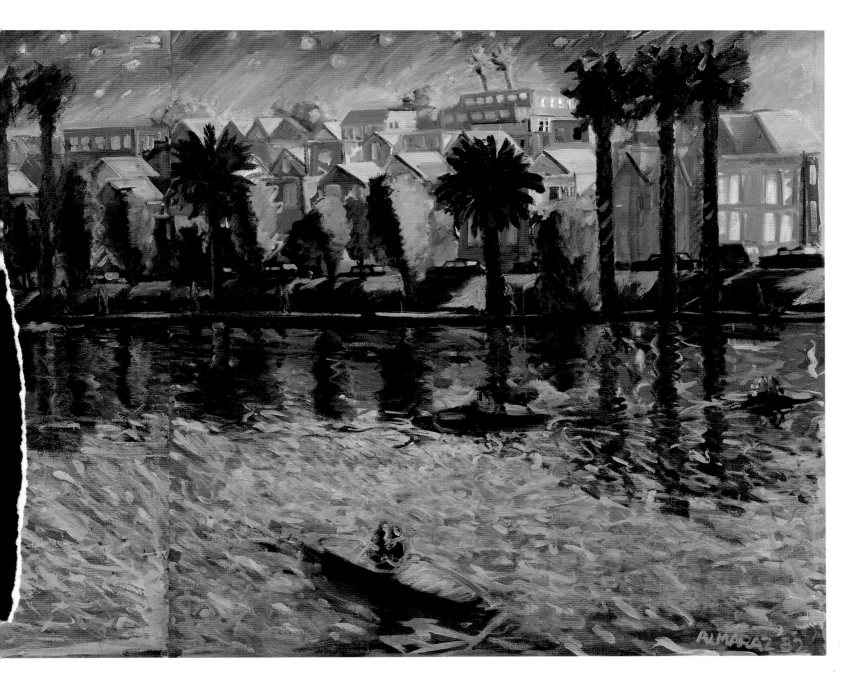

Carlos Almaraz. *Echo Park Lake #1–4*, 1982. Oil on linen, four panels, 72 × 72" each. #1 Courtesy of Jan Turner Gallery, Los Angeles; #2 and #3 Collection of Paul, Hastings, Janofsky & Walker, Los Angeles; #4 Mark Bautzer, Los Angeles.

AND/OR: HISPANIC ART, AMERICAN CULTURE

JOHN BEARDSLEY

In the years to come, the many efforts that have been made to define a single, overarching American style in art may come to seem quixotic and not a little futile. From our beginnings until well into this century, we relied heavily on European models, and the differences between American art and its various antecedents in Europe seemed less important than the similarities. Even as our art, in the post-World War II years, began more to affect than be affected by Europe, the geographical spread of our nation and the proliferation of our peoples mitigated against a single look in American painting, sculpture, and architecture. Moreover, the history of art provides many examples of national and regional differences in style, enough to make differences seem more like the rule than the exception. Renaissance art in Germany and the Low Countries,

to cite but one instance, is quite distinct from Renaissance art in Italy; even within Italy, we are accustomed to differentiate a Florentine style from a Venetian one.

Nonetheless, our artists, no less than our art and cultural historians, have long participated in the effort to define a prevailing style. The artists and architects who met in Chicago to plan the World's Columbian Exposition of 1893 did so with the intent of providing a blueprint for the production of the ideal in American painting, sculpture, architecture, urban planning, and landscape architecture. Although the strength of this American Renaissance, as it came to be known, was on the wane by World War I, another and vastly different style did achieve the appearance of national hegemony in more recent years. The completeness with which American art came to be synonymous with first gestural and then geometric abstract painting and sculpture on the one hand and Bauhaus-derived, International Style architecture on the other, must have

Carmen Lomas Garza. *Abuelitos Piscando Nopalitos*, 1979–80. Gouache on Arches paper, 11 × 14″. Collection of Richard Bains, San Francisco.

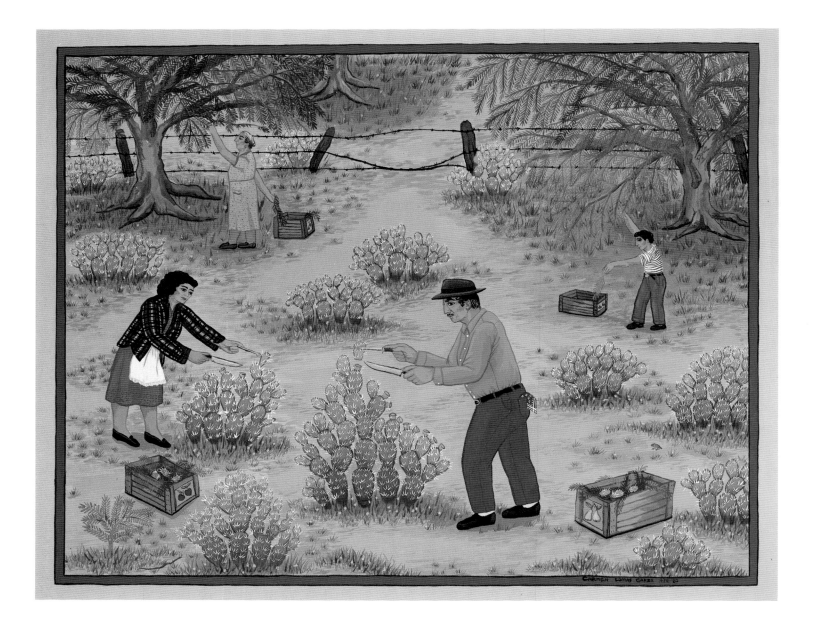

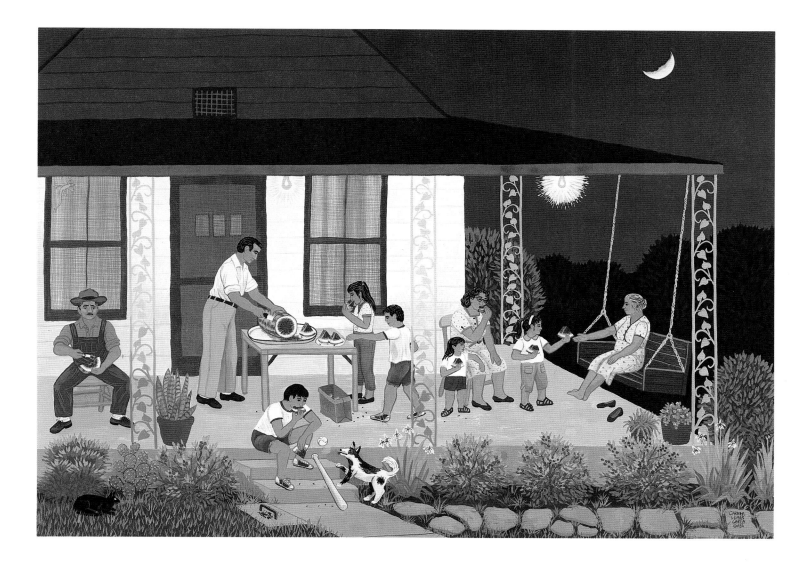

Carmen Lomas Garza. *Sandía/Watermelon,* 1986. Gouache on Arches paper, 20 × 28". Collection of the artist.

made it seem, in the 1950s and the first half of the 1960s, that an aesthetic consensus had at last been achieved. Certainly, the notions that American art could be many things simultaneously and that it might be invigorated by alternative—and particularly ethnic—traditions were then very much in retreat.

In recent years, for reasons that will be the focus of the first part of this essay, the idea that enduring ethnic distinctions could be a creative force in our culture has won a measure of acceptance. The Smithsonian Institution's Festival of American Folklife and the National Heritage Fellowships administered by the Folk Arts Program at the National Endowment for the Arts, not to mention the folklife programs at the Library of Congress and various universities, have all contributed to an appreciation of the traditional crafts and folk art of various ethnic groups. In a more cosmopolitan realm, however, the position of the ethnically conscious artist remains considerably more problematic. There seems to be an unwritten presumption that the nearer an artist aspires to the level of high art, the more leached out will become the ethnic content of the work. While this is often the case, it does not seem to have the validity of

universal law. The second part of this essay will explore the different ways that painting and sculpture of the first rank can be made of traditions, subject matter, and styles that separate themselves somewhat from the often uniform and seemingly arbitrary dictates of taste that we routinely accept as mainstream. If, as we noted in the preface, the artists exhibited here do not comprise a Hispanic school, then neither are they necessarily alike in how—or how much—their particular cultural heritage surfaces in their work. Yet, taken together, they provide the basis for investigating the degree to which an enduring sense of ethnic distinctiveness can enter the legitimate territory of high art. Indeed, it may be that ethnicity, along with other forms of regional or cultural particularity, can now be perceived as one of the primary ingredients in the alchemy that is good art.

In taking ethnicity as part of their subject, this book and the exhibition it documents are both an expression of and a contribution to the continuing debate over what measure of ethnic identification, if any, is most desirable in our society. It has long been expected, even hoped, by many that the patchwork of peoples who settled this land would eventually form a seamless fabric. The failure of this to occur has in the past several decades become the subject of serious inquiry among scholars of immigration and ethnic history. The metaphor of the melting pot was replaced in the work of one writer with that of the wave, with troughs and crests in the history of ethnic self-consciousness.[1]

Although it may now be evident that we have not blended into a homogenous whole, it is still unclear whether or not this was ever an appropriate and achievable goal, and whether or not it might ever be so again. The promise of assimilation was never unambiguous: from one point of view, it seemed to offer complete equality through the elimination of prejudice and discrimination; from another, it merely deprived people of a sense of self-identity while denying them the full benefits of membership in society. Despite several decades of improvement, it is still not always apparent that the fruits of our society are available equally to people of every race and both sexes. From this perspective, ethnicity confirms our failure to redeem everyone from economic and educational disadvantage. It can arise unself-consciously among the truly isolated, as is the case with such artists as Gregorio Marzán, Felipe Archuleta, and with Martín Ramírez, who was doubly exiled, both culturally and psychologically.[2] It can also surface volitionally, as an expression of resistance to the dominant group, a phenomenon that will be examined in this text for its importance in the emergence of Chicano art in California and Texas especially.

A willingness to assimilate would seem to require a sense of what it is to which a person is assimilating. This, too, has never been terribly clear. Inasmuch as we have a unifying culture now, it is one that is conveyed—even, it seems at times, determined—by the mass media and the advertising industry. It is little wonder that we have seen in the past two decades a resurgence in the will to resist a unified national identity, as one of its traits has come to seem more and more like the tyranny of conformity to the lowest common cultural denominator.

Those who have sought an alternative to assimilation have found a countervailing doctrine in pluralism. Originally a philosophical concept, it was given its initial currency in this country by William James, first in *The Will to Believe*

César Martínez. *Bato con Sunglasses*, 1985. Acrylic on canvas, 47 × 40". Collection of the artist.

Overleaf:
Ismael Frigerio. *The Loss of Our Origin*, 1985–86. Tempera and acrylic on burlap, two panels, 84 × 144" overall. Collection of the artist.

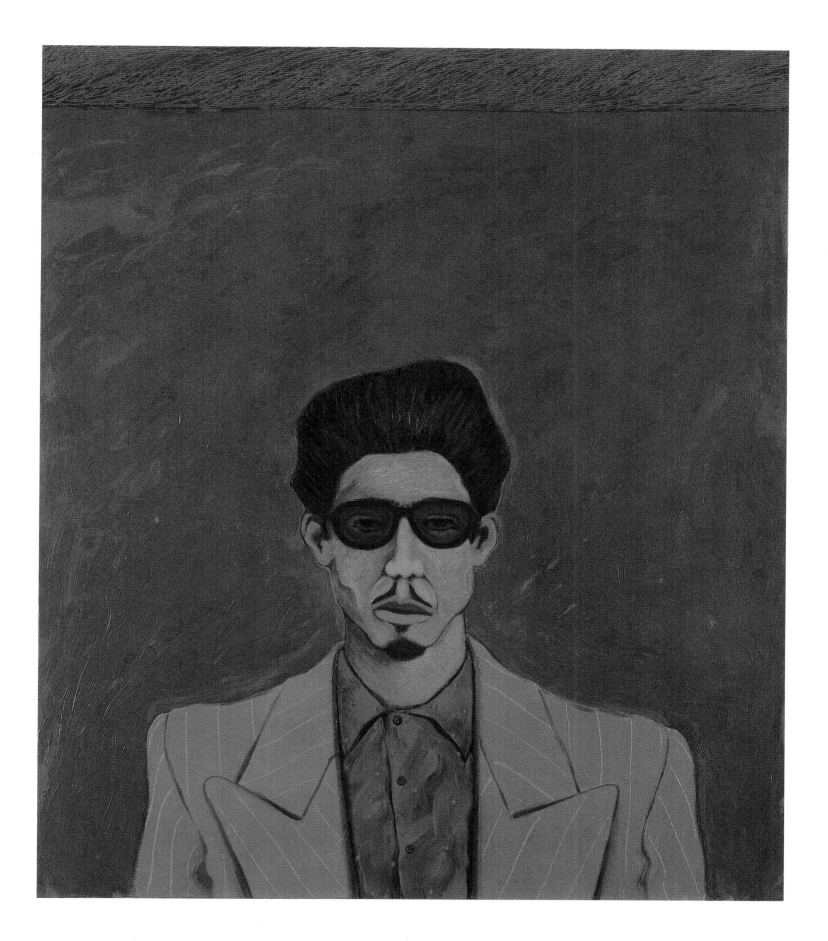

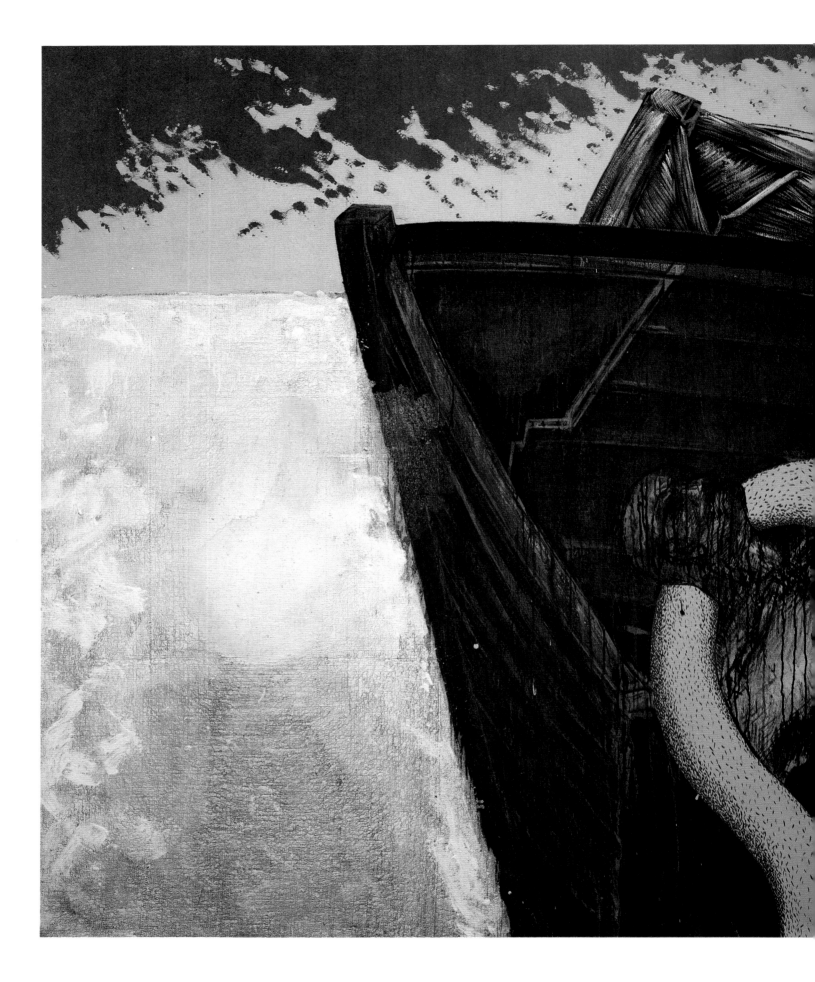

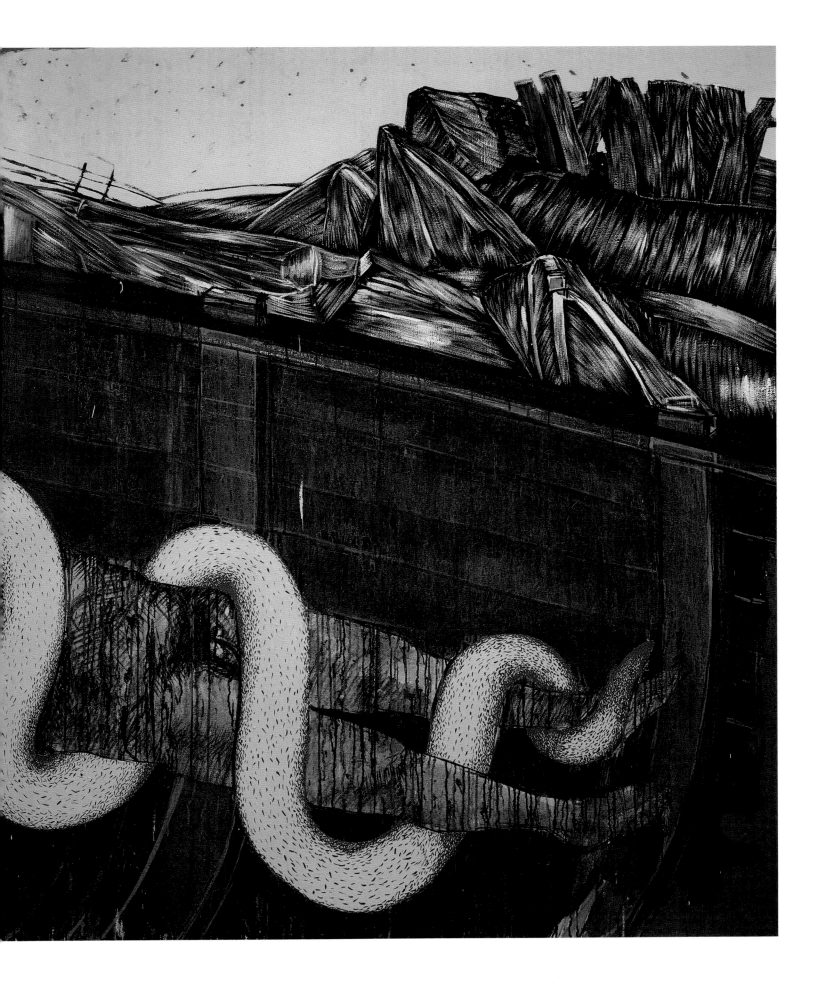

(1897), then more extensively in *A Pluralistic Universe* (1909). It was a student of James's, Horace Kallen, who applied this notion to his observations of American society and coined the term "cultural pluralism." Going far beyond a plea for the recognition and tolerance of diversity, Kallen would be rebuked by many critics for, among other things, suggesting that a person's "psychophysical inheritance" was inalienable and for proposing Switzerland as a model for the evolution of the United States into a federation of different national groups (something one commentator suggested would "result in the Balkanization of these United States").[3]

Among other scholars, the pluralist idea would subsequently receive considerable modification. Oscar Handlin acknowledged that ethnic groups "provided the means for satisfying significant personal and emotional needs" and "tended to hold together those who might otherwise be cast adrift without direction," but only as long as participation in the group was "not restrictive, authoritarian, and exclusive." As he later put it, the ethnic group could help a person "assert his distinctive individuality if he wishes to do so." Cultural inheritance, to Handlin, was not inescapable.[4]

In the turbulent years that began in the middle of the 1960s, the pluralist idea enjoyed its greatest vogue; by the middle of the 1970s, its popularity led to renewed criticism of the original notion and dissent from some of its contemporary manifestations. Most importantly, it was argued that pluralism failed to describe the common values that would unite us in our diversity and that the cultural differences endorsed by pluralism could not only flow from but could also reinforce social inequities.[5] Yet virtually no one rejected pluralism outright. Even critics of the notion have sought a middle way, one that recognizes diversity as a given in American culture but seeks to dissociate it from intolerance and to reconcile it with the need for some measure of national consensus. John Higham has found his unifying faith in a concept he terms "pluralistic integration," in which "both integration and ethnic cohesion are recognized as worthy goals, which different individuals will accept in different degrees."[6] In its suggestion that there is a middle ground between full assimilation and full ethnic particularity, Higham's pluralistic integration embraces ambiguity, hybridization, and inclusiveness, while calling for a reexamination of those values that might hold together an increasingly kaleidoscopic culture.

The debate, then, over the most desirable measure of ethnic self-identification is far from over. Yet despite the limitations of the original notion and the excesses committed in its name, some variation of the pluralist idea—perhaps Higham's —seems destined to become the prevailing model for ethnic relations in our society. We seem to be making peace with and even coming to appreciate the fact that many Americans will continue to take comfort and pride in their sense of kinship with an alternative tradition or national identity long past the second or third generation of family presence in the United States, the time when such feelings have traditionally been expected to wane, without experiencing any diminishment of their Americanness.

The life of this debate is reinvigorated with the appearance of each new group on American soil. It has derived a special measure of strength from the Hispanic presence: not only are they among the first settlers of this country, but their

Luis Cruz Azaceta. *Homeless*, 1986. Acrylic on canvas, 120 × 84″. Allan Frumkin Gallery, New York.

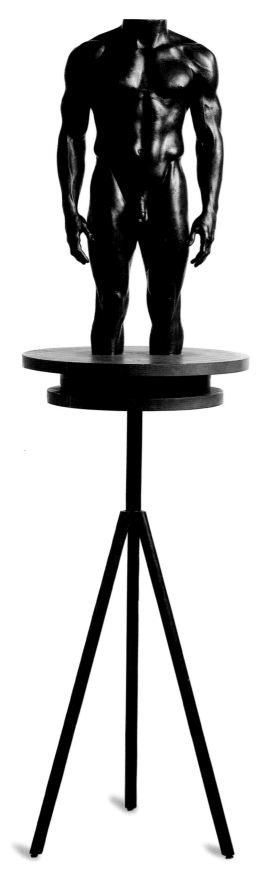

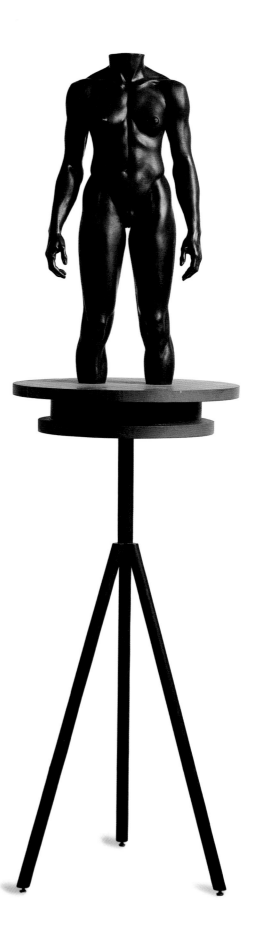

Robert Graham. *Olympic Torso, Male,* 1983.
Cast bronze, 27 × 12¼ × 6½″; base 40 × 18″
diameter. Courtesy of Robert Miller Gallery,
New York.

Olympic Torso, Female, 1983. Cast bronze,
27 × 12 × 6″; base 40″ × 18″ diameter.
Courtesy of Robert Miller Gallery, New York.

Jesús Bautista Moroles. *Spirit Inner Column
#1,* 1985. Dakota granite, 77 × 8 × 6½″.
Courtesy of the artist and Davis/McClain
Gallery, Houston.

numbers are growing and their culture seems destined to have an increasing impact on the United States. We are somewhat accustomed to viewing art as a reflection of social, economic, and historical forces; indeed, art often does register the tremors of an age. What is less familiar but no less true, however, is that art can serve as a model, as a signpost to the future. The balance of this essay will address the various ways and the differing measures in which these artists have sustained a sense of their distinctiveness despite the pressures of assimilation and mass culture. These ways include, among other strategies, the continuation or revitalization of alternative traditions; the depiction of historical subjects or those drawn from daily life; and the deployment of competing, often "underground" styles. How these artists have reconciled their particular ethnic heritage with their desire to participate in the larger life of American art should be a source of comfort if not inspiration to the student of American ethnicity.

It is a truism, but one that bears repeating, that ethnic groups are themselves pluralistic. Perhaps in no case is this as pronounced as it is among those who are collected in this country under the term *Hispanic*. American Hispanics are less a people than an agglomeration of peoples: Mexican Americans, Cuban Americans, Puerto Ricans, and numerous others of Central and South American origins, as well as the descendants of the original Spanish settlers of the Southwest. Even among these subsets there is considerable diversity: while there is a tendency to equate Chicano with Mexican American, for example, to many the terms designate people with different points of view on a range of cultural and political issues. Mexican Americans can be separated into those who are descended from settlers who arrived in the land long before it was part of the United States, those who arrived in the mass exodus that followed the Mexican Revolution, and those who are recent emigrés—and these last can be further divided into the legal and the illegal. Each group can be seen to have somewhat different experiences, difficulties, and aspirations. Puerto Rican embraces both those who were born on the Island and their descendants born here; those who live on the American mainland as full citizens as long as they are here; and those who live on the Island in an ambiguous status of citizenship. Puerto Ricans and Cubans both include some people who are more obviously descended from African or European stock than others; the same is true of Mexicans with respect to Indian versus European heritage. The attitudes of these different groups to each other have been conveyed with them all, in some measure, to this country.

Moreover, Hispanics in the United States have made the full range of choices with regard to assimilation. A position at one extreme has been articulated by the writer Richard Rodríguez, whose autobiographical book, *Hunger of Memory*, disclosed his conflict-ridden passage from private to public citizenship. Despite the pain of separation from his family and their particular culture, he ratified both "the value and necessity of assimilation. . . . Only when I was able to think of myself as an American, no longer alien in a *gringo* society, could I seek the rights and opportunities necessary for full public individuality." By comparison,

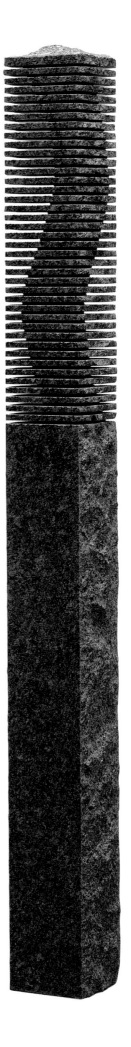

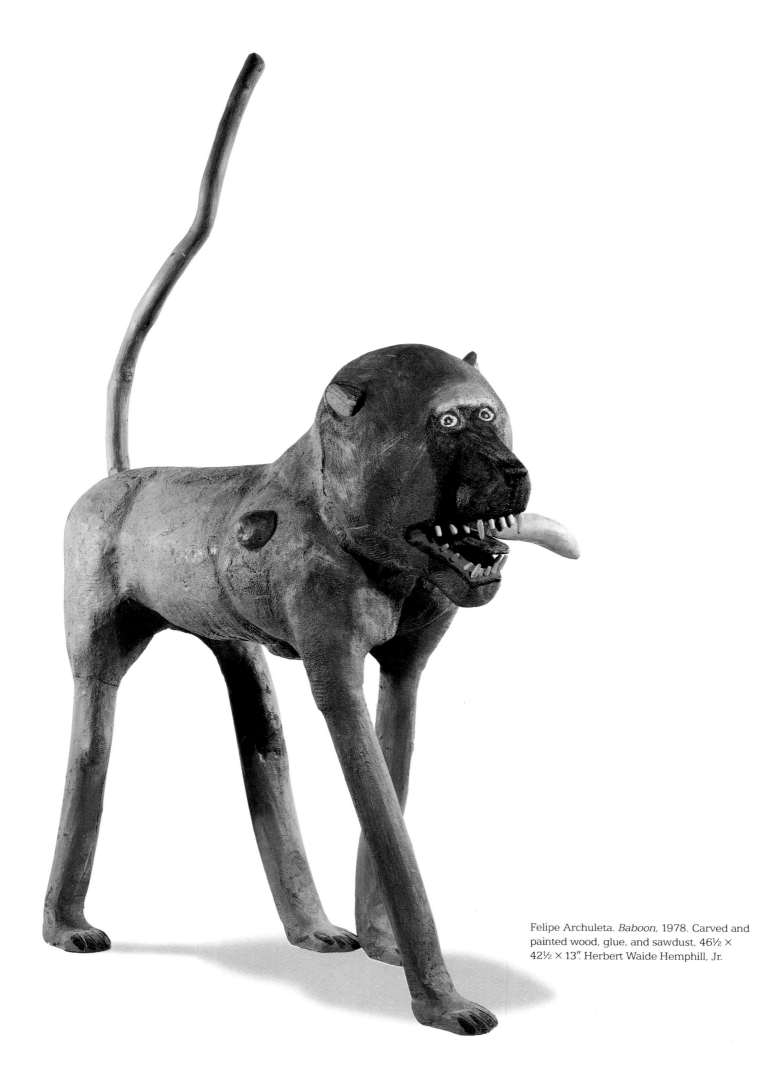

Felipe Archuleta. *Baboon,* 1978. Carved and painted wood, glue, and sawdust, 46½ × 42½ × 13″. Herbert Waide Hemphill, Jr.

the Chicano author Rolando Hinojosa seems to exemplify one for whom assimilation is not an either/or but a both/and proposition—writing both in English and in Spanish, and taking for the subject of his novels *Mi querido Rafa* and *Dear Rafe* the bilingual and bicultural lives of the inhabitants of the Rio Grande Valley in South Texas.[7]

Of the less assimilated, a variety of observations can be made about their situations. Some Cubans, for example, constitute a kind of community in exile, retaining the hope of returning to Cuba in a post-Castro era. The ease, both legal and physical, with which Puerto Ricans can pass from island to mainland diminishes for them both the necessity of assimilation and, one assumes, the inclination to do so. Among Mexican Americans, there is some sense of being a conquered people, inasmuch as a number of them live in a land that was originally Mexico, although this is clearly a historical insult rather than a personal one. But for all, patterns of discrimination breed resistance and, for "*los illegals*," dubious legal status perpetuates cultures in isolation.

Gregorio Marzán. *Striped Giraffe,* early 1980s. Mixed media, 40 × 20 × 7″. El Museo del Barrio, New York.

Dachshund, early 1980s. Mixed media, 16 × 31 × 7½″. El Museo del Barrio, New York.

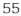

55

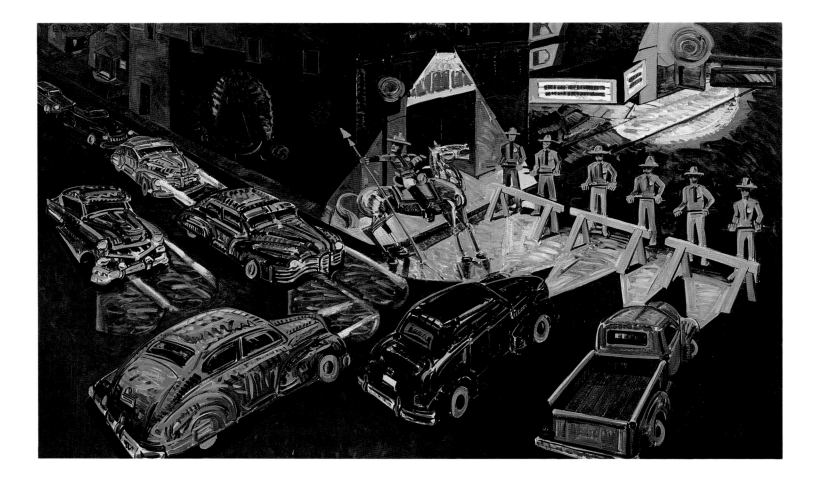

Frank Romero. *The Closing of Whittier Boulevard*, 1984. Oil on canvas, 72 × 120". Courtesy of the artist.

It was resistance in part that generated the first highly visible artistic episode among Hispanic Americans. This was the art that grew out of *El Movimiento:* the Chicano struggle for civil rights, greater educational opportunities, improved economic conditions, and enlarged political representation. Spearheaded by César Chavez and the organization of the National Farm Workers Association, now the United Farm Workers Union, the movement had its beginnings in a strike called against grape growers on September 16, 1965, in Delano, California. The strike drew national attention and provided the momentum for Chicanos to extend their efforts to other causes. Initially, the movement was a reflection of broader efforts to achieve greater equity in American society, and Chicanos worked in cooperation with black civil rights groups: Rodolfo "Corky" González, for example, issued one of the original manifestos of the movement, *El Plan del Barrio,* at the Poor People's Campaign in Washington, D. C., in 1968. But Chicanos also pursued their cause separately: an independent and openly nationalistic political party, *La Raza Unida,* was formed at a meeting in Crystal City, Texas, by José Angel Gutiérrez and others in 1970.

The cultural agenda of the Chicano movement included a call for bilingual education, the establishment of Chicano studies departments and study centers, and for Chicano control over these and other cultural programs. In general, the intent of these programs was to strengthen Chicano culture by promoting group

identification. Many artists joined the cause, painting didactic and exhortative murals on barrio walls and producing political posters. A historian of the Chicano movement, Jacinto Quirarte, has characterized these artists as "primarily concerned with articulating Chicano identity." Their impetus, as he saw it, "was not self-expression . . . or personal recognition, but . . . responding to the needs of the community as defined by the Chicano movement." He described their public works—that is, primarily their murals—as "a bulwark against the eroding influence of Anglo-American culture"; he said their intent was "to teach the Chicano community about itself, to strengthen it, to nurture it."[8]

Numerous artist groups were formed, both to advance the general aims of the movement and to further the work of member artists. Among the first and most prominent were *Con Safos*, established by Mel Casas and Felipe Reyes in San Antonio in the early 1970s, and The Royal Chicano Air Force (originally the Rebel Chicano Art Front), organized by José Montoya and others in Sacramento. In virtually every major city in California, the Southwest, Texas, and the upper Midwest, however, there was such a group.

To some degree, the sheer quantity of Hispanic artists now to be found in our midst is inconceivable without the movement, for it provided these artists on the margins of our society with a sense of purpose and, above all, with a sense of the validity of their vision, at least within the confines of their own community. Many of the Chicano artists in this study—Carlos Almaraz, Gilbert Luján, Frank Romero, John Valadez, Carmen Lomas Garza, and César Martínez, among others—came of age within the movement and owe some of their early accomplishments to it. (Numerous Hispanic artists of Caribbean or South American origin, it should be said, were never involved with the movement; even among Mexican Americans, there are those—Robert Graham and Manuel Neri, for example—whose careers were well under way by the time the movement emerged.) It was not long, however, before many Chicano artists began looking beyond their own group for recognition and economic sustenance. A still discernible rift developed between those who felt that Chicano art was inextricably linked to its community origins and those who felt that its forms could evolve and its purposes grow beyond its sources in the movement.

The debate between these points of view surfaced repeatedly in the early 1980s, once in a very pointed exchange between art historian and critic Shifra Goldman and artist Judithe Hernández de Neikrug. In a review of an exhibition of mural paintings on canvas by Chicano artists at the Craft and Folk Art Museum in Los Angeles, Goldman charged that the exhibition "placed a framework around East Los Angeles muralism which decontextualizes it and violates its function." In her mind, the exhibition reflected a larger problem then confronting Chicano artists. "What is at stake, basically," she wrote, "is the question of commitment: should Chicano artists, at the cost of economic security and possible artistic recognition, continue to express themselves artistically around the same matrix of social change and community service that brought their movement into existence? Or should they, now that some of the barriers are cracking, enter the mainstream as competitive professionals, perhaps shedding in the process their cultural identity and political militancy?"[9]

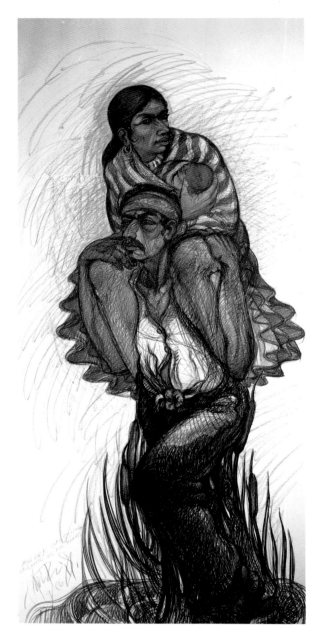

Luis Jimenez. *Working Drawing for Cruzando el Rio Bravo (Border Crossing)*, 1986. Crayon on paper, 130 × 60". Collection of the artist.

John Valadez. *Fatima*, 1984. Pastel on paper, 60 × 42". Peter and Eileen Norton, Santa Monica, California.

Hernández, a participant in the exhibition, took exception to the suggestion that her cultural identity might be threatened by her professional success: "Why should changes in my work and social-political attitudes be construed as compromising my commitment to . . . Chicanismo, while in another artist the same would be perceived as personal and professional growth? Are Chicano artists so shallow and corruptible that at their first chance at mainstream success they'll forget who they are?" Hernández answered her own question:

> Those of us who have persisted in the face of great odds and pursued our careers as artists will grow in spite of people, like Ms. Goldman, who would eternally chain us to "Chicano art." . . . Our work will mature and change. Chicano art and Chicano artists, I am sure, will always pay homage to the traditions of the Mexicano/Chicano culture. As time goes by, the relevance of our work to a larger international audience will become more and more apparent."[10]

Even as she wrote, Hernández's words were proving true. On the wane was the group solidarity that had been so instrumental in providing Chicano artists with the self-confidence to commence their careers and in launching their art into the consciousness of the wider art community. Emerging in its place was a sense of greater individuation among the artists and a desire to find a place in the company of other, non-Chicano artists, not merely so that Chicanos might avail themselves of the opportunities and rewards open to other artists, but also so that they might know how their work compared, formally and qualitatively, to that of their more mainstream peers. Yet the observation that, even as their work evolved and diversified, Chicano artists would continue to be aware of and pay homage to their own tradition likewise continued to be true.

The recent work of a number of the Chicano artists in California and Texas bears this out. Some of the pastels of John Valadez—*Beto's Vacation,* for example—are intensely personal and enigmatic. Others are literally depictive and very particular, notably his portraits of the blacks, Orientals, and Chicanos who comprise the increasingly disparate population of downtown Los Angeles, where the artist has his studio. Some of the best of these pastels, such as *Fatima* or *La Butterfly,* convey an uncaricatured and yet unidealized empathy that must surely have its origin in some continuing measure of group identification. The same observation can be made of Carmen Lomas Garza's exceptional gouache paintings; based on the artist's recollections of Mexican-American life in the Texas border country, they convey an emotional engagement that in each case is intensified by the shallow picture space.

César Martínez manifests a slightly more detached perspective: because the *pachucos*—Mexican-American rebels—he depicts are rigidly frontal and isolated, as with *Bato con Sunglasses,* they are nearly iconic. One senses that these are historical rather than intimately observed personages, a feeling confirmed both by the fact that pachuco culture reached its apogee in the years immediately after World War II, and by the fact that the characters are composites created from, among other sources, back issues of *Lowrider* magazine and old high school yearbooks. Luis Jimenez has likewise depicted the pachuco, but also reached back to one of the original Mexican-American character types, the *vaquero*—cowboy—and forward to one of the most recent—the illegal alien. In

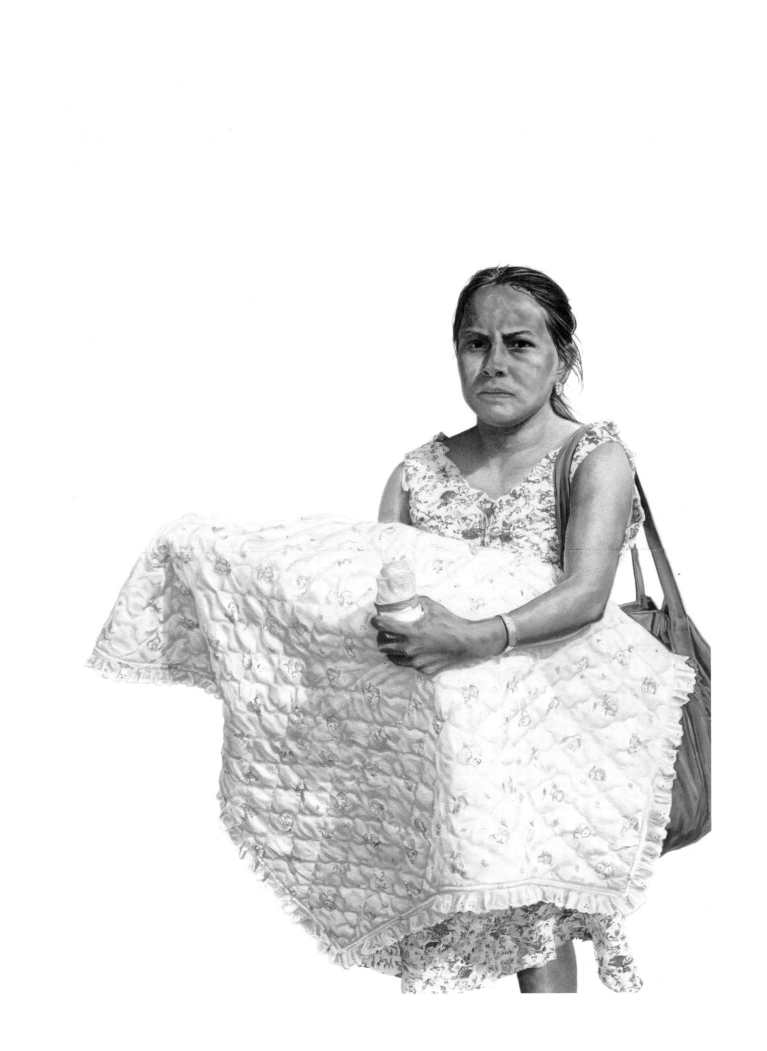

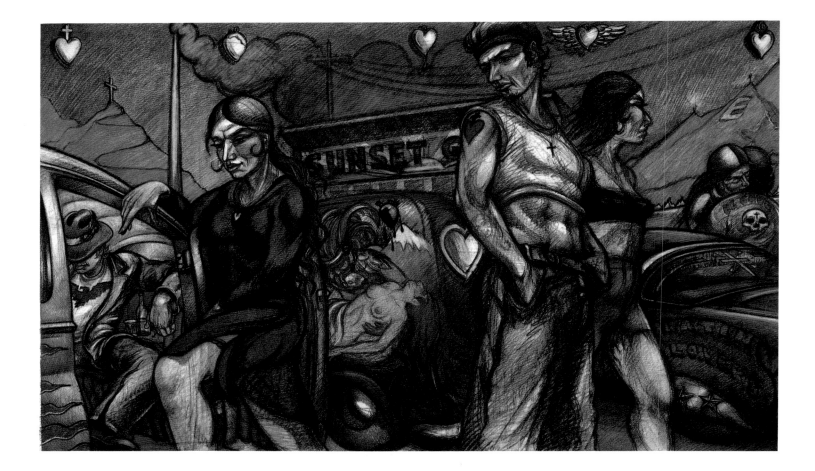

Luis Jimenez. *El Chuco,* 1984, detail. Two colored pencil drawings on paper, and neon with transformer; drawings 33 × 59″ (shown) and 16 × 48″. Mr. and Mrs. James Harithas.

addition to his more personal work, Frank Romero has executed a number of nearly epic paintings that take as their subject the clash of Anglo and Chicano cultures in Los Angeles, notably *The Closing of Whittier Boulevard.* These paintings, together with the works of Martínez and Jimenez, are representations of Chicano history, drawing not so much on personal experience as on a common past. To some degree, they retain the public purpose that characterized much preceding Chicano art: they are at once didactic and celebratory.

Carlos Almaraz can be seen to exemplify by far the most complex position with respect to the multiple inspirations and intentions of Chicano artists today. The sheer virtuosity of his painting overwhelms any other reading of his work— the obvious bravura and exuberance with which he selects his colors and applies the paint to the canvas, bringing his images, as in *Love Makes the City Crumble,* to the point of dissolution but always stopping at that moment when structure and anarchy are in tensest equilibrium. And while many of his images are drawn from the landscape or culture of Southern California or, more recently, that of his second home, Hawaii, others have an origin in Mexican or Chicano culture. *Europe and the Jaguar* is perhaps the best example of this, an amusing and astute summation of the divergent, even antithetical, characters— the European and the pre-Columbian Indian, the sophisticated and the wild, the sumptuous and the spartan, the effete and the heroic—that struggle for reconciliation in Mexican and Mexican-American culture.

Other artists likewise blend American with Mexican themes. Roberto Gil de Montes has executed a number of paintings based on the myths of Southern California: the movies and the automobile, in particular. Others draw on the artist's extensive knowledge of Mexico's artistic and cultural past—he is both painter and art-history instructor. *The Receptor,* one of his most ambitious works to date, evokes thematically and stylistically the hallucinatory writings of Antonin Artaud, part of whose *Voyage to the Land of the Tarahumara* (1936–37) recreated his experience of an Indian peyote dance in the Mexican interior. An equally enigmatic painting, *Nocturne,* takes as its point of departure the Olmec belief that they were descended from the mating of a jaguar and the earth. Yet here the personification of the earth, customarily female, is male. One can extrapolate from this painting not only a possible revelation of the artist's psyche, but a profound ambivalence about *machismo,* the stereotype of Latino masculinity. The male here combines in human and jaguar forms the attributes that machismo divides between the male and the female. He is both active and passive, powerful and submissive, conquistador and victim.

Gilbert Luján. *Hot Dog meets La Fufú con su Poochie,* 1986. Acrylic on archival board, 13 × 28½ × 18″. Collection of the artist.

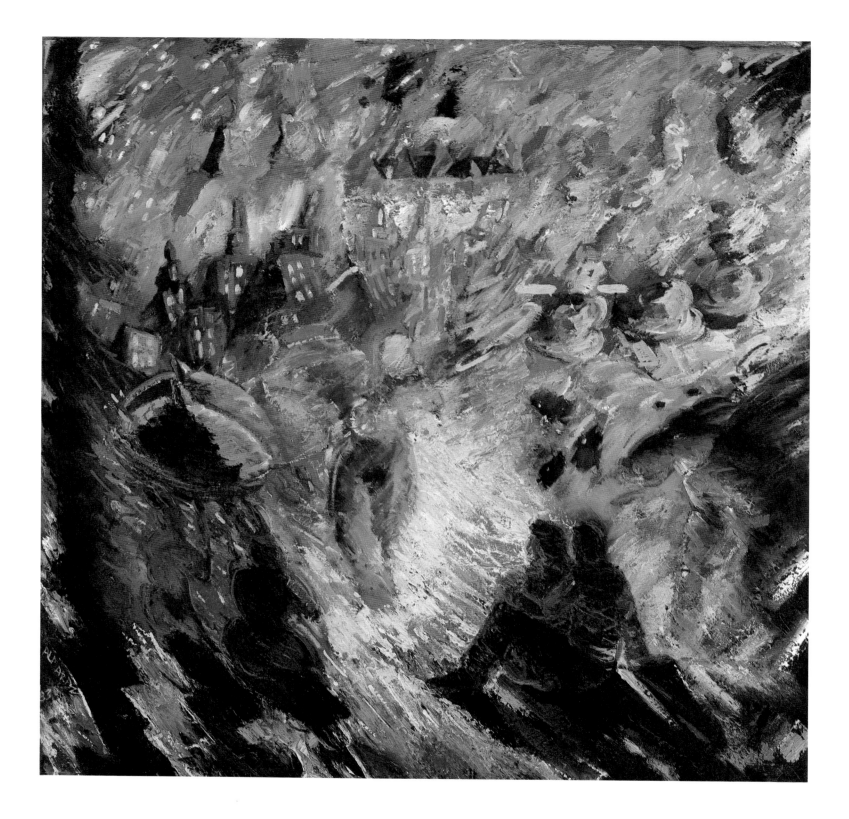

Carlos Almaraz. *Love Makes the City Crumble,* 1983.
Oil on canvas, 66 × 66". Collection of Rodney Sheldon.

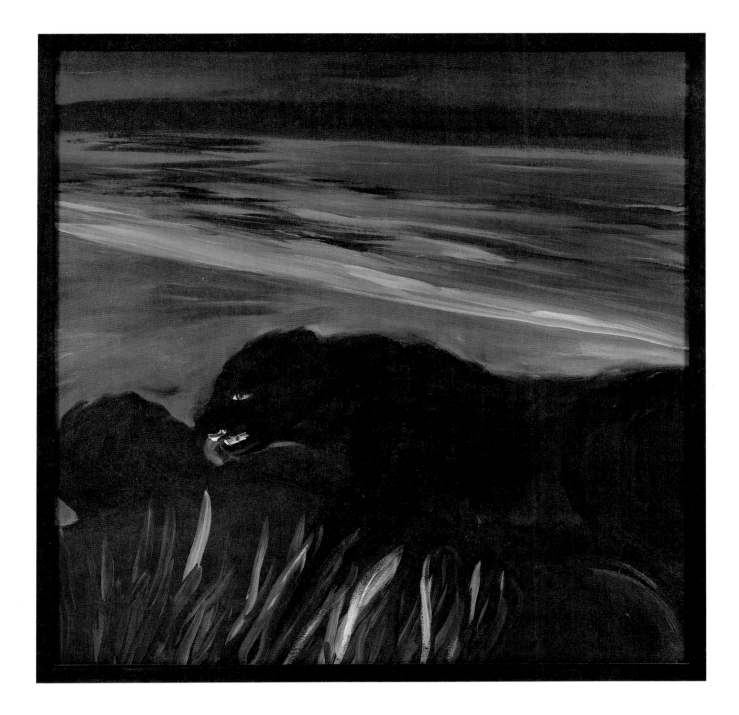

Roberto Gil de Montes. *Nocturne,* 1985. Oil on linen, 50¾ × 50¾".
Julianne Kemper, Santa Monica, California.

There are broader traditions in Mexico—and Latin America more generally—that also surface in the work of Hispanic artists in the United States. North America knows its southern neighbors largely for their fiestas, fervid celebrations of life and death. While much of this work has the kind of extravagance of color and manner we associate with *carnaval,* the spirit of another festival has also been transmitted to the United States, the observances on November first and second of All Saints and All Souls Days, known as the *Días de los Muertos.* Both a festival of remembrance and a reminder of the vanity and transience of life, the Days of the Dead are marked primarily by the fabrication of elaborate *ofrendas,* home or public altars dedicated to the deceased. These are covered with sugar or plaster skulls, photographs, flowers, food, and candles, much like the one created for this project by Carmen Lomas Garza. Her *ofrenda* derives an added measure of poignancy from its dedication to Frida Kahlo, a painter who has served as an inspiration to many Mexican-American women artists.

Another tradition that long ago made its way into what is now the United States is exemplified in the religious art of the Southwest. Statuary and painting brought into New Mexico by Franciscan missionaries in the late sixteenth and early seventeenth centuries from Mexico provide the earliest local precedent for this art, but these and images imported subsequently were insufficient to meet local demand for religious furnishings. Native-born Hispanic artists began producing their own images of holy personages—*santos;* their art reached its most remarkable proliferation and perfection between about 1750 and 1850. A

Carmen Lomas Garza. *Día de los Muertos Ofrenda: Homage to Frida Kahlo,* 1978–86, general view and details. Mixed-media installation, 9 × 7 × 4′ overall. Collection of the artist.

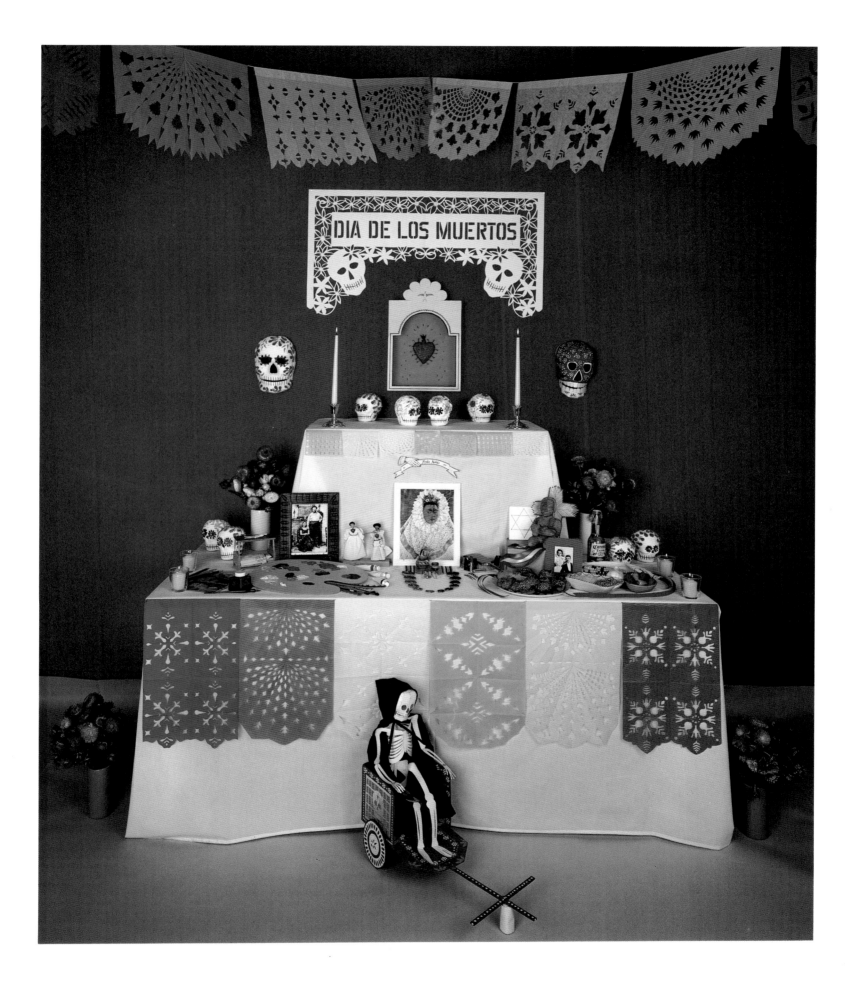

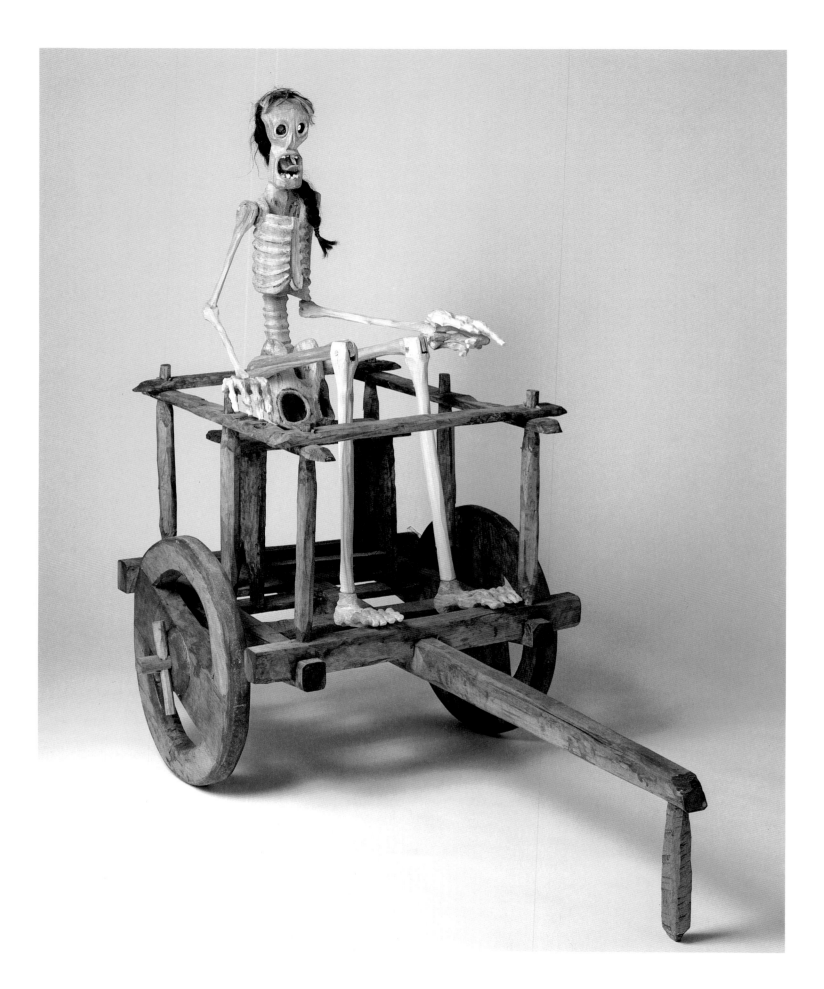

distinctly regional style emerged that was considerably less theatrical and grandiose than the Mexican Rococo and Spanish Baroque art from which it sprang, reflecting both the less sophisticated training and materials available to the local artist and the possible influence of Franciscan religious values of humility and simple piety.[11]

Images took two principal forms: that of the *bulto*—the polychromed, three-dimensional carving—and the *retablo*—the painted panel. Two- and three-dimensional images were sometimes combined to form the reredos, or altar screen, the often elaborate structure behind the altar table. Extraordinary examples of this type, dating mostly from the early years of the nineteenth century, can be found in the churches at Ranchos de Taos and Chimayó, among many others.

The production of all these images declined in the late nineteenth and early twentieth centuries. When the tradition was revived under the influence of secular and usually "Anglo" patrons, especially after about 1920, the preferred form was the monochromatic *bulto*. It was not until quite recently that the more authentically traditional polychromatic pieces once again came into favor. Luis Tapia, along with a somewhat older artist, Horacio Valdez, was one of the principal figures in the reapplication of polychromy; both artists used commercial acrylics. Félix López may be the closest of all to his artistic forebears in the use of colors, for his are homemade, often from natural pigments derived from indigenous plants, rocks, and soils. In any event, the return to polychromy surely testifies to an increasing interest among contemporary New Mexican Hispanics in the significance and undisputed excellence of their cultural heritage.[12]

Tapia has likewise been pivotal in the revitalization of other traditions. He has restored a number of nineteenth-century reredos; more recently, he has created entirely new ones, based on his own interpretations of historical forms. One was made for the pueblo church at San Idelfonso in New Mexico; another was created for this exhibition. He has also made a number of death carts—*Carretas del Muerto*—in the tradition of those objects that have exerted perhaps the strongest influence of any Hispanic religious image on the larger American imagination. Originally created for the Penitente Brotherhood, a lay religious group known to outsiders mostly for their practice of self-flagellation and simulated crucifixions, the death carts carried a skeletal figure armed with a bow and arrow, often identified as Dōna Sebastiana, and were pulled in processions to a designated Calvary during Holy Week observances. Although Tapia's death carts are not used in the traditional fashion, they retain the horrific aspect of the earlier works. Like the use of polychromy and the creation of the wholly new reredos, they are symbols of a revitalized ethnicity. The death cart has also inspired other artists: Carmen Lomas Garza has created a more delicate version in paper cutout.

The strength of the Latin American religious tradition—paramountly the Catholic church—provokes other kinds of reactions as well. Pedro Perez's goldleaf constructions, especially *God*, can be interpreted as less than reverent variants of religious images. Even a work like *La Esmeralda (The Queen That Shoots Birds)*, which does not take an obviously religious subject, is at once a

Félix A. López. *San Francisco*, 1982. Cottonwood, pine, gesso, and natural pigments, 36" high. Collection of Robert and Barbara Bogan, Albuquerque.

Luis Tapia. *Death Cart*, 1986. Cart: pine; figure: carved aspen, human teeth and hair, and mica, 38 × 24 × 36" overall. Collection of the artist.

Pedro Perez. *La Esmeralda (Queen that Shoots Birds),* 1982. Mixed media, 36 × 36 × 5". Jock Truman and Eric Green.

parody of and a rival to the elaborately overwrought furnishings of European and Latin American Catholic churches. At the same time, other artists have explored alternatives to the prevailing dogma. Paul Sierra and Carlos Alfonzo have investigated the Afro-Caribbean religious sects of their native Cuba. Sierra's study resulted in a number of paintings of effigies and shrines such as *Cuatro Santos* and *La Famba.* Alfonzo's experience, more personal than Sierra's, is also more internalized and surfaces in his use of certain mysterious, seemingly prophylactic images: the knife through the tongue, the disembodied eye.

A similar penchant for the fantastic is manifest in much more of this work, especially in the treatment of landscape. Seldom is landscape depicted literally; more often, it is drawn from commingled recollections and imaginings. Ibsen Espada alludes to the multifarious textures and colors of the Puerto Rican rain forest in *El Yunque;* he takes us underwater in *Aquarium,* a shimmering world that becomes the locus of alien life in Carlos Alfonzo's *Sea Bitch Born Deep.* Alternating nocturnal and diurnal landscapes signify the passage of time in Paul Sierra's *Three Days and Three Nights,* while Patricia Gonzalez suggests the ways in which fecundity can assume bizarre and even malevolent characteristics: winged and feathered creatures are secreted among colossal plants in

Paul Sierra. *La Famba,* 1985. Oil on canvas, 44 × 44". Courtesy of Halsted Gallery, Chicago.

Carlos Alfonzo. *Petty Joy,* 1984. Acrylic on canvas tarp, 72 × 96".
Collection of Juan Lezcano, Miami.

Ibsen Espada. *Aquarium I,* 1985. Oil and ink on paper applied to canvas,
84 × 120″. Rundy Bradley, Houston.

Eccentricities in Nature, and the landscape is virtually engulfed by a glorious flowering vine in *Affection.*

Latin American culture is widely recognized to be as autocratic as it is dogmatic, with dictatorships of the left and right only sometimes yielding to truly participatory forms of public administration. It is little wonder that the image of the strong man, the *caudillo,* should also appear in Hispanic art, as in Luis Stand's *El General sin Manos,* who has been symbolically disempowered by the absence of his hands. Most of the Latin American countries likewise share a history of conquest; this subject appears in the work of Ismael Frigerio, although in a more allusive than literal way. *The Lust of Conquest,* with its boat and immolated figures, suggests the subjugation of indigenous peoples, while *The Loss of Our Origin* can be interpreted as implying that, for both conquistador and victim, conquest irrevocably divorces them from their pasts. Unlike Chicanismo or Catholicism, dictatorship and conquest are themes more directly relevant to Latin Americans than to American-born Hispanics; not surprisingly, Frigerio and Stand are quite recent émigrés to this country.

Patricia Gonzalez. *Affection,* 1985. Oil on canvas, 54 × 66". Courtesy of Candice Hughes, New York.

Luis Jimenez. *Working Drawing for Howl,* 1983. Oilstick on paper, 89 × 60". Collection of the artist.

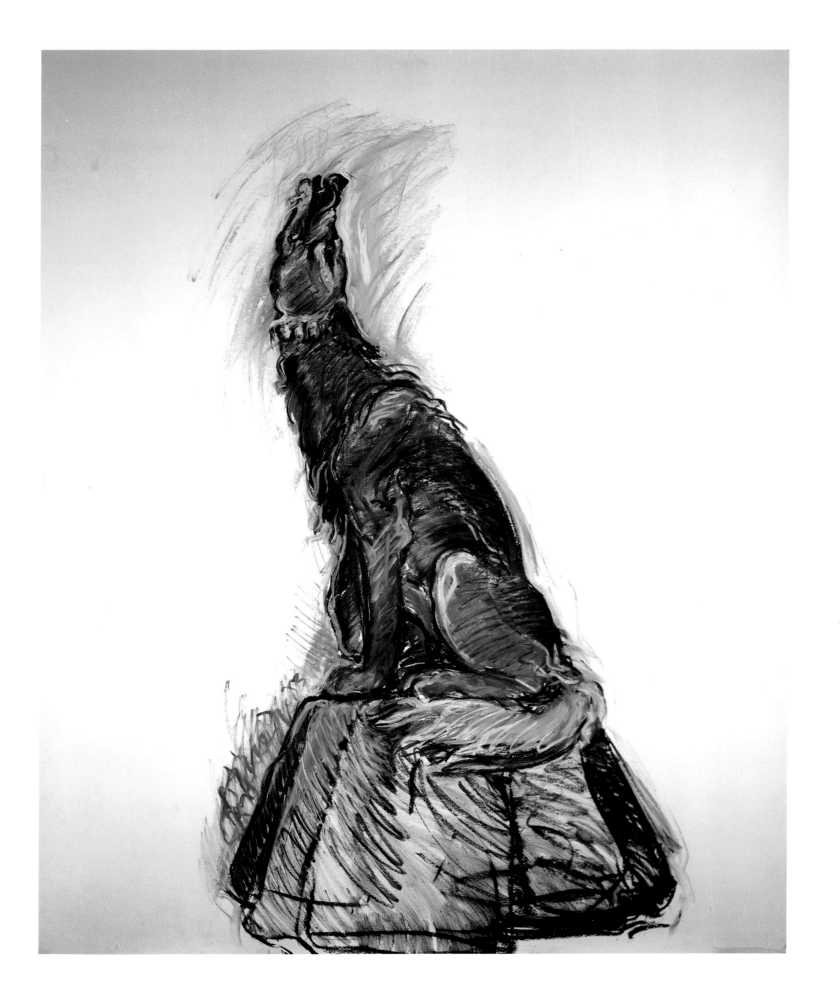

Thus far, my observations have centered primarily on the ways that subject matter—whether drawn from tradition or contemporary life, religion or politics, landscape or mythology—can differentiate the work of Hispanic artists. Style can also be deployed as a distinguishing feature. The full stylistic range of Hispanic art and its relationship to contemporary and recent modern art in both the United States and Latin America is discussed by Jane Livingston; I will not anticipate that analysis here, but will confine discussion to the more limited subject of how style can convey a sense of otherness.

The ostensibly "mainstream" look to the sculpture of Manuel Neri and Robert Graham belies the fact that when their work first emerged, in the late 1950s and early 1960s respectively, the practice of sculpture in the United States was on the cusp, midway between the waning of welded metal abstraction (a genre that reached a zenith in the work of David Smith but also one that had numerous *pasticheurs*) and the emergence of Minimalism's industrially fabricated box. That is to say, if their sculptures look familiar from the large viewpoint of art history, they were nevertheless at their inception an anomaly in the context of recent American art. Their unrelenting reliance on the human figure as subject had, it is true, a precedent in a style of painting in Northern California that has come to be known as the Bay Area Figurative School. But this accounts more for Neri than for Graham, especially Neri's expressionistic treatment of surface and color. Graham's refined classicism and Neri's evocatively sacramental bronzes owe more to an Italianate tradition that had all but disappeared from American art; one might explain this as much in terms of a link to European culture via their Mexican heritage as in terms of contemporaneous painting in California.

A decade later, to eyes accustomed to the pared-down aesthetics of geometric abstraction and to the virtual disappearance of the very art object in conceptual art, the emergence of such artists as Luis Jimenez and Luis Cruz Azaceta must have seemed discordant at the least. Azaceta was working in an emotionally charged style the likes of which had not been commonplace in Western art since the prewar years in Germany. Jimenez, with his spray-painted fiberglass sculptures of barmaids and automobiles, seemed simply to be working toward the apotheosis of bad taste. Indeed, one critic described Jimenez's sculptures in 1972 as "monuments to sheer, screaming vulgarity," though he nevertheless felt they were redeemed somewhat by the artist's self-awareness: "Jimenez knows what he is doing; his suffering, his bearing up under vulgarity, has resulted in works with a grasp of their own meaning."[13]

What was evidently not apparent at the time was that Jimenez was not suffering at all. Far from bearing up under the "overload of the urban landscape," Jimenez was celebrating a taste both regional and ethnic, inspired by the neon trade signs that his father and many others were fabricating for the western landscape, and by the more particular enthusiasm of certain Chicanos for blatant decoration, especially of their automobiles and upper arms. The same "bad taste" can be detected in Gilbert Luján's elaborately painted 1950 Chevy lowrider. Nothing could be further from the canons of high art—even those used to evaluate industrial products, as in the design department at the Museum of Modern Art.

We are presented with a paradox in these works: they are "vulgar," yet they are examples of consummate manual skill. Jimenez wields a torch and a paint sprayer with every bit as much skill as he displays in his extraordinary drafts-manship; Luján has taken endless pains over both interior and exterior details of his car. Rudy Fernandez presents another, perhaps even clearer example of this paradox. His works are exceedingly sincere, even ingenuous, in their use of regional and ethnic images, yet they have few rivals in the care with which they are fabricated. Style, in these instances, may be conditioned by cultural prefer-ences even as it affirms them; that is, style may be relative, but craftsmanship most decidedly is not.

If Azaceta's expressionistic work was anomalous when it first appeared, taste has since caught up with him—even, to some degree, swallowed him up. Yet even now, few artists would use a palette as jarring as the greens and purples of his *Self-Portrait as a She-Wolf;* nor would they wrestle so openly with the problems of self-identification and alienation, as in *Homeless,* a figure Azaceta describes as "looking for a place to plug in." A similarly painful sense of inward exploration is evident in the self-portraits of Arnaldo Roche; he, too, deals with the theme of alienation, but finds its antidote by laying the canvas on top of his models and literally rubbing their images onto it, touching them physically and psychologically. Expressionism, for both men, is a matter of substance as well as style; in the hands of most recent American artists, it is merely a technique, one that ironically conveys real skepticism about the capacity of painting either to express or to resolve emotional conflicts. In this context, there is something embarrassingly frank in the work of Roche and Azaceta. In any event, their candidness certainly marks them as outsiders.

Like Luis Jimenez, Gronk and Roberto Juarez use style to challenge our visual paradigms, but they do so in a more ironic, even subversive way. With their heavy black outlines and broad patches of color, some of Gronk's paintings look like they belong on the side of a subway car; their roots are clearly in a rebellious ghetto culture, their visual language drawn from "lowbrow" sources, cartoons and tabloid illustrations. But an elaborate sense of social observation, sometimes affectionately humorous, sometimes satirical—as in *Cabin Fever*—imparts a level of maturity and subtlety to these works that most graffiti does not attain. Gronk deliberately cultivates ostensibly divergent aims. He recalls his teenage years: "My life was watching Daffy Duck on TV in the morning and having Camus in my back pocket. That combination set the whole pattern of my sensibility early on. It was okay that these two very different elements were coming together. I learned to sabotage seriousness along the way, and that was the direction I wanted to go in with my work."[14] Gronk's deployment of an underground style, superficially self-defeating in depriving his works of "high seriousness," is supremely self-confident. It plays on and undermines the assumption that the products of ghetto culture are in fact not worthy of serious attention, while providing Gronk with the slightly distanced perspective neces-sary to scrutinize his subjects.

On the face of it, the work of Roberto Juarez is another matter entirely. Juarez paints pictures that, coloristically and compositionally, are extremely supple.

Manuel Neri. *Annunciation No. 2,* 1981–82. Bronze with oil-based enamel, 46½ × 17¼ × 29". Collection of Lannan Foundation.

Luis Stand. *El General Sin Manos,* 1984. Oil on canvas, 108 × 40". Collection of Orlando Godoy.

Gronk. *Cabin Fever,* 1984. Acrylic on canvas,
72 × 95". Daniel Boley.

Rudy Fernandez. *Waiting,* 1985, detail. Wood, lead, neon, and oil on canvas, 42 × 45 × 8". Collection of Thomas E. Trumble, Boulder, Colorado.

They shift effortlessly from hue to hue, from image to image, even, in the recent work, from surface to surface—canvas to collaged terry-cloth towel and back again. They are also remarkable in the knowing range of images they recall from the history of modern art: a Cézanne still life in a painting like *Fruit Boat,* or the late series of bird paintings by Braque in *Three Birds,* to cite just two examples. But Juarez overloads his paintings and juxtaposes images drawn from both European and "primitive" sources. The *Two Sister Dolls* have the look of pre-Columbian figures, while *Sun Woman,* with its brilliant colors, its palm trees, and its imposing "native" woman, has an unsophisticated look that seems incompatible with the other works of this artist.

If the existence of such a painting in Juarez's oeuvre is jarring, it is also intentional. This is a highly ironic work. One senses that it is Juarez painting the way he knows an ethnic is "supposed" to paint, depicting in a somewhat crude way—the figure is massive but unarticulated, the torso frontal but the legs in profile—the stereotypes of a less advanced culture. But this is no mere parody; in what one observer aptly describes as "the highly contrived language of innocence," it is Juarez challenging our cultural presumptions, ennobling, through compositional and coloristic intricacy and the sheer magnitude of the figure, the very stereotype it presents.[15] We are accustomed to our artists drawing on primitive traditions to invigorate their art; we trust them to know how to graft those traditions onto sophisticated art styles. It is another matter when an artist who springs from that tradition does this. We tend to think of it as provincial.

In this sense, the problems Roberto Juarez confronts can be seen as representative of those faced by many of these artists—how to follow their impulse to

Roberto Juarez. *Three Birds,* 1984. Acrylic on canvas, 86 × 58". Collection of PaineWebber Group, Inc., New York.

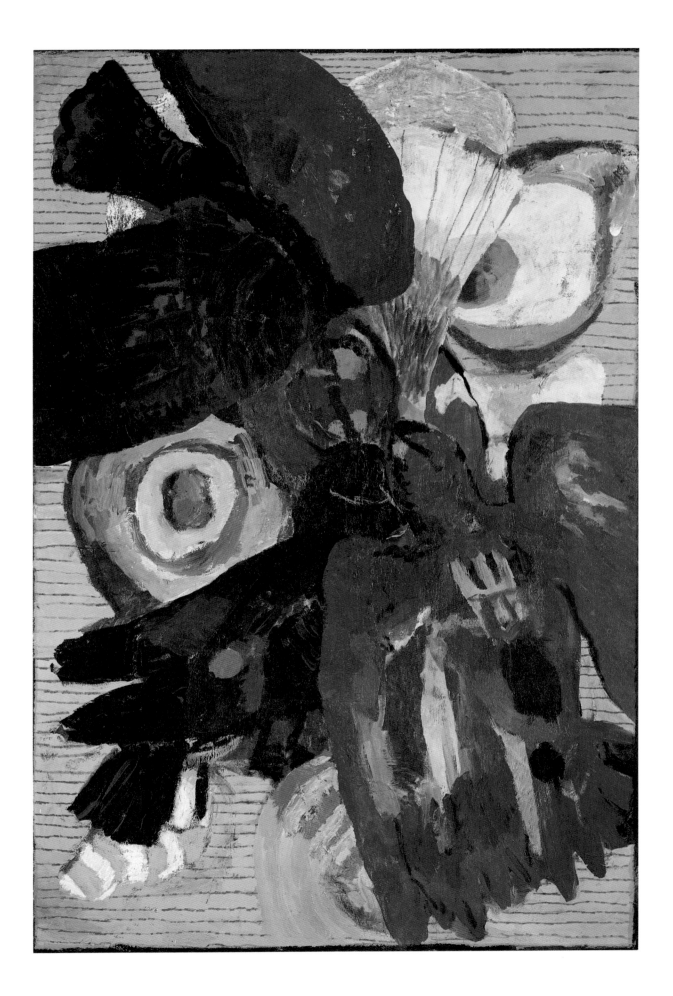

use deeply ingrained or consciously distinct images and styles without being dismissed by the art establishment as provincial. That establishment is necessarily judgmental, but it is also reflexive and conformist in seemingly increasing measures. We live in the era of the international "art star," evidence that cultural homogenization is becoming a global, not merely a national issue. What differentiates these artists is a quality of resoluteness in the face of this trend. They take the styles and the images of their particular heritage and blend them with styles and images received from an exposure to the larger culture, bequeathing in return an art more allusive, more elaborate, more reverberative than what they found, an art that affirms both the values of universality and particularity. This process is epitomized in an unself-conscious way by Martín Ramírez—his figures on horseback are both cowboys and *Zapatistas,* his deer evocative of both Disney cartoons and Mexican legends—and in a volitional way by Roberto Juarez, among many others.

Geographical isolation and cultural separateness, however, can be more than sources of alternative traditions; they can also keep alive traditions of the prevailing culture that have long since yielded to other tastes. So-called provincial culture is known to be *retardataire;* but, on occasion, discarded traditions arise again from it, transmuted, reinvigorated, and newly apposite. This is the lesson of Neri and Graham and, with respect to classically inspired painted ceramics, Lidya Buzio. The willingness of these artists to persist with out-of-date or not yet rediscovered styles anoints them the guardians of cultural history, with the task of redeeming art from fashion.

Whether preserving or extending the traditions of art, however, the position of so-called marginal artists is supremely paradoxical, for they are presumed to be peripheral, yet they conform more to the historically observed facts of art than do their nationally and internationally conformist peers. They uphold the notions that art can and does manifest regional and national differences and that the characteristics that distinguish the art of one group or region from another are at least as compelling as those that describe them in common. In this sense, not only do those on the margins enlarge the life of art in America, but they also challenge any assumptions about what constitutes the parochial in art and what the cosmopolitan.

Yet distinctiveness, in the context of these Hispanic artists, is seldom if ever synonymous with divisiveness. In finding their elixir in a commingling of styles and images, they draw on the alternating currents of competition and conciliation that invigorate so much of American art and thought. They contribute thereby toward the realization of an ever-more encompassing, fluid, and unprejudiced definition of our collective culture. Already we are beginning to discern how their particular situations have given rise to some of the most compelling art of our time. However, the achievement of Hispanic artists may ultimately be seen to be as important to American life as to American art. While their work is sometimes ironic, it is never skeptical about the capacity of art to address, perhaps even to help resolve, the larger dilemmas that confront us all as Americans.

Roberto Juarez. *Sun Woman,* 1982. Acrylic on canvas, 97 × 70". Collection of Phoebe Chason.

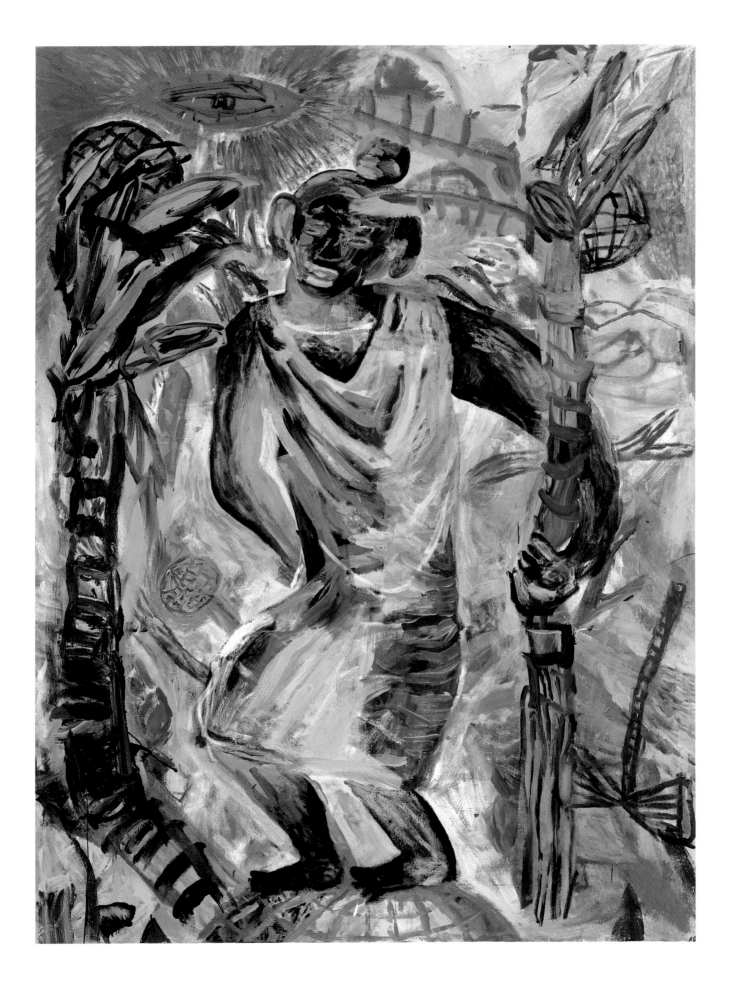

Lidya Buzio. *Round Blue Roofscape*, 1986.
Burnished earthenware, 11¼ × 13″ d.
Garth Clark Gallery, New York.

Notes

1. Nathan Glazer, *Ethnic Dilemmas, 1964–1982* (Cambridge: Harvard University Press, 1983), p. 17.

2. We documented the phenomenon of the unself-conscious expression of ethnicity in a previous exhibition and its accompanying book, *Black Folk Art in America: 1930–1980* (Jackson: University Press of Mississippi, and Washington, D.C.: Corcoran Gallery of Art, 1982).

3. William James, *The Will to Believe* (New York: Longmans, Green and Co., 1897); see especially the preface. See also William James, *A Pluralistic Universe* (New York: Longmans, Green and Co., 1909). Kallen's ideas were articulated first in "Democracy Versus the Melting-Pot," *The Nation* 100 (1915): 190–94, 217–20; then in the books *Culture and Democracy in the United States* (New York: Boni and Liveright, 1924), in which he first used the term "cultural pluralism"; and *Cultural Pluralism and the American Idea* (Philadelphia: University of Pennsylvania Press, 1956). His views and those of his critics are summarized in Arthur Mann, *The One and the Many* (Chicago: University of Chicago Press, 1979), pp. 136–48; see also John Higham, "Ethnic Pluralism in Modern American Thought," in *Send These to Me* (New York: Atheneum, 1975; reprint ed., Baltimore: Johns Hopkins, 1984), pp. 198–232.

4. Oscar Handlin, *Race and Nationality in American Life* (Boston: Little, Brown, 1957), pp. 217–18; Handlin, "Historical Perspectives on the American Ethnic Group," *Daedalus* 90, no. 2 (Spring 1961): 232.

5. In particular, Arthur Mann noted that the recent "white ethnic revival [found among people of Eastern and Southern European descent] . . . added to the fragmentation and discord from which it emerged"; he found the "new pluralism" like the "old dualism," with white ethnics banded together against blacks in competition for jobs, housing, and educational opportunities; see *The One and the Many,* pp. 41–42; 32–34. On the notion that cultural differences can perpetuate social inequity, see especially Nicholas Lemann, "The Origins of the Underclass," *The Atlantic* 257 (June 1986): 31–55; and 258 (July 1986): 54–68. Basing his conclusions on a study of Chicago, Lemann states that "in the ghettos, . . . it appears that the distinctive culture is now the greatest barrier to progress by the black underclass, rather than either unemployment or welfare." On the failure of pluralists past and present to describe the common values that might preserve social cohesiveness, see especially chapters nine and ten in John Higham, *Send These to Me:* "Apparently, a decent multiethnic society must rest on a unifying ideology, faith, or myth" (p. 232).

6. Higham, *Send These to Me,* p. 244.

7. Richard Rodriguez, *Hunger of Memory* (Boston: D. R. Godine, 1982), p. 26. Although there is much in his experience with which other ethnics in general and other Hispanics in particular might identify, some of the conclusions he has drawn have provoked dissent, particularly his opposition to affirmative action and bilingual education: "What I needed to learn in school was that I had the right—and the obligation—to speak the public language of *los gringos*" (p. 19). Rolando Hinojosa, *Mi querido Rafa* (Houston: Arte Publico Press, 1981) and Rolando Hinojosa, *Dear Rafe* (Houston: Arte Publico Press, 1985).

8. Jacinto Quirarte, *A History and Appreciation of Chicano Art* (San Antonio: Research Center for the Arts and Humanities, 1984), pp. 281, 192.

9. Shifra Goldman, "Chicano Art: Looking Backward," *Artweek* 12 (June 20, 1981): 3–4.

10. Judithe Elena Hernández de Neikrug, letter in "Reader's Forum," *Artweek* 12 (August 1, 1981): 16. For an earlier and more extended version of this debate, see Malaquías Montoya and Lezlie Salkowitz Montoya, "A Critical Perspective on the State of Chicano Art," *Metamorfosis* 3 (Spring/ Summer 1980): 3–7; and Shifra M. Goldman, "Response: Another Opinion on the State of Chicano Art," *Metamorfosis* 3/4 (1980/81): 2–7; both are reprinted in Jacinto Quirarte, ed., *Chicano Art History: A Book of Selected Readings* (San Antonio: Research Center for the Arts and Humanities, 1984).

11. See William Wroth, *Christian Images in Hispanic New Mexico* (Colorado Springs: Taylor Museum of the Colorado Springs Fine Arts Center, 1982), pp. 37–38.

12. For a discussion of the impact of non-Hispanic patronage on the Hispanic artists of northern New Mexico, see especially chapter three in Charles Briggs, *The Wood Carvers of Cordova, New Mexico* (Knoxville: University of Tennessee Press, 1980); for a more detailed discussion of the implications of the return to polychromy, see Briggs, pp. 203–206.

13. Carter Ratcliff, "New York Letter," *Art International* 16 (May 1972): 46.

14. Gronk in an interview with Julia Brown and Jacqueline Crist, in *Summer 1985* (Los Angeles: Museum of Contemporary Art, 1985), unpaginated.

15. Quotation from Gary Indiana, *Roberto Juarez* (New York: Bellport Press for Robert Miller Gallery, 1986), unpaginated.

Martín Ramírez. *Untitled* (Cities and Courtyards), 1953. Pencil, tempera, and crayon on collaged paper, 67 × 35". Jim Nutt and Gladys Nilsson.

RECENT HISPANIC ART: STYLE AND INFLUENCE

JANE LIVINGSTON

Since the mid-1970s waning of Minimalism—an artistic episode that seemed to most observers the end of the line in late modernist art that had commenced with the "second generation Abstract Expressionists" of the 1950s—a number of styles and sub-styles have proliferated in the American visual arts. So many indeed are these artistic modes and so multifarious their media and sources, that, beginning in about 1975, the only term that gained general currency to describe the aesthetic temper of the times was *pluralism*. This inadequate and variously interpretable word denoted the apparently chaotic explosion of "mainstream" styles that seemed to follow upon an essentially orderly dialectical progression. This progression started in late and post-Abstract Expressionism and evolved through Op Art, Pop Art, "Post Painterly Abstraction," Tech Art, Minimalism, and, finally, Conceptualism.

With the perspective given by the passage of a decade, we notice a more coherent manner of "mainstream" artistic development than was clear in 1975.

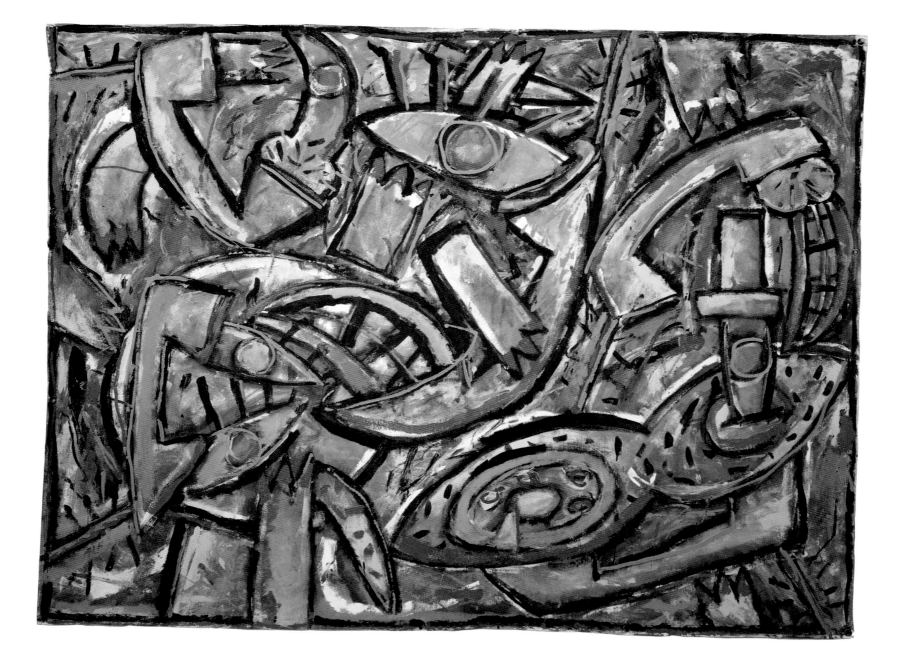

Carlos Alfonzo. *On Hold in the Blue Line,* 1984. Acrylic on canvas, 72 × 96".
Collection of Peter Menendez.

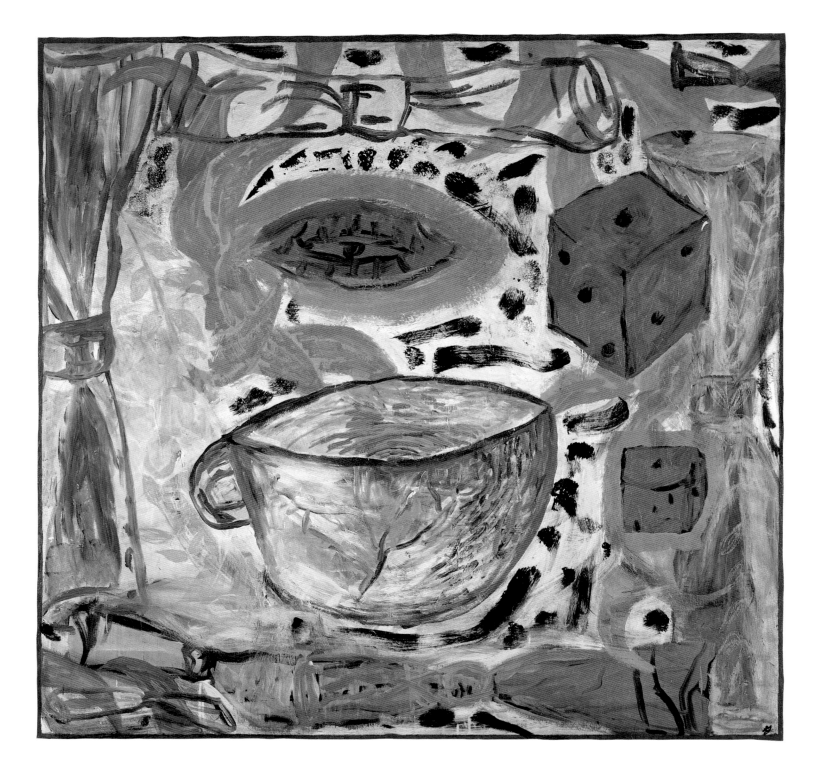

Roberto Juarez. *Broken Cup,* 1981. Acrylic on canvas, 78 × 80″. Emily and Jerry Spiegel.

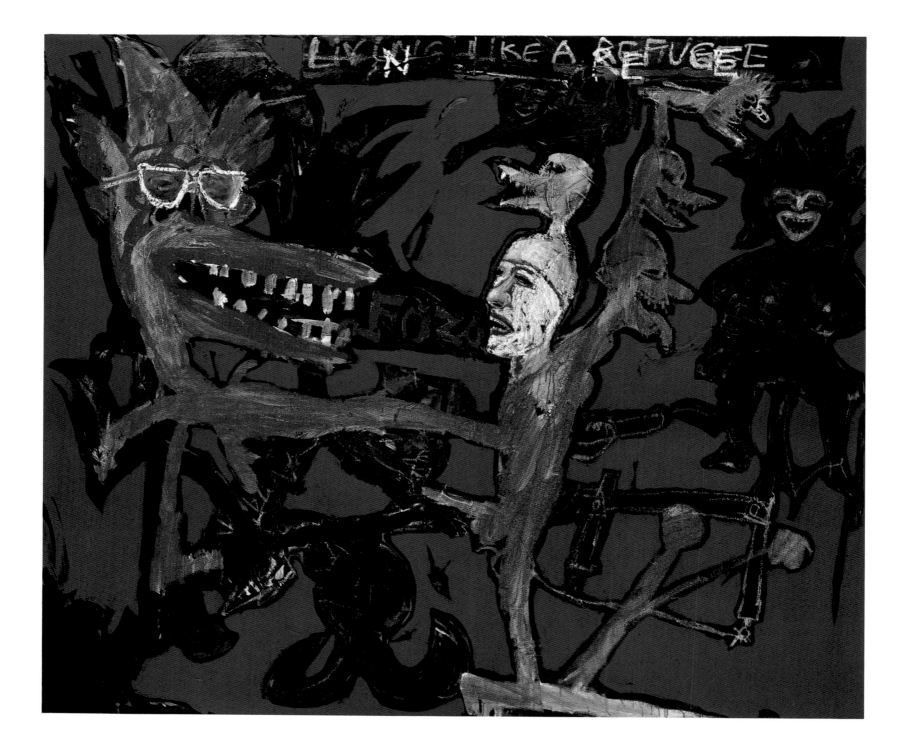

Two phenomena in particular have emerged through the thicket of anarchic activity in the mid to late 1970s. For the first time since the late 1940s, much of the best painting, sculpture, and photography—and, just as important, much of the most innovative and immediately influential—was being produced outside New York. And it was occurring not just in Los Angeles and Chicago, hitherto the primary "second cities" in American visual art, but in Texas, Michigan, Minnesota, Florida, Alabama, Louisiana, nearly every state. The "looks" in painting that began to appear in Whitney and Corcoran biennials and in most New York "new talent" museum shows took their inspiration from everything from folk artists in Louisiana and quilters in North Carolina, to young, often conservatively trained photographers in San Francisco or Santa Fe. Much was said and written about the "new regionalism."

The second overarching development in the new art of this recent period was its virtually wholesale rejection of abstraction, particularly the geometric abstraction that had led to Minimalism. The sorts of terms that were applied to these newly representational styles ranged from "Narrative Art" to "New Expressionism" to "New Image Painting." Eventually, a few figures were anointed in the task of reviving the wavering art market and proclaiming a fragile continuity in the recent succession of American art stars; but these five or six artists, most of whom moved to New York from Texas or California to bear their mantle in the traditionally prescribed arena, will perhaps be seen to have succeeded only briefly, if at all, in reassuring us that a discernible progression of main styles had continued.

Thus the art establishment, the critics and artists and dealers and museum curators, acceded to the idea that an era had ended, a paradigm receded, in short, that modernism was being replaced by post-modernism, or by nothing. The definition of the term *post-modern* (sometimes called *post-post modern*—depending upon the observer's views of modernism's decline, whether after Matisse or after Pollock or after Roy Lichtenstein, for instance) has yet to be given substance. And with good reason. Contemporary art, which now again integrates the European and, to a lesser extent, Latin American scenes into its vocabulary, is exceedingly multifaceted.

Given this situation of wildly proliferating and quickly assimilated styles on the one hand, and, on the other, an unchanging compulsion to sort out, name, and, for economic purposes, to elevate to apotheosis the new developments under an *ism*, it is not surprising that some recent artists fail to receive the attention they deserve or, if noticed, are not easily understood in their achievement. In other words, when we have so few intelligible criteria for judging "important" art, a certain contingent of good and authentic and original art becomes invisible. So, upon occasion, the work of immensely gifted and serious (and often alienated) painters and sculptors is confused with the plethora of work by the multitude of *pasticheurs,* or other less talented followers of the fashionable, which finds its way into the ever-expanding network of galleries and publications.

But in any time and place, even one so aesthetically sophisticated and expansive as our own, there exists only a handful of truly great artists and relatively few of the merely extraordinary. It is somewhat curious, then, that so

Pedro Perez. *Living Like a Refugee,* 1982. Acrylic on canvas, 72 × 84". Courtesy of Marilyn Pearl Gallery, New York.

many of the significant artists now working in our midst who do come under the rubric of the "undiscovered" happen to be of Mexican or Latin American origin. And more, it is worth noting that among these, many are not only practitioners but precursors of the main styles and impulses of our "post-post-modernist era." They are not, for the most part, figures whose work is aesthetically aberrant or marginal in any sense. They are painters and sculptors, such as Robert Graham, Carlos Almaraz, or Manuel Neri, whose early work ignored the conventions of their peers and engaged more timeless and more subjectively imperative concerns. The relatively high proportion of major artists who are *regionally* isolated and happen to descend from Mexican Americans or are more recent emigrés from Chile or Colombia might be explained by patterns of immigration and settlement in our country that date back one hundred years. But this alone is not enough to account for the psychological sense of marginality they so often evince.

What I want to do here, rather than dwell upon the social, geographic, or cultural factors that may have conditioned at least some of these individuals in the decision to become artists and in the character their work assumed, is to suggest some ways of placing the work of these thirty artists within a few broad stylistic categories, and to connect these contemporary styles to some of the various artistic traditions from which they may have arisen.

The intricacy of the lines of influence that can be traced within the artistic expressions we confront here is daunting. If one were to attempt to be exhaustive in enumerating both the individual artists whose influence has been felt (Joaquín Torres-García, Wifredo Lam, Roberto Matta, André Masson, Diego Rivera, José Clemente Orozco, David Alfaro Siqueiros, Rufino Tamayo, Francisco Zuñiga, Frida Kahlo are only a few of the more obvious figures) as well as the precursory movements (all the North and South American subgenres of Constructivism, Cubism, and Surrealism), one would need far more space than is available here. Moreover, not only would this enumeration entail a mechanical exercise in influence-tracing, but such a detailed and specific genealogy would interfere with each observer's inclination to hypothesize for himself the affinities and departure points for each of the artists. Indeed, if we allow the experience of viewing the work of these thirty painters and sculptors to enter our consciousness without too much cerebration, letting the images penetrate to our own associative life in whatever sequence and mood they will, we shall, I think, each of us sense a personally modified group of related traditions, an entire elaborate culture. But the fact that these artists create work at once personal and evocative of an ethnic culture that, however multifarious, is shared, should not set them outside the universe of aesthetic influence, of art. I want, then, to propose some broad and often imprecise categories or tendencies of influence with which these artists may be identified in the context of art history. Each of the stylistic phenomena I am attempting to characterize is grounded either in movements in contemporary art or in recent historic traditions.

To number among these artists three who are self-taught—including one, Martín Ramírez, who was emotionally disturbed and institutionalized during his entire life as a working artist—may initially seem to create an inexplicable anomaly within what is otherwise an exhibition of contemporary painting and

Lidya Buzio. *Tall Green Roofscape*, 1986. Burnished earthenware, 18 × 12½" d. Martin and Dawn Davidson.

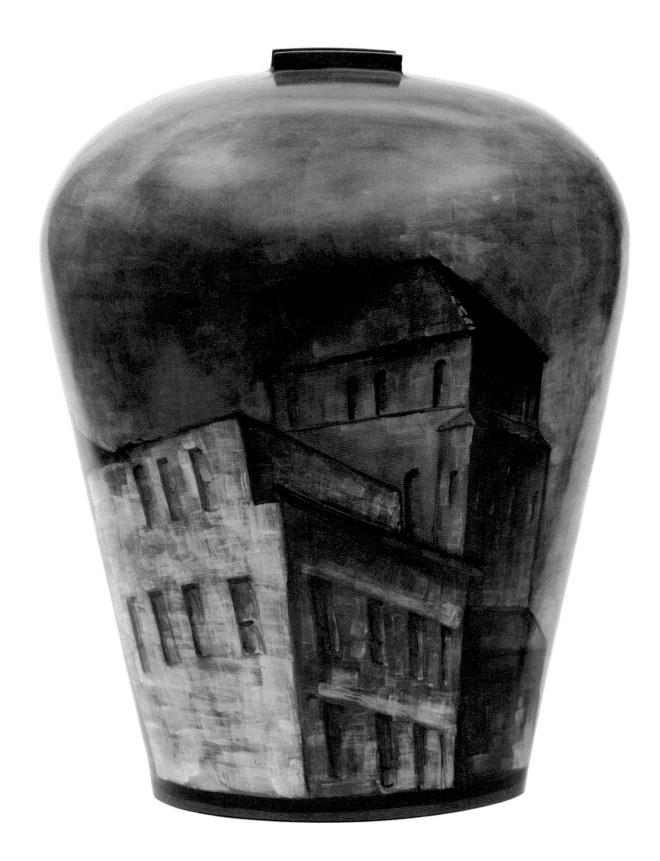

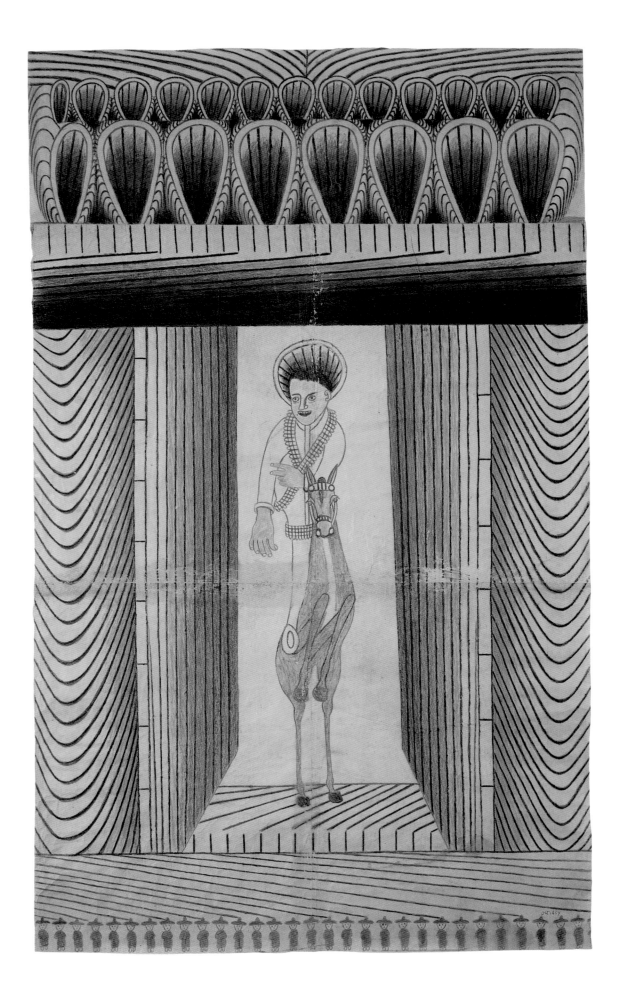

Martín Ramírez. *Untitled* (Horse and Rider), 1954. Pencil, tempera, and crayon on collaged paper, 58¾ × 35″. Jim Nutt and Gladys Nilsson.

Gregorio Marzán. *Red Goat,* early 1980s. Mixed media, 20 × 24 × 6½″. El Museo del Barrio, New York.

sculpture by conventionally trained artists. But if one looks further at the work of Martín Ramírez and at that of the self-taught sculptors Felipe Archuleta and Gregorio Marzán, and compares these oeuvres to those of their younger and more schooled fellow artists, one discerns affinities among them all, both of style and subject. The comparison suggests that they share a language of images and, maybe more important, *gestures* mined from their culture. Ramírez's images of the Madonna and his elaborate constellations of animal imagery hark backward and look forward in time. Archuleta and Marzán seem to personify country and city, respectively, in their use of materials—and they express entire worlds of innueundo about each culture by means of subtle caricature. Such images and gestures cross boundaries between the trained and self-taught, between generations, and between regions, whether of origin or current residence. As we shall see, this is not to discount particular regional and even circumstantial influences, but it is to say that the artists are essentially united in their Hispanic identity. Within this essential union is an almost chaotic abundance of individual expression, but the condition of a Hispanic heritage

Felipe Archuleta. *Porcupine,* 1976. Cottonwood, plastic broomsticks, twine, plastic pipe, and paint, 19¼ × 13 × 30″. Collection of Davis and Christine Mather, Davis Mather Folk Art Gallery, Santa Fe.

Rabbit, 1976. Painted wood, plastic pipe, and frayed twine, 18 × 8 × 24″. Paul and Patricia Winkler.

93

bequeaths to virtually all of the artists under discussion here such common denominators as shared or private mythic (or more narrowly religious) images, a combined sense of intensity and abandonment in painterly execution, and, often, some episodic or narrative conception that—again, often—embodies innuendo, caricature, and subtle satire.

With so-called folk artists, there can be no doubt that what is represented in their work is, from a subjective point of view, at least as important as the manner of depiction. It is evident upon seeing Archuleta's animals that they are based upon an impulse to impart human characteristics to the animal forms: these extraordinarily vital and humorous pieces somehow heighten and distill the characteristics specific to the animals generically and convey a sense of personality that often seems human. In both Archuleta and Marzán a quality of pungency, an improbable vividness of gesture and expression in their animals, combines with their unerring sense of form, color, and materials to create works that transcend the quaint or decorative. They become powerful expressions of anthropomorphized states of being. Indeed, in the case of Marzán, who began making his sculptures after retiring from a long career working in a commercial toy factory, the sheer force of characterization emanating mysteriously from these superficially rather gaudy, even clumsy, objects pushes them quite far beyond the realm of the quaint.

The quality of ceremony these three artists share, most acutely sensed in Ramírez, the quality of formality and ritual in their work, links them to traditions in Mexican or Puerto Rican church and festival observances. Ramírez's combined formal and representational stateliness, a rhythmic beauty that conveys not just lyricism but great seriousness of purpose, springs in part from a deep Mexicanness of iconography and style. The great *Madonna* of Ramírez—that somber, undulant figure of compassion and redemption whose spiked halo both summons and transcends the specific visual motif of the Virgin of Guadalupe— this majestic work stands as a virtually timeless evocation of the transplanted Mexican American's ambivalent nostalgia and the singular, deeply altered quality of his religious faith. Felipe Archuleta and Gregorio Marzán, of course, seem less grave, less far-reaching in their artistic vision; nevertheless, in them also reside qualities of style and gesture that are undeniably personal, based both in a transplanted consciousness of the world and an observation and love of nature equal to the reverence for ritual artifacts.

It is well known among enthusiasts of the long New Mexican mission-church decoration traditions that certain Hispanic/Mexican *santero* families and individuals, descended from the earliest Spanish artists, continue today to keep alive their traditions. What is interesting in the present context is not so much the purity and strict continuity of the *santos, bultos,* and altar-screen painting styles that may have been kept intact through strictly conservative restoration techniques, but those contemporary Hispanic/Mexican artists who have steeped themselves in the local mission-church art and who use it as direct inspiration for their own highly individual artworks. Two of the most successful of these artists, one living in Santa Fe and the other in the nearby Española Valley, are Luis Tapia and Félix López. Tapia has taken the images and colors of seventeenth- and eighteenth-century *santos* and reredos paintings as his point of departure and

Luis Tapia. *Reredos,* 1986. Carved and painted aspen and pine, 144 × 96 × 24". Courtesy of the artist.

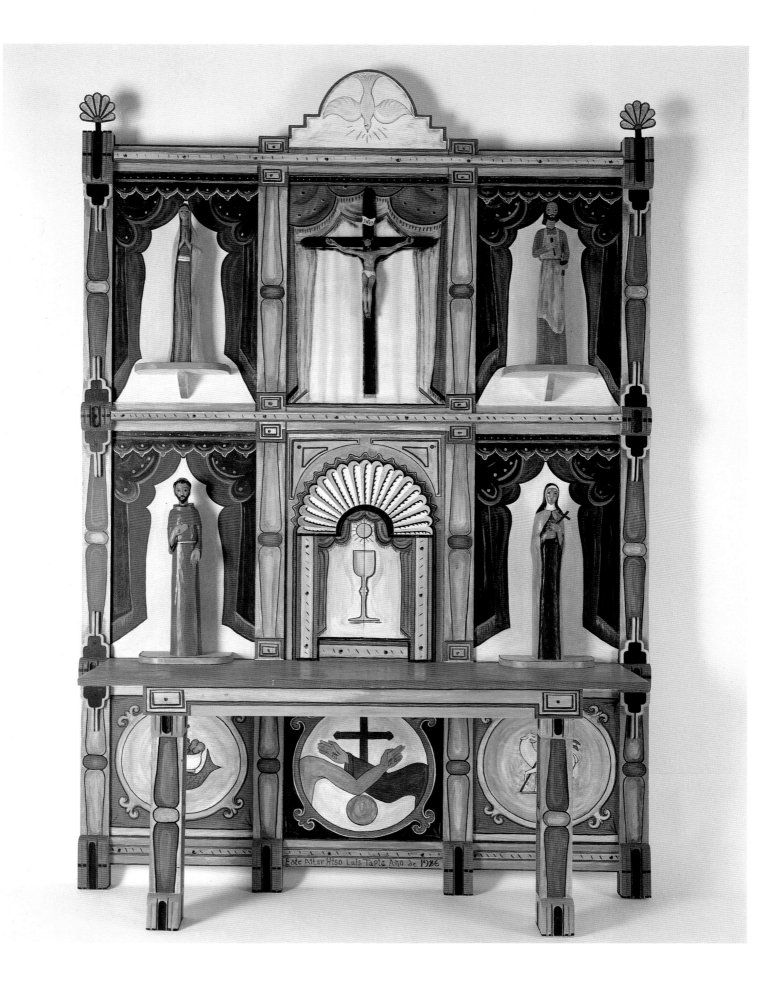

Este Altar Hiso Luis Tapia Año de 1986

Luis Tapia. *Reredos*, details.

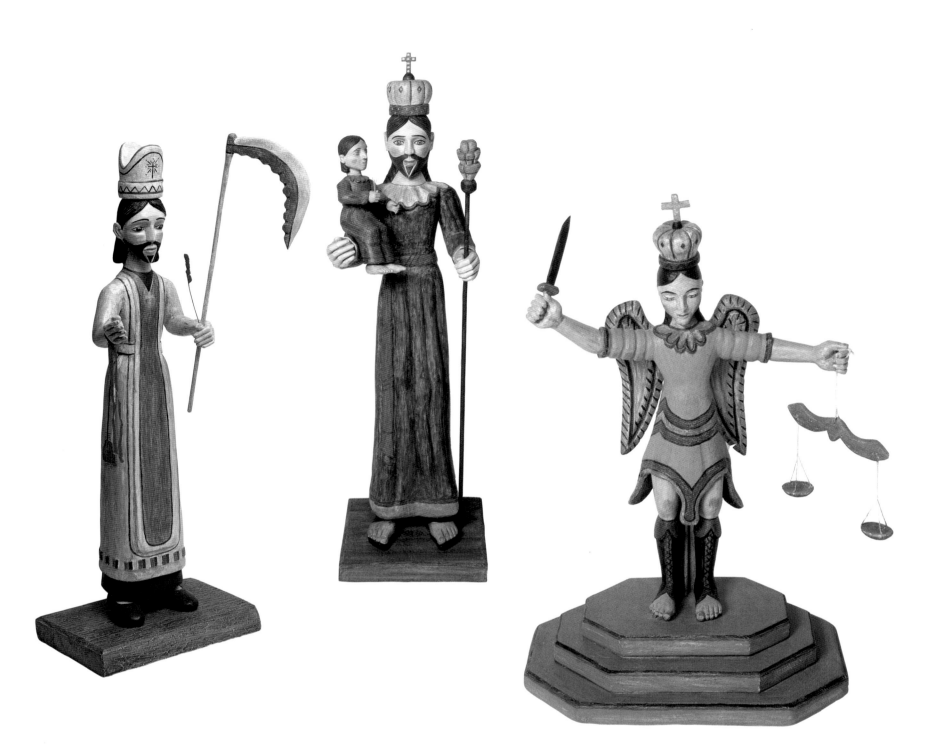

Félix A. López. *San Augustín Obispo,* 1985. Cottonwood, pine, gesso, and natural pigments, 30½″ high. Collection of Leo Polo-Trujillo, Española, New Mexico.

San José, 1983. Cottonwood, pine, gesso, natural pigments, and wheat straw, 57″ high. Collection of Mr. and Mrs. Robert E. McKee III.

San Miguel, 1984. Cottonwood, pine, gesso, and natural pigments, 27½″ high. Collection of Mrs. and Mrs. Robert E. McKee III.

has created a vivid, even theatrical series of works. The very accuracy of their chromatic treatment—they look like *un*aged painted period sculptures—give them a strikingly novel look. Accurate though his colors are, Tapia, unlike Félix López, whose pigments are all made from local natural materials—rocks, plants, and insects—takes considerable liberties in both his technique and his iconography, while adhering to certain prototypical conventions, synthesizing the old and the invented. Félix López is more literally traditional in all respects; his extraordinarily gentle, graceful figures seem to me to place him among the great *santeros,* along with José Rafael Aragón, the Truchas Master, José Benito Ortega, and the López family sculptors.

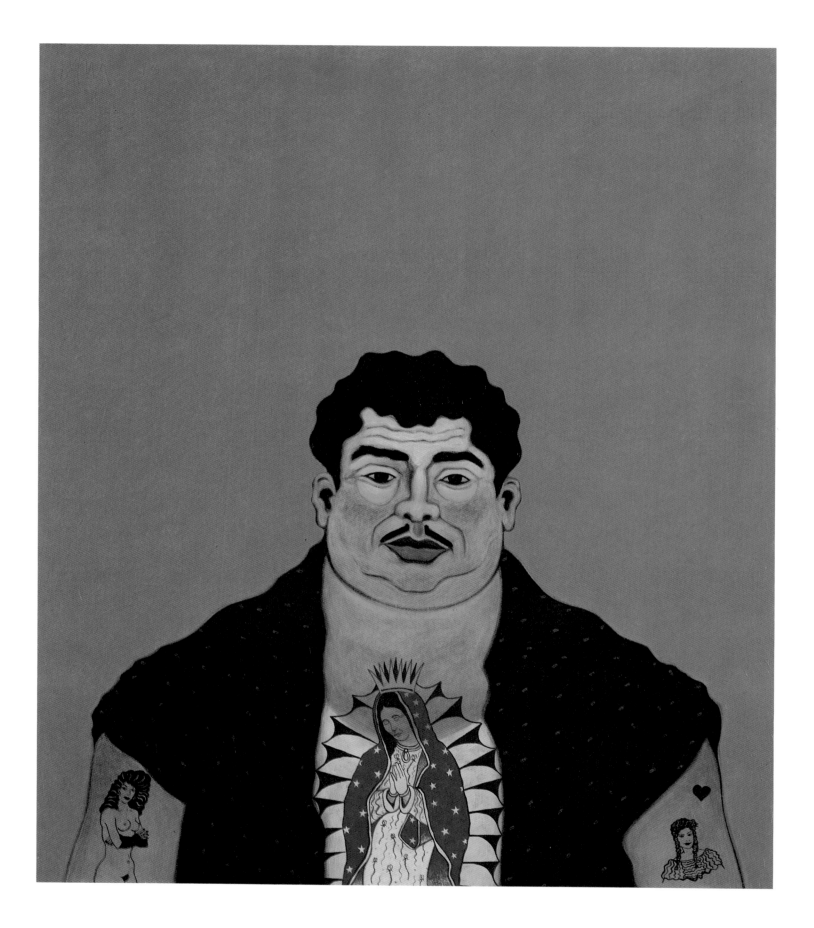

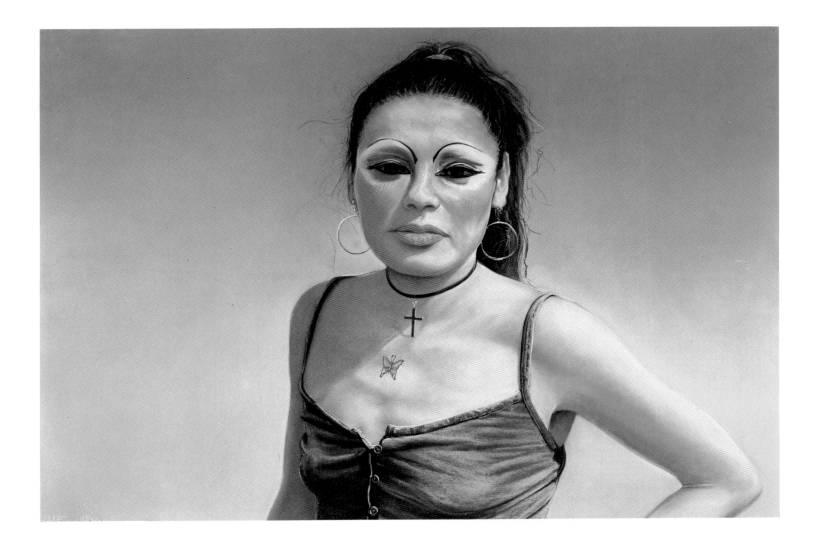

John Valadez. *La Butterfly,* 1983. Pastel on paper, 30 × 44". Collection of Ann Calhoun, Los Osos, California.

César Martínez. *Hombre que le Gustan las Mujeres,* 1986. Acrylic on canvas, 64 × 54". Collection of the artist.

Considerable attention has been given to the so-called "Chicano art" movement, primarily centering upon the city mural movement that began in Chicago about 1968 and that has flourished in many cities ever since. The murals have tended to depict scenes inspired by current or recent political issues—the farm workers' movement, immigration policies, eventually the whole history of Mexican liberation—and have often been influenced both stylistically and iconographically by the Mexican muralists. This book and exhibition do not include murals, though the works featured do embody the spirit begun in the Chicano murals and carried on, refined, and transformed in the drawings, paintings, and sculptures of a few artists who participated in the mural movement. The artists I am characterizing as primarily "Chicano" in their sensibility, however, did not necessarily begin their artistic careers as muralists. They share, simply, a sensitivity to the southwestern Chicano experience, and they use its imagery in their work. Each of these artists employs, often in an almost heraldic way, images of "Chicanismo": indeed, the two works that perhaps most potently distill the portrait of the Chicana and the Chicano are John Valadez's *La Butterfly* and César Martínez's *Hombre que le Gustan las Mujeres.* Both Valadez

and Martínez have chosen primarily to depict people, often urban characters, in a manner so role-specific as to be satiric and verging on stereotype—but with an underlying spirit of compassion and a particularity that make their subjects finally come alive as portraits rather than caricatures. These qualities of individuation and intensity elevate the best works of Valadez and Martínez to a level far above that of typical Chicano mural depictions of either street characters or cultural heroes. They are extrapolations from and refinements of mural conventions, drawing as well upon other popular and classical forms.

Three artists who live and work in Los Angeles—Gilbert Luján, Frank Romero, and Gronk—diverge perhaps more significantly from the broadly public, mythic, and political character of the Chicano mural form than either Martínez or Valadez and make greater use of the general contemporary art vocabulary. In each, and especially in the work of Frank Romero, one is aware of masterful draftsmanship, an inventiveness and fluidity of imagery and technique that place them alongside the most accomplished artists of our time—except in their insistence on subjects drawn from their Chicano roots and environment, particularly in the cases of Luján and Romero.

Gilbert Luján. *Hanging Out.* 1986. Pastel on paper, 30 × 44″. Collection of the artist.

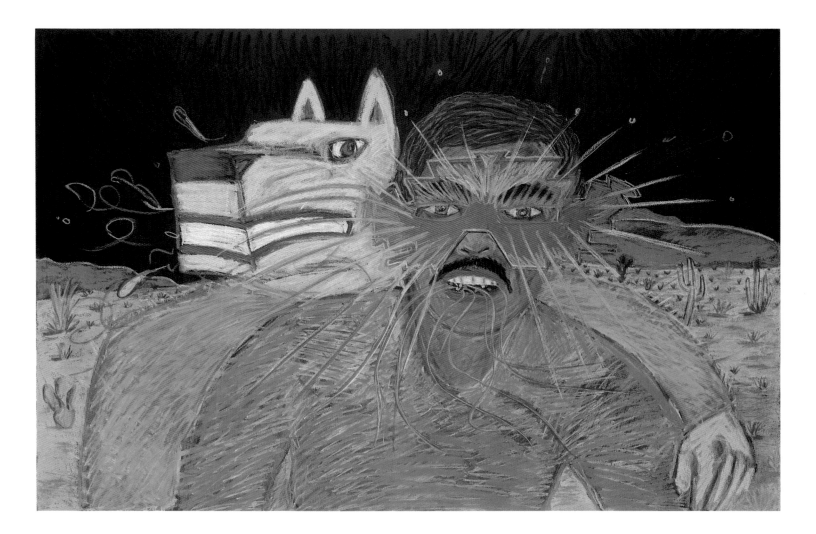

Frank Romero. *Fritzmobile,* 1984. Acrylic on canvas, 66 × 108". Collection of Laurel Erickson, NBC News, Los Angeles.

Overleaf:
Gilbert Luján. *Our Family Car,* 1985–86. 1950 Chevrolet two-door sedan; exterior: lacquer, chrome, and polyurethane; interior: painted linen and canvas upholstery, painted wood and canvas figures, and ceramic objects; height hydraulically adjustable. Collection of Mardi Luján.

Gilbert Luján's 1957 Chevy is of course in itself an icon of the Chicano urban culture; Romero, too, uses the automobile repeatedly in his work and has made virtually a personal mythos of scenes and icons from the barrio culture. Gronk employs imagery reminiscent of a more recent "urban punk" aesthetic; his extremely flat, decorative painting style and the repeated use of certain mythic figures—primarily *La Tormenta*—in different settings suggest that the artist is less concerned with Chicano politics than with broader satire. Yet, as much as any artist working today, Gronk manages to convey a strong sense of East Los Angeles Chicanismo. In fact, Gronk continues to work in the scale of the mural; although his allegorical subjects may be private rather than communal and his work international in look, he keeps tenaciously to certain of the methods of his ethnic milieu.

Rudy Fernandez's way of forging an art that has its sources in Chicano life and icons reflects his own work in Colorado, Utah, Arizona, and New Mexico. The technique and palette of his exquisitely crafted relief paintings and sculptures express both a raw, popular gaudiness and a subtle, evocative combination of ideas. What may seem almost transparent symbols—the cactus, the heart, the rooster, the knife—become, in varied juxtaposition and rendered in various scales and materials, unexpectedly complex metaphors for aspects of the artist's life in the Southwest.

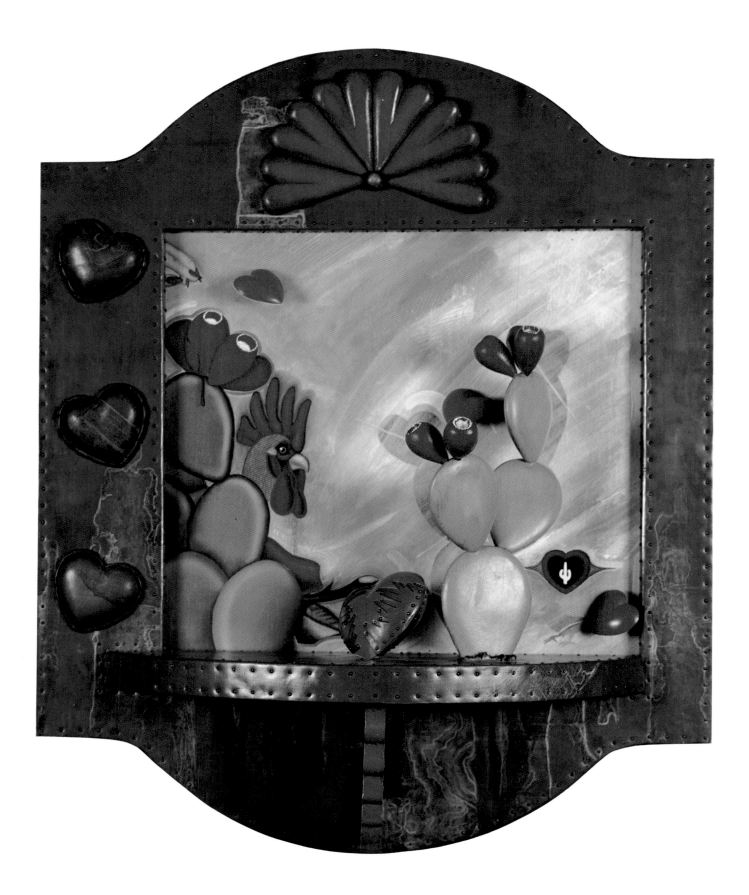

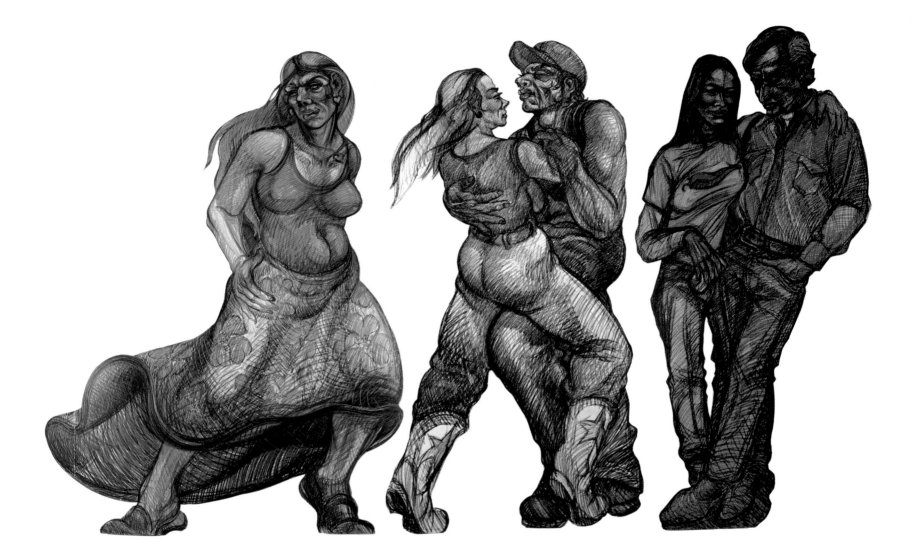

Luis Jimenez. *Honky Tonk,* 1981–86, details.
Crayon on paper mounted on foam core and
plywood, with neon element, approximately
8 × 16′ overall. Collection of the artist.

Rudy Fernandez. *Sal si Puedes,* 1985. Wood,
lead, and oil on canvas, 37½ × 29 × 9″.
Collection of Dennis and Julie Hopper,
Phoenix.

Luis Jimenez's subjects, while paralleling Frank Romero's or John Valadez's in
their immediate Chicano sources, are vastly different in at least one sense: they
avoid the East Los Angeles artist's obsessive urbanism. Jimenez has invented a
distinctive narrative voice, the visual language of the rural southwestern Chi-
cano experience, the culture of the border crossing, the Texas dance hall, the
Chicano cowboy.

While the artists discussed thus far draw on obviously ethnic visual traditions and on current political and social circumstances for the sources of their work, the artists I am about to discuss, while they have unmistakable affinities with the "folk"-inspired and southwestern Chicano artists, belong more securely to the mainstream of contemporary art.

One group finds its sources and flavor largely in what we might call "Latino/ Hispanic Modernism," a tradition shaped by Joan Miró, Pablo Picasso, and the Mexicans, José Clemente Orozco, David Alfaro Siqueiros, Diego Rivera, and Rufino Tamayo. For the Cuban painters Carlos Alfonzo and Paul Sierra, the Mexican/Puerto Rican painter Roberto Juarez, and, to a lesser degree, the Cuban Pedro Perez and the Puerto Rican Ibsen Espada, the work of latter-day Latino/Hispanic Modernists Wifredo Lam, Robert Matta, André Masson, and Joaquín Torres-Garciá is at least as important as that of the "original" practitioners. To be sure, Alfonzo, Sierra, Juarez, and Perez have variously altered and subverted modernism, but in the work of each of these artists an atmosphere of both chromatic and compositional lushness on the one hand, and a kind of timeless, mythic, often primitive imagery on the other distinguishes them especially from the much more circumscribed and often politically derived vocabulary of the Chicano painters. Perhaps Carlos Alfonzo, of all the artists in this group, exemplifies most directly the ties to a sort of substyle within Latino/ Hispanic Modernism, which I am calling Picassesque Surrealism (Picasso via Lam, Matta, and Miró), that was taken up especially in Cuba and Puerto Rico. Alfonzo, who only recently transplanted himself from Havana to Miami, has responded instantaneously to his contemporary surroundings to produce a series of paintings amazingly fresh and distinctly *non*imitative, yet that nevertheless spring directly from the specific tradition just outlined. His compatriot, Paul Sierra, who has lived in Chicago for twenty-five years, necessarily evinces in his work a more locally influenced style than Alfonzo does, although Sierra's work, related as it may be to certain North American "New Expressionist" tendencies, still resonates with a palette and a dreamlike primitivist imagery strikingly reminiscent of Wifredo Lam and even of Henri Rousseau. The artist himself locates his own sources, or at least enthusiasms, elsewhere, citing such artists as Willem De Kooning, Francis Bacon, and Balthus.

It is more through Pedro Perez's paintings and drawings than through his anomalous gold-leaf objects that one can identify him with this Latino/Hispanic Modernist mode. Again one thinks of Lam, Matta, and the various abstract painters in South America and the Caribbean who have been active in recent decades. But, in contrast to these highly self-conscious painters, Perez creates imagery that is nearly always satiric, either of ethnic culture per se or its religions. The gold-leafed pieces derive partly from his exposure in childhood to his father's jewelry-making, yet these, too, incorporate satire, and use symbols and stylistic referents that link Perez to both a Hispanic and a Surrealist hierarchy of methods and syntax. For example, as in the piece titled *God*, to create within the outer cruciform shape a centered image of God the Father as a kind of grinning—really, leering—St. Nicholas is to turn upon its head both the religion of Perez's cultural heritage and the dicta of an anti-illustrational modernist style. Perez provides a clear example of the coexisting, seemingly irrecon-

Carlos Alfonzo. *Where Tears Can't Stop*, 1986. Acrylic on canvas, 96 × 120″. Collection of the artist.

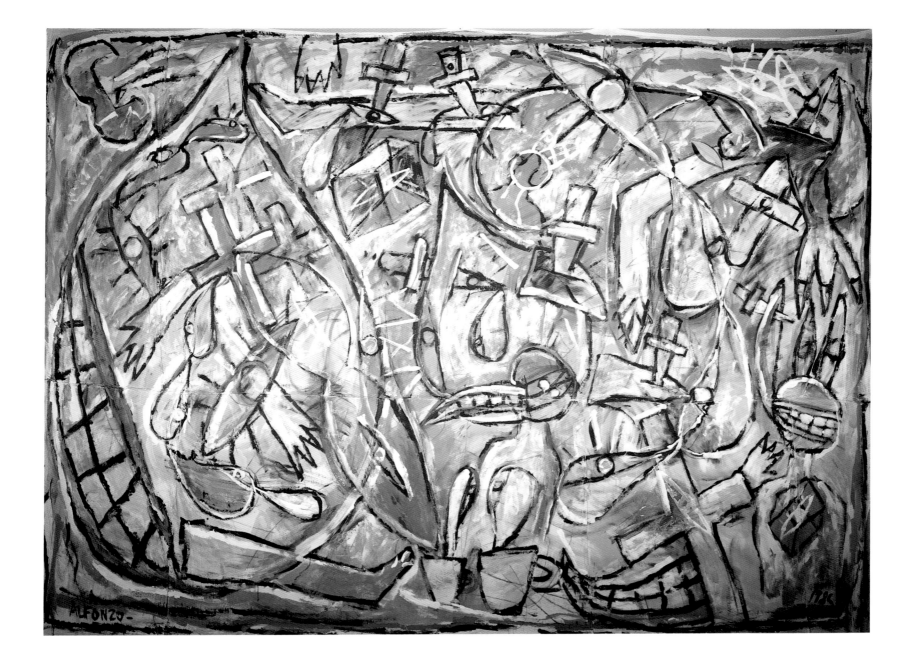

ciliable yet oddly harmonious attributes that characterize many of the thirty artists whose work we are exploring. He is at once clearly in the mainstream, quite accountable in terms of recent art history, yet he is just as clearly steeped in the heritage that informs the work of the artists discussed in the first part of this essay.

While Ibsen Espada seems on the face of it equally akin in his sense of line and color to Miró and to the calligraphic rhythms of contemporary urban graffitti, he, too, should be identified with the Latino/Hispanic Modernist sensibility. Through study with the Cuban artist Rolando López Dirube, the variations wrought on international abstract painting in the 1940s and 1950s in Puerto Rico, among other Latin American countries, inevitably conditioned Espada. Although his recent work has diverged significantly from what he produced earlier, the influence of Dirube and abstraction is still apparent and sharply distinguishes even the newer work from the main body of contemporary "New Expressionist" painting.

The artist who perhaps most maturely configures the new version of the Latin American modernist styles that have arisen variously from European Cubism, Surrealism, and early modernist Expressionism, is Roberto Juarez. Juarez has come to his complex style circuitously, since his formative artistic years were spent in Chicago and the Bay Area. Though partly of Puerto Rican descent, Juarez's direct influences, as a Mexican American living in San Francisco and associating intimately with the highly self-conscious California vanguard milieu, would seem inevitably to have molded him in either the "Chicanismo" or the "New Expressionist" patterns of the 1970s and 1980s. Yet Juarez has somehow

Pedro Perez. *God,* 1981. Gold leaf, acrylic, and costume jewelry on wood, two elements: cross 55 × 29½ × 2"; spear 55" h. Jock Truman and Eric Green.

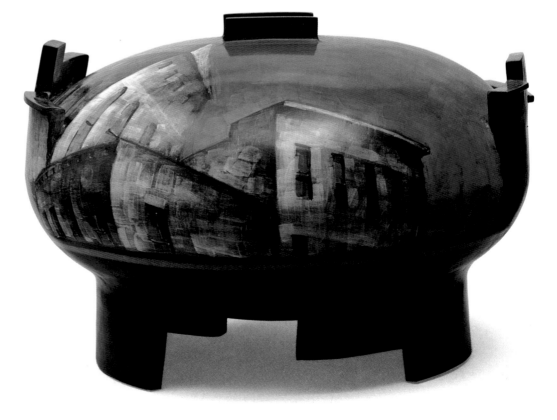

Lidya Buzio. *Large Blue Roofscape,* 1986. Burnished earthenware, 11 × 15" d. Collection of Katharine and Anthony Del Vecchio.

109

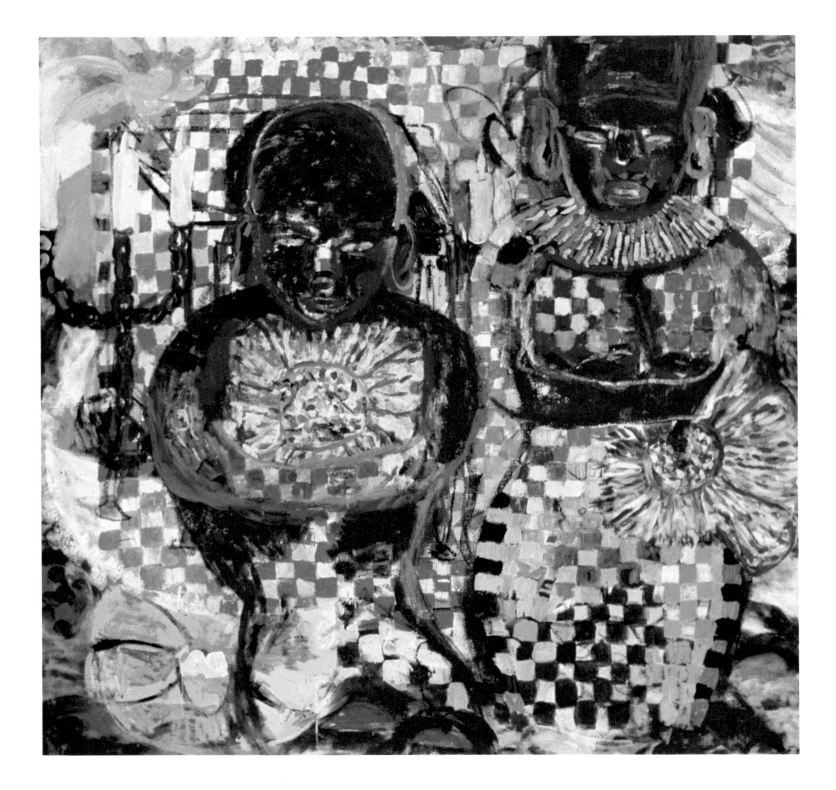

Roberto Juarez. *Two Sister Dolls,* 1984. Oil on canvas, 78 × 78″. Courtesy of Betsy Rosenfield Gallery, Chicago.

Carlos Almaraz. *Two of a Kind,* 1986. Oil on canvas, 80 × 66″. Courtesy of Jan Turner Gallery, Los Angeles.

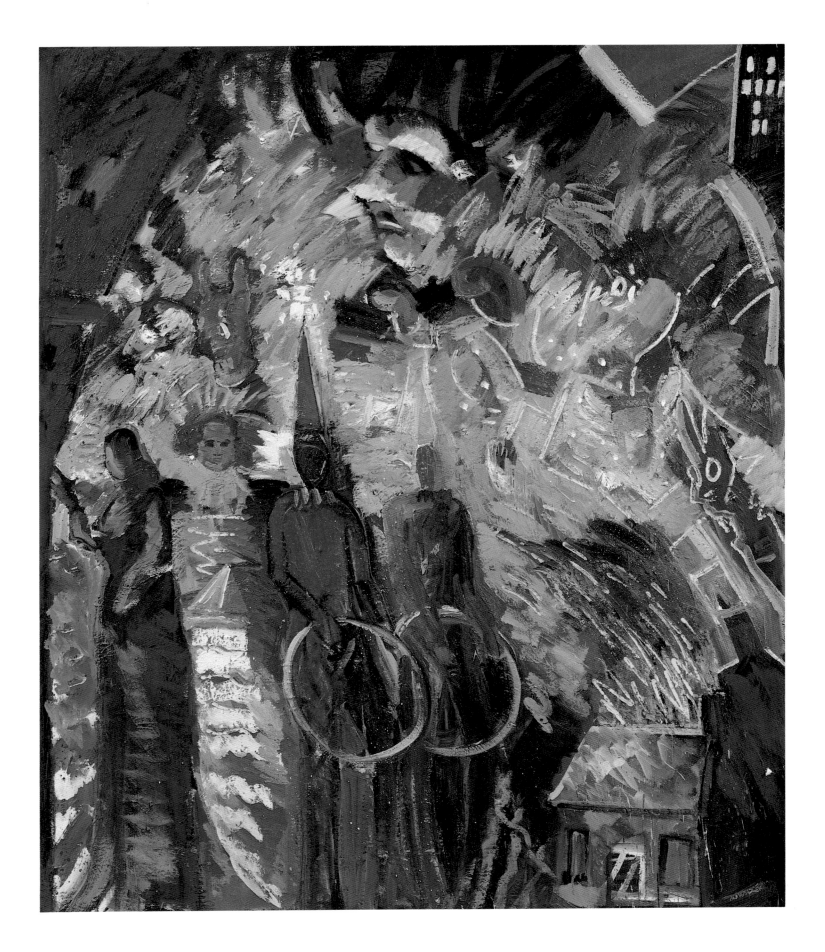

Ibsen Espada. *Orchestra II,* 1986. Oil, ink, and watercolor on rice paper applied to canvas, 40 × 58". Courtesy of the artist and McMurtrey Gallery, Houston.

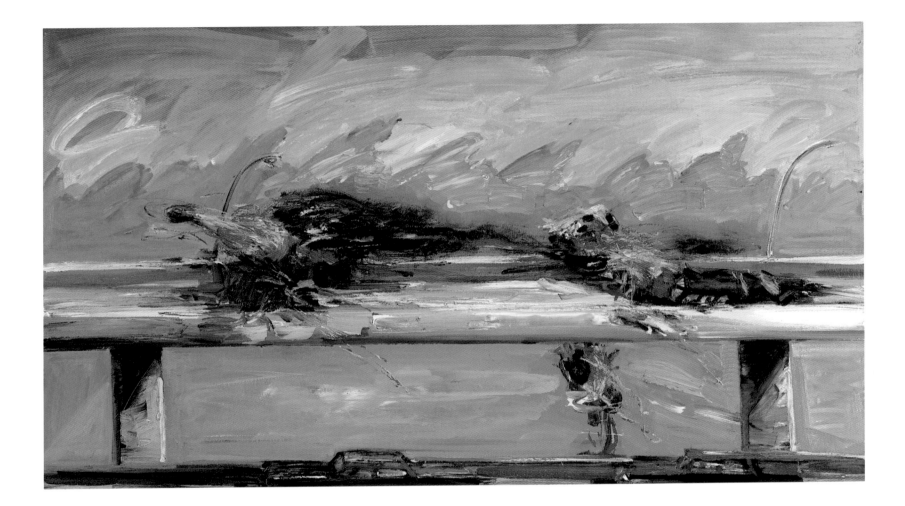

Carlos Almaraz. *Crash in Pthalo Green,* 1984. Oil on canvas, 42 × 72".
Collection of Mobil Oil Corporation, New York.

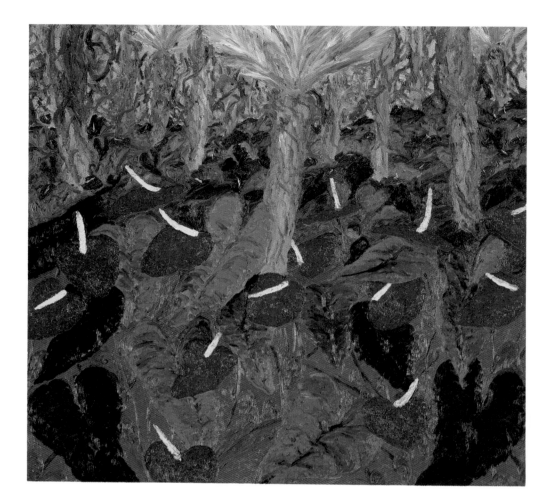

Patricia Gonzalez. *Heart Forest*, 1985. Oil on paper, 36 × 36". Private collection.

come to embrace and transform the Latino/Hispanic Modernist style, particularly in its specifically Caribbean subgenre that we identify with Wifredo Lam, his fellow Cuban Mario Carreño, or even with some Haitian painting.

It is partly in Juarez's sometimes flamboyant, sometimes somber palette, his frequent use of mythic female figures, and his many free-associative juxtapositions in the still-life and figure paintings alike, that he relates to another subgenre I will mention, the Mexican Neo-Surrealism identified with Frida Kahlo, Dorothea Carrington, and Remedios Varo, among others. In its tight, often illustrational handling of paint and drawing, and in its extremely literary emphasis, this is distinctly separate from the "Picassesque Surrealism" mentioned earlier. And to make matters more complicated, the affinities with this peculiarly Mexican phenomenon can, we find, be evinced equally, if in differing spirits, through the work of Carmen Lomas Garza, Patricia Gonzalez, Paul Sierra, and, perhaps more emphatically, in that of Luis Cruz Azaceta. However, Juarez—like many other artists in this book and exhibition—can also be seen in other contexts, and certainly his oeuvre springs from a multitude of sources.

A more generalized movement in the twentieth-century art of South America is a transmutation specifically of European Cubism, a mode we associate primarily with the work of the great Uruguayan, Joaquín Torres-García. Torres-

Patricia Gonzalez. *Eccentricities in Nature*, 1985. Oil on canvas, 66 × 50". Courtesy of the artist and W. A. Graham Gallery, Houston.

Overleaf:
Arnaldo Roche. *The Fall*, 1985. Oil pastel on gessoed paper, 72 × 60". Collection of John Belk and Margarita Serapion.

Don't Play My Song, 1985.
Oil pastel on gessoed paper, 84 × 60".
The Archer Huntington Art Gallery, The University of Texas at Austin, Archer M. Huntington Museum Fund, 1986.

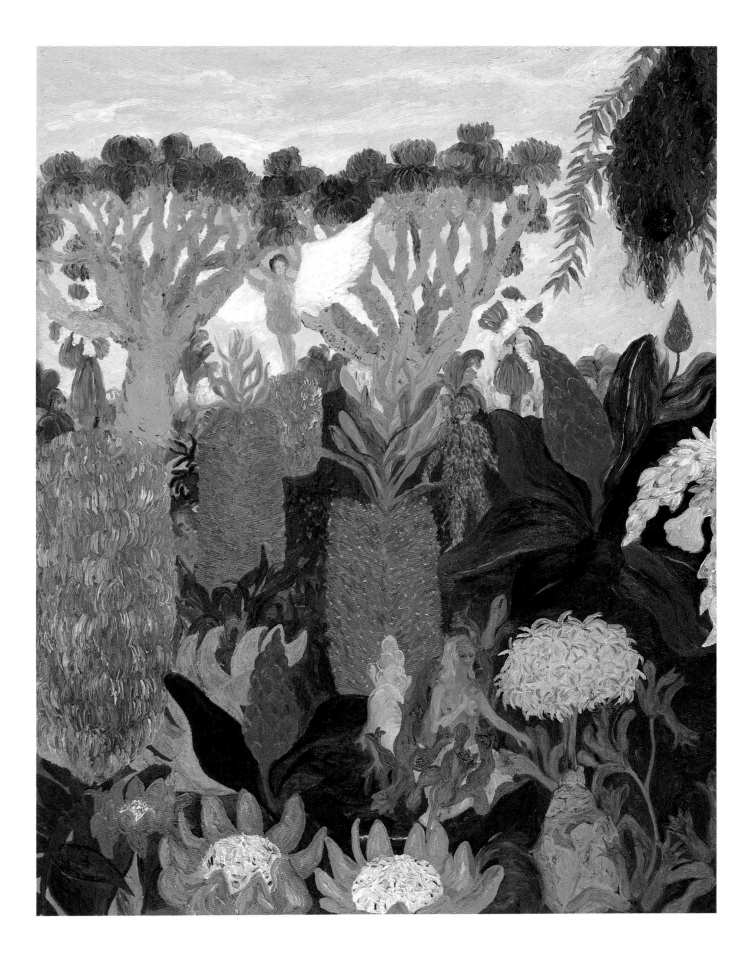

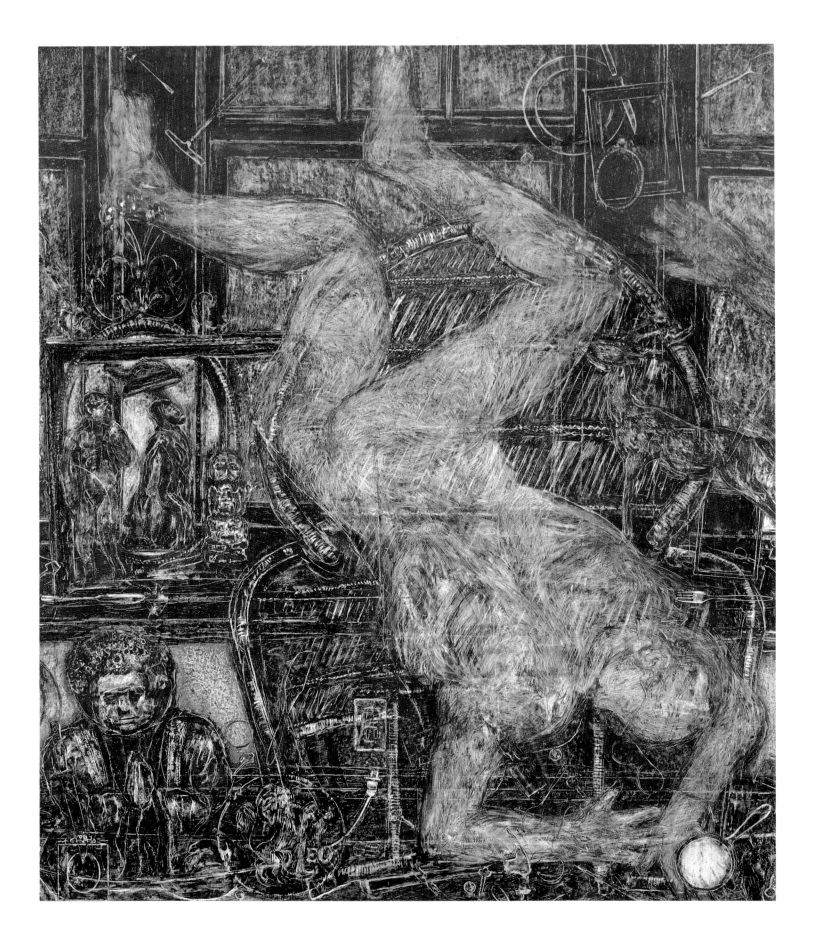

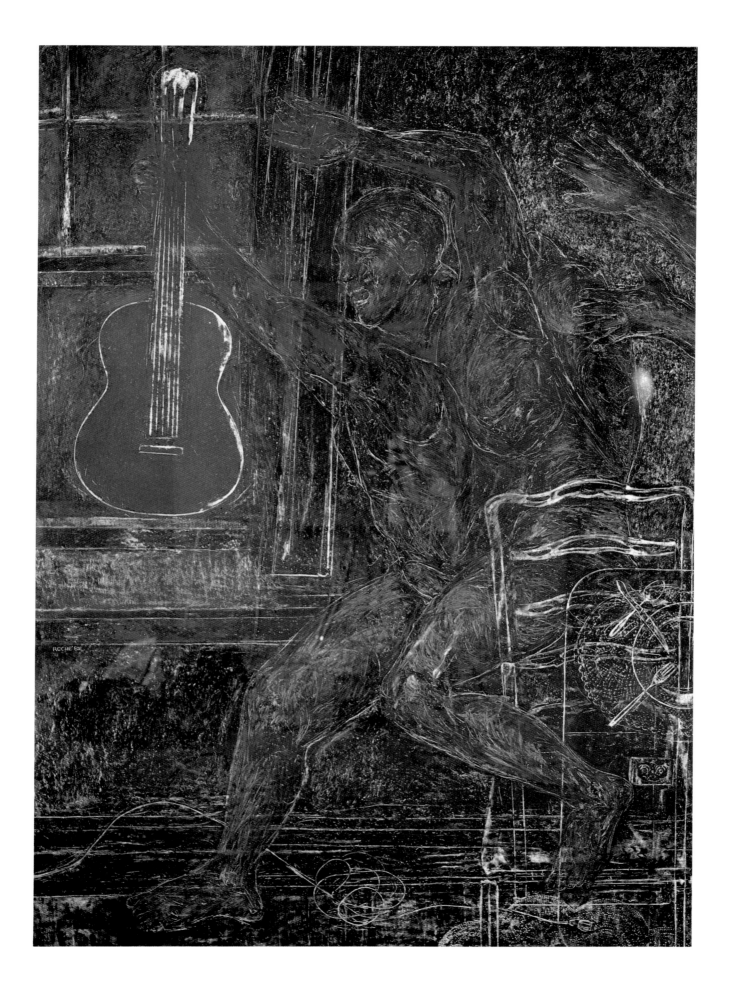

García's South American Cubism has directly influenced Lidya Buzio, who studied with Torres-García's son, Horacio, and has known the older artist's work since childhood. But the tradition is not limited to such direct lineage; it is also manifest here in virtually every painting of Carlos Alfonzo, in many of Roberto Juarez's still-lifes, and in Arnaldo Roche's self-portraits.

The last two artists, however, seem to belong more firmly to yet another large stylistic category I propose: something that might be termed "International New Expressionism." This broadly configured style is associated with a variety of contemporary painters from Italy to California. Indeed, the New Expressionist idea can be identified as the ascendent mode in the vanguard art of the 1980s. It includes such well-known painters as Malcolm Morley, Enzo Cucchi, Sandro Chia, and Georg Baselitz, as well as dozens of other European and American artists. It embraces landscape and figure painting and combinations thereof. At least six of the artists under consideration here fall squarely under the New Expressionist rubric. Some concentrate chiefly on a landscape-based approach; others incorporate figures. Of the former, I would single out as prime examples Carlos Almaraz and Patricia Gonzalez, for all that they differ from one another. Of the latter, I would point to Arnaldo Roche, Rolando Briseño, and Luis Cruz Azaceta. Ismael Frigerio, Paul Sierra, Roberto Juarez, Roberto Gil de Montes, and Luis Stand also take their places within this overarching phenomenon, although each of them diverges from the wholehearted commitment to the international vanguardism implicit in the work of Almaraz and Gonzalez in particular.

Within New Expressionism are two subgenres, practiced by several of the artists here, who emphasize either narrative content or mythic images. The main proponents of a truly narrative painting style are Frank Romero, Rolando Briseño, Luis Jimenez and, in certain works, Luis Cruz Azaceta. Carlos Almaraz usually straddles the ground between the narrative and the mythic. Luis Stand, Ismael Frigerio, Paul Sierra, Roberto Gil de Montes, and Roberto Juarez tend more to engage mythic themes and images, not so much telling stories as creating settings for them, or depicting only vaguely recognizable episodes or images. Each of these artists, whether "narrative" or "mythologizing," incorporates, often obsessively, scenes or fragments drawing upon personal history and ancient legend. Not surprisingly, many of the shared images are extracted from Mexican, Latin American, or pre-Columbian myth and history. Though Jimenez and Romero, for instance, employ elaborate and explicit Chicano narrative motifs, such as the automobile culture vocabulary or that of the southwestern dance hall, many images in their work are drawn from more universal mythic sources. Gonzalez's dreamlike landscapes, Frigerio's deeply primitivistic scenes, depicting a serpent or an arklike vessel with fish or in flames, and Azaceta's archetypal figures enter into the vanguardist mainstream of invented images that transcend specific cultural references to become virtually universal.

To contrast the active, specifically narrative compositions of Rolando Briseño—which often incorporate references to other art as well as contemporary popular imagery—with the work of Carlos Almaraz, whose vibrant bravura compositions depict either actual scenes derived from the artist's own experi-

Paul Sierra. *Mad Dogs,* 1984. Acrylic on canvas, 41 × 44". Courtesy of Halsted Gallery, Chicago.

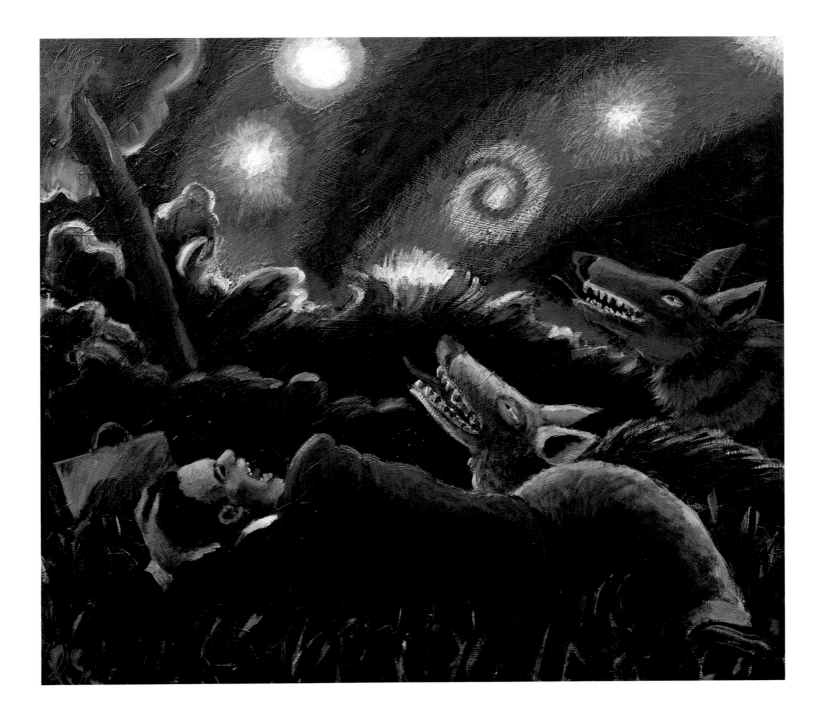

ence or imagined scenes of violence—the car crashes—is to get a sense of the immensity of the territory circumscribed by the Expressionist classification in contemporary Hispanic art. It encompasses Arnaldo Roche's peculiarly atavistic, Cubist-like, rotated figures; Paul Sierra's strangely hallucinatory scenes of primitive ritual or fantastic landscapes; Roberto Gil de Montes's simultaneously whimsical and menacing depictions of godlike totems, role-playing women, or humanoid animals; and Luis Stand's masklike, often explicitly allegorical, figures of men and animals structured as political maps or ecclesiastically symbolic shapes.

The variegation of palette or painterly technique is as intense among the international New Expressionists as among those in the Hispanic aspect of the phenomenon. If there is substantial, rather than merely atmospheric, difference between the "Expressionism" exemplified by the artists of the New York/Berlin/Rome axis and those treated here, it is usually in the ethnically derived, and thus culturally limited legibility of symbolic or metaphoric signs rather than in style. Virtually all of the contemporary painters and sculptors who inhabit the astonishingly supranational territory loosely called Hispanic Art would, even in acknowledging cultural, ethnic, or aesthetic kinships, insist on a uniqueness of

Roberto Gil de Montes. *The Receptor,* 1985. Oil on linen on wood, 72 × 98½ × 5½". Jan Baum Gallery, Los Angeles.

Luis Cruz Azaceta. *The Immigrant,* 1985. Acrylic on canvas, 103 × 84". Allan Frumkin Gallery, New York.

Overleaf:
Ismael Frigerio. *The Lust of Conquest,* 1985—86. Tempera and acrylic on canvas, two panels, 89 × 140" overall. Collection of the artist.

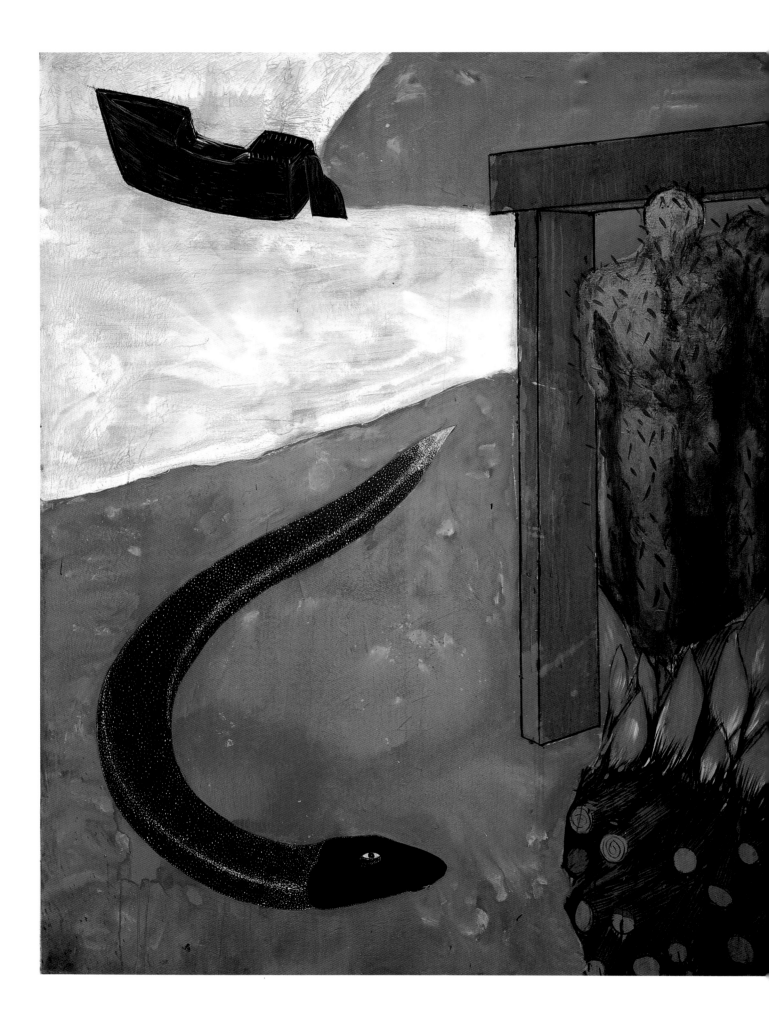

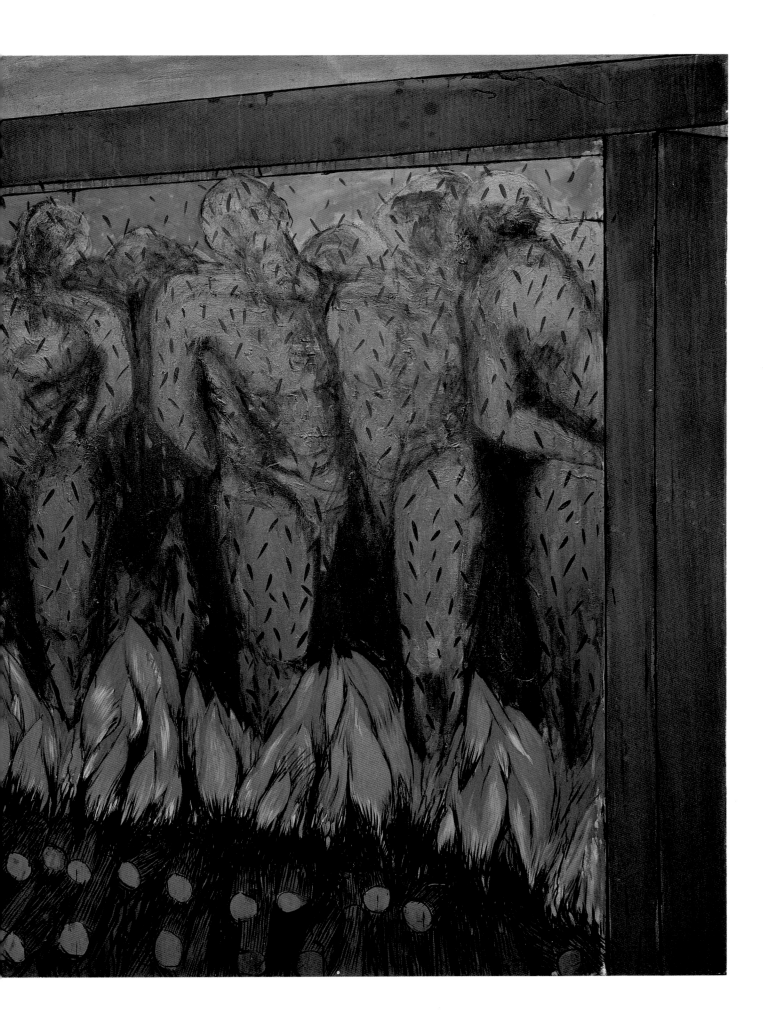

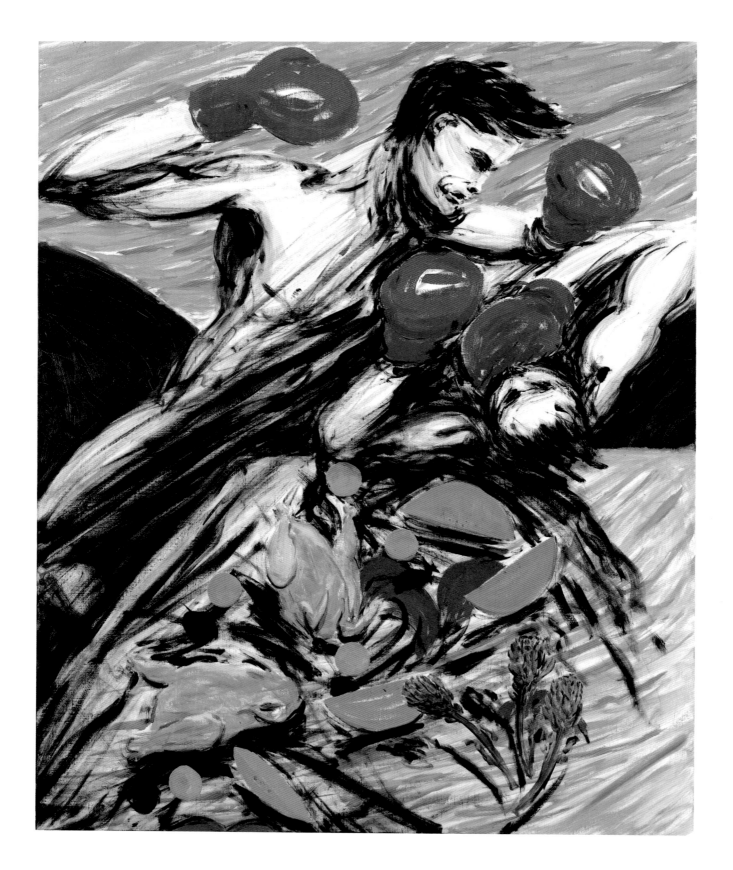

vision. Each of the Hispanic artists discussed here proclaims his or her autonomy, usually arrived at through a long process of personal experimentation and profound, conscious eclecticism. But unlike the strangely neutral, universally interpretable, often Jungian character of the images brought forth by such contemporary painters as the Germans Anselm Kiefer or Georg Baselitz, or the Italians Francesco Clemente or Sandro Chia, the subjects or symbols bodied forth in the painting of Carlos Alfonzo, Carlos Almaraz, or Roberto Gil de Montes, to take three especially suggestive examples, seem by comparison highly resonant of a specific culture: Alfonzo's Cuban origin comes through more in the language of a South American modernist heritage than through a sense of his immediate connection to a popular culture; Gil de Montes hints at his East Los Angeles Mexicanness more directly through his imagery, though much of it is universally mythic in nature; Carlos Almaraz draws in equal measure upon the great modern Mexican muralists and the Los Angeles milieu that fed him.

Rolando Briseño. *Fighting at the Table #4*, 1986. Oil on linen, 59 × 47". Courtesy of Wessel O'Connor Gallery, Rome.

Naturalezza Viva, 1986. Oil on wood, 51 × 43½". Courtesy of Wessel O'Connor Gallery, Rome.

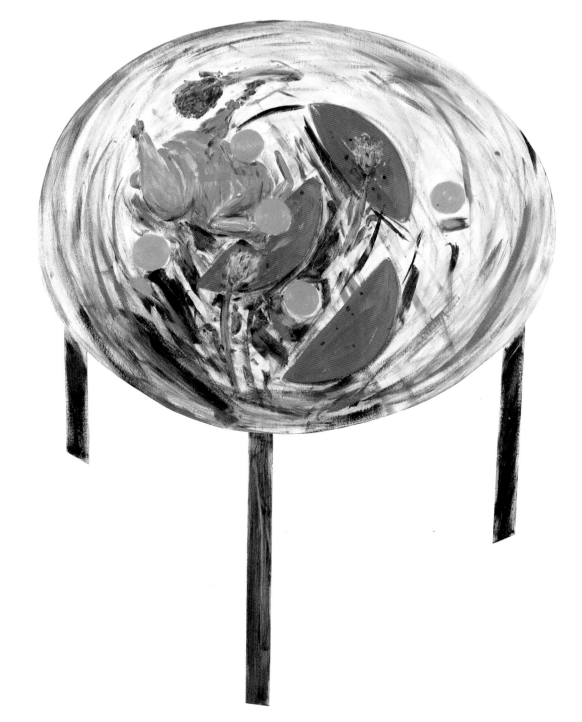

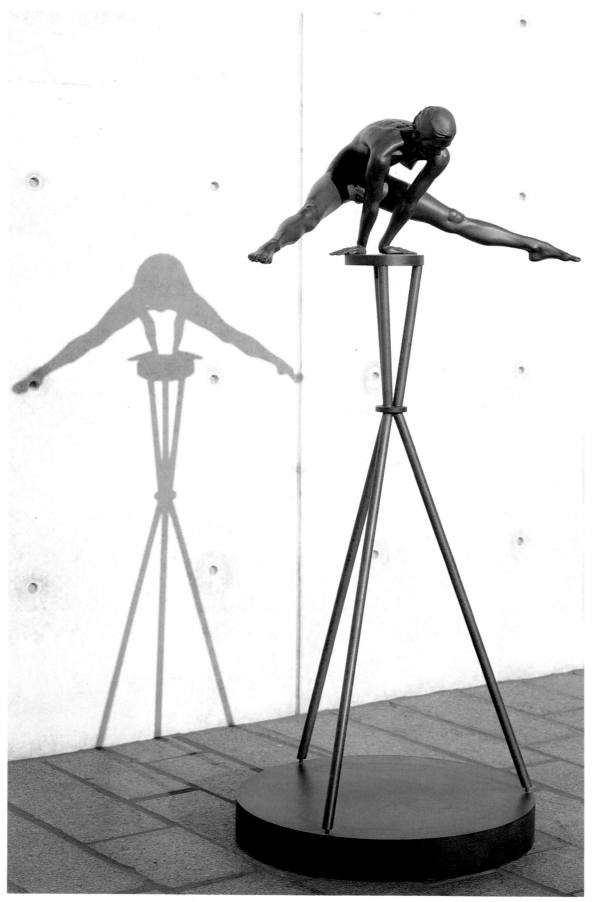

Robert Graham. *Fountain Figure #2*, 1983. Cast bronze, 16 × 41 × 20"; base 60 × 30" diameter. The Museum of Fine Arts, Houston: Museum purchase with funds provided by Mr. and Mrs. Theodore N. Law.

Jesús Bautista Moroles. *Georgia Stele*, 1986. Georgia granite, 82 × 13½ × 10". Courtesy of the artist and Davis/McClain Gallery, Houston.

One of the artists among our thirty seems to stand very much alone in his use of materials and in his relation to art history. Jesús Bautista Moroles works in a tradition we want to associate with such figures as Isamu Noguchi, Max Bill, Tony Smith, Michael Heizer. His obsession with monumentality and with the physical properties of quarried stone, together with a sure grasp of modernist geometry, place him in a familiar modernist context. But alongside (really, underneath) this aspect of Moroles's artistic heritage and concern is something else, some characteristic that definitively separates him from the art-historical mainstream. The nature of this quality is risky to speculate about. It might simply be said, in its geometries and proportions, to be overtly pre-Columbian—Aztec or Olmec. But it is more complicated than that; Moroles somehow makes contemporary, makes new, and quite clearly makes *culturally specific,* his version of polished stone sculpture. We are never in any doubt about the artist's ties to the world he lives in, rural Texas, and its landscape, nor can we understand this work without some intuition of the artist's Mexican-American identity.

The same cannot be said for the supremely classical, essentially Platonic figure sculpture of the Los Angeles artist Robert Graham, or for the more ruggedly process-revealing figure sculpture of the Northern Californian, Manuel Neri. Each of these artists, though they share little aside from their common identity as figure sculptors, establishes a separate pinnacle of achievement within the Hispanic-North American artistic episode. Each takes his departure point from the long European tradition of figurative sculpture and painting, and yet each has developed securely within the milieu of recent California mainstream vanguardism. Graham, whose early work may have been interpreted as an offshoot of Pop Art, has emerged now as perhaps the definitive living master of an essentially neoclassical mode, the austerely idealized yet naturalistic rendering of the nude. His will to operate within the arena of public art, creating pieces whose scale and placement make them part of the urban landscape and not just of the elitist interior art environment, is one aspect of Graham's art that allies him with the Mexican modernist tradition.

In his use of materials, scale, and subject, Manuel Neri may appear to be more Italianate than Latin American in his artistic temperament. But something in Neri's poignantly rough yet lyric figures—their lack of sentiment and their paradoxical beatitude—resonates in a spirit entirely consistent with that of the other artist under discussion. Neri's figures provide a key example of a body of work that began against the grain of an entire historical set of expectations only to appear, after a few decades, entirely precedented, readily dovetailing with a full panoply of later-developed styles. In the 1960s or 1970s Manuel Neri's identity could not have been fully understood in any of the contexts imposed upon him at the present moment: "Hispanic in the United States," "new figurative classicist," "Neo-Expressionist." His affinities with Michelangelo and Rodin have always been clear, but perhaps now these analogies seem less compelling than the more current cultural environment he inhabits.

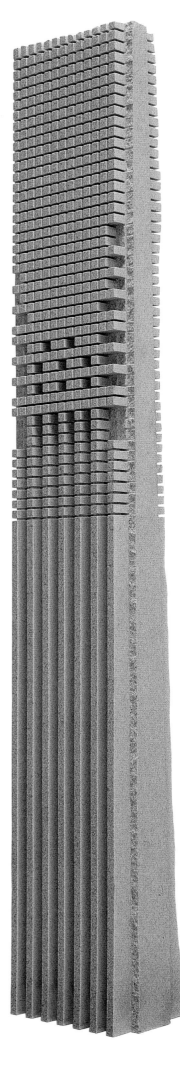

The shared resistance, among all of these Hispanic artists, to easy or permanent "contextualization" creates a paradox of a sort. For if it is the very premise of our endeavor that the thirty artists here do operate in a common cultural matrix—as painters and sculptors of Hispano-Latin American descent living in the United States—it is also axiomatic that they fit into other contexts perhaps more readily and sometimes into several "styles" or "movements" at once. It is also true, as we see especially in the cases of Graham, Neri, and Ramírez—and to different degrees with such artists as Carlos Almaraz and Roberto Juarez—that many of these artists may appear to belong at different points in their own histories to different artistic or even different cultural tendencies. And it is tempting to compare this rather astonishing fluidity and interchangeability of the background contexts against which various of these personal styles may be cast, with the same notion of potential flexibility—or lack of it—when we think of the contemporary European painters and sculptors who are their counterparts. There simply does not arise a comparable complexity of historic and stylistic location among the vanguard of Italian, Dutch, German, or British painters of the 1980s. For the American vanguard in general, a significantly greater *ambiguity* comes into play than is the case with the Europeans. And for those American painters and sculptors whose bicultural existence is an issue, we find still greater complexity of context, and more hybridization of styles.

When art itself is not the primary source and stimulus for making art—when, that is, an artist feels impelled in his imaging and technical education not only by the inner dialectic of art history but also by a specific ethnic (often popular) set of symbols and myths, and, moreover, by his or her *personal* history—the result is often a peculiarly fluid, or contextually flexible, product. By and large, the art in this book and exhibition is less art about art than it is art fueled by a compound of cultural symbols and private experiences that want to find dramatic expression. A language that is Anglo yet tenaciously Hispanic echoes through these images; we recognize its *differentness* from other languages. Yet, even as we hear it through the layered filters of other art, and of our own knowledge of life in the United States, we recognize it as our own.

ARTISTS' BIOGRAPHIES

John Valadez. Beto's Vacation (Water, Land, Fire), triptych, 1985. Collection of Dennis Hopper. Venice, California.

Water. Pastel on paper, 67½ × 50¼".

Land. Pastel on paper, 72 × 50¼".

Fire. Pastel on paper, 65 × 50¼".

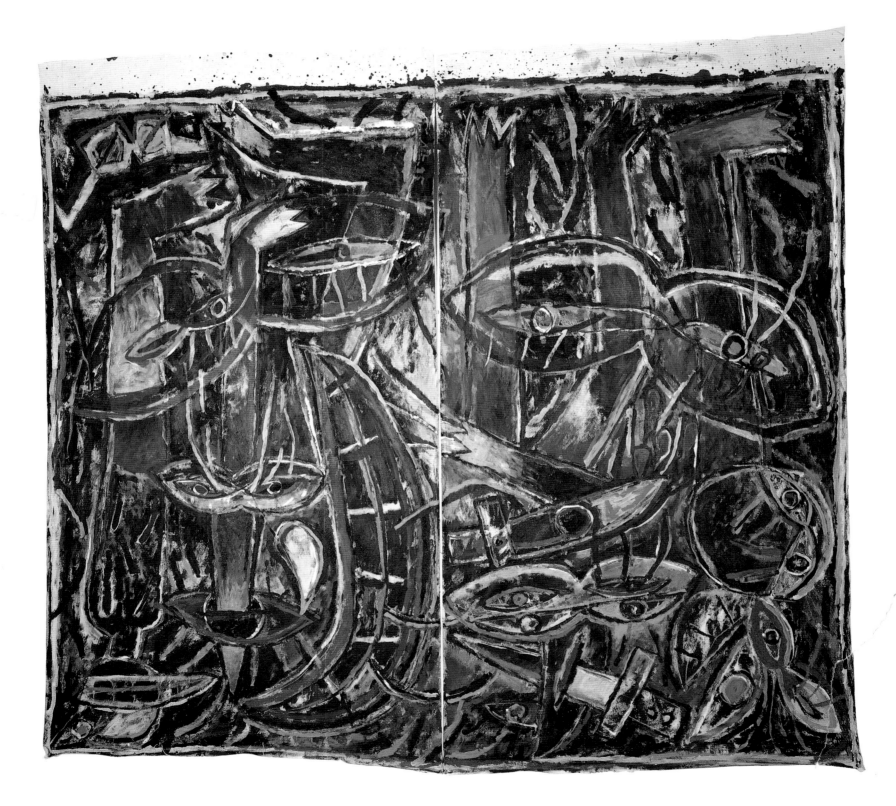

CARLOS ALFONZO

Born 1950, Havana, Cuba

Carlos Alfonzo's father had a career in civil aviation that spanned Cuba's pre- and post-revolutionary eras; at his retirement, he was head of flight control at the Havana airport. His mother was a bilingual secretary in an American advertising agency before the revolution; after, she worked in the Ministry of Communications. Both parents welcomed the changes that came with Fidel Castro's rise to power; Alfonzo's father had been especially active in the struggle against the Batista government, raising money and printing articles for the opposition. Following the lead of his parents, Alfonzo felt Castro's administration was "a positive change at the time."

The political shift had a dramatic effect on the artist's mother. Openly and devoutly Catholic before the revolution, she transferred her allegiance to the secular authorities afterward. Yet Alfonzo credits her with revealing the spiritual world to him—"she gave me the opportunity to meet with magic"—but he pursued that world in his own way. While he was an art student, friends initiated him into one of the Afro-Cuban religious sects—an experience that would subsequently inform his paintings.

Although he had always drawn, it was not until near the end of his mandatory three-year stint in the army that he decided to study art. He spent a semester at Havana University and then enrolled in the Academia de Bellas Artes San Alejandro in Havana. There he studied painting, sculpture, and printing during 1969–73, and then art history at the University of Havana during 1974–77. Meanwhile, he had begun a teaching career, first at the Academia San Alejandro as instructor in art history during 1971–73, and subsequently in the art schools of the Ministry of Culture, as a teacher of studio courses between 1973 and 1980.

Alfonzo's career as an artist also developed significantly in these years. He had his first solo exhibition at the Amelia Pelaez Gallery in Havana in 1976; the next year, a traveling exhibition of his work visited eight Cuban cities, and in 1978 he was given a one-man show of painting and ceramics at the National Museum of Fine Arts, Havana. He was included the same year in a group

Carlos Alfonzo. *Trail*, 1985. Acrylic on canvas, 96 × 120". Collection of the artist.

exhibition sponsored by the National Museum, which toured thirteen countries in Latin America, Europe, and Asia. The University of Havana organized another solo exhibition of his work in 1980.

This exhibition never opened; Alfonzo defected during the 1980 Mariel boatlift. His motivation for leaving was both ideological and professional. The artist had become seriously disenchanted with the Castro government, and he felt the need to see more art than was available to him in Cuba. He departed over the objections of his family, especially his parents; he left behind a former wife, whom he had married in 1971, and a son, born in 1973.

In his decision to leave Cuba, Alfonzo is conscious of having followed the example of other Cuban artists, notably Wifredo Lam, whom Alfonzo feels "had to leave as an artist. Everybody says there's a strong history of painting in Cuba. I'm not so sure. The painters there are often a little behind." He describes his own work in Cuba as "the typical painting of a Latin American artist, with a slick finish that comes from looking at magazines and old slides. No brush strokes. My goal in the United States has been to get rid of that." But he has not forgotten everything he brought with him from Cuba. Many of his images are drawn from the Afro-Cuban religious tradition. The knife through the tongue, for example, is an Afro-Cuban visual idiom for keeping evil quiet; the knife also affords protection from the evil eye. Alfonzo notes that he uses such images as much for their formal as for their associative values.

Alfonzo is gradually rebuilding his career in the United States. He has been included in several group shows here, notably "10 Out of Cuba" at Intar Gallery, New York (1981); "Florida Figures" at the Frances Wolfson Art Gallery on the Mitchell Wolfson Campus of Miami-Dade Community College (1985); and "The Art of Miami," at the Southeastern Center for Contemporary Art, Winston-Salem, North Carolina (1985). In 1983, he received a Cintas Fellowship in the Visual Arts, and the next year he was awarded a Visual Artists Fellowship in Painting from the National Endowment for the Arts. He participated in a two-man exhibition at the Kouros Gallery, New York (1983) and another at Intar (1985), and he had a solo exhibition at Galeria 8, the Wolfson Campus of Miami-Dade Community College (1984). In 1985, Alfonzo was commissioned by the Miami-Dade Art in Public Places program to execute a ceramic tile mural for the new Santa Clara Metrorail Station in Miami, the city in which he now lives.

Carlos Alfonzo. *Sea Bitch Born Deep,* 1986. Acrylic on canvas, 96 × 120". Collection of the artist.

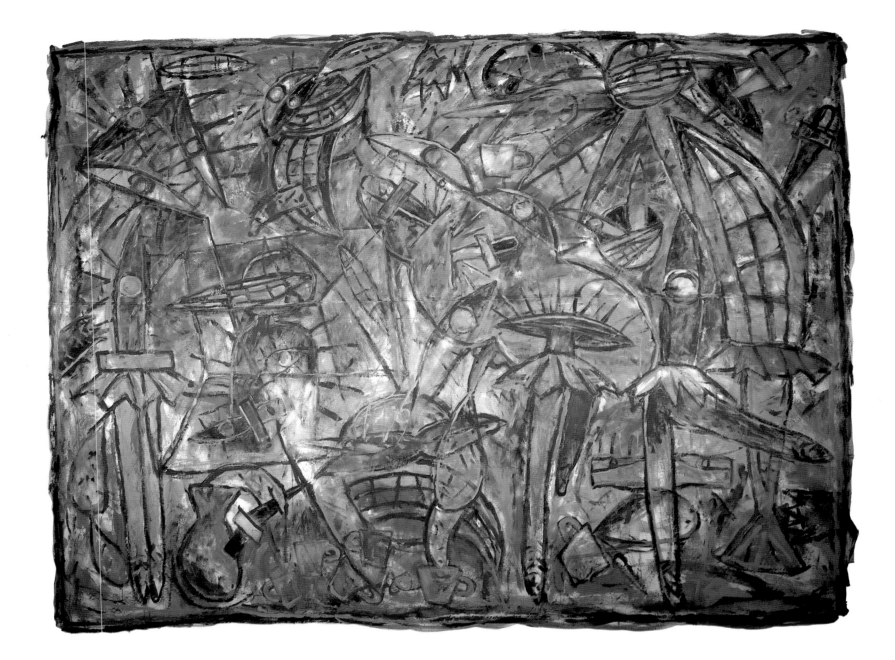

CARLOS ALMARAZ

Born 1941, Mexico City

Both of Carlos Almaraz's parents were born in Mexico—his mother in Mexico City, his father in Aguascalientes. His father came to the United States as a child and lived in Chicago during the Depression, returning periodically to Mexico, where he met his wife and where Carlos was born. The family moved to Chicago when Almaraz was a year old; they settled there for seven years. The father worked in the steel mills while Almaraz attended public schools, learning English in an environment of multiracial and multicultural tensions. He was aware from an early age, he says, of a sense of "bifurcation" in his surroundings.

When Almaraz was eight, his family, which included his younger brother Rudy, moved to California, settling for a short time in Chatsworth, then a rural Mexican-American railroad village near Los Angeles. Almaraz remembers it as intensely communal, possessed of a culture in which a closely interdependent group of *campesinos* lived as they might have in Mexico. Almaraz's father worked for the Union Pacific as a laborer, but he was also an avid reader who introduced the boy to such American writers as Tennessee Williams, Jack London, and John Steinbeck.

After six months in Chatsworth, the family moved to West Los Angeles, in the vicinity of Santa Monica and San Vicente boulevards, even then an affluent neighborhood, full of celebrities. From there they moved to the grittier East Los Angeles barrio, a Mexican-American city within a city. Almaraz lived there from the third or fourth grade through Garfield High School, surviving the rough and physically competitive atmosphere of school by becoming something of a loner. He was "saved," as he says, from total disaffection by his high school friendship with Danny Guerrero, who was involved in theater, and by life-drawing classes with David Ramírez at Garfield High. An excellent student, he graduated in 1959.

Almaraz spent the summer after graduation at Loyola University and subsequently attended California State College at Los Angeles for two-and-a-half years. Although the college offered no painting or drawing instruction to speak of, he did meet Frank Romero there—"a much superior draftsman to me"—and, with his encouragement, applied to the Otis Art Institute, to which he received a scholarship and where he studied intermittently.

Carlos Almaraz. *Greed*, 1982. Oil on linen, 35 × 43″. Collection of John and Lynn Pleshette.

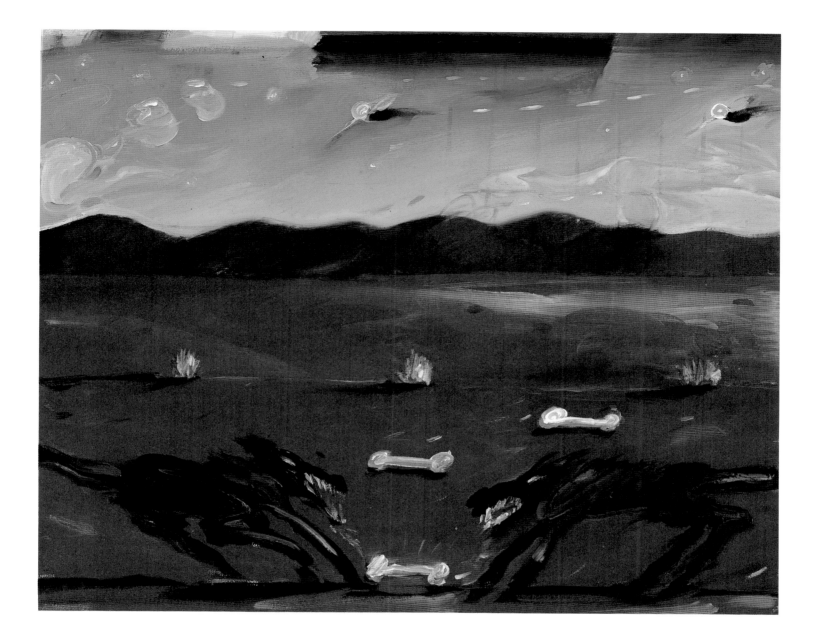

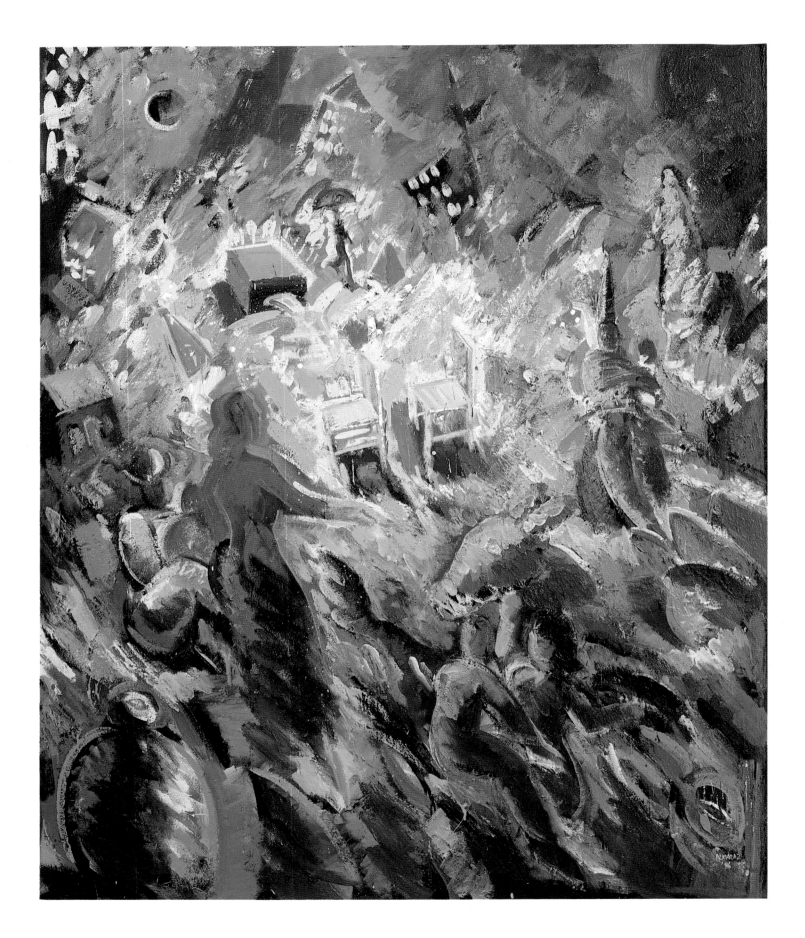

In 1962 the artist felt a strong need to go to New York, which he saw as the center of the contemporary art world. He stayed for six months before returning to study at U.C.L.A. for a year. Then he went back to New York to stay, during 1965–71. He took a loft at 136 West Broadway and subsequently rented the studio of Richard Serra and Nancy Graves for three years. He reports that, although living and working in New York during this period was important for his development as an artist, it was also a singularly bad time for him to attempt to find his way into the stylistic mainstream of American art. It was the height of Minimalism in painting and sculpture, and he was inveterately a painterly painter, a draftsman who cared deeply about color and figure drawing and who needed observed subject matter.

In 1971 Almaraz left New York, exhausted by physical and emotional crisis. He returned to Los Angeles, where he was hospitalized with severe pancreatitis and experienced extended hallucinations accompanied by "a sense of complete depletion and collapse. I realized I needed to start over again, but had no idea how I was going to do that."

Almaraz's solution was to immerse himself in the Chicano movement through various sources, including the Los Angeles cooperative gallery; Mechicano; Luís Valdez's Teatro Campesino; and the farm workers' movement led by César Chávez. For several years Almaraz lived in Frank Romero's house. He returned to the Otis Art Institute to complete his M.F.A. (1974), and he became involved in the Los Angeles mural movement. Between 1973 and 1978, an active mural-painting scene centered in the East Los Angeles Mexican-American community attracted virtually every talented Chicano artist. Almaraz met the artists Gilbert Luján and Beto de la Rocha, which, with the addition of Frank Romero, resulted in the first major exhibition of "Los Four," during 1974 at the University of California, Irvine, the Los Angeles County Museum of Art, and several other institutions. In 1975, the artist visited China, with which he was fascinated; and in 1977, he went to Cuba, which, compared to what he had "sensed in China," was disillusioning.

Like other artists who had participated in the Chicano movement, Almaraz gradually detached himself from it as the 1970s waned. In 1981, he married the painter Elsa Flores, whom he had met when she was working in the studio above his in downtown Los Angeles. Their daughter, Maya, was born in 1983. The couple began to visit Hawaii regularly and bought property on the island of Kauai, which they visit each year for several months.

Almaraz's work has received significant national attention during the 1980s, partly due to solo exhibitions at the Los Angeles Municipal Art Gallery in Barnsdall Park and the Janus Gallery during the 1984 Olympics in Los Angeles. He has also had one-man shows at the Arco Center for the Visual Arts, Los Angeles (1982); the La Jolla Museum of Contemporary Art (1983); Fuller Goldeen Gallery, San Francisco (1985); and Jan Turner Gallery, Los Angeles (1986). Among group exhibitions in which his work has appeared are "Chicanarte," Los Angeles Municipal Art Gallery (1975); "The Aesthetics of Graffiti," San Francisco Museum of Modern Art (1978); and "Automobile and Culture," Museum of Contemporary Art, Los Angeles (1984), in addition to the exhibitions of "Los Four."

Carlos Almaraz. *The Two Chairs,* 1986. Oil on canvas, 80 × 66". Courtesy of Jan Turner Gallery, Los Angeles.

FELIPE ARCHULETA

Born 1910, Santa Cruz, New Mexico

Archuleta followed the usual pattern of the self-taught artist: he did not begin making sculpture until late in his life. He worked many of his years as a laborer, picking potatoes and fruit, fry cooking, and doing carpentry to support himself and his five younger brothers and sisters and, later, his own growing family. He became a union carpenter in 1943 and pursued that trade for thirty years.

During slack periods and especially after his retirement, he cast about for some other occupation. Again typical of the self-taught and visionary artist, he appealed to God for a revelation. As he told his Santa Fe dealer, Davis Mather, "you have to do something. So one time I was bringing in my grocery and I ask in God for some kind of a miracle . . . to give me something to make my life with. . . . So I started carvings after that." Divine guidance has continued to direct Archuleta—and very particularly. "You know who help me make this coyote?," he asked Mather. "God, that's the one. No one else. And I try the best I can, that's all you can do. If I was any better, I'd have to be a regular artist, a real McCoy."

Archuleta's divine inspiration has not resulted in the kind of overtly religious wood carving that has long been a tradition in Hispanic New Mexico. When the artist began working in the mid 1960s, he initiated a new tradition in New Mexico, departing from images of saints and creating animal carvings instead. He soon became the victim of his growing fame and popularity. "Too many people come out and want this and that," he complained to Mather. "I can't satisfy the whole world, amigo. I'm not a machine gun, I'm . . . not God." In an attempt to cope with the demand, Archuleta produced quantities of sculptures of dozens of different animals in various sizes. As he grew older, he also took on studio assistants, including one of his sons, and, for several years in the mid 1970s, the young carver Alonso Jiménez. Thus what began as an answer to a personal need evolved into a virtual cottage industry. Moreover, Archuleta's success has inspired several emulators among his Hispanic compatriots in the region.

Archuleta received the New Mexico Governor's Award for Excellence and Achievement in the Arts (1979); he was included in the exhibitions "Folk Sculpture USA," Brooklyn and Los Angeles County Museums (1976); "Hispanic Crafts of the Southwest," Taylor Museum of the Colorado Springs Fine Arts Center (1977); "American Folk Art: From the Traditional to the Naive," Cleveland Museum (1978); and "One Space/Three Visions," Albuquerque Museum (1979). Archuleta lives in Tesuque, New Mexico.

Felipe Archuleta. *Lion*, 1977. Cottonwood, straw, resin, wire mesh, glue, sawdust, nails, and paint, 44⅞ × 66 × 16". Dominique de Menil.

Sheep, 1975. Cottonwood, wool, and paint, 26 × 18 × 42". Collection of Davis and Christine Mather, Davis Mather Folk Art Gallery, Santa Fe.

Catfish, 1981. Cottonwood, paint, marbles, and twine, 9½ × 10 × 23". Collection of Davis and Christine Mather, Davis Mather Folk Art Gallery, Santa Fe.

LUIS CRUZ AZACETA

Born 1942, Havana, Cuba

Azaceta was the elder of two children. His father worked for the Cuban air force as an airplane mechanic; his mother was a housewife. Fascinated by planes, young Azaceta dreamed of becoming a pilot, but the reality was that things were "tough for the family." He determined to learn an employable skill as soon as possible and enrolled in a commercial high school in Havana, where he acquired a variety of office skills, including typing, shorthand, and accounting. Graduating during the revolution, he found it difficult to secure a job and ended up as a drugstore clerk.

Like many other Cubans, Azaceta was at first sympathetic to the new government. But economic turmoil, rumors of Castro's pro-Soviet orientation, and the promise of elections that failed to materialize soon made him skeptical. Not wanting to join the militias that were being organized to further the revolution, he decided that, if he could not commit himself to revolutionary aims, he ought to leave the country. In 1960, he spent three days and nights in a line at the American Embassy and received a visa to settle permanently in the United States. Just eighteen, he came alone; his sisters and parents joined him several years later.

Azaceta had only a schoolchild's acquaintance with art. He recalls that he showed talent, but he never thought seriously about becoming an artist, a vocation he thought reserved for the wealthy. Moreover, as a teenager in Cuba, it seemed to him "a sissy kind of thing to do. I guess there were a lot of taboos about it." Yet it was a possibility that he kept in the back of his mind as he left for the United States. In 1957 or 1958, an aunt who was already living in New York had returned to Cuba, had seen some of his watercolors, and had told him he would be able to exhibit and sell his work in Greenwich Village.

The reality of Azaceta's life in the States was rather different. He settled in Hoboken, New Jersey, with an uncle who was a foreman in a trophy factory and who got him a job assembling trophies. Azaceta worked at this for three years, sixty hours a week, earning a dollar an hour for the first forty hours and a dollar-and-a-half for overtime. When he became involved in an effort to unionize the factory employees, he was fired and spent the next two weeks reading want ads in the morning and going to the movies in the afternoon. One day late in 1963, out of desperation, he wandered into an art supply store. "I became an artist out of boredom," he wryly admits.

Luis Cruz Azaceta. *Deadly Rain,* 1983. Acrylic on canvas, 77 × 94". Allan Frumkin Gallery, New York.

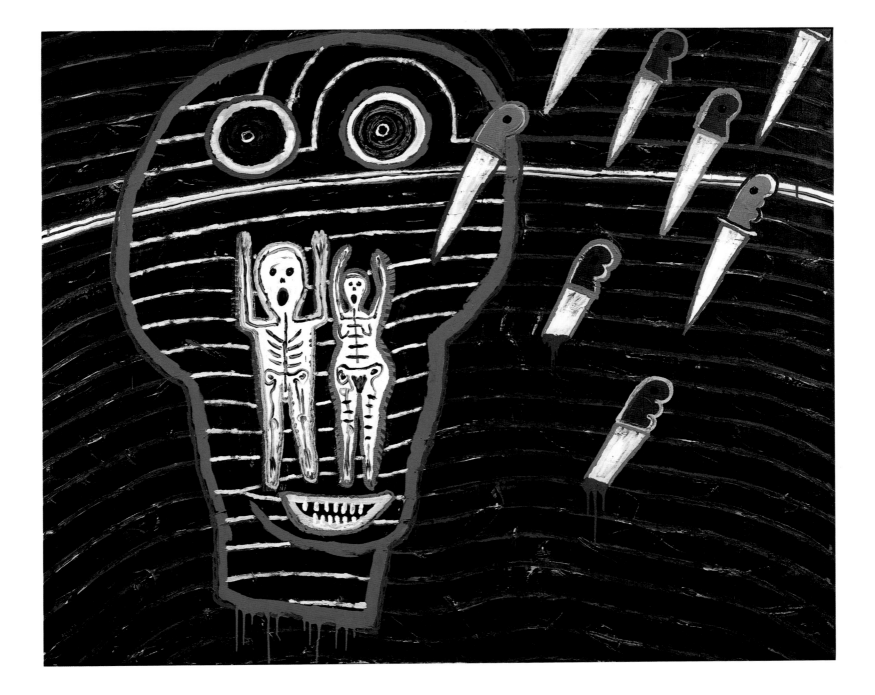

Azaceta worked for the next three years as a clerk in a button factory while taking life-drawing classes at an adult-education center in Queens. One of his teachers encouraged him to go on to art school, and in 1966 he enrolled full-time at the School of Visual Arts, working nights as a clerk in the library of New York University (a job he kept until 1980). He completed his studies in 1969, receiving the equivalent of a B.A. degree.

"I had all kinds of teachers," Azaceta reports, ranging from the Expressionist painter Leon Golub to the Minimalist Robert Mangold. "I got out totally confused." He was then painting geometric abstractions, but returned from a trip to Europe in 1969—which included an exposure to the work of Goya and Bosch— feeling that he had to do something different. "I started wondering why I was painting stripes. It wasn't myself. So I started painting more from the guts, from feelings. I wanted some kind of iconography that would be mine."

It was not until 1974, with a series depicting the New York City subways, that he thought the paintings "truly began to look like my work." Feeling satisfied, he made slides of the paintings and drew up a list of galleries to show them to. The first dealer he approached, Allan Frumkin, was sufficiently taken with the work to include him in a 1975 two-person new talent exhibition. Azaceta has since had solo shows with the Frumkin Gallery in Chicago (1978) and New York (1979, 1982, 1984, 1985, 1986).

The artist's early works were cartoonlike images rendered in bright, flat pigment with black outlines. More recent acrylics exhibit thick, multicolored layers of paint, the images almost carved in relief. The figures portrayed are almost always tormented in some way: pierced by nails, eviscerated, flagellated, or decapitated. Many are self-portraits, though the artist is not so much portraying himself as using his own image to represent everyone. "By showing brutality, I really want to call for compassion. I want to present the victim—that is always my theme."

In addition to his shows with Frumkin, Azaceta has also had solo exhibitions at the Cayman Gallery, New York (1978); the New World Gallery of Miami-Dade Community College (1978); the Richard L. Nelson Gallery, University of California, Davis (1981); and the Museum of Contemporary Hispanic Art, New York (1986). His work has been included in numerous group exhibitions in the United States and abroad, including "Crimes of Compassion," Chrysler Museum, Norfolk, Virginia (1981); "Beast," P.S.1, New York (1982); "New Forms of Figuration," Center for Inter-American Relations, New York (1984); "Seven in the 80s," Metropolitan Museum and Art Center, Coral Gables, Florida (1986); and "Into the Mainstream: A Selection of Latin American Artists in New York," Jersey City Museum (1986).

Azaceta has taught at the University of California, Davis (1980), Louisiana State University, Baton Rouge (1982), the University of California, Berkeley (1983), and Cooper Union, New York (1984). Twice the recipient of a Cintas Foundation fellowship (1972, 1975), he has also received fellowships from the Guggenheim Foundation, the National Endowment for the Arts, and the New York Foundation for the Arts (all 1985).

Twice married, with one child, Azaceta lives in Queens, New York.

ROLANDO BRISEÑO

Born 1952, San Antonio, Texas

The artist's father and paternal grandparents were Texans of Mexican descent. Briseño's father, who had a high school education, made a modest living at a San Antonio dairy. His mother was born and grew up in Michoacán, Mexico, of a well-to-do family hard hit by the Depression. They moved to San Antonio as part of a general migration of upper-middle-class Mexicans to the United States during the hard times. Briseño's parents met in San Antonio and had four sons and a daughter, of whom all but Rolando still live in the city. His brothers include the owner of a successful statewide laundry business, an assistant to the city manager of San Antonio, and an internist.

Briseño attended Catholic elementary school and Catholic military high school. Neither offered art classes, but his parents sent Briseño to art-instruction courses at the Witte Museum and later to a private tutor who had studied in Mexico City and who taught him about the Mexican muralists. After high school, Briseño was accepted at the Cooper Union in New York City. He stayed there for a year-and-a-half (1970–72) before returning to Texas, where he enrolled in the applied art program at the University of Texas at Austin. He remained there for four years, except for a semester in Lima, Peru, and six months in Europe, before receiving a B.A. and B.F.A. in 1977 and returning to New York.

Briseño enrolled in the M.F.A. program at Columbia University, studying painting and sculpture with Leon Golden, David Lund, and William Tucker, among others, while becoming increasingly involved in the New York art scene. He met another artist, Marina Capelletto, with whom he lived after receiving his master's degree from Columbia in 1979. The couple shared a studio in Brooklyn for six years, during which Briseño established his reputation through various exhibitions. He developed a distinctive pictorial device combining expressionistic, figurative painting with shaped elements (typically an ovoid tabletop with appended legs) and forged a relatively large body of mature work.

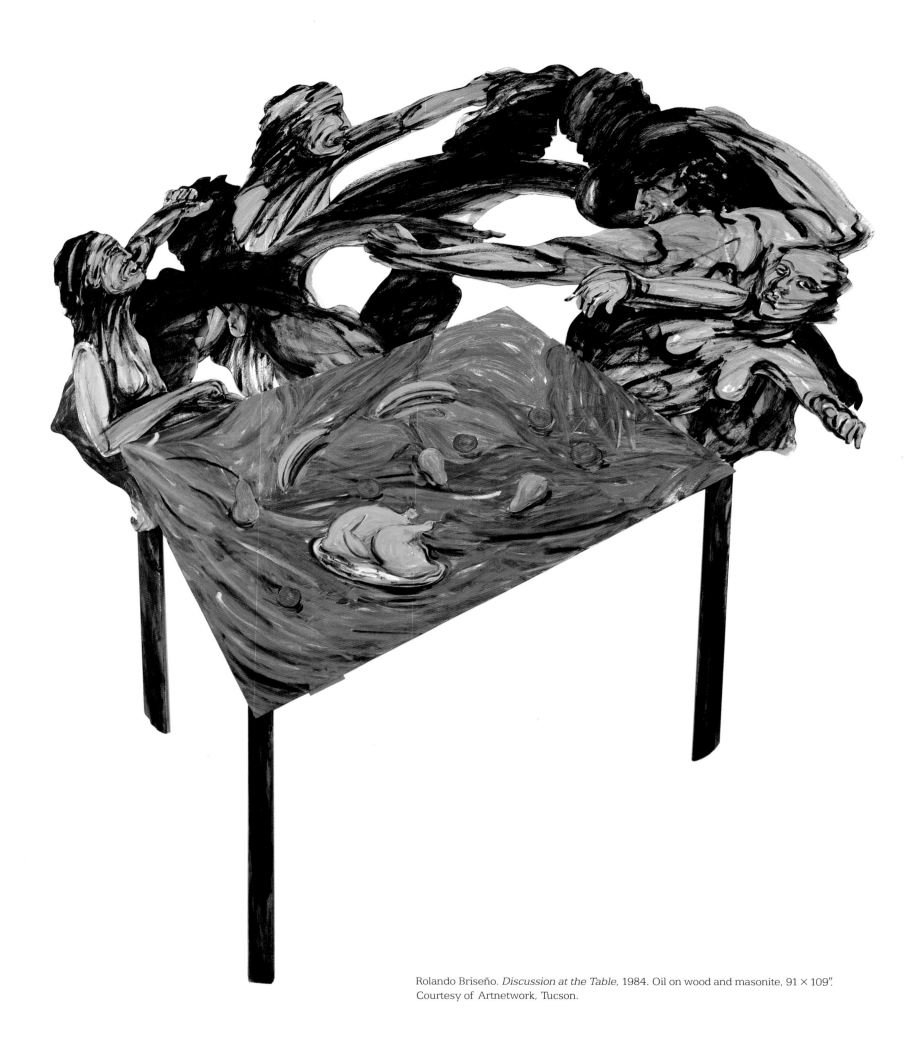

Rolando Briseño. *Discussion at the Table,* 1984. Oil on wood and masonite, 91 × 109″.
Courtesy of Artnetwork, Tucson.

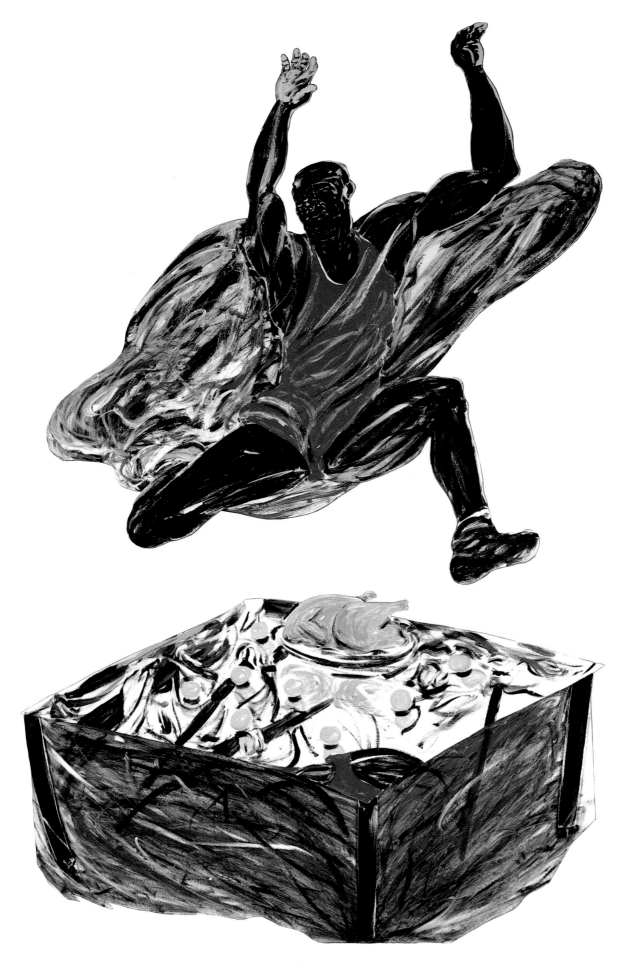

Rolando Briseño. *American Fighter,* 1985. Oil on masonite, 120 × 72″ overall.
Collection of New York National Bank, New York.

In 1985, Briseño and Capelletto separated, Briseño relocating in Manhattan to a loft he was renovating. All of his stored paintings were moved there. He had nearly completed remodelling when, on November 27, 1985, the entire building burned. The only mature oil paintings left were the handful he had lent to galleries, friends, or exhibitions.

Briseño was, for several weeks, devastated. He returned to work by leaving New York for Rome, where, with help from friends in Italy, John Wessel and Billy O'Connor, and a sister living in Germany, he found an apartment and temporary studio quarters in a Communist Party recreational center on the outskirts of the city. Most of the work in this book and the exhibition it accompanies was produced in Rome and shown at Idra Duarte Centro Prossemico di Cultura in Naples and at Wessel-O'Connor Gallery, Rome (both 1986).

Briseño has had other solo exhibitions at the Cayman Gallery, New York (1981); the Bronx Museum of the Arts, New York (1982); and the Institute for Art and Urban Resources (P.S.1), New York (1984); he was featured in a two-person exhibition at 55 Mercer Street, New York (1982). Among the group exhibitions that have included his work are "Hispanics U.S.A. 1982," Ralph Wilson Gallery, Lehigh University (1982); and "Contemporary Latin American Art," Chrysler Museum, Norfolk, Virginia (1983). In 1984, Briseño received an Award in the Visual Arts and participated in the exhibition of the recipients' work, "Awards in the Visual Arts 3," San Antonio Museum of Art and tour. He was also the recipient of a New York State CAPS fellowship in painting (1982) and a Visual Artists Fellowship from the National Endowment for the Arts (1985).

LIDYA BUZIO

Born 1948, Montevideo, Uruguay

Buzio's parents still live in Montevideo, where her father, descended from a family of Italian artisans and jewelers, is a businessman. The artist's sister, herself a jeweler, married the family's neighbor, the painter Horacio Torres, son of the great Uruguayan painter Joaquín Torres-García. It was partly through such proximity to these artists that Buzio gravitated toward art. Her two brothers would become agronomists: one, who studied at the University of Maryland, is now in Argentina; the other is in Uruguay.

Buzio attended private schools in Montevideo and studied drawing and painting privately with José Montes and Guillermo Fernández (1964–66), and worked with the ceramicist, José Collell (1967–68). In 1972, she came to New York with her sister and brother-in-law on the occasion of a retrospective exhibition of Torres-García's work at the Guggenheim Museum and moved to the city. In New York, she began studying with the painter Julio Alpuy, a disciple of Torres-García; she also initiated a study of frescos, especially through trips to Italy. Her admiration of frescos combined with the Constructivist influence of Torres-García and his circle to form the basis of her work.

Buzio developed technically and artistically through her work with Collell, who painted abstract figures on his pots. Based on his approach, she made a large number of pieces incorporating pre-Columbian, Greek, and Chinese designs. Gradually she moved to painting still lifes on clay, then friezelike compositions inspired by ancient Greek art. Beginning in the mid 1970s, she began to incorporate the New York cityscape into her increasingly complex pieces, integrating the image and sculptural form on which it is presented through distorted perspectives and occasional projecting elements.

Buzio constructs her vessels from earthenware slabs. She draws directly on the unfired clay of each work, gradually elaborating and filling in color and detail with pigmented slips. She burnishes the surface, fires, and lightly waxes the vessel. She works mono- and polychromatically, steadily increasing her mastery of draftsmanship as well as three-dimensional sculpture.

The artist has had solo exhibitions at the Everson Museum of Art, Syracuse (1985); at Garth Clark Gallery, Los Angeles (1983, 1985) and New York (1983, 1986); Thomas Segal Gallery, Boston (1983); Greenberg Gallery, St. Louis (1984); and Fuller Goldeen Gallery, San Francisco (1986). Among the group exhibitions that have included her work are "Ceramic Echoes," Nelson-Atkins Museum of Art, Kansas City (1983); "Contemporary American Ceramics/Twenty Artists," Newport Harbor Art Museum, Newport Beach, California (1985); "American Potters Today," Victoria and Albert Museum, London (1986); and "Painted Volumes," Chrysler Museum, Norfolk, Virginia (1986).

In 1984, Buzio married Dan Pollack; they live in New York.

Lidya Buzio. *Dark Blue Roofscape,* 1986.
Earthenware, 13¾″ h. Collection of
Betty Asher.

Green Roofscape with Church, 1986.
Burnished earthenware, 15½ × 11″ d.
Marvin E. Milbauer.

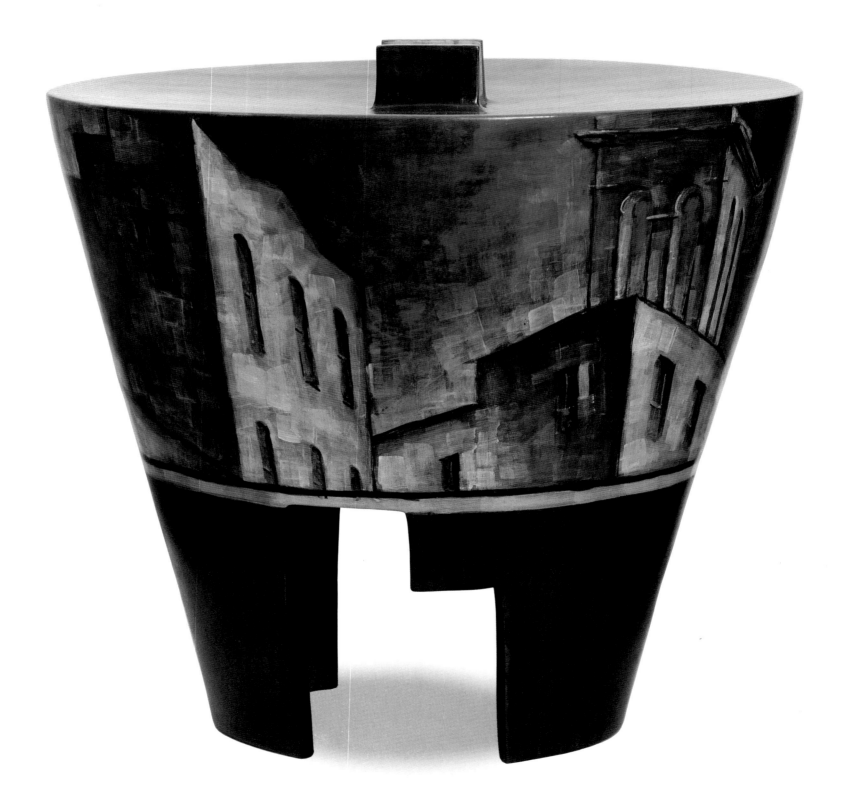

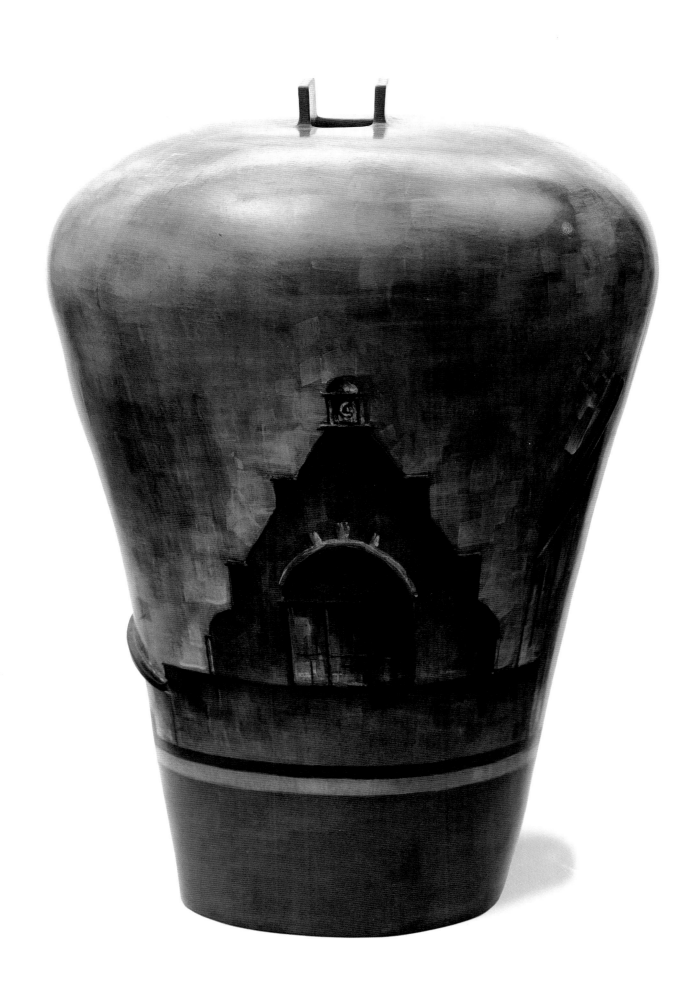

IBSEN ESPADA

Born 1952, New York

Although he grew up in San Juan, Puerto Rico, Espada was born in New York. His father worked for the Puerto Rican government's product-promotion group, Fomento Industries. The family returned to Puerto Rico when Espada was still an infant.

Espada's childhood and teenage years were characterized by two basic realities: first, he was born with a heart defect that led to two major surgeries and the potential for a prolonged invalidism; second, he loved art and, even as a child, doodled and drew continually.

When Espada was eleven or twelve, his grandfather, with whom he was living at the time, mentioned his talented grandson to Rolando López Dirube, an eminent Cuban artist and teacher who had moved to their neighborhood in San Juan. Dirube was to become Espada's mentor and "second father." From age twelve, Espada worked under Dirube's tutelage, with other—mostly Cuban—art students. This, he says, rescued him from drowning "in the mentality of being a sick kid" and determined his future commitment to art.

After high school, Espada studied art at Sacred Heart, a Catholic college in San Juan, but instead of pursuing his course full time, he became increasingly involved in the local art scene. He continued to work with Dirube, now more as apprentice than student, helping the older artist in both a sculptural and a book project; and he secured a scholarship grant from Gulf + Western, which permitted him to work in this way.

But, Espada says, at a certain point he realized he had learned all he could from the Puerto Rican contemporary art scene, and he needed to expand his experience. His parents, who had been living in Florida for some time, moved to Beaumont, Texas, where his father worked for a newspaper, the *Journal Enterprise*. Espada visited his family and determined to stay in Texas. At first he worked in a local oil refinery; then one weekend he visited Houston, went to the Museum of Fine Arts, spotted the adjoining Glassell School of Art, and decided to move to Houston and continue his art study.

Ibsen Espada. *Warriors in the Park*, 1985. Oil and ink on rice paper, 37 × 72½". Rundy Bradley, Houston.

Ibsen Espada. *El Yunque,* 1985. Oil and ink on paper applied to canvas, 53¼ × 63″. Rundy Bradley, Houston.

Octopus I, 1984. Oil and ink on paper applied to canvas, 84 × 60″. Rundy Bradley, Houston.

At Glassell he "found his independence." In the beginning, he concentrated on printmaking, working primarily with Suzanne Manns. Then he studied painting with various Houston teachers, particularly Dorothy Hood and Dick Wray. Eventually, though he never graduated, Espada established a foothold in the Houston artistic scene, as he had done in Puerto Rico—though more significantly now, since he was maturing as an artist. He credits Sally K. Reynolds, formerly a Houston art dealer and now director of the city's Art League, for helping him make the transition into the professional arena.

Espada recently visited Europe for the first time, but otherwise has not traveled extensively, having never been to the West Coast, Mexico City, or Central America. The artists whose work he particularly admires—though many of them he knows primarily through reproduction—are Miró, Picasso, Wifredo Lam, Jean Dubuffet, Pierre Alechinsky, Gorky, Matta, Klee, and Brancusi.

Espada has had solo exhibitions at the Harris Gallery, Houston (1980); the North Harris County College, Texas (1982); the Sally K. Reynolds Gallery, Houston (1983); and with his current dealer, McMurtrey Gallery, Houston (1985). His work was included in the group exhibition "Fresh Paint: The Houston School," Museum of Fine Arts, Houston, and tour (1985).

Ibsen Espada. *Aquarium I,* 1985, detail. Oil and ink on paper applied to canvas, 84 × 120". Rundy Bradley, Houston.

RUDY FERNANDEZ

Born 1948, Trinidad, Colorado

Although generations of Rudy Fernandez's family on both sides had lived in the vicinity of Trinidad, near the San Luis Valley and the New Mexico state line, Rudy spent only his first nine months there. His father, a mechanic for a core-drilling and mineral exploration company, moved his family from job sites in Arizona, New Mexico, Colorado, and finally Utah, where they settled in North Salt Lake City when Rudy was nine years old. Although this life took its toll—he was kept back a year because of the frequent interruptions in his schooling—it also had its advantages, nurturing an intense affection for the landscape of the Southwest, especially the high deserts of New Mexico.

Fernandez, whose parents are Catholic, attended Catholic primary schools and went on to public high school in Bountiful, Utah, graduating in 1967. He spent several months traveling with a rock band, then worked as a driller's helper on core-drilling rigs to earn money for college. He entered the University of Utah in 1968, to major in geology. After marrying in 1969, he transferred to the University of Colorado, where he spent two more years as a geology student before changing his major to art. He received a B.F.A. in painting in 1974 and continued at Washington State University in Pullman, where he studied with Robert Helm and Pedro Rodríguez, and came into contact with such artists as Gaylen Hansen and Rubén Trejo—who taught in Spokane but who had an exhibition at Washington State while Fernandez was there. He received an M.F.A. in sculpture in 1976.

Fernandez spent the next two-and-a-half years working in a family-owned industrial fiberglass company in Utah. In 1978, he accepted an invitation to exhibit in a group show in Phoenix and decided to move there, feeling that it was emerging as a center for art in the Southwest and that it was time for him to rededicate himself to his work as an artist. In 1980, he settled in Scottsdale with his wife (from whom he is now divorced) and his two children.

Fernandez worked between 1980 and 1982 installing exhibitions for the dealer Elaine Horwitch in her Scottsdale gallery; he began exhibiting his elaborately carved and painted objects with her in a group show (1981) and had solo exhibitions at her Santa Fe Gallery (1982, 1985) and at Smith-Anderson Gallery, Palo Alto, California (1986). He has participated in numerous group shows in the Southwest and California, including several at the Galería de la Raza in San Francisco, where he also had a two-person exhibition with Luis Jimenez (1984); he was included in "Showdown: Perspectives on the Southwest," Alternative Museum, New York (1983), and "Chicano Expressions," Intar

Rudy Fernandez. *Entangled,* 1986. Wood, lead, neon, and oil on canvas, 42 × 45 × 7″.
Courtesy of the artist; Elaine Horwich Gallery, Santa Fe; and Smith-Anderson Gallery, Palo Alto.

Rudy Fernandez. *Mocking Me,* 1985. Wood, lead, and oil on canvas, 38½ × 48 × 8½".
Courtesy of the artist; Elaine Horwich Gallery, Santa Fe; and Smith-Anderson Gallery, Palo Alto.

Latin American Gallery, New York (1986). He received a Visual Arts Fellowship in Painting from the Arizona Commission on the Arts (1981) and a public commission from the San Francisco Parks and Recreation Department for a sculpture at the Mission Recreation Center (1985).

In addition to the landscape of the Southwest, Fernandez identifies his Catholic upbringing and a graduate-student study he made of New Mexico religious art as influences on his art. The format of the *retablo*—the traditional two-dimensional image of a saint, often on a shaped panel and with an elaborately painted frame—is especially important to Fernandez, although he has adapted it to his own secular purposes. Some of his images have an apparent source in Chicano culture—the rooster, for example, emblematic of machismo—while others sum up less directly the complexity of his cultural heritage and personal history. The image of the heart, for example, can be read as the flower of a cactus, the Sacred Heart of Jesus, or a popular emblem of the triumphs and tribulations of romantic love.

Fernandez presently lives in Tempe, Arizona.

Rudy Fernandez. *Waiting,* 1985, detail. Wood, lead, neon, and oil on canvas, 42 × 45 × 8″. Collection of Thomas E. Trumble, Boulder, Colorado.

ISMAEL FRIGERIO

Born 1955, Santiago, Chile

The oldest of five children, all born in Santiago, Frigerio attended American and French schools in Chile in his early years, but didn't learn English until 1979, when he first came to New York.

Frigerio's father, who died when the boy was eighteen, was and remains rather a mysterious figure to his son. An Italian who left Europe before World War II, he met his Chilean wife in Santiago and settled there permanently, never speaking of his past to his children. During his son's childhood, he was president of the Chilean Coca-Cola Workers Union and a powerful man personally and professionally. He left a haunting sense in Frigerio's mind of a long journey and a rich history, which have continually informed the artist's imagery. His mother is a "typical Chilean," who today operates a successful catering business in Santiago.

Frigerio attended the University of Chile for three-and-a-half years, studying philosophy and then fine arts. His transition from the first course of study to the second coincided with the coup of 1973, which transformed virtually all of Chilean society. The university's art professors departed and were replaced en masse in that year; as a result, Frigerio says, he received at best marginal training in art. Yet his own interest in art and aesthetics, coupled with his background in the philosophy of aesthetics, has consistently strengthened his development as an artist. He says that he is always aware of connecting his painting to history, to keep it "conscious."

In 1979, Frigerio came to New York to work on his B.F.A. thesis. He returned to Chile to finish his studies in 1980 and the next year made a permanent move to New York. His activity as a painter in Santiago led to association with a number of other artists who called themselves "The Group from the Eighties," a coalition that has attracted considerable attention in Chile, but not beyond. Frigerio is still virtually unknown in the United States and has never traveled either to Europe or Mexico, though he had spent substantial time in Brazil, Bolivia, and Argentina. His main influences have come from studying both the pre-World War I German Expressionists, and the post-World War II American Expressionists.

Ismael Frigerio. *The First Opportunity of Pain,* 1985. Tempera and acrylic on burlap, two panels, 68 × 112″ overall. Collection of the artist.

Married twice, with an eight-year-old daughter by his first wife, Frigerio has survived in New York through a series of jobs, ranging from dishwashing and carpentry to his current part-time work with a furniture designer. His situation has advantages as well as disadvantages: "I'm not an American—New York is not my city or my country. As an immigrant, I'm put in a special position. People in the United States are separated by race; in South America they're separated by social class. This is an extremely important difference between our societies, and something I'm studying all the time. It's difficult in a way to be put in this racial category, outside the mainstream—but it's almost impossible for me as an artist to stay in Chile, for various reasons. It's just too distracting from art. In this country, unlike Chile, I can do what I have to do to survive as an artist—I can have any kind of outside job; I don't have to be engaged in the political struggle. So I've made the choice that will protect me as a painter."

Frigerio continues to study philosophy—at the present time he is particularly interested in the New French philosophers. He visits Chile at least every other year, often on the occasion of exhibitions of his work there. In the United States he has had solo shows at Yvonne Seguy Gallery, New York (1983); Art Space, New York (1985); and the Museum of Contemporary Hispanic Art, New York (1986). Among the group exhibitions that have included his work are "Contemporary Latin American Art," the Chrysler Museum, Norfolk, Virginia (1983); and "Art and Ideology," the New Museum of Contemporary Art, New York (1984).

CARMEN LOMAS GARZA

Born 1948, Kingsville, Texas

Garza's mother's family had lived in Texas for many generations, working as ranch hands or cowboys—*vaqueros*—and on the railroad. One of her maternal great-grandfathers was a chuck-wagon cook on the famous King Ranch. Her father was born "in the crossing"— in Nuevo Laredo, just before his parents crossed the Rio Grande in flight from the hardships of the Mexican Revolution. Garza's parents met in Kingsville, where her father was employed as a sheet-metal worker at the naval air station. After raising five children, of whom Carmen is the second, her mother began working as a florist.

Garza recalls that both her grandmother and mother were artistically inclined. Her grandmother produced crochet and embroidery works and paper flowers; her mother was a self-taught painter who specialized in handmade playing cards for *lotería*, a Mexican game similar to bingo. Inspired in part by their example, Garza decided as a teenager to become a professional artist—an audacious decision for her, given the economic difficulties that face artists in

Carmen Lomas Garza. *Doña Sebastiana,* 1977. Paper, mat board, and acrylic paint, 20″ h. Collection of the artist.

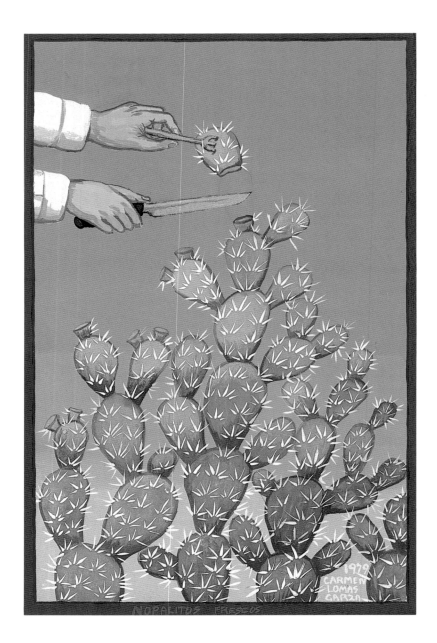

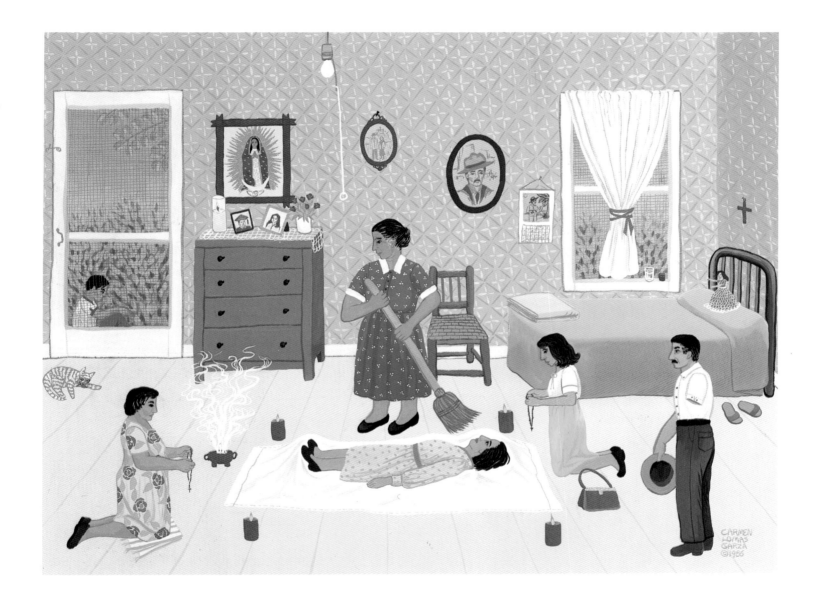

Carmen Lomas Garza. *Curandera barriendo de susto/Faith healer sweeping away fright,*
1986. Gouache on Arches paper, 14 × 18″. Collection of Lidia Serrata, Victoria, Texas.

Nopalitos Frescos, 1979. Gouache on Arches paper, 6 × 9⅛″. Collection of the artist.

general and the intimidating stereotypes that confront Mexican-American women in particular. But she saw art precisely as an alternative to a woman's traditional roles and as a way out of the circumscribed life of her small South Texas town.

Garza attended public schools in Kingsville, where (she recalls) Mexican-American students were spanked for speaking Spanish—even among themselves. It was then against the law. She went on to Texas Arts and Industries University, also in Kingsville, earning a B.S. in art education in 1972. When the Chicano movement emerged during her college years, she became involved in applying its aims to the visual arts. Among her responses to the movement was a turn to the subject matter of Mexican-American life: "I wanted to depict in fine art form all the things of our culture that are important or beautiful or very moving."

Garza continued her education at the Juárez-Lincoln Campus of the Antioch Graduate School in Austin, earning a master's in education (1973); at Washington State University, Pullman, (1975–76); and at San Francisco State University (1978–79), where she received a master's in art. She worked at Galería de la Raza, San Francisco, between 1976 and 1981 as an administrative assistant and curator and had two-person exhibitions at the Mexican Museum, San Francisco (1977); at the Frank C. Smith Fine Arts Center, Texas Arts and Industries University (1978); and at the Museum of Modern Art, San Francisco (1980). She has recently had solo exhibitions at the Olive Hyde Art Gallery, Fremont (1984), and Galería Posada, Sacramento (1985); another is planned for the Mexican Museum in 1987. Her work has been included in numerous group exhibitions, among them "Dalé Gas: Chicano Art of Texas," Contemporary Arts Museum, Houston (1977); "Hispanics USA 1982," Wilson Gallery, Lehigh University, Bethlehem, Pennsylvania (1982); "¡Mira!," El Museo del Barrio, New York, and tour (1985–87); and "Chicano Expressions," Intar Latin American Gallery, New York (1986).

Garza presently lives in San Francisco.

ROBERTO GIL DE MONTES

Born 1950, Guadalajara, Mexico

When Gil de Montes was seven, his parents left Guadalajara for Chicago, where his father found employment in the steel mills, and his mother, among other jobs, worked on a Bell and Howell assembly line. Gil de Montes and his four brothers stayed behind in Guadalajara, living with their grandparents and going to school there. His parents visited once a year; they preferred separation from their children to uprooting them, at least when they were young, and they remained apart for eight years. In 1965, the parents resolved to reunite the family, but not in Chicago. "They wanted a cultural atmosphere that would not be too shocking for us," Gil de Montes recalls. They returned to Mexico and moved the family in a 1957 Ford to Los Angeles.

Despite his parents' hopes, Gil de Montes reports that he felt "life here was totally different." They settled in East Los Angeles, into an environment that the boy found "rowdy" compared to the settled, even rather cultivated life he had experienced in Mexico. While his brothers went to Catholic schools, Gil de Montes opted for the public system; he knew he wanted to study art, and he knew that no art classes were available in the Catholic schools. He graduated from Roosevelt High School in 1969. During high school, he became aware of

Roberto Gil de Montes. *Self-Portrait,* 1985. Oil on wood, 11¼ × 27½ × 2½". Richard and Jan Baum, Los Angeles.

the emergence of the Chicano Movement in both its political and cultural aspects, but he felt separate from it, in part because of the attitudes of American-born Chicanos: "If you were newly arrived, you were looked down on. They called you 'T.J.s.'"—an acronym for Tijuana, way station for many Mexican migrants. "Three years later," he says, "everybody was trying to get in touch with their roots," and they had more empathy for things—and people—Mexican. But even then, Gil de Montes remained apart; for example, he did not participate in the Chicano mural movement. "I felt it was 'retro' in some way. I had grown up with the Orozco murals in Guadalajara. Some [Los Angeles murals] were exact reproductions of Mexican murals I had seen. I didn't see any sense in that." Moreover, he felt that "Chicanos here were struggling with their identity. I finished my formative schooling in Mexico, so I knew who I was. I didn't need to rediscover my past."

After high school, Gil de Montes spent two years at Trade Technical College, learning photography while also taking classes in philosophy and the history of religion at East Los Angeles College. He entered Otis Art Institute in 1972, earning an M.F.A. (1976). He found himself slowly drawn into the orbit of Chicano art and artists, including Carlos Almaraz and Judithe Hernández—"the only other Latins" at the college. He went on to study Latin American politics and culture at California State University, Los Angeles (1976–78). During this time he became one of the founding members—with Gronk, Willie Herron, and Harry Gamboa—of LACE Gallery.

In 1979, the artist was invited to Mexico City by the magazine *Artes Visuales* to help edit a special issue devoted to Chicano art. He stayed in the city for two

Roberto Gil de Montes. *Jaguar Man-Panther Man*, 1983. Ink on paper, 26 × 34". Jan Baum Gallery, Los Angeles.

Salsa Man, 1984. Oil on wood, 16½ × 20½". Jan Baum Gallery, Los Angeles.

years, working on the magazine and making photographs. Mexico City, he says, had a major impact on him. He was by then deeply involved in Latin American and Chicano culture and politics. Only while in Mexico did he realize that, as a member of a minority in the United States, he had felt his potential greatly circumscribed. Mexico City, "more international, literate and informed," enlarged his views, and he returned to Los Angeles in 1981 "with a whole different attitude. I felt freer to do what I wanted to do. I got more serious about myself, more serious about painting."

So Gil de Montes eased himself out of the collective activities of the Chicano art movement, and his paintings began to reflect more personal reactions to the landscapes and myths of Los Angeles. But he did not abandon his Mexican origins. He has taught drawing and Latin American art history in the art department at California State, Los Angeles, since 1981. "Teaching pre-Columbian art opened my eyes. There are things that are so embedded in our culture." Some of these are expressed in the images of his own art: the jaguar, the deer dancer, and the dog, for example, all creatures invested with religious or cosmological significance by the pre-Columbian peoples of Mexico.

The artist has been included in numerous group exhibitions, including "Hecho en Latinoamerica" at the Museum of Fine Arts, Mexico City (1981); "Aquí: 27 Latin American Artists Working and Living in the United States," at the Fisher Gallery, University of Southern California, Los Angeles (1984); "New Forms of Figuration," Center for Inter-American Relations and the City Gallery, New York (1984); and "Chicano Expressions," Intar Latin American Gallery, New York (1986). He had a solo exhibition at Jan Baum Gallery, Los Angeles (1985).

Roberto Gil de Montes. *El Auto Cinema,* 1985. Oil on wood, 13¼ × 15⅝ × 2½". Jan Baum Gallery, Los Angeles.

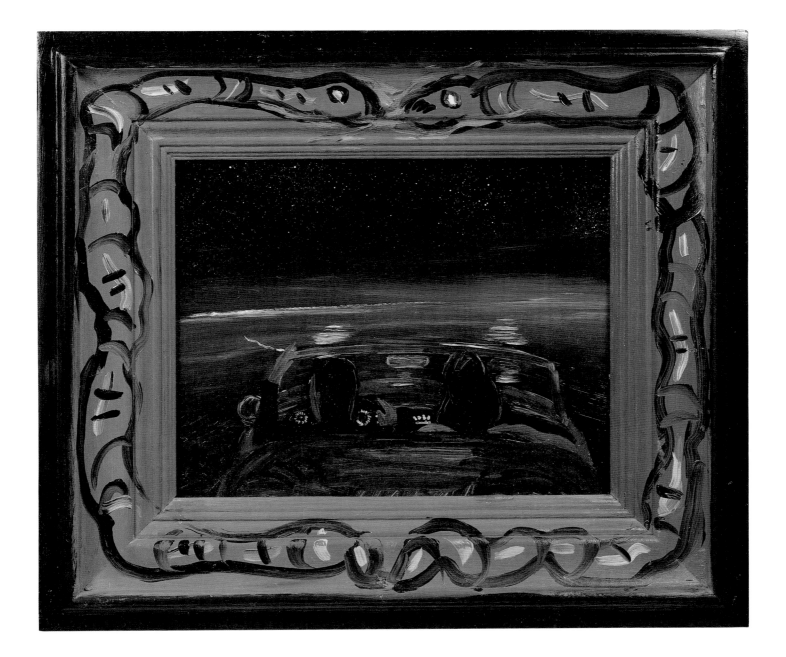

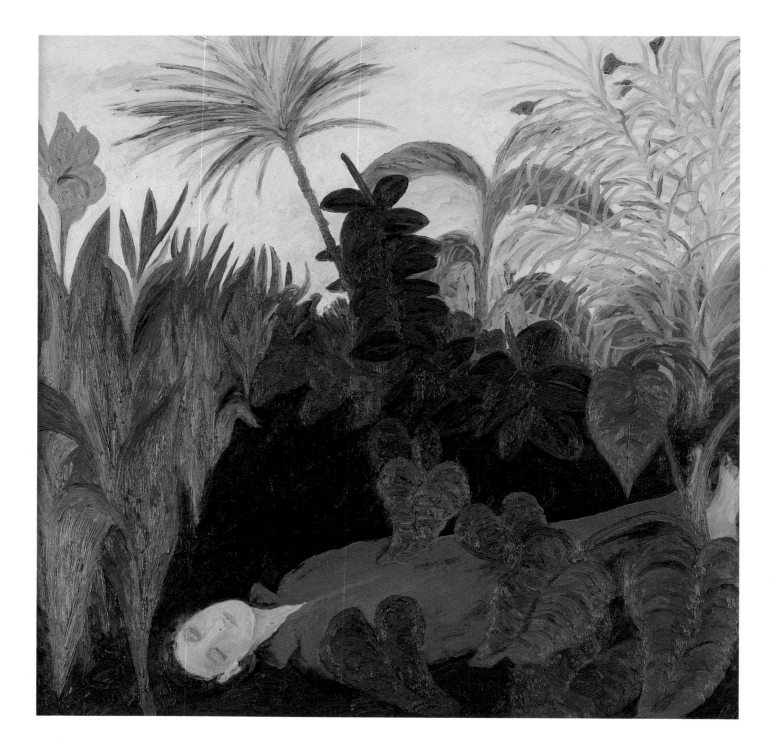

PATRICIA GONZALEZ

Born 1958, Cartagena, Colombia

Both of Gonzalez's parents studied architecture, although only her father went on to practice. When Gonzalez was seven, her parents separated, and she lived with her paternal grandmother until her mother decided to move to London with her three children—Patricia (then age eleven), a middle brother, and younger sister. Gonzalez and her younger sister spent one year in a Catholic boarding school in Sussex, subsequently joining her mother and brother in London, where Gonzalez would live for the next twelve years, enrolling in art school only after undergoing a general British education.

She entered art school with the intention of becoming a fabric designer, but discovered over the period of the next two years her real forte, painting. After a foundation course at the Central School of Art and Design, she attended the Wimbledon School of Art (1977–80), where she received her B.F.A. At the Central School she met the painter Derek Boshier, who taught there; he encouraged her painting from the beginning. She says that she received strong training in art at the British schools, but except for Boshier, she was little inspired by her teachers, who "were good, but at the time I was one of only two figurative students and most of the tutors did not take this seriously."

In 1980, she decided to go back to Cartagena, with which she still had ties, although her father had moved to the United States and her mother to London. She lived with her father's mother and tried to find a life as a Colombian, working twelve hours a day, teaching art and English at the American elementary school and English as a foreign language at the Colombo-American Institute. But she couldn't adjust to life in Cartagena: "I could hardly paint at all," she says. "There was no art scene, and I felt I just couldn't make the adjustments I needed to make to enter into a working life there. It lasted nine months." She particularly recalls feeling that, in comparison to what she had experienced in London, her personal and professional activities were circumscribed in Colombia.

In the summer of 1981, she returned to London, "to think things over during the holidays." Derek Boshier, who had been in Houston, Texas, teaching at the

Patricia Gonzalez. *Sleep,* 1985. Oil on paper, 36½ × 36½". James T. Chambers, Jr.

University of Houston, came back to London temporarily—and Gonzalez decided to join him in Houston at the end of 1981. They remain there, together, today. She easily adapted to living in Texas, both because of the "ease and friendliness" of the people there and because she found herself speaking both English and Spanish in daily transactions.

Gonzalez's painting style has evolved steadily, starting in 1980 in Colombia, when her work was "more detailed than it is now." She never painted abstractly or for mere design. In Texas, she worked at the Glassell School, making prints, and then gradually got back to painting full time. Her stylistic development has been, she feels, only indirectly influenced by any "Texas school" or other local factors. Her paintings, though they seem related to landscape imagery of the Southern Hemisphere, come primarily from memory and fantasy, using real places or situations only as "springboards." The painters she particularly admires include Van Gogh, Nolde, Frida Kahlo—whose work she discovered when she was at art school in London—and, more recently, the early Italians, Lorenzetti, Giotto, Fra Angelico. Among contemporary artists, she mentions Malcolm Morley. She rarely visits New York but has recently been to Italy (on a grant from the Dallas Museum of Art) and to Mexico; she continues to visit London at least once a year. "But I'm not aware of needing to be in the center of anything," she says. "Being true to myself and doing what I need to do is the most important thing. I don't especially identify with other Hispanics, nor with anything fashionable in painting. And I try to focus less on my career than on my work."

Gonzalez has had solo exhibitions at the Graham Gallery, Houston (1984, 1985). She has been represented in numerous group exhibitions in Texas, including "Chulas Fronteras: Contemporary Texas Hispanic Art," Midtown Art Center, Houston, and tour (1986).

Patricia Gonzalez. *Fountain View,* 1985. Oil on paper, 40 × 44". Private collection, Houston.

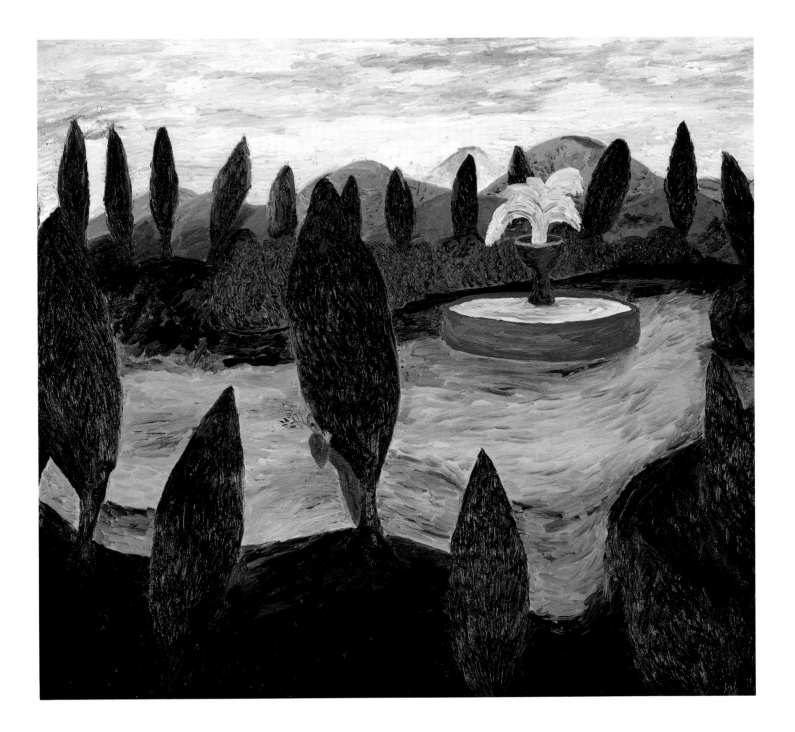

ROBERT GRAHAM

Born 1938, Mexico City

Robert Graham lived his early childhood in Mexico City, where his father, a government official, and his mother had lived most of their lives. His father died when he was seven, and shortly thereafter he and his mother moved to San Jose, California. Graham attended public schools there, leaving at sixteen to enlist in the Air Force. He spent four years in the service, much of it in Japan, before returning to the Bay Area in 1960 and attending San Jose State College (1961–63) and subsequently the San Francisco Art Institute (1963–64).

Graham's interest in art began in his early school years. He worked with plasticene and made drawings virtually from the time he can remember. During his years at San Jose State, Graham began associating with other California artists, including the painters Frank Lobdell and Richard Diebenkorn and the sculptor Alvin Light.

In 1966, Graham exhibited his work at the Nicholas Wilder Gallery in Los Angeles, a show that launched his career. The sculpture he exhibited at this early stage of his career took the form of miniature tableaus, small architectural boxes inhabited by tiny figures, usually female and idealized, sometimes parodic. From the beginning, his work was odd, even in the context of the extremely individualistic artistic expression of California in the 1960s. Graham moved to Los Angeles in the mid 1960s, and beginning in 1970, he spent much of his time in London. This was a period of a vital Los Angeles-London artistic connection: Graham's friends, Joe Goode, Ed Ruscha, and Billy Al Bengston also often worked in London and the European cities. "It was via Europe," says Graham, "that I was really introduced to New York."

Despite his travels, the artist has continued to consolidate his base in Venice, California. As his work evolved from small-scale pieces to increasingly monu-

Robert Graham. *Fountain Figure #3*, 1983. Cast bronze, 48 × 12 × 14"; base 60 × 16 × 16". The Museum of Fine Arts, Houston: Museum purchase with funds provided by Mr. and Mrs. Meredith Long.

Fountain Figure #1, 1983. Cast bronze, 38 × 13 × 9"; base 60 × 26" diameter. The Museum of Fine Arts, Houston; Museum purchase with funds provided by the Charles Engelhard Foundation.

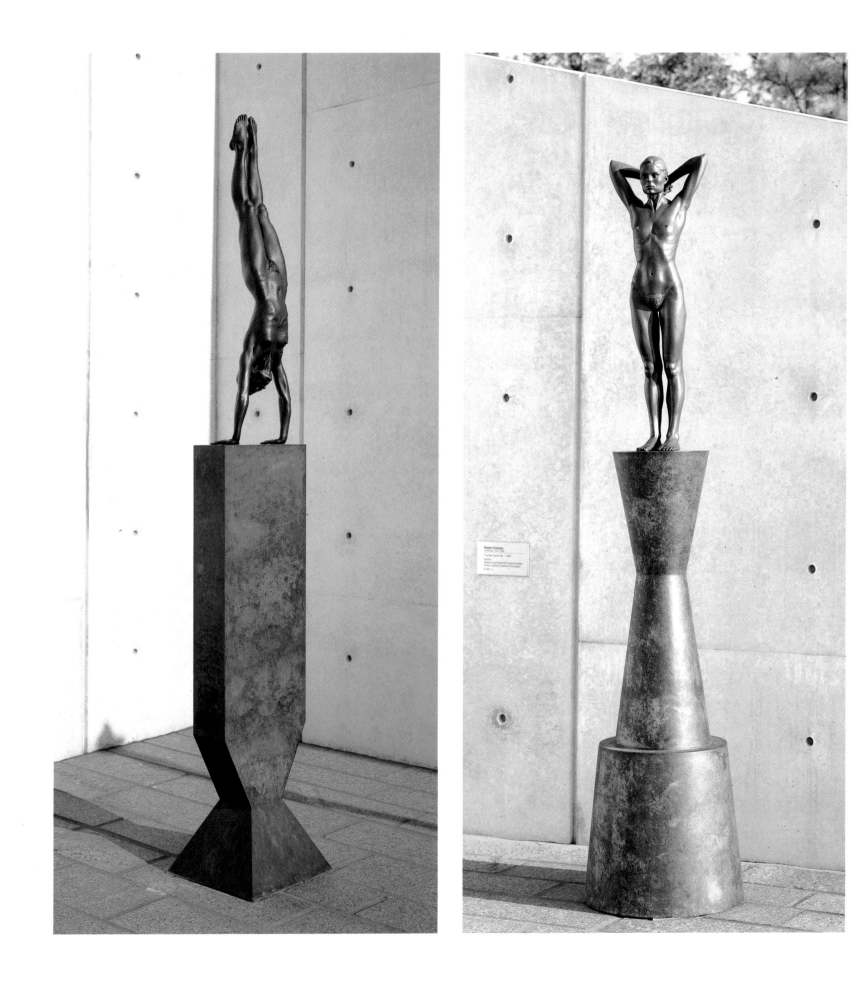

mental bronze figures, and as he has undertaken such important commissions as the one for the 1984 Los Angeles Olympics, his Venice studio has become the site of a virtual private industry.

Graham sees himself as part of the continuum of Western art: "Whenever I think I've invented something, I recognize it in other work. I keep returning to Florence, for instance. The progression from Giovanni Pisano to Giovanni Bologna to the San Marcos convent into easel painting—this is where it starts for me. My main confirmation is in earlier art, in understanding what happens to an innocent idea as it progresses to a perversion of a form—from early Christian art to the late Renaissance."

Graham has had numerous solo exhibitions in the United States and Europe, including those at the Whitechapel Gallery, London (1970); the Kunstverein, Hamburg (1971); the Dallas Museum of Art (1972); the Los Angeles County Museum of Art (1978, 1981); the Walker Art Center, Minneapolis, and tour (1981–82); and the Arco Center for the Visual Arts, Los Angeles (1984). He continued to exhibit with Nicholas Wilder (1974, 1975, 1977), and has more recently had several exhibitions with Robert Miller Gallery, New York (1977, 1978, 1979, 1982). Along with the 1984 Olympic commission, Graham was selected in 1978 to be one of four artists to work on the still-unrealized FDR Memorial in Washington, D.C. He is currently completing a Detroit memorial to Joe Louis and will soon begin work on a New York memorial to Duke Ellington.

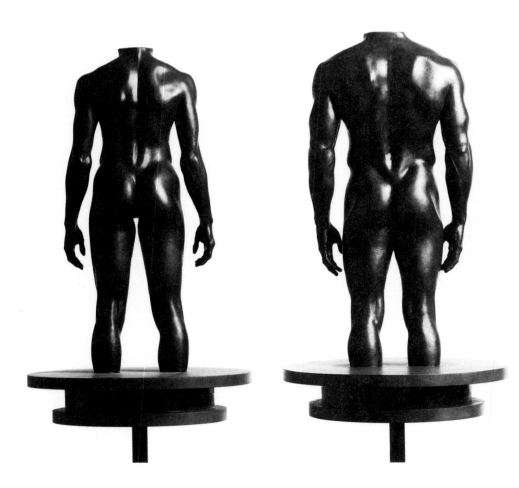

Robert Graham. *Olympic Torso, Female,* 1983, detail. Cast bronze, 27 × 12 × 6"; base 40 × 18" diameter. Coutesy of Robert Miller Gallery, New York.

Olympic Torso, Male, 1983, detail. Cast bronze, 27 × 12¼ × 6½"; base 40 × 18" diameter. Courtesy of Robert Miller Gallery, New York.

GRONK

Born 1954, Los Angeles

The artist was born Glugio Gronk Nicandro; his mother chose his middle name, a Brazilian Indian word meaning "to fly," from an issue of *National Geographic* she was reading during labor. Gronk describes his mother as "somewhat radical" both personally and politically. Born in Mexico, she came to Los Angeles as a youth with her family, where she met Gronk's father, who was also Mexican-born. Their union was brief, and Gronk saw his father only on his birthdays. His mother subsequently had four other children out of wedlock, and Gronk lived intermittently with her and various of her relatives. He admits to having felt "stigmatized" as a child because of his unconventional family situation, especially in the context of the strong commitment to the family shared by Chicanos in his East Los Angeles community, and also in the face of the stereotyped happy families he saw on television. His own childhood, he says, "was not like 'Leave It to Beaver.'"

Gronk attended public schools in East Los Angeles, dropping out at age sixteen from a high school that had the highest dropout rate in the nation. He had known from an early age that he wanted to be an artist. "Drawing was an escape for me—from poverty, from my environment. It was a way of creating new worlds for myself." His high school teachers were not sympathetic to such ambitions—they wanted him to learn a more practical trade—so Gronk took his ambitions onto the street, literally. With friends from East Los Angeles, he began working in performance art. This activity crystallized in 1972 around a group that came to be known as Asco—the Spanish word for nausea—and that, in addition to Gronk, included writer and photographer Harry Gamboa, painter and photographer Patssi Valdez, and painter (now rock musician) Willie Herron. Street performances included Day of the Dead celebrations, anti-war protests, and "instant murals"—parodies of murals in the form of events staged against or on a wall. Asco also exhibited and performed together numerous times in California and the Southwest, in such galleries as LACE (Los Angeles Contemporary Exhibitions) and Galeria de la Raza, San Francisco. These activities included some collaborative mural projects, a few of which Gronk executed with Herron, and gallery-sized installations. In 1980, Asco was featured in Agnes Varda's film *Murs Murs*.

Meanwhile, Gronk was also pursuing his own work in the form of drawings, paintings, and solo performances. By the mid 1970s, he was known as the Skid Row Manicurist for painting the toenails of sleeping derelicts. "I was bringing

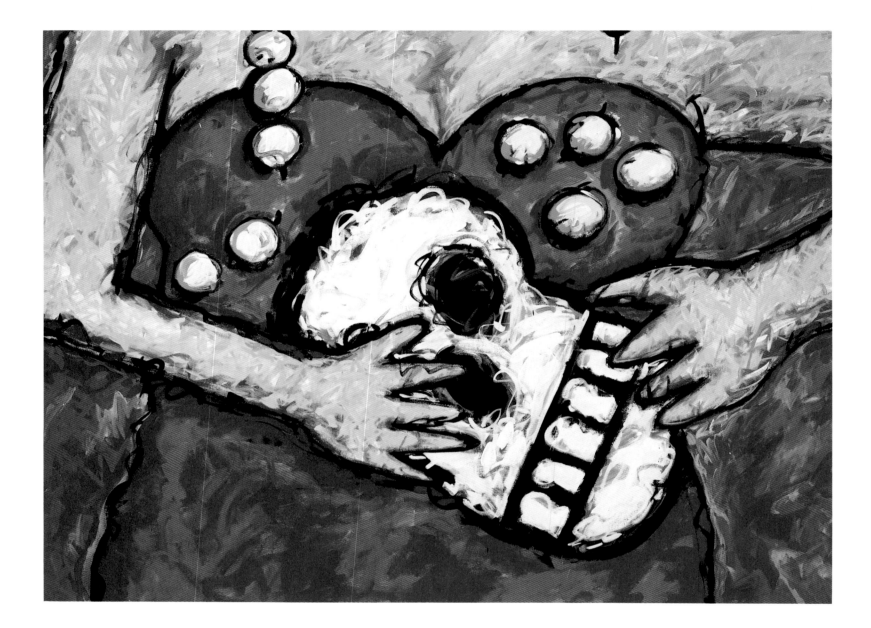

Gronk. *Broken ~~Blossoms~~ Beads,* 1986. Acrylic on canvas, 72 × 96¼". Saxon-Lee Gallery, Los Angeles.

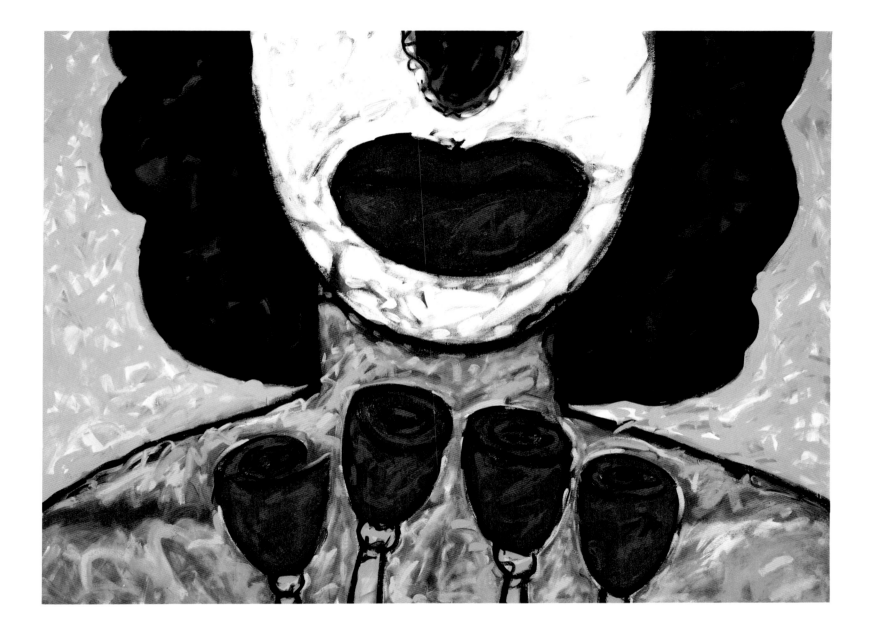

Gronk. *No Nose,* 1986. Acrylic on canvas, 72 × 96″. Saxon-Lee Gallery, Los Angeles.

beauty wherever I could," he says. Gradually, however, his work has acquired a more ambitious, less impromptu character. In 1978, he began keeping a kind of visual diary, a series of bound drawings executed daily, which now runs to some forty volumes. His paintings on canvas have grown in scale and receive more consistent attention today than they had in the 1970s. His work with Asco has also evolved; its most recent production was a play entitled *Jetter's Jinx*, by Harry Gamboa, directed by Gronk and starring Gronk and Humberto Sandoval.

Gronk's work has grown somewhat beyond its roots in the streets of Los Angeles; in paintings and performance, he is now trying "to reach a broader audience." But he does so still with his characteristic humor and his loyalty to his Chicano heritage: "Who I am is what I do." *Jetter's Jinx*, for example, embodies the extravagance of dress and behavior characteristic of some Chicanos in the 1960s, while Gronk's paintings owe something to the melodrama of the photo-novellas popular in Mexico and the sensationalism of such tabloid papers as *Alarma*, Spanish-language equivalent of the *National Enquirer*.

Gronk has had solo exhibitions at Molly Barnes Gallery, Los Angeles (1984) and Saxon-Lee Gallery, Los Angeles (1986). In 1985, he was one of nine Los Angeles artists chosen for concurrent solo exhibitions at the Los Angeles Museum of Contemporary Art in a project entitled "Summer 1985." He received a Visual Artist Fellowship from the National Endowment for the Arts (1983). Gronk lives in Los Angeles.

Gronk. *La Tormenta*, 1985. Acrylic on canvas, 90 × 60". Kuwada/Grimm Collection.

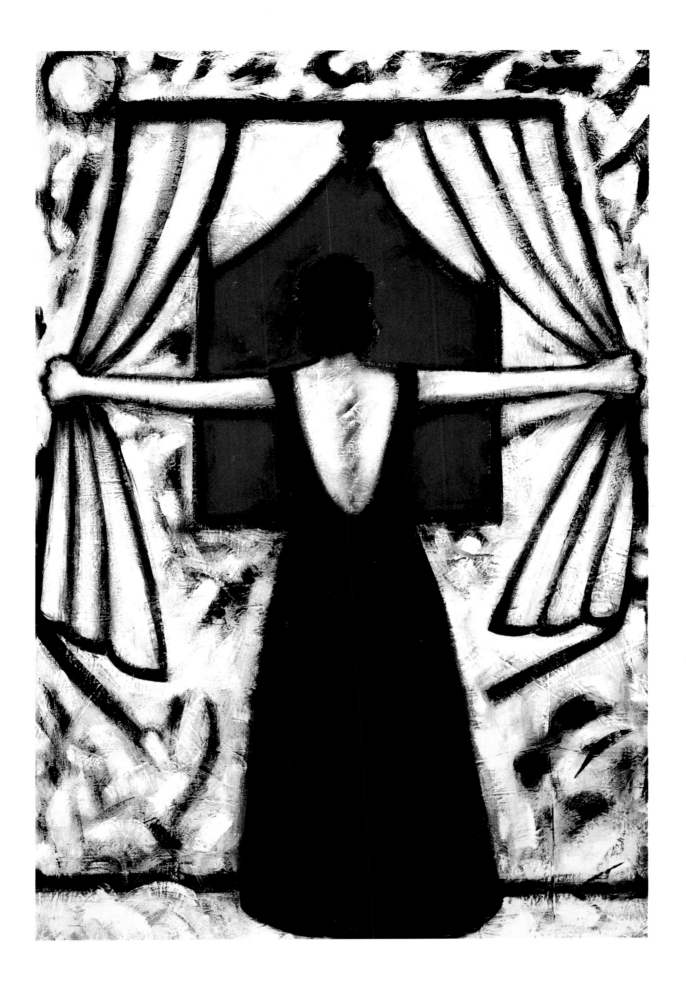

LUIS JIMENEZ

Born 1940, El Paso, Texas

Luis Jimenez's father came to Texas with the artist's grandmother in the 1920s; the artist's mother was born here to Mexicans who fled the Revolution. Jimenez recalls a strong tradition of craftsmanship on both sides of the family. His maternal grandfather found work in the United States as a finish carpenter; his paternal grandfather had been a glassblower. His father became first a sign painter and eventually the proprietor of a firm in El Paso known for neon "spectaculars," enormous lighted signs that have become the emblems of shopping centers and Las Vegas hotels.

Jimenez began working with his father when he was about six years old. One of the first projects he helped with was a white concrete and neon polar bear for a dry-cleaning establishment. At sixteen, he assisted with two ten-foot crowing red roosters (one of which he still owns) for a chain of drive-in restaurants. His work with his father was very important in providing both a vocabulary of popular images and a foundation in commercial techniques; by the time he was sixteen, Jimenez could weld, spray-paint, blow glass, and work tin.

After graduating from high school, the artist went on to study architecture, first at the University of Texas at El Paso, then the University of Texas at Austin. He increasingly gravitated toward sculpture and drawing; after four years of a five-year program, he changed his concentration from architecture to art, receiving a B.S. in art in 1964.

By this time he had married, and he and his wife spent three months in Mexico City, to which Jimenez had traveled ostensibly to study art. But, he says, the trip was more of a pilgrimage, serving to strengthen pride in his Mexican roots and to affirm his commitment to figurative art—which he saw in Mexico City's murals and which he knew had no place in the then-dominant American style, Abstract Expressionism.

Jimenez and his wife settled in El Paso for a year, where he taught junior high school art classes and where his daughter Elisa was born. Shortly after, driving with a friend to Canada, his car went off a cliff in Idaho, resulting in an accident that temporarily paralyzed him from the chest down. He spent nearly a year recovering, after which he returned to Austin, where his wife got a commercial art job while he struggled to launch his own career. Spurred by a combined sense of frustration and ambition, Jimenez left Austin—and his family—for New York in 1966. The move ultimately resulted in divorce. He took a job in the city recruiting children—mostly Puerto Rican—for the Headstart Program and, later, supervising Youth Board activities in Hispanic neighborhoods.

Jimenez stayed in New York for five years, a period that saw his emergence as a mature artist. He worked briefly as a studio assistant to Seymour Lipton, then

Luis Jimenez. *Howl,* 1986. Cast bronze, 60 × 29 × 29". Collection of the artist.

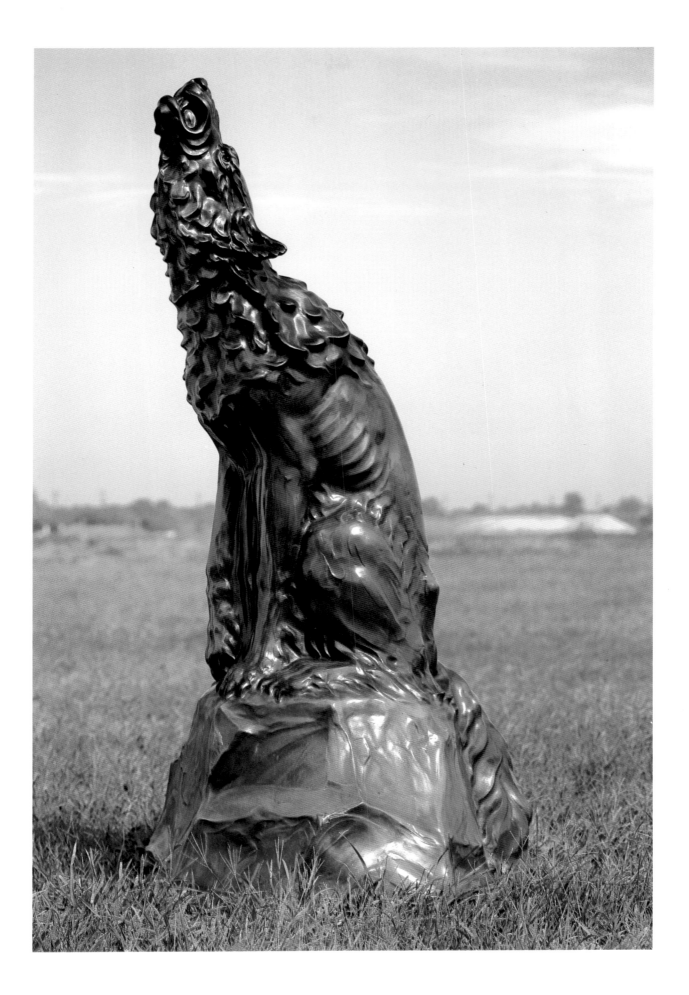

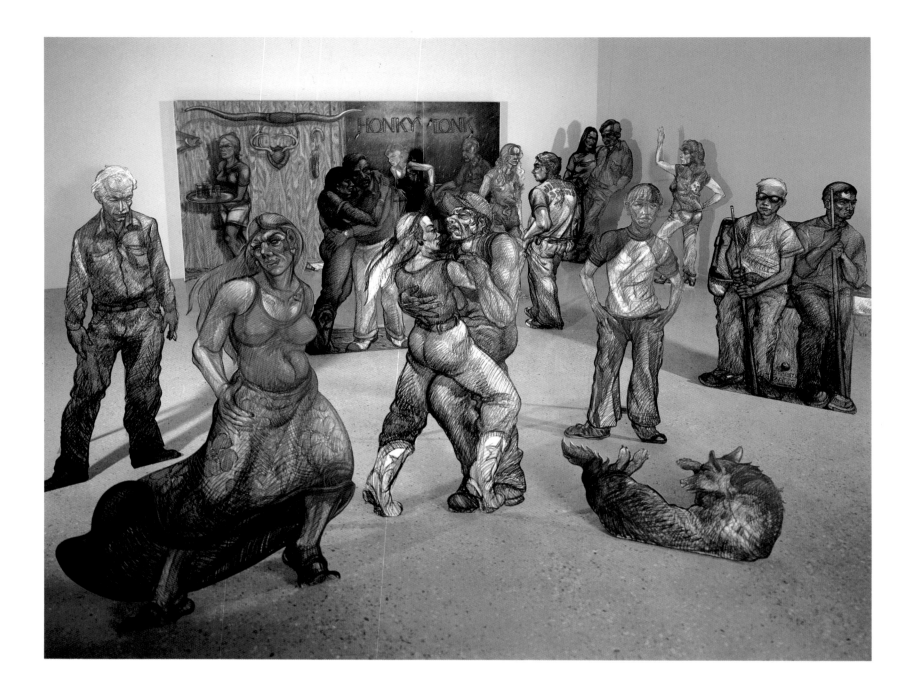

began producing the figurative works in painted fiberglass that have become his signature. He made the rounds of dealers, showing slides of his work, but failed to attract attention. So one day he loaded three of his sculptures on the back of a truck and, finding the Castelli Gallery empty and its director, Ivan Karp, nowhere in sight, carried the pieces in and set them up in the gallery. Karp was taken aback, but impressed with the work; he suggested that Jimenez try the Graham Gallery—which gave him his first solo exhibition in 1969 and a second in 1970.

In 1971, Jimenez returned to El Paso and started working in a building at his father's sign company. A third solo exhibition in New York, with Karp at his new gallery, O. K. Harris, had not been a financial success, and Jimenez was left without the resources to work on the scale and with the materials he wanted. He interested oil man and art patron Donald Anderson in his work, who invited him to Roswell, New Mexico, providing him with work space, living quarters, and some financial assistance. Jimenez remained in Roswell for about six years and produced the *Progress* sculptures, which depict southwestern images and which are larger and more complex in format than anything he had previously attempted.

The tendency toward larger scale and greater complexity became more pronounced as the 1970s progressed and as Jimenez worked on public commissions. In 1977 came *Vaquero*, a classic Mexican image for a Chicano neighborhood in Houston; the same year he began work on *Sod Buster* for Fargo, North Dakota. Several others are in progress, including *Southwest Pieta* for Albuquerque, *Howl*—a coyote—for Wichita State University, and a steelworker for the Niagara Frontier Transportation Authority, Buffalo.

Jimenez has continued to show in museums and galleries, including solo exhibitions at the Long Beach (California) Museum of Art (1973); the Contemporary Arts Museum, Houston (1974); the Museum of New Mexico, Santa Fe (1979); the Joslyn Art Museum, Omaha (1980); the Laguna Gloria Art Museum, Austin (1983); and the Alternative Museum, New York (1984). Among group exhibitions that have featured his work are "Human Concern/Personal Torment," Whitney Museum of American Art, New York (1969); "Recent Figure Sculpture," Fogg Art Museum, Harvard University, Cambridge (1972); "Biennial Exhibition of Contemporary American Art," Whitney Museum of American Art, New York (1973); "Dalé Gas: Chicano Art of Texas," Contemporary Arts Museum, Houston (1977); "Ancient Roots/New Visions," Tucson Museum of Art and tour (1977–79); "The First Western States Biennial Exhibition," Denver Art Museum and tour (1979–80); and "Showdown," Alternative Museum, New York (1983). He received the Hassan Fund Purchase Award from the American Academy and Institute of Arts and Letters (1977); fellowships from the American Academy in Rome and the National Endowment for the Arts (1979); and an Environmental Improvement Award from the American Institute of Architects in Houston (1982).

Jimenez returned from Roswell to El Paso for several years. He now lives with his present wife, Susan, and their young son, Adán, in Hondo, New Mexico, a small community in the mountains west of Roswell, where Jimenez has converted an old school into a studio and living quarters.

Luis Jimenez. *Honky Tonk*, 1981–86. Crayon on paper mounted on foam core or plywood, with neon element, approximately 8 × 16′ overall. Collection of the artist.

ROBERTO JUAREZ

Born 1952, Chicago

Juarez's parents met in Chicago, the father a transplanted Mexican-American farm worker and truck driver from San Benito, Texas; the mother a Puerto Rican who came to Chicago after living in Buffalo. The Juarezes moved from Chicago to nearby Romeoville, Illinois, when the artist was twelve. There Juarez's father worked—and still works—as a truck driver for a fruit juice company.

Juarez remembers that his parents played an active role in his cultural education: they drove their children around Chicago to look at architecture and took them on visits to the Field Museum of Natural History and the Art Institute. His mother in particular provided another kind of inspiration. She is a devout Catholic, and the family journeyed several times to the shrine of the Virgin at San Juan de los Lagos, a small town near Guanajuato, Mexico, once to express gratitude for the return of a son from military service in Vietnam. Juarez attributes to these visits much of his own interest in the mystical as well as his sense of his particular and complex heritage.

Like others of his generation, Juarez was also affected in his early years by television and the movies. He made drawings of movie advertisements in the newspapers and, later, drawings inspired by the movies themselves. After seeing Walt Disney's *Sleeping Beauty*, at about the age of twelve, he made drawing after drawing, inspired by the images in the film—a practice he continued throughout adolescence.

Juarez spoke only Spanish until he entered grade school. By junior and senior high school, he was fluent in English, but suffered from a speech impediment that resulted in his being placed in a special class for students of below-average learning ability. He knew he was not in the right place; far from being learning-disabled, he was extremely bright. Juaraez was "rescued by an art teacher who got me involved with an art club. Finally, I had my own ground. I became a real organizer and leader, but I was still a loner."

After high school, Juarez graduated from Joliet (Illinois) Junior College and went on to Southern Illinois University "to become an art teacher. It didn't occur to me I could ever make a living as an artist." There he met two artists who were to influence him profoundly: the instructor J. C. Wright, a Chicago Imagist, and fellow student Arch Connelly. When Connelly moved to San Francisco, Juarez left Southern Illinois and moved there as well.

Roberto Juarez. *Three Mushrooms*, 1986. Acrylic and charcoal on burlap, 72 × 108". Courtesy of Robert Miller Gallery, New York.

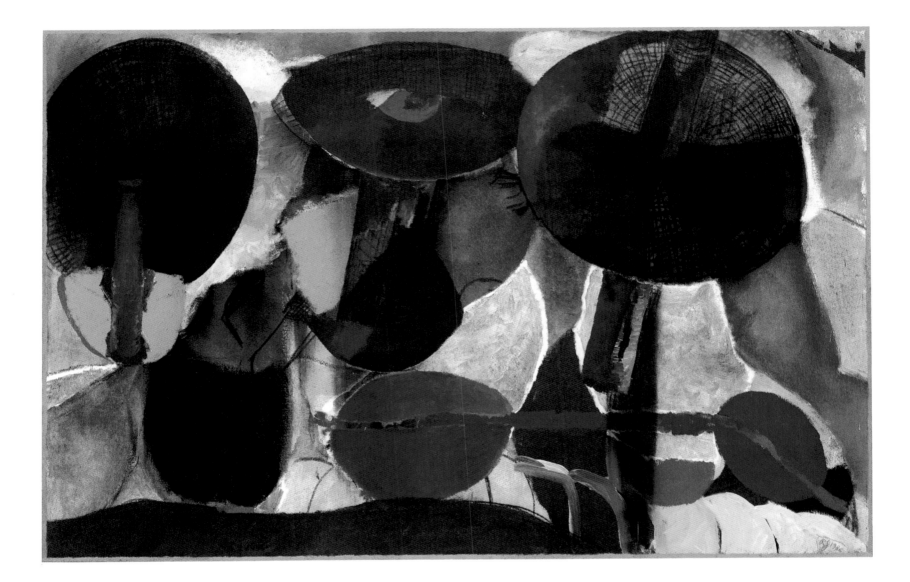

He arrived with little money and no significant contacts, but managed to put himself through the San Francisco Art Institute, receiving a B.F.A. in 1977. Attracted neither to the artistic nor teaching styles of the painters and sculptors at S.F.A.I., he gravitated instead to film and video classes, which seemed more exciting and experimental. "I spent hours alone, editing—this seemed a kind of salvation. I was out of sync with everything else." In 1978 and 1979 Juarez lived in Los Angeles and studied at the U.C.L.A. graduate school of filmmaking, where, through the documentary filmmaker Shirley Clark, he became involved in producing a weekly television show. "I was still secretly drawing and painting, and eventually I realized it was never going to work for me—being in the movie and TV business. I was never satisfied with the results of the work I did."

In 1979, Juarez decided to take a "leave" from his Los Angeles commitments by visiting a friend in Paris. There he encountered the artist Jed Garet, with whom he had become friends in San Francisco. Garet provided him with the opportunity to go to New York; he lived and painted in Garet's studio, working briefly as his assistant. He subsequently took a job at the Robert Miller Gallery, and in 1980, began to show as an artist in Miller's stable.

Juarez has had solo exhibitions at the San Francisco Art Institute (1977); the Robert Miller Gallery, New York (1981, 1983, 1985, 1986); the Myra Godard Gallery, Toronto (1983, 1986); the Betsy Rosenfield Gallery, Chicago (1984, 1985); Altos de Chavon, the Dominican Republic (1984); the Texas Gallery, Houston (1985); and the André Emmerich Gallery, Zurich (1984). He has participated in numerous group exhibitions throughout the United States and Europe, including "New Wave, New York," at the Institute for Art Urban Resources, P.S. 1, New York (1981); Stockholm International Art Expo (1982); "The Expressionist Image: American Art from Pollock to Today," Sidney Janis Gallery, New York (1982); and "An International Survey of Recent Painting and Sculpture," Museum of Modern Art, New York (1984).

Roberto Juarez. *French Arrangement,* 1985.
Acrylic and oilstick on canvas, 58½ × 78⅜".
Elizabeth and William Landes, Chicago.

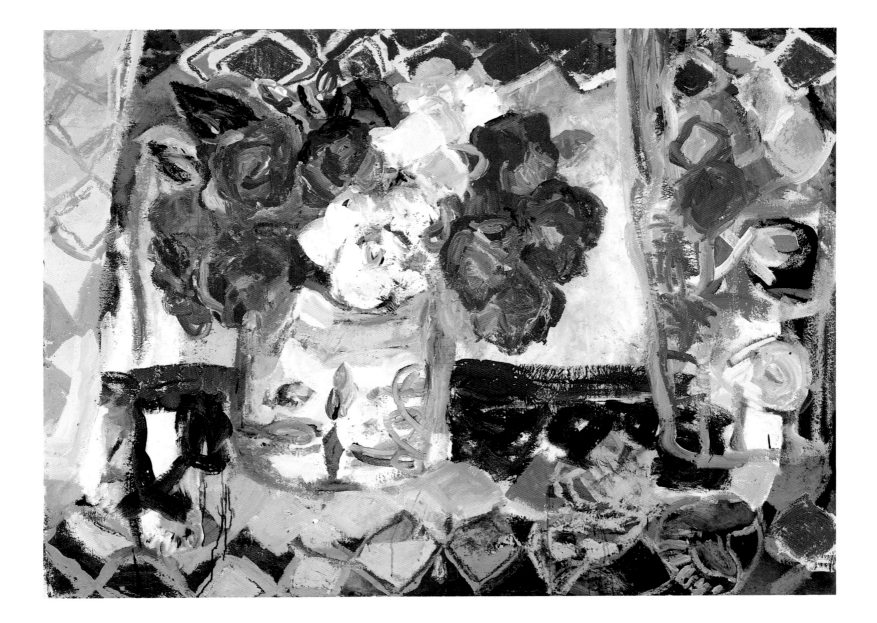

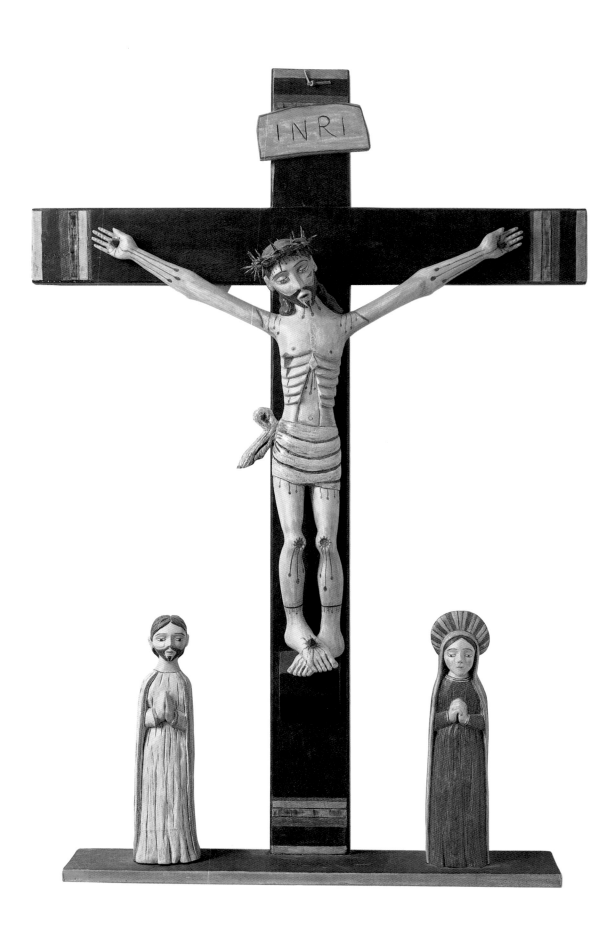

FÉLIX A. LÓPEZ

Born 1942, Gilman, Colorado

Both of López's parents were from Truchas, New Mexico, a small village in the Sangre de Cristo range north of Santa Fe; both were descended from families that had resided in the town for many generations. Because jobs were scarce in Truchas, López's father migrated back and forth between northern New Mexico and central Colorado during the late 1930s and early 1940s with his growing family—the artist was the sixth of eleven children. In Gilman, Colorado, he worked as a zinc miner.

By the time López was three, the family was back in northern New Mexico to stay. His father had broken his leg on the job and was also beginning to show symptoms of silicosis, a lung disease contracted from exposure to silica dust in the mines. After convalescing in a Denver hospital, he bought a house in Santa Cruz, in the Española Valley north of Santa Fe—a location he preferred to Truchas for the sake of his children's education. He found work as a carpenter in Los Alamos and in Española; it was a trade more suited to his talents than mining. López remembers his father as a hard-working man. At home, if not tending the farm animals or gardening, he was busy with wood, making looms, tables and chairs, and cabinets. "At the time, I didn't really take an interest in the things he made. Now that I work with wood, I wish I had learned more from him."

Through the eighth grade, López attended Holy Cross, a Catholic school in Santa Cruz. He attended Española High School, graduating in 1961, and continuing at New Mexico Highlands University in Las Vegas, New Mexico. He graduated in 1965 with a major in Spanish, a minor in German, "and almost another minor in French." A recruiter from a high school in central California offered him a job teaching Spanish; so López left for Corcoran, in the San Joaquin Valley near Bakersfield and Fresno, spent a year there, then relocated to Orange, California, where a sister lived and where he taught Spanish and German in a local high school. In 1968, he married a woman from Santa Fe, who joined him in Southern California.

The following year, López and his wife returned home. Neither had been happy in the Los Angeles area: "The city was not for me. I missed the mountains, the space, the fresh air." López got a job in his old high school in Española, where he works today, teaching Spanish to native speakers. In 1972, he received a master's degree in Spanish literature from the University of New Mexico.

Félix A. López. *Cristo*, 1984. Cottonwood, pine, gesso and natural pigments, 46½ × 27½ × 5½". Collection of Mr. and Mrs. Robert E. McKee III.

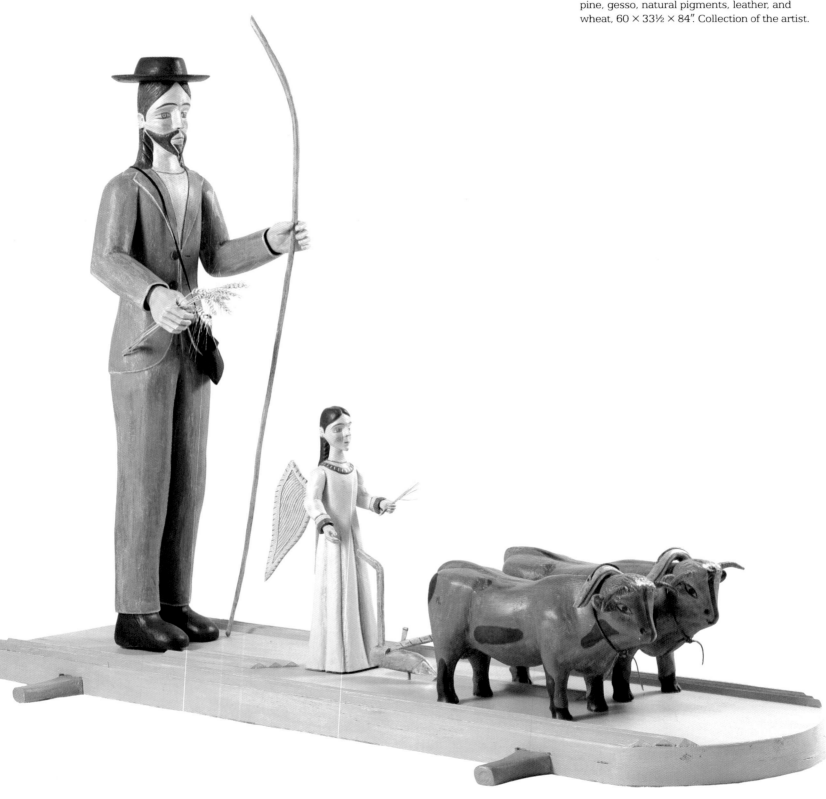

Félix A. López. *San Ysidro*, 1986. Cottonwood, pine, gesso, natural pigments, leather, and wheat, 60 × 33½ × 84". Collection of the artist.

The chain of events that would culminate in the emergence of López's parallel career as an artist began in 1975 with the death of his father, who succumbed after his long battle with silicosis. The family made preparations for a conventional funeral, but López's youngest brother, Alejandro—also an artist of considerable skill—proposed an alternative. "He wanted to do it the old way," López recalls, and Alejandro convinced the family to hold the observances in the Penitente *morada*, the meetinghouse of a traditional lay religious brotherhood, in Santa Cruz, which had been out of use for many years. For two nights and three days the body lay in the *morada* on a serape woven by López's grandmother. The family sang *alabados*—old Spanish hymns—and listened to Catalonian chants. They were inspired, if exhausted, by the experience: "Nobody wanted to leave."

During those days, López says that he looked hard at the *bultos*, the carvings of the saints that decorated the *morada*, images like those he had seen all his life but never really noticed. As he told Jim Sagel, a New Mexico novelist and occasional journalist, "I focused on the *santos*. They were physically and spiritually close to me. The high energy and the *alabados*—it all came together for me. The culture came alive for me."

After the funeral, López reports, he felt a need "to make something— something meaningful—to fill the void." At Alejandro's urging, he began experimenting with ceramics. Then, about 1977, he picked up a piece of wood and began carving a face. The *bultos* from the *morada* came back to him, and he began working with the images of the saints. Without artistic training, he at first closely studied the old carvings in churches and in books, seeking guidance and inspiration. After a couple of years, he began following his own instincts, creating in the spirit of the old works but not copying them.

López's work is distinguished not only by his skill at carving, but also by his remarkable sensitivity to color. He uses pigments he makes himself from such materials as soot, crushed rocks and clays, boiled leaves, blood, and indigo. Many of these substances he collects on excursions into the New Mexico landscape. His colors, developed through a process of experimentation, do not replicate the traditional colors, but they are true to the spirit of the ancient *bultos* and "more subtle" than commercial paints. His wood he gathers from the forests of cottonwood, pine, and aspen near Taos and Questa.

López's sculpture has been included in numerous group exhibitions and festivals in New Mexico, as well as in "Hispanic Crafts of the Southwest," Taylor Museum of the Colorado Springs Fine Arts Center (1977); "One Space/Three Visions," Albuquerque Museum (1979); and "Santos de New Mexico," Galería de la Raza, San Francisco (1983). He received a Visual Artists Fellowship from the National Endowment for the Arts in 1984. Recently, he has restored *bultos* for the church in Santa Cruz and has been commissioned to make a replacement crucifix for an old chapel in the Santa Cruz parish. López lives near Española with his wife and two children.

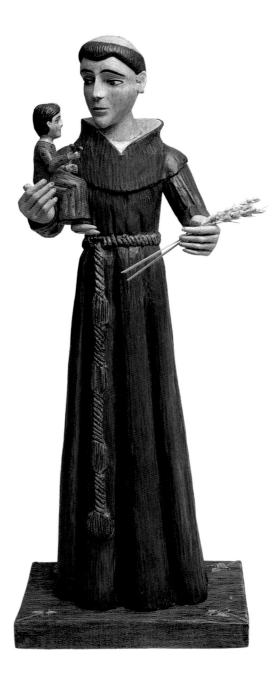

Félix A. López. *St. Anthony of Padua*, 1985. Cottonwood, gesso, and natural pigments, 32½ × 11½ × 9". Collection of the artist.

GILBERT SÁNCHEZ LUJÁN ("MAGU")

Born 1940, French Camp (Stockton), California

Gilbert Luján's parents came from two long lines of Mexican-Dutch and south-western Mexican-American families, his mother's from the state of Jalisco—she was born in Guadalajara; his father's from Texas, where he was born in the small town of Polvo. Luján is the oldest of six boys; his four youngest brothers are half-siblings.

Luján spent his first months in a migrant workers' settlement in Northern California, where his parents worked, having met and married in Los Angeles and followed the boy's paternal uncle to Northern California, where he was a prosperous contractor. The family soon relocated permanently in East Los Angeles; Luján spent his elementary and high school years in the sprawling, half-rural, half-suburban environment of the towns of La Puente and El Monte. Essentially extended parts of the East L.A. metropolis, they were multiethnic communities whose culture was defined largely by the cult of the automobile. Luján developed an early and lasting obsession with customized cars. As a teenager, he drew them constantly. When the artist was in high school, his step-father bought him a 1941 Chevy, which he was allowed to drive only up and down the driveway. "Fortunately," he says, "we had a very long driveway."

After graduating from El Monte High School—"a real rock 'n' roll hot spot, the place I got my love for black music"—Luján joined the Air Force. He served from age seventeen to twenty-one and was stationed in Texas and England. During this period he visited France, Italy, and Spain. "I discovered my own culture when I was in the Air Force. It gave me the perspective to see what I was and what I had come from." During this time, too, Luján began to read, starting with Hemingway, Sinclair Lewis, William Saroyan; only much later moving on to such writers as James Joyce.

When Luján returned to Los Angeles in 1962, he enrolled at East Los Angeles Junior College, where he was first exposed to art, through an instructor who invited him to make a clay sculpture. From there he went to Long Beach State, where he received his B.A. degree; he then obtained his M.F.A. at the University of California at Irvine, which boasted an extraordinary art department. It was at Irvine that Luján solidified his technical mastery, working with the ceramic

Gilbert Luján. *Stepping Out.* 1986. Pastel on paper, 30 × 44". Collection of the artist.

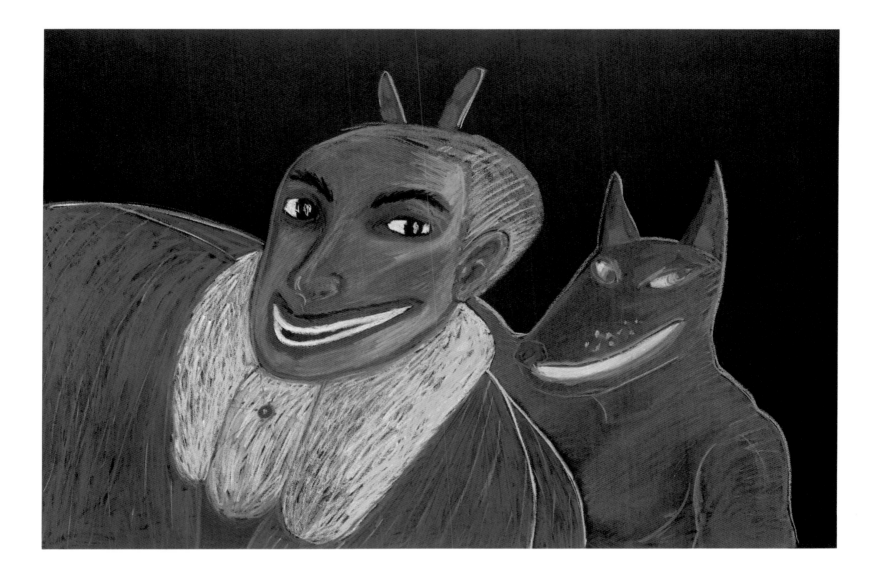

sculptor John Mason as well as with John Paul Jones and Tony Delap, and strengthened his commitment to Chicano art and politics. He assumed an organizing role in dozens of small exhibitions in various parts of California and the Southwest.

It was at this time that Luján joined forces with the artists Beto de la Rocha, whom he had known since 1963, Carlos Almaraz, whom he met in 1971, and Frank Romero to form the exhibiting group known as "Los Four." Their first show was at Irvine in 1974; this was followed by the successful expanded exhibition the same year at the Los Angeles County Museum of Art and then by an intense two-year period of increasing recognition and collaboration with various artists.

In 1976, with his wife Mardi, whom he had married in 1973, Luján moved to Fresno, California, where for five years he taught ethnic studies at Fresno City College, served as chairman of La Raza Studies Department, and became involved in a great deal of social and community work, organizing a health clinic and other services for Chicanos in the area. In 1977, he oversaw and helped execute, with John Valadez and members of the East Los Angeles Street-scapers, and Fresno artists, an immense farm workers' mural called "Una Sola Unión," which was exhibited at a three-day conference in Fresno and then simply "rolled up by the farm workers and thrown behind some warehouse. Now it's gone."

Gilbert Luján. *¿Dónde está la pelota?,* 1986. Acrylic on archival board, 14 × 31 × 8¼". Collection of the artist.

Gilbert Luján. *Beach Couple at Santa Monica*, 1986. Acrylic on archival board, 23½ × 42½ × 11½". Collection of the artist.

By 1981, Luján says, he was "exhausted, burned out. I had overstayed my time in Fresno." He returned to Los Angeles, where he got a job teaching at the Municipal Art Center at Barnsdall Park and took a few years to focus more on his three children and reinvigorate his commitment to sculpture and painting. He says much of his inspiration as an artist has been from sculptors, rather than painters, particularly Giacometti, Henry Moore, Picasso. He particularly likes William King. His favorite Mexican artists—"soulmates," he says—are Diego Rivera and Francisco Zuñiga. He has traveled frequently to Mexico, and more recently visited his father's relatives in New Mexico and investigated his lineage there.

Luján has shown in many group exhibitions since 1972, primarily "Los Four" (1973–74); "Chicanarte," Municipal Art Gallery, Los Angeles (1975); "The Aesthetics of Graffiti," San Francisco Museum of Modern Art (1978); "Low Rider," Galería de la Raza, San Francisco (1979); and "Off the Street," Old City Print Shop, Los Angeles (1985). In 1983 and 1984, he showed his *Magulandia*, an environment of doglike sculptures, at the Galeria Otra Vez in Los Angeles and Galeria Posada, Sacramento.

CÉSAR AUGUSTO MARTÍNEZ

Born 1944, Laredo, Texas

Both of Martínez's parents were born in Northern Mexico and came to Texas as children with their families, who, like so many others in the years after the Mexican Revolution, suffered economic hardship. On his mother's side, the family retains close ties with Mexico through their cattle ranch in the state of Nuevo León not far from the Texas border.

The artist's mother and father met and married in Laredo. He was their only child; his father died when Martínez was less than a year old. Thereafter, Martínez and his mother lived with his grandmother and his mother's two unmarried sisters. His mother held clerical and sales jobs, eventually working as a drugstore cashier until her retirement in the mid 1970s.

Martínez spent part of each summer on the ranch in Mexico, where he learned "all the ranch things: riding, planting with oxen, driving cattle." He wasn't aware at the time of how his life differed from those of other people. "When I was a kid, I thought every town had a Mexican counterpart across the river, an *otro lado*. It wasn't until I was in my teens that the meaning of being Mexican American started to sink in." But he does not recall feeling discriminated against on that account: there were many Mexican Americans in Laredo of all social classes, and Martínez was more aware of class barriers than ethnic ones. He continued to cross the border frequently as a teenager, especially during what he describes as his "bullfight episode," when he went to the fights regularly in Nuevo Laredo and, for a few years, trained to become a matador.

César Martínez. *El Bizco,* 1985. Acrylic on canvas, 65 × 50". Collection of the artist.

Martínez graduated from public high school in Laredo in 1962 and went on to spend two years at Laredo Junior College. He had always drawn and painted, but "I also knew that artists didn't make any money. I thought taking business courses would be more practical, but I didn't do well. I just wasn't interested." In 1964 he entered Texas Arts and Industries University in Kingsville where, combining pragmatism with his enthusiasm for art, he changed his major to art education. He received his B.A. in 1968.

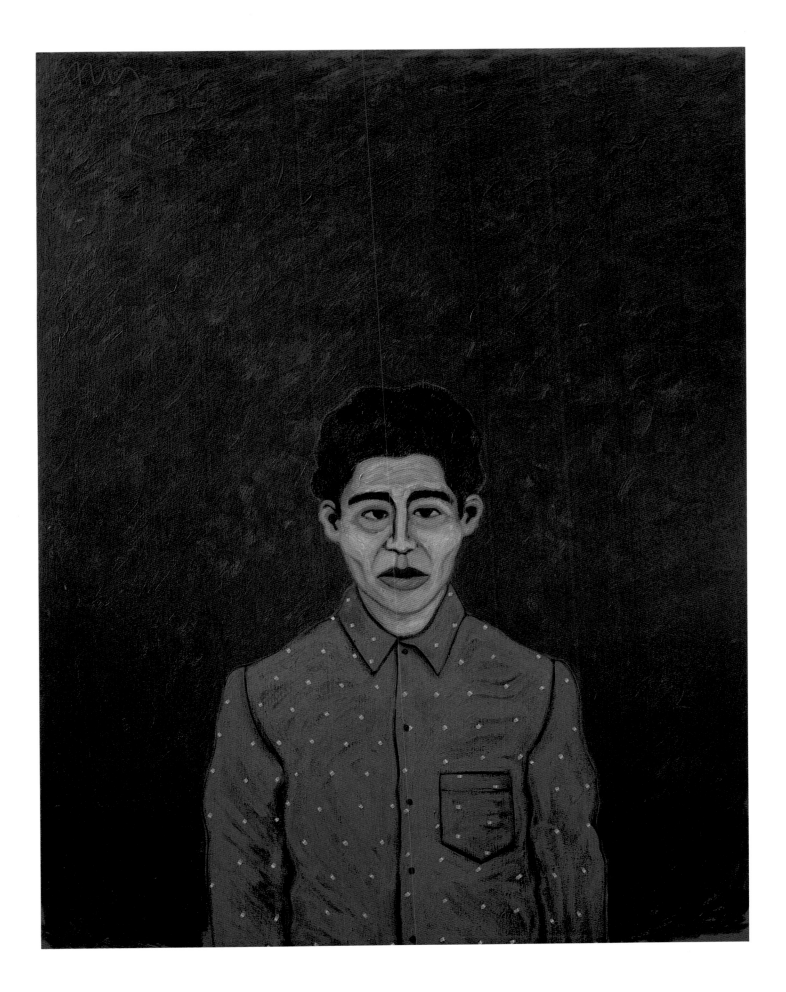

After graduation, Martínez took a job as a trainee in a Freeport, Texas, chemical plant for about six months. He was drafted into the army in the summer of 1969, was trained as a radio operator, and served eventually with a medical battalion in Korea. In the Orient, access to inexpensive equipment prompted him to take up photography, which became his principal artistic pursuit after his discharge in 1971.

Martínez returned to Texas and settled in San Antonio, where he had many friends from his college days, among them Carlos Guerra, one of the principal Chicano political figures in the state and director of the Texas Institute for Educational Development, a Chicano activist organization. Through Guerra, Martínez had first gotten interested in the Chicano movement while still at Texas A.&I.; now, again through Guerra, he became involved in the work of the Texas Institute. Among other projects he produced for them was a slide package on the history of Chicano art that is still widely used. He was also one of the founders of the Chicano periodical *Caracol*—also under the auspices of TIED— for which he served as photographer, designer, and occasional columnist. At the same time, he joined the group Con Safos, one of the first of the Chicano visual arts organizations, founded in San Antonio by the artists Mel Casas and Felipe Reyes. These various associations "informed me culturally and aesthetically," Martínez recounts. "It was at this time that my cultural, political, and visual ideas started to unify and manifest themselves. It was an important time in my development as an artist."

By the middle of the 1970s, Martínez found himself drifting away from Con Safos. More and more he wanted to concentrate on developing his own art: the group did "a lot of talking and not enough work." He became involved briefly with Los Quemados—"the generally burned out"—which he cofounded with Carmen Lomas Garza and the San Antonio painter Amado Peña. At this point Martínez abandoned art photography and returned to painting, which remains his primary pursuit to this day. He wields a camera now only for his bread and butter, photographing houses for San Antonio's weekly real estate listings.

Martínez has been included in numerous group exhibitions, including "Ancient Roots/New Visions," Tucson Museum of Art and tour (1977–79); "Dalé Gas: Chicano Art of Texas," Contemporary Arts Museum, Houston (1977); "Showdown," The Alternative Museum, New York (1983); "Chicano Expressions," Intar Latin American Gallery, New York (1986); and "Chulas Fronteras," Midtown Art Center, Houston, and tour (1986). He had a two-person exhibition at the Frank C. Smith Fine Arts Center, Texas Arts and Industries University, Kingsville, with Carmen Lomas Garza (1978), and solo exhibitions at the Xochil Gallery, Mission, Texas (1978) and Dagen Bela Gallery, San Antonio (1980). Martínez lives in San Antonio.

César Martínez. *El Enano White,* 1986. Acrylic on canvas, 64 × 54". Collection of the artist.

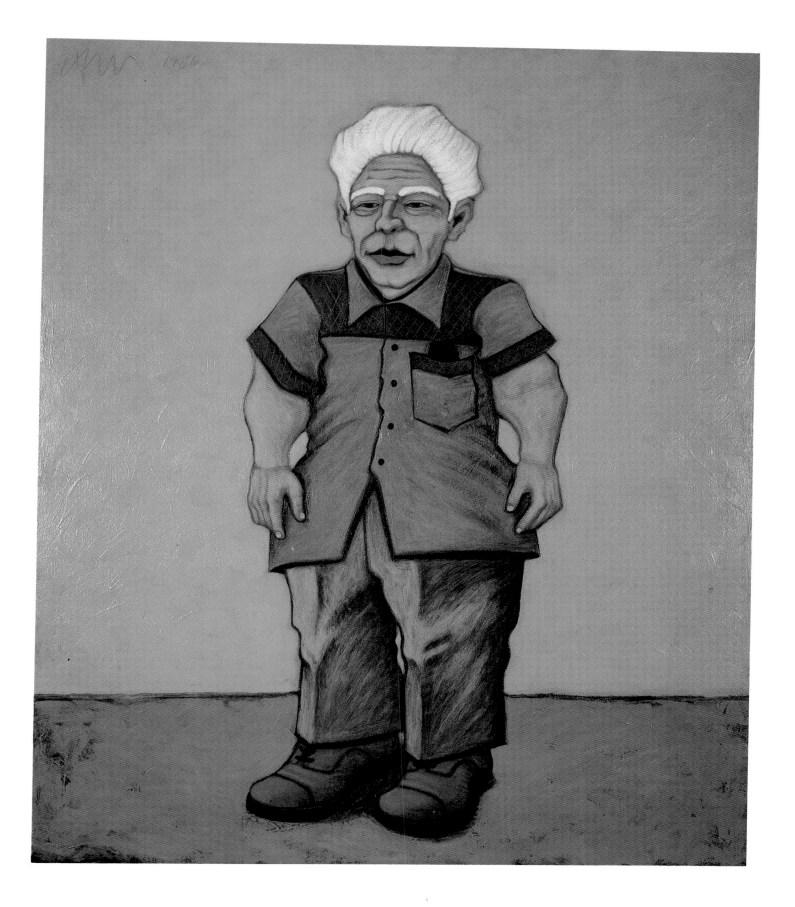

GREGORIO MARZÁN

Born 1906, Vega Baja, Puerto Rico

Gregorio Marzán. *Striped Butterfly,* early 1980s. Mixed media, 22½ × 20 × 7″. El Museo del Barrio, New York.

Lizard, early 1980s. Mixed media, 12½ × 31 × 7″. El Museo del Barrio, New York.

Marzán attended school only until he was nine years old, when economic circumstances compelled him to find a job. For more than twenty years, he worked on the Island as a carpenter and as a field hand, planting and harvesting sugarcane. During those years he married; he and his wife produced five children. In 1937, driven again by economic necessity, he decided to move to New York. By then, his wife had died, and he came alone on one of the many sailings of the *Coamo,* a major carrier of Puerto Rican migrants to the mainland. Marzán joined an older brother and sister in New York, his children gradually joining him as he could afford their passage.

In the city, Marzán tried unsuccessfully to find employment as a carpenter. Through the Works Progress Administration, he was eventually hired as a sewer worker, a job he held for seven months until, concerned because of his poor hearing, the W.P.A. transferred him to a less dangerous position in a toy factory on Manhattan's West Side. Except for three days at the beginning of World War II during which he worked at the Brooklyn Navy Yard, Marzán spent the next thirty-two years making dolls and stuffed toys at a variety of New York factories. He retired in 1971, and lives alone in Spanish Harlem.

Several years into his retirement, Marzán began making small houses, typical of those of rural Puerto Rico. His notion, he says, was to sell them for home

decoration. He took them first to shops on Third Avenue, none of which was interested. He went next to the shop at the Museum of the City of New York, which *was* interested—but only if Marzán would make them smaller. Unwilling to reduce their scale, Marzán then tried the shop across the street, at El Museo del Barrio. His work—the houses as well as some small birds—came to the attention of the museum's director at the time, Jack Agüeros, who felt that it belonged not in the museum's shop, but in its collection. He encouraged Marzán to continue bringing pieces to the museum—this was about 1979—which steadily acquired them thereafter.

Of late, Marzán has been making mostly birds and mammals, in relief and in the round. He has also done a few portrait heads and full figures, as well as a replica of the Empire State Building. He says that his ideas come to him while he is walking around and are based on things he has seen in New York or Puerto Rico (which he has visited some nine times since settling in New York). Like many other artists who are self-taught, he does not claim the title. "I don't consider myself an artist, I consider myself a professional. I can make anything I see." Told that others consider him an artist, he responded: "That distinction only [they] can give me."

The exhibition this book accompanies is Marzán's first.

Gregorio Marzán. *Spotted Bird (with orange beak),* early 1980s. Mixed media, 10½ × 22 × 6″. El Museo del Barrio, New York.

Rooster, early 1980s. Mixed media, 23 × 26 × 9″. El Museo del Barrio, New York.

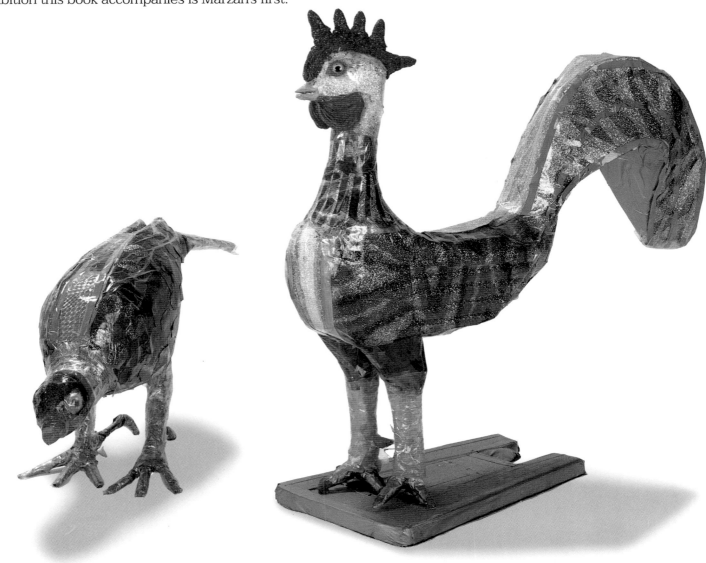

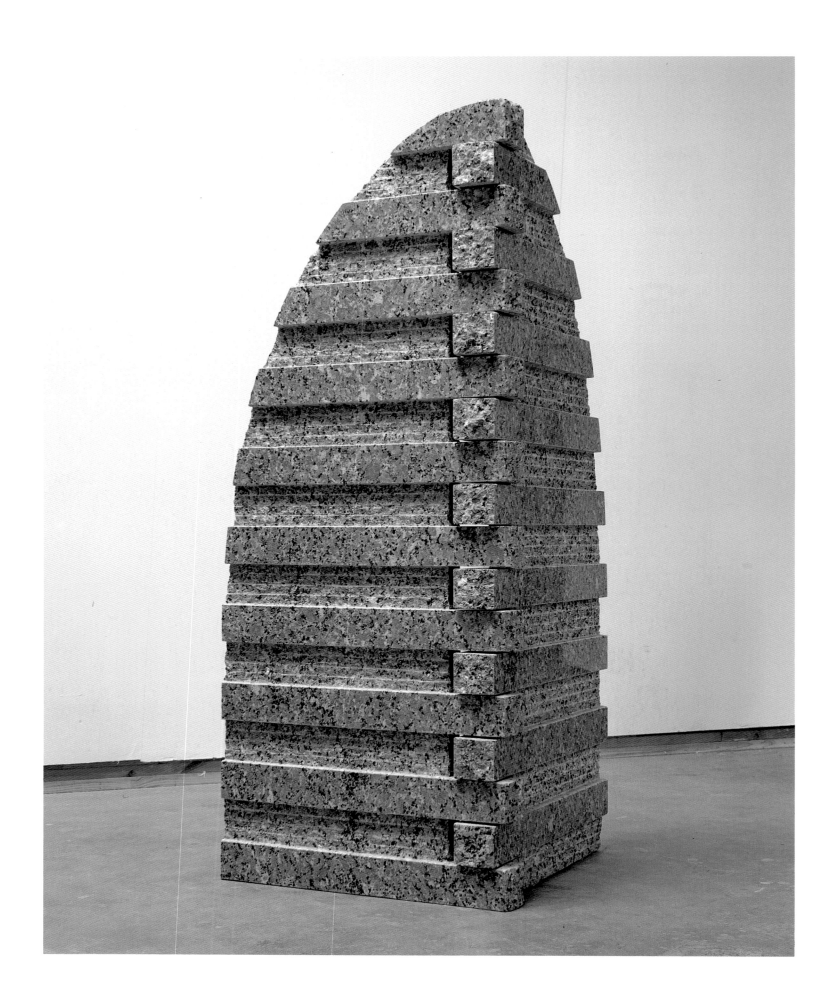

JESÚS BAUTISTA MOROLES

Born 1950, Corpus Christi, Texas

The artist was the first of six children born to José Moroles, an emigré from Monterrey, Mexico, and Maria Bautista; they met and were married in coastal Texas, moving to Dallas when Jesús was in elementary school. The family lived in public housing in an area known as the Trinity River Bottoms. Moroles recalls his childhood there as "rough." Eventually, José Moroles bought a shell of a house in Oak Cliff. Moroles helped his father to renovate it, and he also spent several boyhood summers in Rockport, Texas, where an uncle, trained in Mexico as a master mason, helped him to get various construction jobs, including work on a Gulf Coast seawall.

An artistic bent was evident early in Moroles's life—by the third grade—and his parents encouraged him by saving even his earliest drawings and teaching him various manual skills. An education at Crozier Tech, a downtown Dallas vocational school, served more to further manual training than to educate in a "liberal arts" sense. Moroles says his teachers "were old-timers who believed in their vocations and in having job skills." Moroles focused on commercial art at Crozier Tech and edited the school yearbook. Just after graduation, he received—on the same day—his first job offer and his draft notice.

After four years in the Air Force, in which he repaired computers and was stationed successively in Nebraska, Mississippi, and Thailand, Moroles returned to Dallas in 1973 and enrolled at El Centro Junior College. He took art courses his first year, required courses his second, and went on to North Texas State University in Denton, intending to become a sculptor. At North Texas he strengthened his skills in the basic crafts he would need later—drafting, electronics, math, and woodworking—gaining what he says was a uniquely valuable emphasis on the industrial arts rather than "purer" art training. Moroles feels he had the advantage of a "non-directive" artistic/technical education, one in which he was allowed to experiment independently and was required to learn skills rather than styles.

During his final year at North Texas in 1978, the artist attended a workshop given by Luis Jimenez, at that time already a relatively established Texas sculptor. Moroles and Jimenez became friends, and Moroles spent the next year apprenticing with the sculptor in his El Paso studio. Notwithstanding the radical difference in their approaches—Moroles relies on ancient materials and architectonic traditions, while Jimenez renders popular images in industrial materials—Moroles considers his exposure to Luis Jimenez one of the most important events in his artistic life.

Jesús Bautista Moroles. *Texas Shield,* 1986. Texas granite, 75 × 43 × 27". Courtesy of the artist and Davis/McClain Gallery, Houston.

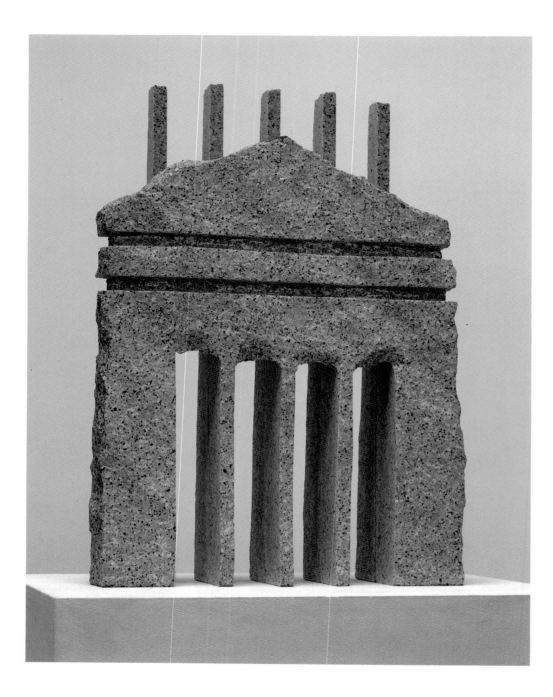

Jesús Bautista Moroles. *Texas Facade*, 1986. Texas granite, 29¼ × 21½ × 7¼″. Courtesy of the artist and Davis/McClain Gallery, Houston.

After the year in El Paso, Moroles went to Carrara, Italy, an obligatory pilgrimage for a stone sculptor; but he found the place neither sympathetic nor conducive to producing work. He returned to Texas in 1980 and took advantage of a friend's offer to use an old monument company in Waxahachie. It was here that Moroles, at age thirty, commenced to make the prodigious body of sculpture for which he is now acclaimed. His first work—*Fountain* (1980)—was shown at the Shidoni Foundry in Santa Fe, New Mexico; it is now in the courtyard of a private home in Houston.

Since moving to Waxahachie, Moroles has worked steadily, producing major pieces in varying scales, many on commission. In 1982, he resettled with his parents in Rockport, Texas, to which they had recently retired, and has estab-

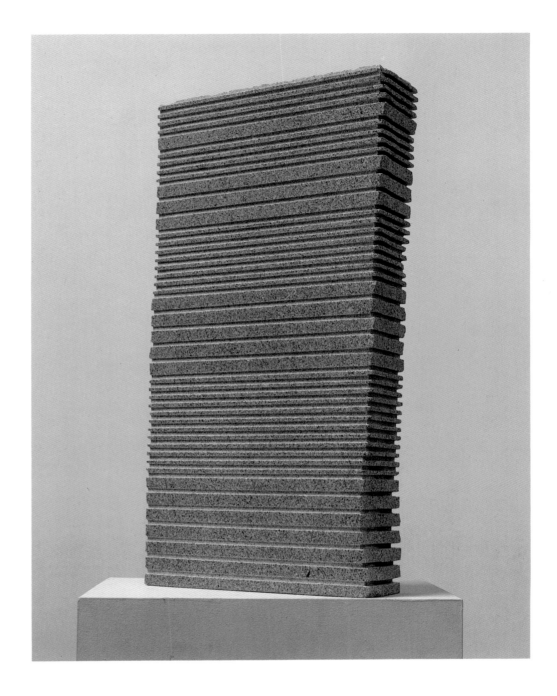

Jesús Bautista Moroles. *Vanishing Edge,* 1985. Georgia granite, 30 × 6 × 17″. Courtesy of the artist and Davis/McClain Gallery, Houston.

lished a heavily equipped workshop there. His brother, Hilario, assists the artist. Jesús and his son live in an ever-expanding complex of buildings that includes a main house, office space, a warehouse, garage, and the 1949 bus Moroles used as home for several years in the 1970s.

The artist's work has been featured in many solo, two-person, and group exhibitions. Among the solo shows were those at the Davis/McClain Gallery, Houston (1982, 1984, 1986); the Mattingly Baker Gallery, Dallas (1982, 1983); the Janus Gallery, Santa Fe (1984, 1985, 1986); the Marilyn Butler Gallery, Scottsdale (1986); the Baumgartner Galleries, Washington, D.C. (1985, 1986); the Amarillo Art Center (1982); the Koehler Cultural Center, San Antonio College (1983); and the Rockport Art Center (1985).

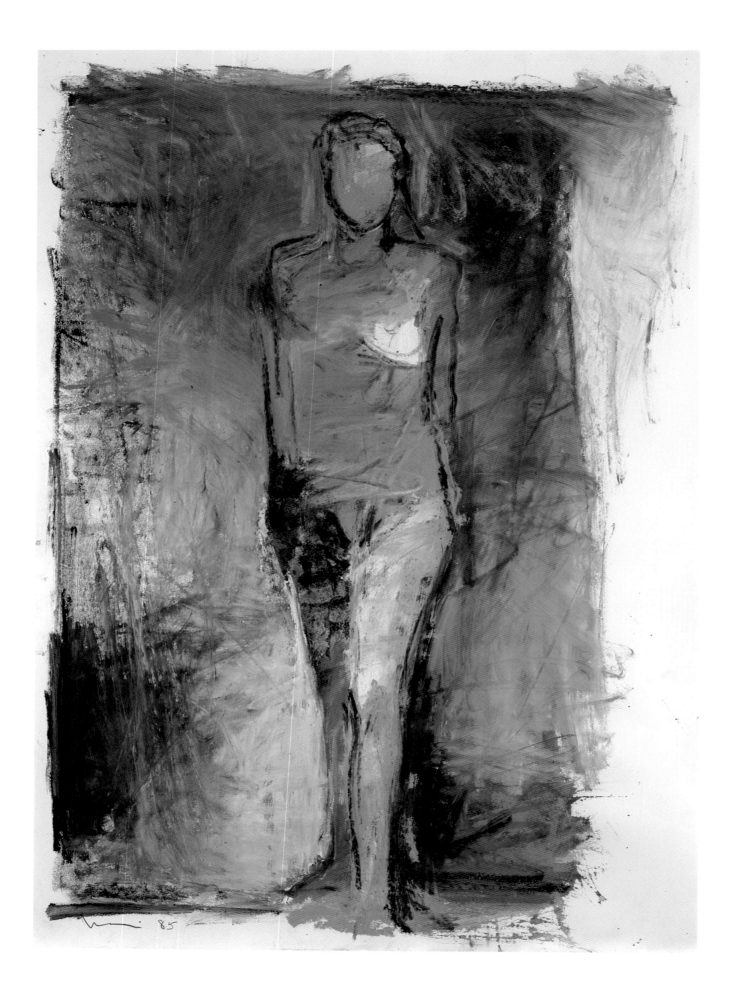

MANUEL NERI

Born 1930, Sanger, California

Both of Manuel Neri's parents came in adulthood to the United States from their native Mexico. Neri himself is bound up with the cultural milieu of Northern California. His mother and two sisters—his father died when he was nine—all live in California, and Neri has been intimately associated with the development of a complex and specific school of painting in the Bay Area since the 1950s.

Neri's parents came from the small town of Arandas, in Jalisco, from families of Italian derivation, both with the Neri name. The artist's father, a lawyer, was forced to leave Mexico in the early 1920s because of threats against his life; he was a representative of the government in a town where revolutionary zeal was active long after the Mexican Revolution. The senior Neri went alone to Chicago, eventually returning to Mexico for his wife and daughter, Neri's older sister; by 1930, when Neri was born, the family was settled temporarily in Sanger.

As a young child, Neri grew up first in the Southern California towns of Tarzana and Canoga Park, and sometimes more rural areas where his father worked intermittently in the fields. The boy was raised bilingually, speaking Spanish at home (at his father's insistence) and English with friends and at school. After his father died, his mother moved back to Sanger, where her sister lived, and reared her three children, keeping the family together "through sheer hard work, common sense, and determination."

The family subsequently moved to Northern California, where Neri attended Fremont High School in Oakland, quitting temporarily to work, and finally graduating with the notion of becoming an engineer. He says he got all the way through high school without any exposure to or interest in visual art, though he enjoyed opera and poetry. After graduation, he decided to work toward college at the University of California and enrolled in some math and laboratory classes at San Francisco City College. There he stumbled into art training, taking an "easy art class—ceramics, actually"—and meeting a teacher, Roy Walker, who encouraged his more serious involvement with art. At Walker's suggestion, Neri visited Clyfford Still's painting classes at the San Francisco School of Fine Arts (later renamed the San Francisco Art Institute)—"Still was kind of a son of a bitch, but he taught me a few things"—and met the ceramic sculptor Peter Voulkos, then a student at the California College of Arts and Crafts.

Manuel Neri. *Untitled V,* 1985. Mixed media on paper, 49½ × 29¾". Thomson M. and Joanna S. Hirst Collection.

Neri gave up his idea of pursuing an engineering career and began gradually to immerse himself in the project of becoming an artist. In 1952 he enrolled at the California College of Arts and Crafts in Oakland. Neri's initial testing of the waters in Northern California's artistic environment was interrupted in 1953 when he was drafted into the army. He served in Korea and visited Japan twice in 1954. The artist says these visits, during which he became familiar with Japan's traditional as well as contemporary art and culture, were critically important.

Neri returned to the Bay Area in 1955, re-enrolling at the College of Arts and Crafts and coming into contact with such teachers as Richard Diebenkorn and Nathan Oliveira. The marriage he had made before going to Korea, and which produced the first two of his children, dissolved; Neri became seriously committed to being a sculptor, working primarily with "found objects" and plaster during these years.

Throughout the 1950s, Neri visited Mexico and New York. Like many California artists of the time, including his friends William Wiley, Roy de Forest, and Joan Brown (to whom he would be married for a short time beginning in 1962), he found no appeal in the struggle and competitiveness needed to sustain an artistic career in New York. He did, however, meet there many of the important artists of the day, like Willem de Kooning and Franz Kline, though he says he was more directly influenced by such European artists as Fritz Wotruba and Lucio Fontana. He was also fascinated by Picasso and the Mexican painters, Orozco and Siqueiros.

By the early 1960s Neri had settled into what would become a permanent teaching career, first at the San Francisco Art Institute and, starting in 1964, at the University of California at Davis, where he teaches today. In 1964, too, he bought the extraordinary studio he still inhabits in Benecia, near San Francisco: a Congregational Church built in the nineteenth century, which he has made into living and working space. Neri first visited Europe in 1961. Since the early 1970s, he has returned there nearly every year. He now has a home and studio in Carrara, Italy, where Neri and his present wife, Kate, whom he married in 1983, spend part of the year, Neri working the local marble.

Neri has had numerous solo exhibitions, including those at the Quay Gallery, San Francisco (1966, 1968, 1971, 1975); San Francisco Museum of Art (1971); the Oakland Museum (1976); Galerie Paule Anglim, San Francisco (1979); Seattle Art Museum (1981); Charles Cowles Gallery, New York (1981, 1982, 1986); the Mexican Museum, San Francisco (1981); John Berggruen Gallery, San Francisco (1981, 1984); Middendorf Gallery, Washington, D.C. (1983, 1984); and Gimpel-Hanover and André Emmerich Galerien, Zurich (1984). He has also been included in many group exhibitions in California and throughout the United States. He received a Guggenheim Foundation Fellowship (1979); a Visual Artist Fellowship from the National Endowment for the Arts (1980); an Award in Art from the American Academy and Institute of Arts and Letters (1982); and an Award of Honor for Outstanding Achievement in Sculpture from the San Francisco Arts Commission (1985).

Pedro Perez. *La Esmeralda (Queen that Shoots Birds)*, 1982, detail. Mixed media, 36 × 36 × 5". Jock Truman and Eric Green.

PEDRO PEREZ

Born 1951, Caibarien, Cuba

The artist's father was a jewelry and clock designer who, with his wife, owned a business that eventually grew to include shops in several Cuban cities. After Fidel Castro's accession to power in 1959, Perez's father was jailed several times for public opposition to the new government's pro-Soviet policies. Cuban au-

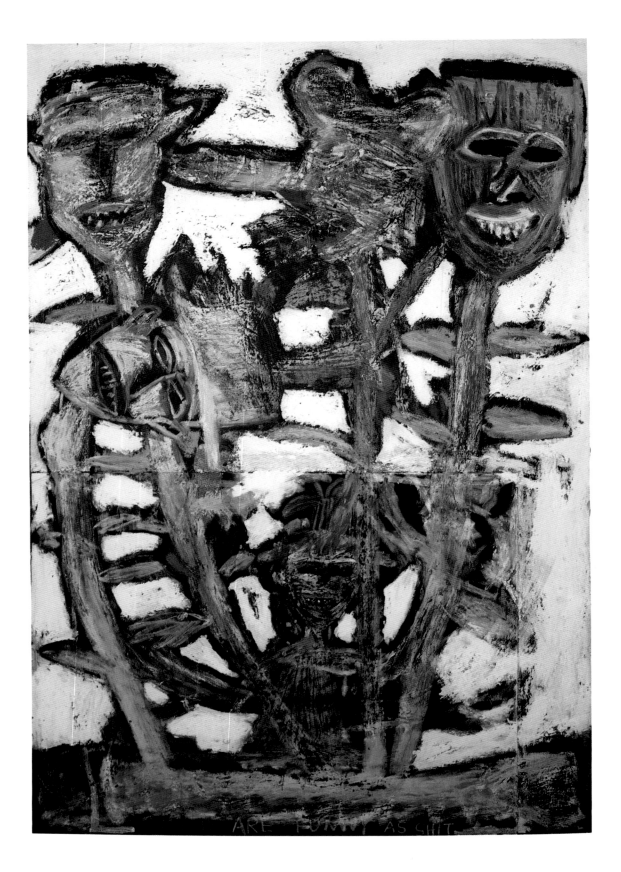

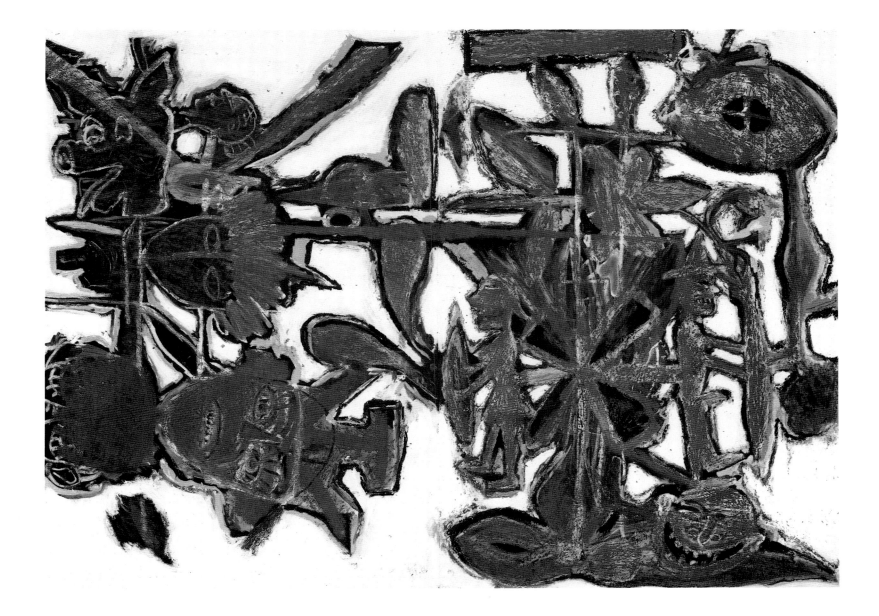

Pedro Perez. *Los Marielitos,* 1983. Oil pastel on black Arches paper, 44¼ × 60″. The Museum of Fine Arts, Houston: Museum purchase with funds provided by Drexel Burnham Lambert Incorporated.

Cubans are Funny as Shit, 1982. Oilstick on paper, 40 × 30″. Peggy D. Kutzen.

thorities denied exit visas in 1962 and again in 1964, finally relenting in 1966, allowing the family to immigrate to the United States.

The fourteen-year-old Perez and his younger brother settled with his parents in Hackettstown, New Jersey, one of only two Hispanic families there (the other consisting of his mother's relatives). He spoke no English, and since, at the time, no special instruction was available in the local school, he was put back a grade, left to learn English "by making mistakes."

Perez left New Jersey for Florida in 1970, when he enrolled in a pre-engineering program at the University of Tampa. Within a year, he knew he was not interested in engineering and changed his major to art, graduating with a B.F.A. in 1974. He spent two more years in Tampa, until 1976, when he received a full scholarship to attend the Hoffberger School of Painting at the Maryland Institute of Art in Baltimore. He received his M.F.A. in 1978, working as an assistant to Grace Hartigan and securing a teaching fellowship in his second year. After graduation he moved to New York, where he has lived ever since.

Perez acknowledges feeling "caught between two cultures" and admits to the presence of some specifically Cuban subjects in his work—notably those drawn from his recollections of *Carnaval*. Caibarien, Cuba, Perez recounts, was "known for seafood and for a *Carnaval* that always ended in gunfights." Yet he is careful to explain that *Carnaval* motifs and other Cuban images—the chicken and the mosquito, for example—are largely unconscious manifestations: "whatever comes out comes out." His early exposure to his parents' business in Cuba—he was frequently given pieces of cut-glass jewelry to play with—also informs his work, particularly his remarkable gold-leaf constructions. Yet Perez feels he is working more in an American tradition than a Cuban one. He received his formal art education in this country, learning about such recent American art movements as Abstract Expressionism, Pop, and Minimalism. "I knew Lam's work, and was not crazy about it, or the [Mexican] muralists. The artists I liked were ones like Dine, Samaras, Twombly." In general, Perez's motivation is formal rather than ethnic: "I think about what will make the work striking or funny, or what will make it contrast with other work."

Perez has had solo exhibitions at the Marilyn Pearl Gallery, New York (1982, 1983, 1985) and the Janus Gallery, Los Angeles (1982). He has participated in several group shows, including "New Epiphanies: Religious Contemporary Art" at the Gallery of Contemporary Art, University of Colorado at Colorado Springs (1983–84); "Covering Up," Intar Latin American Gallery, New York (1984); "Seven in the 80s," Metropolitan Museum and Art Center, Coral Gables (1986); and "Into the Mainstream: A Selection of Latin American Artists in New York," Jersey City Museum (1986). He received a Louis Comfort Tiffany Foundation Award (1981). In addition to his protean artistic production—painting, sculpture, and drawings—Perez has worked in a frame shop, and has taught as a visiting artist at the Tyler School of Art in Philadelphia. He is married, with one child.

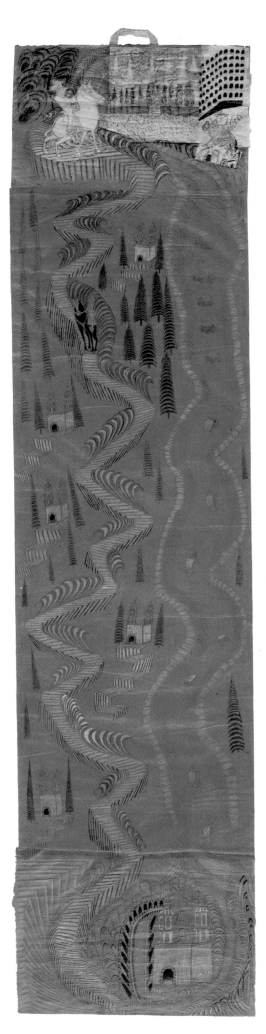

Martín Ramírez. *Untitled* (Scroll), c. 1950s.
Pencil, ink, and crayon on collaged paper
bags, 100½ × 24½". Collection of David
L. Davies.

MARTÍN RAMÍREZ

Born 1885, Jalisco, Mexico
Died 1960, Auburn, California

What little we know of Martín Ramírez comes from the notes of one Dr. Tarmo
Pasto, a teacher of abnormal psychology who befriended the artist late in his life.

Ramírez worked in Mexico as a laundryman, but sometime early in this
century he came to the United States, "half-starved," in search of other employ-
ment. He found work as a railroad section hand, but began to suffer from
the disorientations, delusions, and hallucinations of schizophrenia, which Pasto
explained was in part a reaction to a bewildering, alien culture. He apparently
stopped speaking around 1915; in 1930 he was picked up by Los Angeles police
in Pershing Square (then home to numerous derelicts), classified catatonic, and
placed in a public institution. Seven months later, he was transferred to DeWitt
State Hospital in Auburn, California, where he lived for the next thirty years,
diagnosed as a chronic paranoid schizophrenic. He died in 1960.

It was at the De Witt Hospital in 1954 that Pasto met Ramírez. Pasto was
teaching at Sacramento State University and taking his students to De Witt for
lectures and demonstrations by the hospital staff. Ramírez approached him one
day, handing him a roll of drawings that he had hidden inside his shirt. The
drawings intrigued Pasto, and he arranged to meet the artist; they met fre-
quently thereafter. Ramírez had been working on scraps of paper he had
secreted on his person, under his mattress, or behind a radiator, as it was then
hospital policy to destroy patient drawings in an effort to keep the ward tidy.
Pasto encouraged the hospital staff to view Ramírez's drawing as a form of art
therapy; he also brought Ramírez better materials and collected much of the
work he produced in those years.

According to Pasto, Ramírez began making art in the late 1940s. He worked
constantly, sometimes on scraps of paper that he glued together into larger

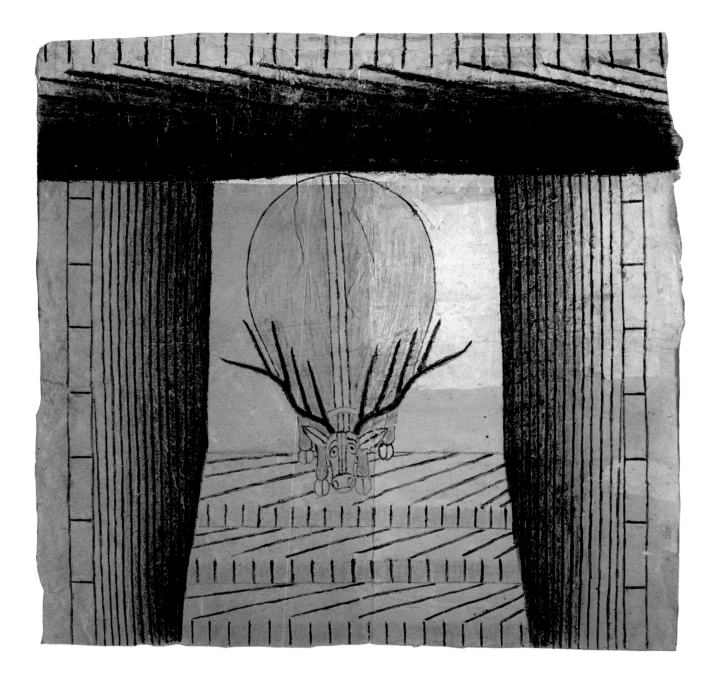

Martín Ramírez. *Untitled* (Animal), c. 1953. Pencil, tempera, and crayon on collaged paper, 28 × 28″.
Jim Nutt and Gladys Nilsson.

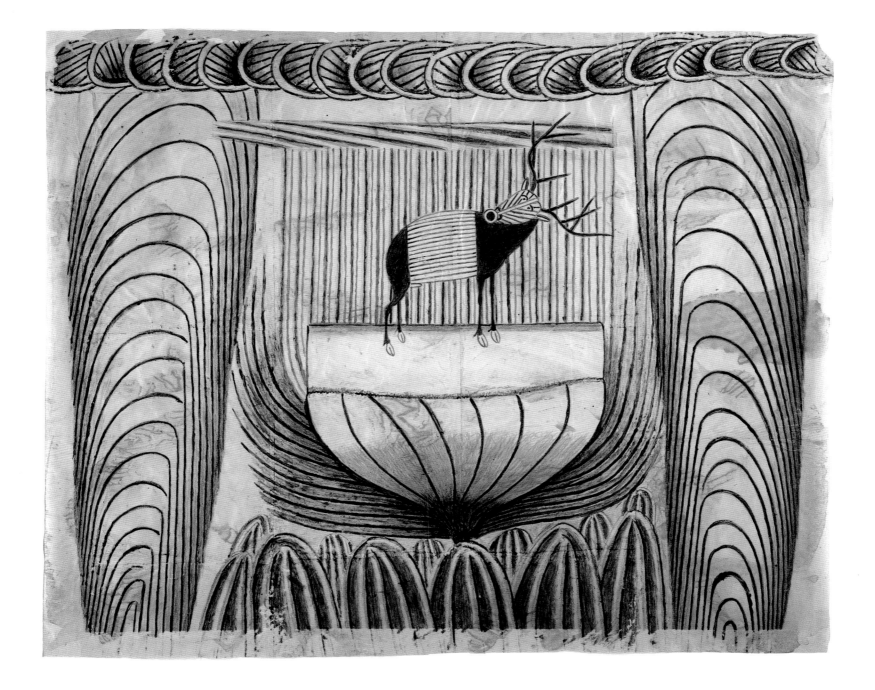

Martín Ramírez. *Untitled* (Animal), c. 1953. Pencil, tempera, and crayon on collaged paper,
28⅜ × 34¾″. Jim Nutt and Gladys Nilsson.

compositions—the "glue" a mixture of mashed potatoes and water, or bread and saliva. At other times he worked on large sheets that he treated like scrolls, exposing only a portion of the drawing at a time. He worked on the floor between the cots, drawing with pencil, colored pencil, or crayon, and occasionally collaging photographs from magazines onto the page. He never spoke, but would hum "in a singsong way" if he was particularly pleased with something.

In 1968, Chicago artist Jim Nutt, then teaching at Sacramento State and running its art gallery, came across some of the work Pasto had collected from psychiatric patients in general and Ramírez in particular. He too was captivated by Ramírez's work, and, with Pasto's help, arranged an exhibition of it at Sacramento State. In 1971, Nutt and his dealer, Phyllis Kind, purchased all of Ramírez's drawings, which numbered around three hundred. A portion of these have remained in the collection of Nutt and his wife Gladys Nilsson; the remainder have been the subject of exhibitions in Kind's galleries in Chicago (1973) and New York (1976, 1980). Ramírez's work has also been shown in the exhibitions "Outsiders" at the Hayward Gallery, London, and tour (1979); "Transmitters: The Isolate Artist in America" at the Philadelphia College of Art (1981); and "American Folk Art: The Herbert Waide Hemphill Jr. Collection," Milwaukee Art Museum and tour (1981–84). The artist was given a major retrospective in 1985–86, "The Heart of Creation: The Art of Martín Ramírez," Goldie Paley Gallery, Moore College of Art, Philadelphia, and tour.

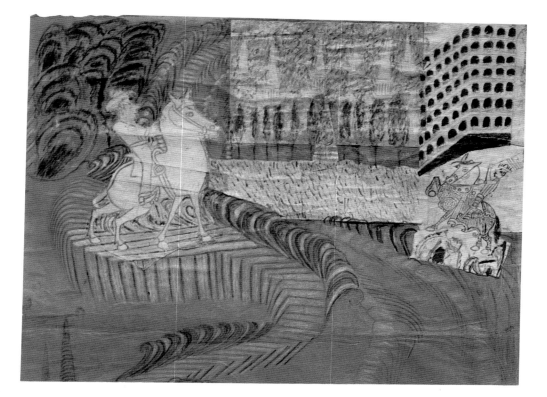

Martín Ramírez. *Untitled* (Scroll), c. 1950s, detail. Pencil, ink, and crayon on collaged paper bags, 100½ × 24½" overall. Collection of David L. Davies.

ARNALDO ROCHE

Born 1955, San Juan, Puerto Rico

Roche's early childhood was spent in the village of Vega Alta, Puerto Rico. His father was a policeman in nearby Cataño, and his mother, whose strength of character has influenced the artist and his five older brothers and sisters profoundly, held the household together through difficult, even tragic times.

Roche was a gifted child; he says he was like a "mad scientist" as a youngster, inventing things, making his own comic books, entering and winning local science fairs. In 1970, when Roche was fourteen, the family moved to Río Piedras, and settled in the small house near the University of Puerto Rico campus where they live to this day. The move coincided with the death of Roche's sister, accidentally shot by the artist's brother (who would die himself a few years later). For Roche, the period of recovery from the family trauma was difficult. He attended the Lucchetti High School from ninth grade on, gaining a crucially supportive outlet for his art—the school centers on artistic training and Roche constantly participated in competitions and exhibitions. His senior year was spent at Central High in San Juan, where he was yearbook photographer and an excellent student.

After high school, Roche enrolled at the School of Architecture of the University of Puerto Rico, completing three years of a six-year program. He realized quickly that he had no desire to become an architect, but had instead an obsession with painting. Indeed, one of the professors there asked him outright, "What are you doing here? You're a painter, not an architect." In the spring of 1979, motivated in part by a dream, Roche telephoned the admissions office of the School of the Art Institute of Chicago to ask for an interview. He was accepted into the B.F.A. program and obtained both a B.F.A. as well as an M.F.A. (1984). While still an undergraduate, Roche won the coveted James Nelson Raymond Fellowship (1982) awarded yearly to outstanding Art Institute students.

Roche's experience in Chicago, where he continues to live much of the year, except for extended visits to Puerto Rico, enabled him to develop rapidly as the extraordinarily original and ambitious painter he has become. He credits his teacher Ray Yoshida with giving him the courage to experiment and ignore convention. His technique of making physical rubbings of figures and objects— actually pressing his canvas onto nude bodies or pieces of furniture and

Overleaf:
Arnaldo Roche. *The Spirit of the Flesh*, 1980. Oil pastel on paper, 50 × 40″. Courtesy of Myrna Baez.

Carving the Spirit of the Flesh, 1980. Oil pastel on paper, 50 × 40″. Courtesy of the artist and Galeria Botello, Hato Rey, Puerto Rico.

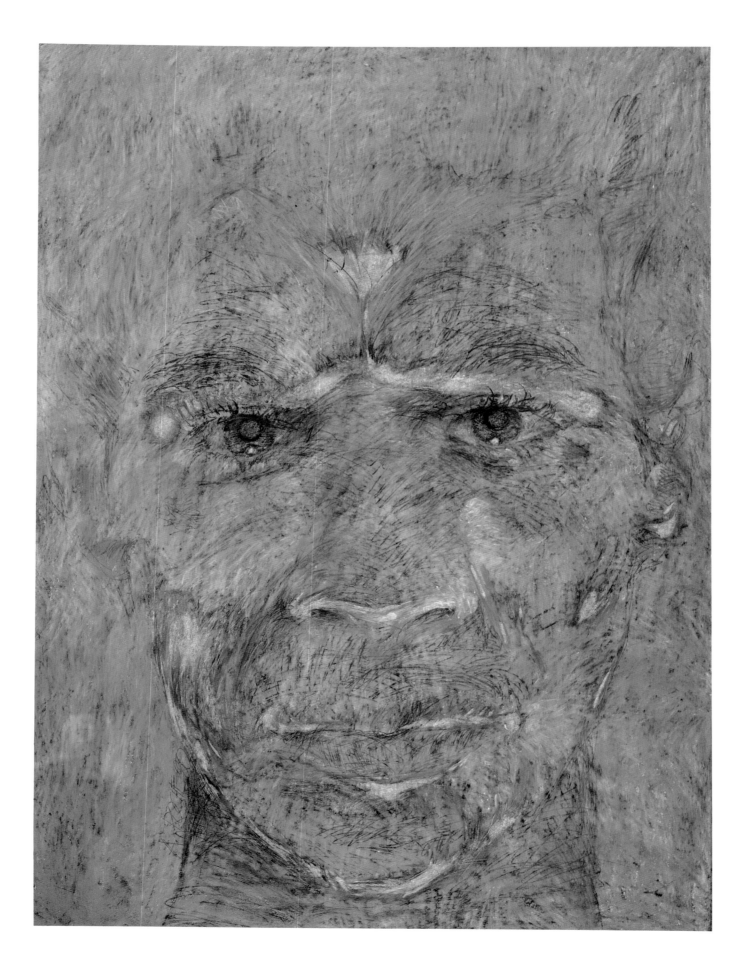

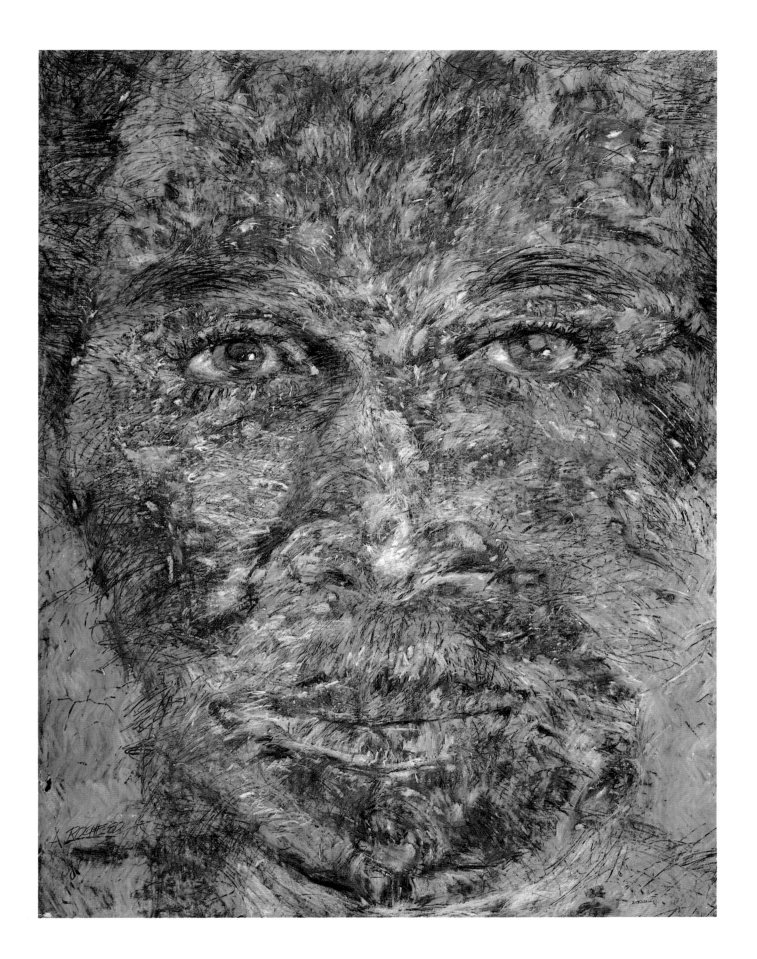

applying pigments to create the formal structure of the paintings—evolved during his Art Institute years. He says he was also influenced by his drawing instructor, Richard Kane. Roche not only had to cope with the enormous cultural and geographic changes he faced when he moved to Chicago, but with the language problem—and, as he was to learn while in Italy with a group of Art Institute students and instructors, with a serious blood-sugar condition as well, which caused dramatic mood swings.

His commitment to becoming a painter, he says, was nurtured not directly through his art education in Puerto Rico or Chicago, but by contact with certain individuals and exposure to other art—though he insists that he is less interested in other paintings or painters than in his own compelling need "to express myself and to be understood. I have a compulsion to communicate emotional states and images so that others can recognize them just as I feel them."

Roche was given a major individual exhibition at the University of Puerto Rico Art Museum (1986). Prior to this, he received solo exhibitions at the Ponce Art Museum, Puerto Rico (1984); the James Varchmin Gallery, Chicago (1983); and the Contemporary Art Workshop, Chicago (1983). He has also been included in numerous group exhibitions in Chicago and San Juan, including "Ocho de los Ochenta," Arsenal de la Marina, San Juan (1986); "Chicago and Vicinity Show," Art Institute of Chicago (1985); and "Arte Actual—Puerto Rico," Chase Manhattan Bank, Hato Rey (1983). He was featured by the Contemporary Art Workshop at the International Art Expo, Chicago (1985).

Arnaldo Roche. *The Dream*, 1986. Oil on canvas, 78 × 78". Collection of Jose B. Andreu.

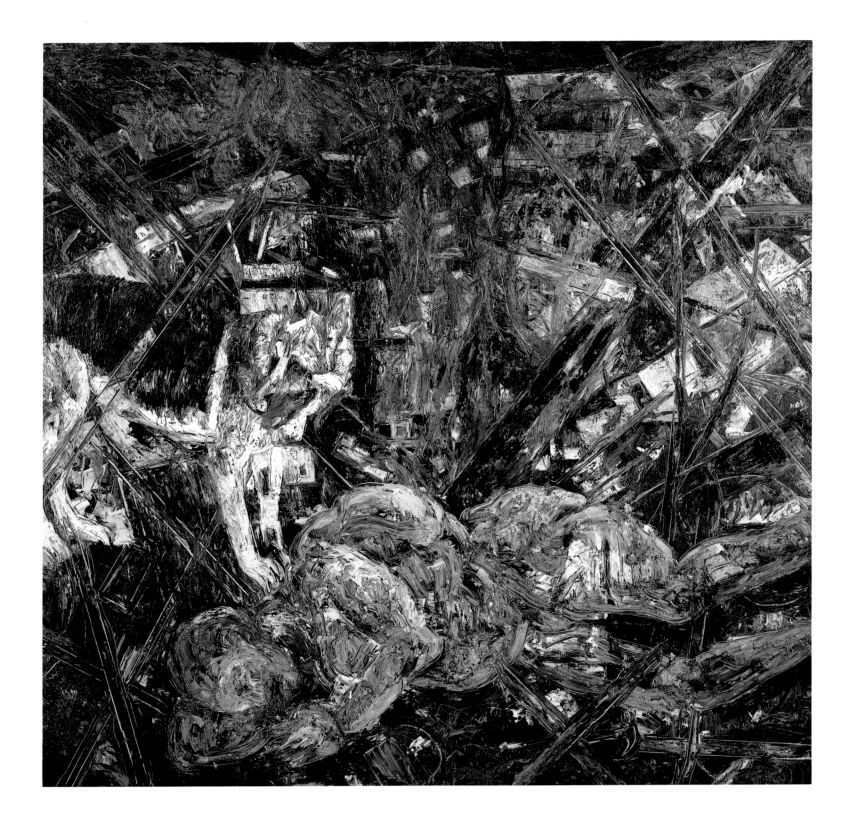

FRANK ROMERO

Born 1941, East Los Angeles

Romero's roots are Spanish and Mexican—his father is descended from a New Mexico land grant family and his mother from more recent settlers in Texas. Although his immediate family was small, he was "surrounded by hundreds of first cousins, all of whom lived within a five-mile radius." He went to school in a racially mixed neighborhood, and English was spoken in his family. He learned Spanish only much later in life and still speaks it haltingly.

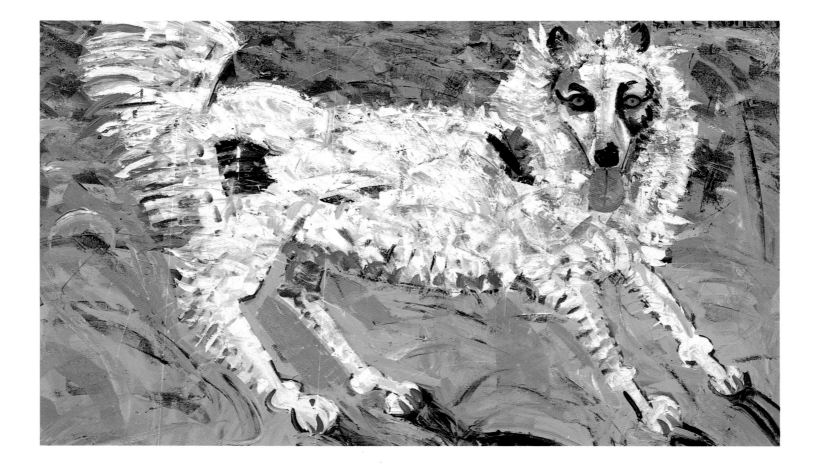

As a student in Los Angeles public schools, Romero gravitated to art teachers wherever he could find them and was encouraged by his mother to "be an artist—even though I don't think she really knew what that meant." He was given a scholarship to study at the Otis Art Institute in downtown Los Angeles and, starting with summer classes, maintained a close relationship with Otis throughout his school years and early career.

As a freshman at California State University, Los Angeles, he met Carlos Almaraz and began an enduring friendship that would strengthen his commitment to his artistic career and his sense of participation in the Chicano community. Later, in 1968–69, Romero stayed with Almaraz in New York. But he found the New York art scene "too cerebral, too conceptual. New York art seemed to lack passion, which is what I thought art should be about." He did take advantage of the museums, however, and met and married his first wife, Dian, with whom he had a daughter. (He has been married to his present wife, Nancy, since 1980; they live with their three daughters.)

Romero's return to Los Angeles in 1969 was met by the Watts riots and an essential sense of change within the Chicano community in its attitude toward social activism. He met two gifted artists, Gilbert Luján and Beto de la Rocha. In the kitchen of his big house (where he still lives); the three—joined by Carlos Almaraz, who had likewise returned to Los Angeles in 1971—had "feverish discussions about *Chicanismo*, and art, and politics." In 1974 they formed an art collective, Los Four. The same year, they had a historic exhibition at the University of California, Irvine, the Los Angeles County Museum of Art, and the Oakland Museum, after which the artists continued to work for several years on a variety of collective projects.

Among the many artists who have influenced Romero in his earlier development were Ben Shahn, Edward Hopper, Pablo Picasso, and Rico Le Brun. His later, highly evolved bravura painting style and his devotion to color and texture are clearly affected by his love of folk art from all countries and, in particular, Mexico and the American Southwest. Repeated trips to Mexico have deeply affected him as an artist, helping him to forge a personal iconography based on his Hispanic roots and contemporary urban concerns. Romero also gained critically important experience working intermittently in the late 1960s and early 1970s as a designer for Charles Eames. He especially admired the latter's "sense of wonder," his enthusiasm for everything from toys to the most sophisticated design, and his sense that "anything was possible." Romero continues to create art in various media, including photography, graphics, ceramics, and textile design, in addition to painting and drawing.

Frank Romero. *Toto,* 1984. Oil on canvas, 36 × 60". Courtesy of the artist.

Romero has participated in numerous individual and group exhibitions, mostly in California. They include solo shows at the Koplin Gallery, Los Angeles (1984); the Simard Gallery, Los Angeles (1984); and the Arco Center for the Visual Arts, Los Angeles (1984). Group exhibitions include several at the Craft and Folk Art Museum, Los Angeles; "Ancient Roots/New Visions," Tucson Museum of Art and tour (1977–79); "Chicanarte," Los Angeles Municipal Art Gallery (1975); and various manifestations of "Los Four" (1974). He was a key contributor to the 1982 Olympics in Los Angeles, executing a major freeway mural.

Frank Romero. *Piso de Sangre,* 1986. Oil on canvas, 36 × 60". Courtesy of the artist.

Still Life with Red Car, 1986. Oil on canvas, 47 × 50". Courtesy of the artist.

PAUL SIERRA

Born 1944, Havana, Cuba

The son of a lawyer, Paul Sierra was likewise expected to pursue a profession, to become a doctor. His early private schooling in Havana was rigorous, but he remembers little of his lessons and much about scoldings for filling his notebooks with drawings rather than homework. By high school, Paul was thoroughly involved with the arts, including film and painting. His father collected books on painting; Paul devoured them. And he continued to draw, even without the benefit of much encouragement or formal training.

In 1961, when he was sixteen, Sierra left Cuba with his family for the United States. After a few months in Miami, the family moved to Chicago, where Sierra's father worked as a lawyer for the Union Tank Car Corporation. In 1963, Sierra began formal training as a painter, enrolling at the School of the Art Institute of Chicago. He spent three years there, "chasing girls and learning more about social life than art"—except for the important connection he established with one of his painting teachers, the Puerto Rican artist Rufino Silva. Silva, with whom he studied painting, drawing, and design, became a close personal friend and a friendly political disputant.

By 1966, Sierra felt he had exhausted the possibilities of the Art Institute. He dropped out and, with no gallery or art world contacts (beyond Silva), he entered the commercial art field as an advertising layout artist. Sierra has continued to work in advertising—he is now creative director of a small agency—but he says now that dropping out of school was "the biggest mistake of my life—it broke the momentum of my development as a painter. I've had to do a lot of making up for lost time."

Shortly after leaving the Art Institute, he met his first wife, a writer, and with her had a daughter, now sixteen. When that marriage ended in 1970, the artist spent the next five years dividing his creative energies between photography and filmmaking with a little painting in between. A turning point came in 1975, when he married his second wife, then a writer, now a management consultant. A honeymoon in Puerto Rico—as close as he could safely go to his native Cuba—renewed boyhood memories of Caribbean life and spawned the tropical imagery and exotic coloring that has more or less characterized his painting ever since.

Paul Sierra. *Cuatro Santos,* 1985. Oil on canvas, 36 × 48″. Courtesy of Halsted Gallery, Chicago.

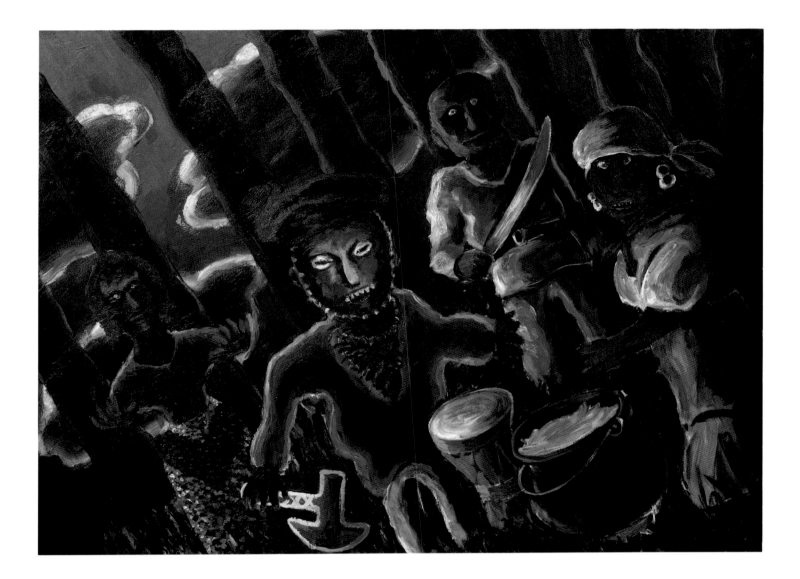

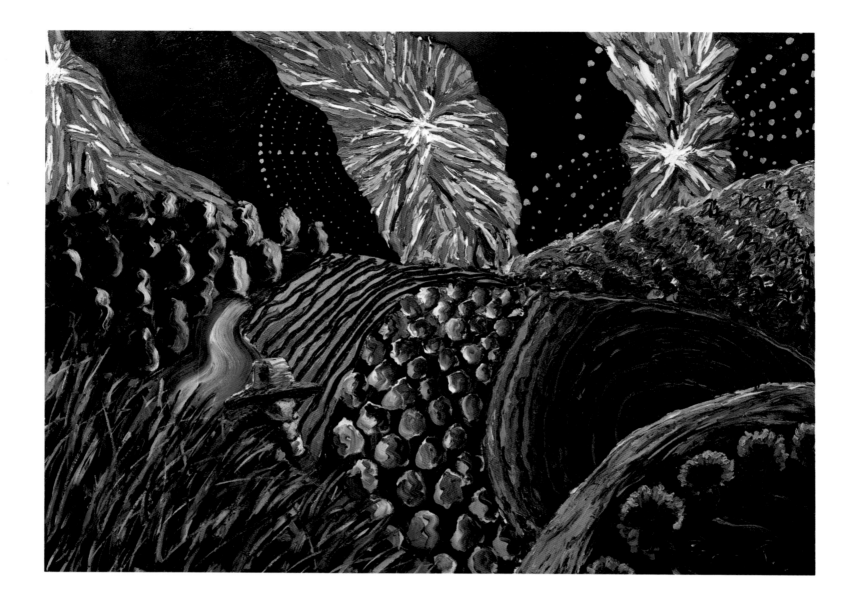

In the wake of this experience, Sierra has settled into two lives, working in advertising by day and painting by night and on weekends. "I discovered that I really like to lead a middle-class existence. I've had my share of living from hand to mouth. I like being married, having a decent home in a quiet neighborhood, being allowed to support my painting through other means. And I've found there's an enormous freedom in not having to rely on sales of paintings for a livelihood—it takes off the pressure of painting what people expect me to paint. I paint for *myself*."

Sierra has managed to engage himself in the artistic life of Chicago through an intensive involvement with the Halsted Gallery, an artists' cooperative. He has not traveled extensively, though he visits New York regularly; his only European travel has been two trips to Italy with his wife. Other than Puerto Rico, he has never been to Latin America, nor has he returned to Cuba. His artistic influences have been shaped therefore largely by research and the museums and artistic milieu of Chicago. The painters who have most directly inspired him are Francis Bacon, Goya, Jackson Pollock ("as much for his life as his work"), Willem de Kooning and Balthus. Only in the last two years, he says, has the process of painting become a pleasure—"like working with pastry"—rather than an arduous discipline. "I only hope to live long enough to make a good painting."

Sierra has had solo exhibitions at the Artemisia Gallery, Chicago (1986); and the Halsted Gallery, Chicago (1985). Among the group exhibitions that have included his work are "American Artists of Cuban Origin," South Campus Art Gallery, Miami-Dade Community College (1985); "Aquí," Fisher Gallery, University of Southern California, Los Angeles (1984); and "New Forms of Figuration," Center for Inter-American Relations, New York (1984).

Paul Sierra. *Three Days and Three Nights,* 1985. Oil on canvas, 44 × 60". Courtesy of Halsted Gallery, Chicago.

LUIS STAND

Born 1950, Barranquilla, Colombia

Stand's father managed a variety of small businesses, including a trucking firm and a machine shop; his mother had been a teacher before marriage. The artist was the first of six children. All except the artist now live in Venezuela, whose oil industry has created a more vigorous economy than Colombia's.

Stand graduated from high school in Barranquilla in 1969 and resolved "to do something different," inspired in large part by *Carnaval*, with its mixture of music, theater, and the visual arts—he had long been involved in producing costumes for it. But "it was the craziest thing I could have done there to be an artist." In his mind, such a vocation was practical in Colombia only for the elite, who could afford to study abroad and support themselves without a regular job. He decided to come to the United States in the hope of making a life as an artist.

Stand arrived in New York in 1969, staying first with an aunt in Upper Manhattan. He spent his first months in school learning English and working as a dishwasher—known in Hispanic New York as "recording discs"—at a Horn and Hardart cafeteria. A succession of other odd jobs, including clearing tables and working as a stock and receiving clerk at a book company, kept him going until he entered the School of the Visual Arts in New York in 1975. He was back in Barranquilla for eleven months in 1976, awaiting the visa that would make him a legal resident in the United States. He became in his home town a founding member of an experimental art group known as "El Sindicato," which introduced to Colombia such innovations as performance and conceptual art.

When he returned to New York, Stand reentered the School of the Visual Arts and graduated with a B.F.A. in 1980. Among his teachers was Rafael Ferrer. While in school he worked as a studio assistant for Elizabeth Murray and May Stevens, and subsequently in a gallery and as a printer in a silk-screen workshop. After graduation, he took a studio on the Lower East Side and invited several of the newly emerging graffiti artists, including Futura 2000 and Fab Five Freddy, to share the space with him. Although initially sympathetic to their art, he soon drifted away from them, feeling that they represented "an explosion" while he was more methodical and more slowly maturing.

Luis Stand. *El Viejo Tigre,* 1985. Oil on canvas, 54 × 54". Collection of the artist.

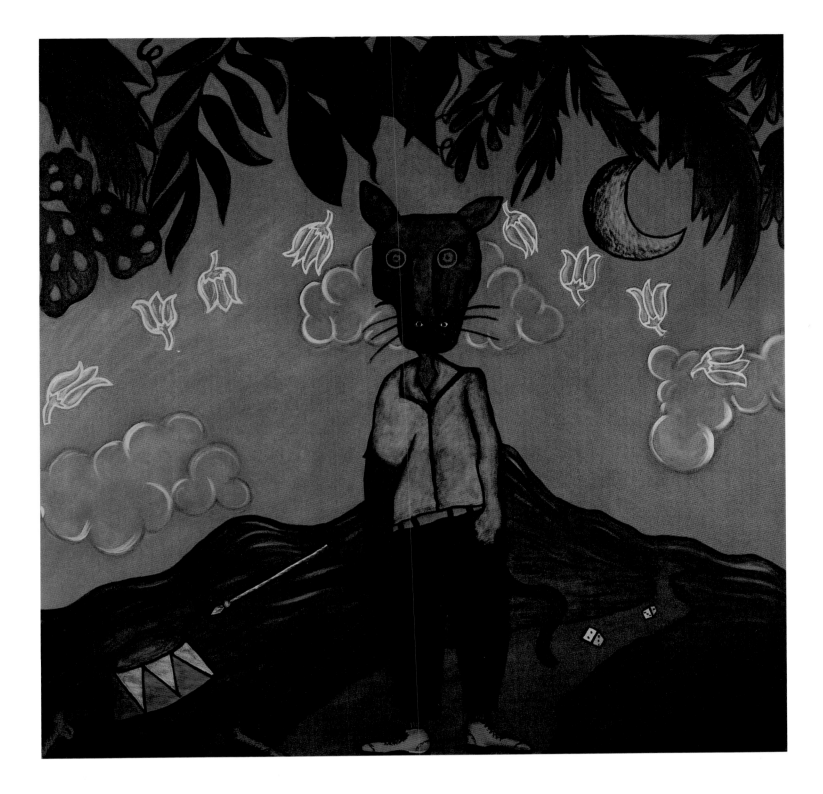

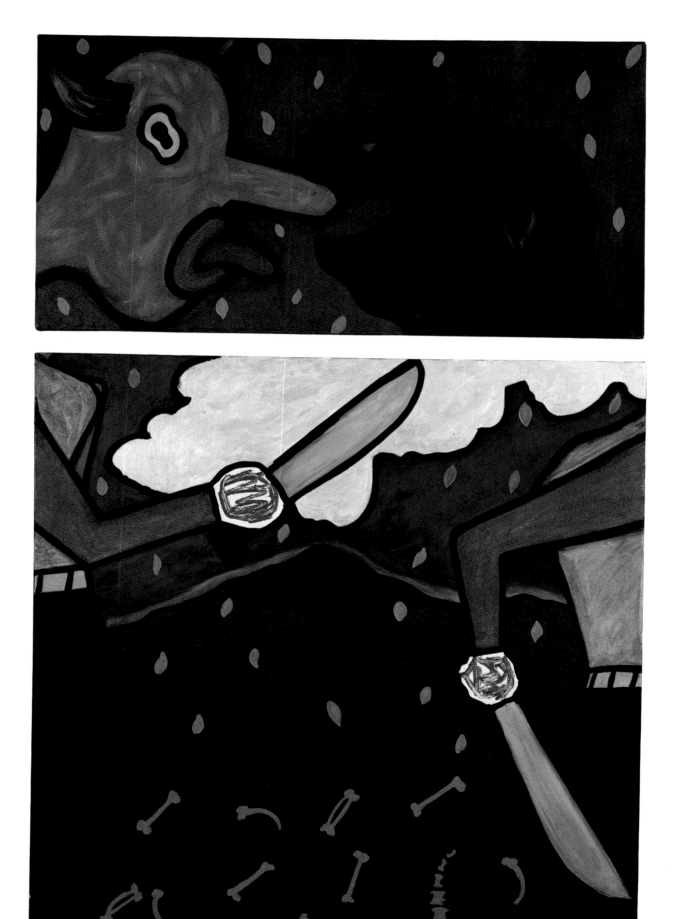

Stand now works on his own in a Brooklyn studio, though he is loosely affiliated with a group of Colombian artists in New York. At the instigation of the president of Colombia and Colombian writer Gabriel García Márquez, this group was invited to exhibit at the Museo de Arte Moderno de Bogotá in 1985 in a show entitled "Arte Colombiano en el Mundo: Nuevas Figuras," which subsequently traveled to Caracas, Venezuela. Later the same year, a group of some of the same Colombian artists exhibited at the Museum of Contemporary Hispanic Art in New York and showed concurrently in the Museo de Arte in Bogotá. Stand was also included in the exhibition "¡Mira!" at El Museo del Barrio, New York and tour (1984); "Contemporary Latin American Art," the Chrysler Museum, Norfolk (1983); and "Dictadores y Caudillos," the Jamaica Art Center and Intar Latin American Gallery, both in New York (1983). He has had solo exhibitions at the Cayman Gallery, New York (1983) and the Museum of Contemporary Hispanic Art, New York (1985). Despite his growing reputation, he supports himself by working as a waiter.

Luis Stand. *Untitled* (Figures with Machetes), 1984. Oil on canvas, 72 × 48". Collection of the artist.

LUIS ELIGIO TAPIA

Born 1950, Santa Fe, New Mexico

Luis Eligio Tapia's family, on both his mother's and father's side, descend from early Tapia settlers in New Mexico; his father, a fireman who died when Luis was a young child, came from the town of Tapia, thirty miles from Santa Fe, a farming region where many of Luis's cousins still live. The artist's mother, now retired, worked as a counselor at the New Mexico School for the Deaf.

During his early years Tapia attended public schools and then St. Michael's High School in Santa Fe. There was virtually no art instruction offered; indeed, his teachers discouraged his habit of drawing, and after high school, during the one year he spent at New Mexico State University, he had still been given no art instruction. The artist recounts that his sudden and liberating awareness of native Spanish-American music and the *santos* carving tradition in particular occurred in about 1970, in the aftermath of his awakening to Hispanic issues of civil rights. That year, largely because of his (now former) wife's encouragement, and in spite of his lack of formal training, he began making carvings—first nudes, then *santos*. When he began making *santos*, only one other artist, Horacio Valdéz—a considerably older and more conventional carver—was doing them. He learned his craft not from other contemporary artists, but from studying earlier figures in the storerooms of the Folk Art Museum in Santa Fe.

Tapia began exhibiting his work at the various New Mexican fiestas in about 1972. He was "mocked," he says, for painting his figures in the old style. His highly saturated primary colors, which Tapia felt were more authentic than either unpainted *santos* or those with artificially "aged" colors, were shocking to some. In addition to carving *santos,* the artist began at this time to make and restore furniture, a craft that taught him a great deal that he used in his sculpture.

Tapia has done major restoration work, most importantly at the church in Ranchos de Taos on an early nineteenth-century reredos, whose painted surfaces the artist reworked almost entirely. He also reconstructed the altarpiece at El Valle, in the Rio Grande Valley north of Española, and created a new reredos for San Idelfonso, north of Santa Fe. He has also worked on several private chapels and executed a series of death carts, directly continuing a long Southwestern tradition.

Luis Tapia. *Reredo.* 1986, detail. Carved and painted aspen and pine, 144 × 96 × 24" overall. Courtesy of the artist.

Tapia emphasizes that a major difficulty he faced as a Santa Fe artist, participating annually in the city's "Spanish Market," was being stereotyped as a folk artist or a commercial artisan—with neither of which he identifies. "I believe in the tradition," he says. "I *am* the tradition. But tradition is not copying. What I do to continue my heritage is to renew it, like a growing plant."

Tapia's work has been included in numerous group exhibitions, such as "Hispanic Crafts of the Southwest," Taylor Museum, Colorado Springs, and tour (1977–78) and "One Space/Three Visions," the Albuquerque Museum (1979); he had a solo exhibition at the Governor's Gallery, Santa Fe (1982).

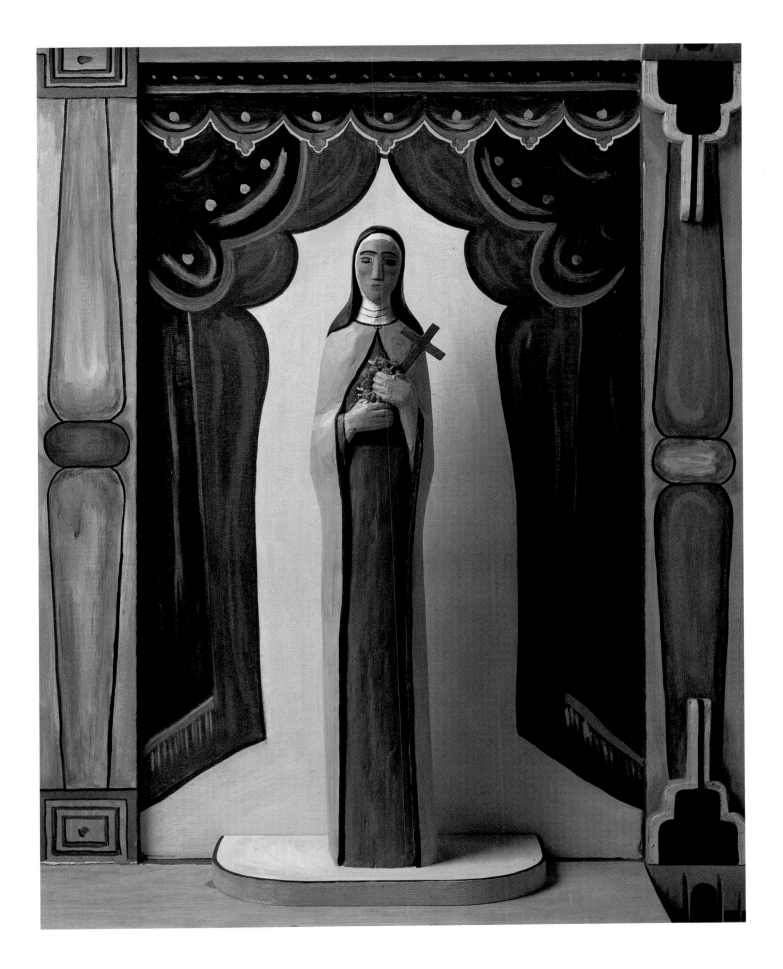

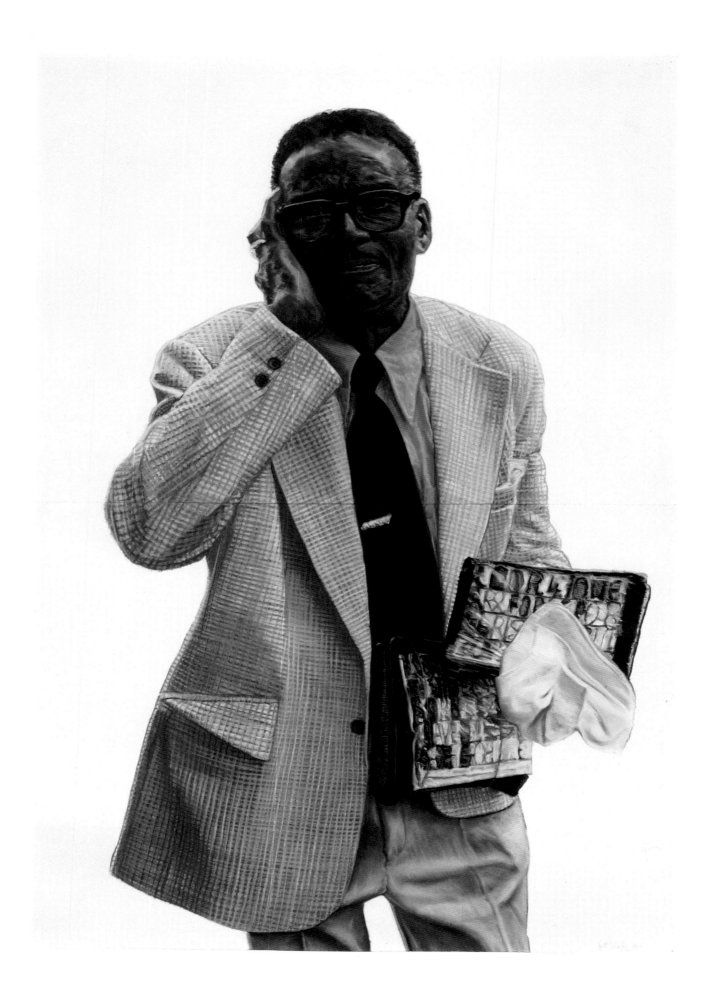

JOHN VALADEZ

Born 1951, Los Angeles

The parents of John Valadez, both of Mexican descent, met when they were high school students in Los Angeles; the artist was the first of two children. Valadez grew up with his mother and younger brother in Boyle Heights, his mother supporting the three of them by working as a secretary and receptionist for an industrial company in East Los Angeles. She had a clear vision for her two children: to finish school and "to keep away from the gangs."

Valadez recalls being "a little bit of an introvert." In consequence, he cultivated "imaginative states of mind," frequently drawing and play-acting. He developed "a sympathy for people who were having a hard time," something that continues to affect his choice of subject matter as an artist.

After graduating from Huntington Park High School in 1969, Valadez went on to East Los Angeles Junior College. There he became involved in various manifestations of the Chicano movement and joined a theater group, MACCA (Mexican American Center for Creative Arts) headed by Emilio Delgado, who is now with Public Television's "Sesame Street." The group presented plays in prisons and community centers; among their productions was a dramatization of the Rodolfo González poem *I Am Joaquín* (1967), one of the first major literary works of the Chicano movement.

John Valadez. *Preacher,* 1983. Pastel on paper, 60 × 42". Collection of the artist.

At this time, Valadez also began to study art, taking courses in art history and painting—the latter with Roberto Chávez and Luis LaNetta. From the outset, he evidenced a strong predisposition toward figurative art. He saw his work as a way of affirming his own identity and that of Chicanos as a group. Yet his art represented something of a departure from that of his peers, who were emulating the great Mexican muralists, with their Revolutionary and pre-Columbian themes. Valadez chose instead to depict the imagery of the city around him—the storefronts, the crowds, the wanton violence. "I was painting my people and starting a Chicano image bank." Not surprisingly, among earlier artists he admires are John Sloan and Reginald Marsh, who impart "a sense of their times."

Valadez continued his education at California State University, Long Beach, earning a B.F.A. in 1976. Before returning to Los Angeles, he worked on a number of mural projects for the Long Beach Parks and Recreation Department—often with the assistance of neighborhood children. In Los Angeles, he took a job in the graphics department of a record company, a position he held for nine months before resigning—"I needed to be independent and commit myself to my art." A number of mural projects followed: a banner for the United Farmworkers Third Constitutional Convention, executed with Gilbert Luján and others in Fresno in 1977; *Zoot Suit*, painted collaboratively by Valadez, Carlos Almaraz, Barbara Carrasco, Leo Limón, and others, for the Mark Taper Forum on the occasion of their production of the play of the same name in 1978; and two works for the City murals program. At the same time, he was one of the founding members, with Almaraz, Frank Romero, and Richard Duardo, of the Public Arts Center in Highland Park, organized to provide studio space and access to cooperative mural projects.

In 1980 Valadez was included in a group exhibition, "Espina," at LACE Gallery, Los Angeles, where his work was seen by the owner of the the Victor Clothing Company on Broadway. Valadez was invited to submit a proposal for portraits to hang in the store; a year and a half later, he completed work on *The Broadway Mural*, which remains one of the most extraordinary achievements to grow out of the mural movement: an oil painting eight feet high, stretching to sixty feet in length, that depicts in an utterly realistic way the many textures of life on one of downtown Los Angeles's busiest and grittiest streets.

In the aftermath of this effort, Valadez has concentrated on smaller-scale studio work, including a number of narrative paintings and portraits in pastel and oil. He has had solo exhibitions at New Directions Gallery, Los Angeles (1983); Simard Gallery, Los Angeles (1984); and the Museum of Contemporary Hispanic Art, New York (1986). His work was featured in a two-person exhibition, "Symbolic Realities," at the University Art Gallery, California State University, Dominguez Hills (1985). It has also been included in such group exhibitions as "Chicanarte," Municipal Art Gallery, Los Angeles (1975); "Murals of Aztlan," Craft and Folk Art Museum, Los Angeles (1981); "Off the Street," Old City Print Shop, Los Angeles (1985); and "Chicano Expressions," Intar Latin American Gallery, New York (1986).

Valadez is married and has one child, a daughter born in 1978.

BIBLIOGRAPHIES

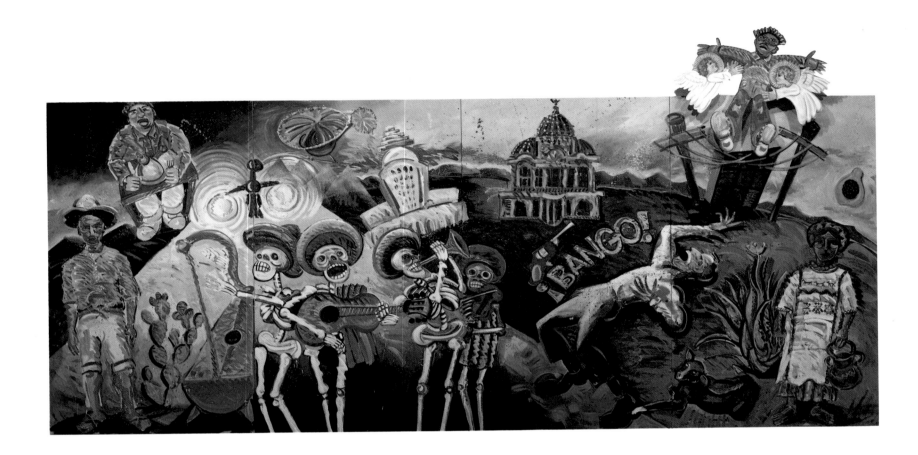

Frank Romero. *¡Méjico, Mexico!,* 1984, detail. Acrylic on canvas, wood, 12′ × 28′ × 16′. Courtesy of the artist.

ARTISTS' BIBLIOGRAPHIES

Works also listed in the General Bibliography are cited here in shorter form.

CARLOS ALFONZO

The Art of Miami (exhibition catalogue). Winston-Salem: Southeastern Center for Contemporary Art, 1985.

Cuban Fantasies (exhibition catalogue). New York: Kouros Gallery, 1983.

Florida Figures (exhibition catalogue). Miami: Frances Wolfson Art Gallery, Miami-Dade Community College, 1985.

González, María. "Six out of Cuba." *Marquee* (Miami, February/March 1983): 41–47.

Gutiérrez, Bárbara. "Latin American Artists Get New Exposure Here." *The Miami Herald* (June 20, 1982): 18.

National Endowment for the Arts/Fellowship Artists, Florida 1983–1984 (exhibition catalogue). Tallahassee: Fine Art Gallery, Florida State University, 1985.

CARLOS ALMARAZ

Aquí.

Automobile and Culture (exhibition catalogue). Los Angeles: Museum of Contemporary Art, 1984.

Baker, Kenneth. "Freeway Landscapes—Painting at Speed." *San Francisco Chronicle* (May 23, 1985): 69.

Carlos Almaraz: Selected Works: 1970–1984/Paintings and Pastel Drawings (exhibition catalogue). Los Angeles: Los Angeles Municipal Art Gallery, 1984.

Chicanarte.

Clothier, Peter. "Carlos Almaraz at Adrienne Simard." *Art in America* 70 (March 1982): 156.

Knight, Christopher. "The Absolute World of Carlos Almaraz." *Los Angeles Herald Examiner* (August 1, 1984): C5.

Wortz, Melinda. "Carlos Almaraz." *Artnews* 82 (January 1983): 117–18.

FELIPE ARCHULETA

American Folk Art: The Herbert Waide Hemphill Jr. Collection (exhibition catalogue). Milwaukee: Milwaukee Art Museum, 1981. Essays by Russell Bowman and Donald C. Kuspit. Dialogue by Michael D. Hall and Herbert Waide Hemphill, Jr.

American Folk Art: From the Traditional to the Naive (exhibition catalogue). Cleveland: The Cleveland Museum of Art, 1979.

Felipe Archuleta: Modern Folk Master (exhibition catalogue). Houston: Contemporary Arts Museum, 1984.

Folk Sculpture USA (exhibition catalogue). New York: The Brooklyn Museum, 1976. Edited by Herbert W. Hemphill, Jr. Texts by Michael Botwinick, Herbert W. Hemphill, Jr., Daniel Robbins, Sarah Faunce and Michael D. Hall, and Michael Kan.

Four Southwestern Folk Artists (exhibition catalogue). Las Cruces, New Mexico: University Art Gallery, New Mexico State University, 1970. Text by Richard Wickstrom.

Hispanic Crafts of the Southwest.

Mather, Davis. "Felipe Archuleta, Folk Artist." *Clarion* 1 (Summer 1977): 18–20.

One Space/Three Visions.

Sagel, Jim. "A Big...Story." *Journal North* (Santa Fe, May 15, 1982): E-4.

Stevens, Mark. "The End of the Trail." *Newsweek* (September 1, 1985): 76–77.

LUIS CRUZ AZACETA

American Artists of Cuban Origin.

Aquí.

Exhibition/Hispanic Artists in New York.

Into the Mainstream.

Luis Cruz Azaceta (exhibition catalogue). New York: Allan Frumkin Gallery, 1984.

McGreevy, Linda. "Painting His Heart Out: The Work of Luis Cruz Azaceta." *Arts Magazine* 59 (June/Summer 1985): 126–28.

¡Mira! The Canadian Club Hispanic Art Tour, 1984.

¡Mira! The Tradition Continues, 1985.

Seven in the 80's.

ROLANDO BRISEÑO

Awards in the Visual Arts 3 (exhibition catalogue). Winston-Salem: Southeastern Center for Contemporary Art, 1984. Essay by John Yau.

The Figure as an Image of the Psyche (exhibition catalogue). New York: Sculpture Center, 1985. Essay by April Kingsley.

Hispanics USA 1982.

Rolando Briseño (exhibition catalogue). New York: Cayman Gallery, 1981. Statement by Kathleen Goncharov.

Santos, John Phillip. "S.A. Native's Art Depicts Basic Conflicts." *San Antonio Express-News* (May 19, 1984): 8-L.

LIDYA BUZIO

Buzio, Lidya. "Line and Rhythm." *Studio Potter* 14 (December 1985): 44.

Ceramic Echoes: Historical References in Contemporary Ceramics. Kansas City: Nelson-Atkins Museum of Art, 1983.

Contemporary American Ceramics/Twenty Artists. Newport Beach: Newport Harbor Art Museum, 1985.

Lebow, Edward. "Lidya Buzio: In Perspective." *American Ceramics* 2/2 (Spring 1983): 34–35.

IBSEN ESPADA

Chulas Fronteras.

Fresh Paint: The Houston School (exhibition catalogue). Houston: Texas Monthly Press, 1985. Essays by Susie Kalil and Barbara Rose; artist's statement: 124–25.

Jarvis, Ron. "Ibsen Espada." *The New Art Examiner* (March l986): 62.

RUDY FERNANDEZ

Chicano Expressions.

Kotrozo, Carol, and Perlman, Barbara. "Male Passages." *Arizona Arts and Lifestyle* 4 (Summer 1982): 32, 34–39.

Kotrozo, Carol. "Rudy Fernandez." *Arts Magazine* 59 (June 1983): 10.

ISMAEL FRIGERIO

Art and Ideology (exhibition catalogue). New York: The New Museum, 1984. Essay by Nilda Peraza.

Brenson, Michael. "Art: Political Subjects." *The New York Times* (February 24, 1984): C21.

Ismael Frigerio: The Lurking Place (exhibition catalogue). New York: Museum of Contemporary Hispanic Art, 1986. Essay by Susana Torruella Leval.

CARMEN LOMAS GARZA

Carmen Lomas Garza (exhibition catalogue). Sacramento: Galeria Posada, 1985.

Carmen Lomas Garza/Prints & Gouaches; Margo Humphry/Monotypes. San Francisco: San Francisco Museum of Modern Art, 1980. Essay by Tomás Ybarra-Frausto.

Chicano Expressions.

Dále Gas.

Hispanics U.S.A. 1982.

¡Mira! The Tradition Continues, 1985.

Ofrendas.

Personal Reflections.

Raices y Visiones/Roots and Visions.

ROBERTO GIL DE MONTES

Aquí.

Chicano Expressions.

"New Forms of Figuration" (unpublished catalogue, 1985). On deposit at Center for Inter-American Relations, New York. 1985.

PATRICIA GONZALEZ

Chulas Fronteras.

Everigham, Carol. "Critic's Choice." *Houston Post* (March 30, 1984): 15D.

Fallon, Gretchen. "Artistic License." *Houston Home and Gardens* 6 (August 1984): 46, 105.

ROBERT GRAHAM

Henry, Gerrit. "Robert Graham at Robert Miller." *Art in America* 70 (April 1982): 137–38.

Isenberg, Barbara. "Robert Graham: Ignoring the Lessons of Modern Art." *Artnews* 78 (January 1979): 66–69.

Kramer, Hilton. "Robert Graham." *The New York Times* (November 9, 1979): C25.

Los Angeles—Eight Artists: Painting and Sculpture 1976 (exhibition catalogue). Los Angeles: Los Angeles County Museum of Art, 1976.

Raynor, Vivien. "Art: By Robert Graham, Four Nudes and a Mare." *The New York Times* (January 22, 1982): C25.

Robert Graham (exhibition catalogue). London: The Whitechapel Art Gallery, 1970.

Robert Graham: Works 1963–69. Cologne: Buchandlung Walther Konig, 1970.

Robert Graham (exhibition catalogue). Dallas Museum of Fine Arts, 1972.

Robert Graham: "Studies for the Olympic Gateway" (exhibition catalogue). Los Angeles: Arco Center for Visual Art, 1984.

Robert Graham: Statues (exhibition catalogue). Minneapolis: Walker Art Center, 1981.

Tuchman, Phyllis. "Artist's Dialogue: A Conversation with Robert Graham." *Architectural Digest* 40 (October 1983): 72, 76–77.

Wilson, William. "Something to Remember Them By." *Los Angeles Times Magazine* (April 15, 1984): 30, 32, 40.

GRONK

Benavídez, Max. "The World According to Gronk." *L.A. Weekly* (September 13–19): 3.

Burnham, Linda. "Gronk and James Bucalo, *Morning Becomes Electricity.*" *Artforum* 24 (February 1986): 110–11.

Castro, Tony. "Art Without Borders." *Los Angeles Herald Examiner* (May 4, 1978): A-3.

Dubin, Zan. "Artist Won't be Confined to Gallery." *Los Angeles Times* (June 6, 1986): 8.

Ellis, Kirk. "Outrageous View of 'Jetter's Jinx'." *Los Angeles Times* (October 5, 1985): V9.

Fiaco, Eduardo. "Chicanismo en El Arte." *Artweek* 6 (May 17, 1975): 3.

Gamboa, Harry. "Gronk and Herron: Muralists." *Neworld Magazine* 2 (April 1976): 29–30.

Gamboa, Harry. "Gronk: Off-the-Wall Artist." *Neworld Magazine* 4 (July 1980): 33–35, 42.

Muchnic, Suzanne. "The Art Galleries: La Cienega Area." *Los Angeles Times* (May 23, 1986): 15. Review of Saxon-Lee Exhibition.

LUIS JIMENEZ

Chicano Expressions.

Dále Gas.

Kingsolver, Barbara. "Destined for a Public Place: The Art and Ideas of Luis Jimenez." *The Tucson Weekly* (December 4–10, 1985): 1, 4–5.

Luis Jimenez (exhibition catalogue). Austin, Texas: Laguna Gloria Art Museum, 1983. Essays by Dave Hickey and Annette Carlozzi.

Luis Jimenez: Sculpture and Works on Paper. (exhibition catalogue). New York: Alternative Museum, 1984.

Rabyer, Jozanne. "Houston: Luis Jimenez at Contemporary Arts Museum." *Art in America* 63 (January/February 1975): 88.

Raíces y Visiones/Roots and Visions.

Ratcliff, Carter. "New York Letter," *Art International* 16 (May 1972): 46.

Showdown.

Southwestern Artists Invitational 1980.

A Spirit Shared.

ROBERTO JUAREZ

About Eighty of the Intimate Collages, Paintings and Drawings of Roberto Juarez from 1973 through 1985 (exhibition catalogue). New York: La Mama's La Galeria, 1985. Text by Frederick Ted Castle.

An International Survey of Recent Painting and Sculpture (exhibition catalogue). New York: The Museum of Modern Art, 1984. Includes text by Kynaston McShine.

Castle, Frederick Ted. "Roberto Juarez at Robert Miller." *Art in America* 73 (March 1985): 153.

Howarth, Kathryn. "Roberto Juarez at Robert Miller." *Art in America* 70 (Summer 1982): 146.

Indiana, Gary. *Roberto Juarez.* New York: Robert Miller Gallery, 1986.

Smith, Duncan. *Roberto Juarez: Spirit and Prism.* New York: Robert Miller Gallery, 1983.

FÉLIX A. LÓPEZ

Griego y Maestas, José. "A New Generation of Santeros." *New Mexico* 60 (August 1982): 24–31.

Hispanic Crafts.

One Space/Three Visions.

Sagel, Jim. "Art of Brothers Taps New Mexican Heritage." *Journal North* (Santa Fe, December 16, 1981): E4.

Santos de New Mexico.

GILBERT LUJÁN

Chicanarte.

Kaiser, Kay. "Centro preserves a heritage." *The San Diego Union* (October 13, 1985): F-6.

Mayor, Anne. "Critic's Choice: Gilbert Luján." *Reader* (Los Angeles: March 14, 1986): Section 2, p. 9.

Off the Street.

Personal Reflections.

Raíces y Visiones/Roots and Visions.

CÉSAR MARTÍNEZ

Artes Visuales.

Chicano Expressions.

Chulas Fronteras.

Dále Gas.

¡Mira! The Canadian Club Hispanic Art Tour, 1984.

¡Mira! The Tradition Continues, 1985.

Raíces y Visiones/Roots and Visions.

JESÚS BAUTISTA MOROLES

Awards in the Visual Arts 2. Winston-Salem: Southeastern Center for Contemporary Art, and Chicago: Museum of Contemporary Art, 1983.

Bell, David. "Jesús Bautista Moroles: Mining the Mysteries of Stone" (interview). *International Sculpture* 4.3 (June/July 1985): 11, 34–35.

Chulas Fronteras.

Showdown.

Winckler, Suzanne. "Art of Stone." *Houston Home and Garden* 2 (April 1985): 40–50.

MANUEL NERI

Albright, Thomas. "Manuel Neri: A Kind of Time Warp." *Current* 1 (April–May 1975): 10–16.

———. "Manuel Neri's Survivors: Sculptor for the Age of Anxiety." *Artnews* 80 (January 1981): 54–59.

Butterfield, Jan. "Ancient Auras—Expressionist Angst: Sculpture by Manuel Neri." *Images and Issues* (Spring 1981): 38–43.

Delehanty, Hugh J. "Manuel Neri: Cast from a Different Mold." *Focus Magazine* (San Francisco: January 1982): 24–27.

Kramer, Hilton. "Art: First Solo Show for Manuel Neri." *The New York Times* (February 27, 1981): C17.

Manuel Neri: Drawings and Bronzes. San Francisco: Western Association of Art Museums, 1981. Essay by Jan Butterfield.

Manuel Neri. San Francisco: Anne Kohs & Associates and John Berggruen Gallery; New York: Charles Cowles Gallery; and Zurich: Gimpel-Hanover and André Emmerich Galerien, 1984. Text by Pierre Restany.

Manuel Neri: Sculpture and Drawings (exhibition catalogue). Seattle: Seattle Art Museum, 1981. Essay by Joanne Dickson.

Tuchman, Phyllis. "A sculptor captive to body language of the female form," *Newsday* (February 16, 1986): 15.

PEDRO PEREZ

Greene, Alison de Lima. "Pedro Perez." *Arts* 58 (September 1983): 8.

Into the Mainstream.

New Epiphanies: Religious Contemporary Art (exhibition catalogue). Colorado Springs: The Gallery of Contemporary Art, University of Colorado, 1983.

Seven in the 80's.

MARTÍN RAMÍREZ

American Folk Art/The Herbert Waide Hemphill, Jr., Collection (exhibition catalogue). Milwaukee: Milwaukee Art Museum, 1981. Essays by Russell Bowman and Donald C. Kuspit. Dialogue by Michael D. Hall and Herbert Waide Hemphill, Jr.

Drexler, Sherman. "Martín Ramírez at Phyllis Kind." *Artforum* 14 (May 1976): 70.

The Heart of Creation: The Art of Martín Ramírez (exhibition catalogue). Philadelphia: Moore College of Art, 1985. Foreword by Elsa Weiner Longhauser. Essays by Russell Bowman, Stephan Martin, and Roberta Smith.

McGonigle, Thomas. "Violated Privacy: Prose for Martín Ramírez." *Arts Magazine* 55 (October 1980): 155–57.

Outsiders: An Art Without Precedent or Tradition (exhibition catalogue). London: Arts Council of Great Britain, 1979. Preface by Victor Musgrave. Essay by Roger Cardinal.

Ratcliff, Carter. "New York Letter." *Art International* 20 (Summer 1976): 28.

Schjeldahl, Peter. "Martín Ramírez at Phyllis Kind." *Art in America* 64 (May–June 1976): 114.

Sozanski, Edward J. "Compelling drawings by a disturbed personality." *Philadelphia Inquirer* (September 8, 1985): 1-J. (Article published but never distributed because of newspaper strike.)

Transmitters: The Isolate Artist in America (exhibition catalogue). Philadelphia: Philadelphia College of Art, 1981. Foreword by Elsa S. Weiner, preface by Marcia Tucker, essay by Richard Flood. Dialogue by Michael and Julie Hall.

ARNALDO ROCHE

Abell, Jeff. "Arnaldo Roche Rabell." *New Art Examiner* 11 (February 1984): 15.

Arnaldo Roche Rabell: Actos Compulsivos (exhibition catalogue). Ponce, Puerto Rico: Museo de Arte de Ponce, 1984. Essays by Gregory C. Knight and Enrique García Gutiérrez.

Arnaldo Roche Rabell: Eventos, Milagros y Visiones (exhibition catalogue). San Juan: Museo de la Universidad de Puerto Rico, 1986. Essays by Enrique García Gutiérrez and Michael Bonesteel.

Ocho de los Ochenta. San Juan: Arsenal de la Marina, 1986. Essay by Teresa Tió.

Rodríguez, Myrna. "The Personal View of Roche Rabell." *San Juan Star Magazine* (July 29, 1984): 7.

FRANK ROMERO

Muchnic, Suzanne. "A Clash of Cultures in '¡Méjico, Mexico!'" *Los Angeles Times* (May 21, 1984): 1, 4.

Nieto, Margarita. "The Devils at Play." *Artweek* 15 (May 19, 1984): 4.

PAUL SIERRA

Aquí.

Bonesteel, Michael. "Paul Sierra at Halsted." *Art in America* 74 (March 1986): 155–56.

LUIS STAND

Columbian Artists in New York: A Selection of Paintings and Photographs (exhibition catalogue). New York: Museum of Contemporary Hispanic Art, 1985. Includes essay by Susanna Torruella Leval.

Dictadores y Caudillos.

Luis Stand: Fatalidad (exhibition catalogue). New York: Museum of Contemporary Hispanic Art, 1985.

¡Mira! The Canadian Club Hispanic Art Tour, 1984.

LUIS TAPIA

Hispanic Crafts of the Southwest.

One Space/Three Visions.

JOHN VALADEZ

Artes Visuales.

Chicanarte.

Chicano Expressions.

David Baze/John Valadez: Symbolic Realities (exhibition catalogue). Dominiguez Hills: University Art Gallery, California State University, 1985.

Donohue, Marlena: "The Galleries: Downtown." *Los Angeles Times* (May 4, 1984): 14.

Valle, Victor.

GENERAL BIBLIOGRAPHY

This is a concise rather than an exhaustive listing, focusing on contemporary art and the continuing tradition of religious art in the Southwest. Readers wishing to pursue the subject of Chicano art in greater detail are referred to the following periodicals, which contain many additional articles on Chicano culture: *Aztlan: International Journal of Chicano Studies Research* (University of California, Los Angeles); *Caracol* (San Antonio); *Chismearte* (Los Angeles); *Metamorfosis: Northwest Chicano Magazine of Art and Literature* (University of Washington, Seattle); and *Revista Chicano-Riqueña*, now *The Americas Review* (University of Houston).

American Artists of Cuban Origin (exhibition catalogue). Miami: Miami-Dade Community College, 1985.

Aquí: 27 Latin American Artists Living and Working in the United States (exhibition catalogue). Los Angeles: University of Southern California, Fisher Gallery, 1984. Includes foreword by Selma Holo, essays by John Stringer, Donald Goodall, and Carla Stellweg.

Armijo, Richard, ed. "Chicano Art: Artistic Manuevers." *Contact II* 6 (New York, Winter-Spring 1984–85): 6–17.

The Art of Miami (exhibition catalogue). Winston-Salem: Southeastern Center for Contemporary Art, 1985.

Arte Colombiano en el Mundo: Nuevas Figuras (exhibition catalogue). Bogotá, Colombia: Museo de Arte Moderno de Bogotá, 1985. Includes foreword by Gabriel García Márquez.

Artes Visuales, no. 29 (Mexico City, June 1981). Special issue on Chicano Art; includes essays by Carla Stellweg and Charlote Mosser.

Benavidez, Max. "Chicano Art: A New Vision of Heaven-Hell." *Contact II* 6 (New York, Winter-Spring 1984–85): 18–20.

Benavidez, Max, and Kate Vosoff. "The Wall: Image and Boundary—Chicano Art in the 1970s." In *Mexican Art of the 1970s: Images of Displacement*, pp. 45–54, 63–66. Nashville: Vanderbilt University, Center for Latin American and Iberian Studies, 1984.

Boyd, E. (Elizabeth Boyd White Hall). *Popular Arts of Spanish New Mexico*. Santa Fe: Museum of New Mexico Press, 1974.

———. *Saints and Saint Makers of Spanish New Mexico*. Santa Fe: Laboratory of New Mexico, 1946.

Brenson, Michael. "Painting: 55 by Hispanic-Americans," *The New York Times* (August 24, 1984): C 24. Review of "¡Mira!" exhibition.

Briggs, Charles L. *The Wood Carvers of Cordova, New Mexico*. Knoxville: University of Tennessee Press, 1980.

Chicana Voices & Visions: A National Exhibit of Women Artists (exhibition catalogue). Venice, California: Social and Public Arts Resource Center, 1983. Includes introduction by Shifra M. Goldman.

Chicanarte (exhibition catalogue). Los Angeles: Los Angeles Municipal Art Gallery, 1975.

Chicano Expressions: A New View in American Art (exhibition catalogue). New York: INTAR Latin American Gallery, 1986. Essays by Inverna Lockpez, Tomás Ybarra-Frausto, Judith Baca, and Kay Turner.

Chicano and Latino Artists in the Pacific Northwest (exhibition catalogue). Olympia, Washington: The Evergreen State College, 1984. Includes essays by Lauro Flores, Erasmo Gamboa, Tomás Ybarra-Frausto, and Sid White and Pat Matheny-White.

Childs, Robert V., and Patricia B. Altman. *Vive tu Recuerdo: Living Traditions in the Mexican Days of the Dead* (exhibition catalogue). Los Angeles: University of California, Los Angeles, Museum of Cultural History Monograph Series Number 17, 1982. Includes a discussion of observances in Los Angeles.

Chulas Fronteras: An Exhibition of Contemporary Texas Hispanic Art (exhibition catalogue). Houston, Texas: The Midtown Art Center, 1986. Essay by Benito Huerta.

Collision (exhibition catalogue). Houston: Lawndale Alternative, University of Houston, 1985. Includes texts by James Harithas, John Yau, and Edward Lucie-Smith.

The Cross and the Sword (exhibition catalogue). San Diego: Fine Arts Society of San Diego, 1976. Includes essays on painting, sculpture, and decorative arts from both sides of the U.S.-Mexico border, from the colonial period to the present.

"Cultura Chicana: Los Angeles," *La Opinión*, Supplemento cultural (Los Angeles, July 13, 1980):1–15. Essays by Sergio Muñoz and Harry Gamboa.

Dále Gas: Chicano Art of Texas (exhibition catalogue). Houston: Museum of Contemporary Art, 1977. Includes a selection of essays, short stories, and poems.

Dictadores y Caudillos (exhibition catalogue). New York: Jamaica Art Center, 1983.

Ennis, Michael. "Trevino's Mother." *Texas Monthly* (November, 1984): 206, 208, 212. Review of "¡Mira!" exhibition.

Espinosa, José Edmundo. *Saints in the Valleys: Christian Sacred Images in the History, Life, and Folk Art of Spanish New Mexico*. Albuquerque: University of New Mexico Press, 1967.

Goldman, Shifra M. "Chicano Art Alive and Well in Texas: A 1981 Update." *Revista Chicano-Riqueña* 9 (Winter 1981): 34–40. Reprinted in Quirarte, *Readings*, pp. 97–99.

———. "Chicano Art—Looking Backward," *Artweek* 12 (June 20, 1981): 3–4.

———. "Response: Another Opinion on the State of Chicano Art." *Metamorfosis* 3/4 (1980/81): 2–7. Reprinted in Quirarte, *Readings*, pp. 124–29.

———. "Thorns and Roses," *Artweek* 11 (September 20, 1981): 1.

Gradante, Bill. "Art Among the Low Riders," in Francis E. Abernethy, ed., *Folk Art in Texas*, pp. 70–77. Dallas: Southern Methodist University Press, 1985.

Guide to Chicago Murals. Chicago: Chicago Council on Fine Arts, 1978. Includes essay by Victor A. Sorell on contemporary murals.

Harper, Hilliard. "Centro Cultural de la Raza Marks its 15th Anniversary," *Los Angeles Times* (February 13, 1985): 1, 13.

Hispanic American Art in Chicago (exhibition catalogue). Chicago: Chicago State University Gallery, 1980. Includes essay by Victor A. Sorell.

Hispanic Artists in New York (exhibition catalogue). New York: City Gallery, 1981. Includes introduction by Ana Hernández-Porto.

Hispanic Arts and Ethnohistory in the Southwest. Santa Fe: Ancient City Press, 1983.

Hispanic Crafts of the Southwest (exhibition catalogue). Colorado Springs: Taylor Museum, 1977.

Hispanics U.S.A. 1982 (exhibition catalogue). Bethlehem, Pennsylvania: Ralph Wilson Gallery, Lehigh University, 1982.

Imágenes: A Survey of Contemporary Chicano Artists from Colorado (exhibition catalogue). Denver: Arvada Center, n.d.

Into the Mainstream: Ten Latin American Artists Working in New York (exhibition catalogue). Jersey City, New Jersey: Jersey City Museum, 1986. Essay by Giulio V. Blanc.

Jasper, Pat, and Kay Turner. *Art Among Us/Arte Entre Nosotros* (exhibition catalogue). San Antonio Museum of Art, 1986. Includes additional writings by Suzanne Seriff and José Limon, and Ricardo Romo.

Johnson, Patricia C. "Exhibit Features Hispanic, Latin Art." *Houston Chronicle* (May 20, 1986) Section 4: 1, 3. Review of "Chulas Fronteras" exhibition.

Leval, Susana Torruella. "Painting from Under the Volcano." *Artnews* 84 (March 1985): 141. Review of "¡Aqui!" exhibition.

Lippard, Lucy R. "Made in the U.S.A.: Art from Cuba," *Art in America* 74 (April 1986): 27–35.

Made in Aztlan: Centro Cultural de La Raza, Fifteen Years (exhibition catalogue). San Diego: Centro Cultural de La Raza, 1986. Includes essays by Philip Brookman, Tomás Ybarra-Fransto, Shifra Goldman, and Guillermo Gómez-Peña.

McBride, Stuart Dill. "Chicano Arts Bloom in East Los Angeles: Mexican-American Street Gangs Take Up Brushes," *Christian Science Monitor* (October 28, 1977): 15–18.

The Miami Generation: Nine Cuban-American Artists (exhibition catalogue). Miami: Cuban Museum of Art and Culture, 1984.

Mills, Kay. "The Great Wall of Los Angeles," *MS* 10 (October 1981): 66–69, 102. Report on Judith Baca's mural project.

¡Mira! The Canadian Club Hispanic Art Tour 1984 (exhibition catalogue). New York: El Museo del Barrio, 1984. Includes essay by Nancy L. Kelker.

¡Mira! The Tradition Continues (exhibition catalogue) New York: El Museo del Barrio, 1985. Includes essay by Jacinto Quirarte.

Montoya, Malaquias, and Lezlie Salkowitz-Montoya. "A Critical Perspective on the State of Chicano Art." *Metamorfosis* 3 (Spring/Summer 1980): 3–7. Reprinted in Quirarte, *Readings*, pp. 120–24.

Muchnic, Suzanne. "Latino Work Escapes Ethnicity." *Los Angeles Times* (November 19, 1984): Section VI: 1, 6. Review of "¡Aqui!" exhibition.

New Art from Cuba (exhibition catalogue). Old Westbury: Amelie Wallace Gallery of the State University of New York at Old Westbury, 1985. Includes texts by Gerardo Mosquera, Benjamin Buchloh, and Luís Camnitzer.

New Figure Drawing: Twelve Latin American Artists (exhibition catalogue). Miami: Frances Wolfson Gallery, Miami-Dade Community College, 1984.

Nuevas Vistas: New Insights into Contemporary Latin American Art (exhibition catalogue). Holyoke, Massachusetts: Wistariahurst Museum, 1985. Exhibition notes by Giulio V. Blanc.

Off the Street (exhibition catalogue.) Los Angeles: Old City Print Shop, 1985.

Offerings: The Altar Show (exhibition catalogue). Venice, California: Social and Public Arts Resource Center, 1984.

Ofrendas (exhibition catalogue). Sacramento: La Raza Bookstore/Galería Posada, 1984.

One Space/Three Visions (exhibition catalogue). Albuquerque: Albuquerque Museum, 1979. Indian, Hispanic, and contemporary art from New Mexico.

Pau-Llosa, Ricardo. "Art in Exile." *Americas* 32, no. 8 (Washington, D.C., August, 1980): 3–8. A report on Cuban artists living off the Island, including some in the United States.

———. "Landscape and Temporality in Central American and Caribbean Painting." *Art International* 27, no. 1 (January–March 1984): 28–33. Includes discussion of some artists living in the United States.

———. "On Latin American Art." *Michigan Quarterly Review* 23, no. 2 (Spring 1984): 237–42. Includes discussion of some artists living in the United States.

Personal Reflections: Masks by Chicano and Native American Artists in California (exhibition catalogue). Sacramento: La Raza Bookstore, n.d. Includes introduction by Tere Romo.

Pincus, Robert L. "Chicano Art Center to Mark 15th Birthday with Exhibit," *The San Diego Union* (September 12, 1985): D-8.

Quirarte, Jacinto, ed. *Chicano Art History: A Book of Selected Readings*. San Antonio: Research Center for the Arts and Humanities, 1984.

———. *A History and Appreciation of Chicano Art*. San Antonio: Research Center for the Arts and Humanities, 1984.

———. *Mexican American Artists*. Austin: University of Texas Press, 1973.

Raices Antiquas/Visiones Nuevas—Ancient Roots/New Visions (exhibition catalogue). Tucson: Tucson Museum of Art, 1977.

Raices y Visiones/Roots and Visions (exhibition catalogue). Washington, D.C.: National Collection of Fine Arts, 1977.

Raynor, Vivien. "Art: '¡Mira!' Exhibition at El Museo del Barrio," *New York Times* (January 3, 1986): C20.

Rickey, Carrie. "The Writing on the Wall." *Art in America* 69 (May 1981): 54–57. Report on Judith Baca's mural project in Los Angeles.

Santos: An exhibition of the Religious Folk Art of New Mexico (exhibition catalogue). Fort Worth: Amon Carter Museum, 1964. Includes essay by George Kubler.

Santos de New Mexico (exhibition catalogue). San Francisco: Galería de la Raza, 1983. Includes essay by José Griego y Maestas.

Seven in the 80's (exhibition catalogue). Coral Gables, Florida: The Metropolitan Museum & Art Center, 1986.

17 Artists: Hispanic, Mexican-American, Chicano (exhibition catalogue). San Antonio: Witte Memorial Museum, 1976. Introduction by Jacinto Quirarte.

Shalkop, Robert L. *The Folk Art of a New Mexican Village*. Colorado Springs: The Taylor Museum, 1969. Arroyo Hondo and vicinity.

Showdown: Perspectives on the Southwest (exhibition catalogue). New York: Alternative Museum, 1983.

Sorell, Victor A. "Barrio Muralism in Chicago: Painting the Hispanic American Experience on 'Our Community' Walls." *Revista Chicano-Riqueña* 4 (Fall 1976): 51–72. Reprinted in Quirarte, *Readings*, pp. 100–109.

Southwest Artists Invitational: An Exhibition of Contemporary Art by Seven Texas Artists of Hispanic American Descent (exhibition catalogue). Corpus Christi: Corpus Christi State University Center for the Arts, Weil Gallery, 1980. Includes essay by Roberto Tomás Esparza.

A Spirit Shared: Twentieth Century Art in Mexico and New Mexico (exhibition catalogue). Santa Fe: Museum of New Mexico, 1984.

Steele, Thomas J. *Santos and Saints.* Albuquerque: Calvin Horn, 1974.

Stroesser, Robert. *Santos of the Southwest: The Denver Art Museum Collection.* Denver: Denver Art Museum, 1970.

Stoller, Marianne. "Hispanic Women Artists and Their Visions of the Southwest." *La Tertulia* 1 (Colorado Springs, Fall 1984): unpaginated.

Ten Latin American Artists Working in New York (exhibition catalogue). New York: International House, 1984. Includes essay by Barbara Duncan.

Valle, Victor. "Chicano Art: An Emerging Generation." *Los Angeles Times* (August 7, 1983): Calendar, 4–6. Reprinted in *Southern California's Latino Community* (Los Angeles: *Los Angeles Times,* 1983): 92–98.

West, John O. "Folk Grave Decoration Along the Rio Grande," in Francis E. Abernethy, ed., *Folk Art in Texas,* pp. 46–51. Dallas: Southern Methodist University Press, 1985.

White, Sid, and Pat Matheny-White. "Chicano/Latino Art and Artists: A Regional Overview." *Metamorfosis* 4/5 (1982/83): 12–19. Reprinted in Quirarte, *Readings,* pp.110–117.

Wilder, Mitchell A. *Santos: The Religious Folk Art of New Mexico.* New York: Hacker Books, 1976. (First published Colorado Springs: Taylor Museum, 1943.)

Wilson, William. "'Los Four': a statement of Chicano Spirit." *Los Angeles Times* (March 10, 1974): Calendar: 64, 67.

Wroth, William. *The Chapel of our Lady of Talpa* (exhibition catalogue). Colorado Springs: Taylor Museum, 1979.

———. William. *Christian Images in Hispanic New Mexico.* (exhibition catalogue). Colorado Springs: The Taylor Museum, 1982.

INDEX

Numbers in *italics* refer to illustrations.

Abuelitos Piscando Nopalitos (Garza), *44*
Affection (Gonzalez), *72, 72*
Alfonzo, Carlos, 68, 106, 118, 125; bibliography on, 251; biography of, 137–38; *On Hold in the Blue Line, 86; Petty Joy, 70; Sea Bitch Born Deep, 68, 139; Self-Portrait #2, 18; Trail, 136; Where Tears Can't Stop, 107*
Almaraz, Carlos, 57, 118, 120, 125, 131, 174, 204, 233, 248; bibliography on, 251; biography of, 140, 143; *Crash in Pthalo Green, 113; Echo Park Lake #1–4, 38–40; Europe and the Jaguar, 42, 60; Greed, 141; Love Makes the City Crumble, 60, 62; The Two Chairs, 142; Two of a Kind, 111*
American art: ethnicity and, 45–46; in mid to late 1970s, 89; pluralism in, 85, 89; sculpture in, 74 (*see also* sculpture); style of, 43–45. *See also* Hispanic art
American Fighter (Briseño), *151*
Annunciation No. 2 (Neri), *74*
Aquarium I (Espada), 68, *71, 160*
Archuleta, Felipe, 46, 93, 94; *Baboon, 54;* bibliography on, 251; biography of, 144; *Catfish, 145; Lion, 145; Porcupine, 93; Rabbit, 93; Sheep, 145*
artists' groups, 57, 143, 185, 188, 204, 208, 233, 240
Asco, 185, 188; assimilation, 46, 50; Hispanics and, 53, 55, 56
Auto Cinema, El (Gil de Montes), *177*
Azaceta, Luis Cruz, 74, 75, 114, 118; bibliography on, 251; biography of, 146, 148; *Deadly Rain, 147; Homeless, 51, 75; The Immigrant, 121; Self-Portrait as a She-Wolf, 17, 75*

Baboon (Archuleta), *54*
Bato con Sunglasses (Martínez), *47, 58*
Bay Area Figurative School, 74
Beach Couple at Santa Monica (Luján), *205*
Beto's Vacation (Water, Land, Fire) (Valadez), 58, *132–34*
bibliographies, 251–54
biographies, 137–248; of Carlos Alfonzo, 137–38; of Carlos Almaraz, 140, 143; of Felipe Archuleta, 144; of Luis Cruz Azaceta, 146, 148; of Rolando Briseño, 149, 152; of Lydia Buzio, 153; of Ibsen Espada, 157, 160; of Rudy Fernandez, 161, 164; of Ismael Frigerio, 165, 168; of Carmen Lomas Garza, 169, 172; of Roberto Gil de Montes, 173–74, 176; of Patricia Gonzalez, 179–80; of Robert Graham, 182, 184; of Gronk, 185, 188; of Luis Jimenez, 190, 193; of Roberto Juarez, 194, 196; of Félix A. López, 199, 201; of Gilbert Sánchez Luján, 202, 204–5; of César Augusto Martínez, 206, 208; of Gregorio Marzán, 210–11; of Jesús Bautista Moroles, 213–15; of Manuel Neri, 217–18; of Pedro Perez, 219, 222; of

Martín Ramírez, 28, 33, 35, 223, 226; of Arnaldo Roche, 227, 230; of Frank Romero, 232–33; of Paul Sierra, 236, 239; of Luis Stand, 240, 243; of Luis Eligio Tapia, 244; of John Valadez, 247–48
Bizco, El (Martínez), *207*
Briseño, Rolando, 118; *American Fighter, 151;* bibliography on, 251; biography of, 149, 152; *Discussion at the Table, 150; Fighting at the Table #4, 124; Naturalezza Viva, 125*
Broadway Mural, The (Valadez), 248
Broken ~~Blossoms~~ Beads (Gronk), *186*
Broken Cup (Juarez), *87*
bultos, 67, 198, 200, 201, *201.* See also santos
Burning the Spirit of the Flesh (Roche), *3*
Butterfly, La (Valadez), 58, 99–100, *99*
Buzio, Lydia, 80, 118; bibliography on, 252; biography of, 153; *Dark Blue Roofscape, 154; Green Roofscape with Church, 155; Large Blue Roofscape, 109; Round Blue Roofscape, 82; Tall Green Roofscape, 91*

Cabin Fever (Gronk), 75, *77*
Cardinal, Roger, 33, 35
Carreño, Mario, 114
Carrington, Dorothea, 114
Carving the Spirit of the Flesh (Roche), *229*
Casas, Mel, 57, 208
Catfish (Archuleta), *145*
Catholicism: Hispanic culture and, 22, 24–26; Mexican, 24
Chavez, César, 56
Chicanos: art of, 57–58, 60, 99–101, 105; civil rights struggle of, 56–57; ethnic identity of, 57–58, 60; Mexican Americans distinguished from, 53. *See also specific artists*
Christianity: in Anglo-American culture, 20–21; in Hispanic culture, 22, 24–26
Chuco, El (Jimenez), *60*
Clemente, Francesco, 125
Closing of Whittier Boulevard, The (Romero), *56*
Con Safos, 57, 208
Crash in Pthalo Green (Almaraz), *113*
Cristo (López), *198*
Cuatro Santos (Sierra), 68, *237*
Cubans, 24, 25, 53, 55. *See also specific artists*
Cubans are Funny as Shit (Perez), *221*
culture: Anglo-American vs. Hispanic, 22, 24; Catholicism and, 22, 24–26; pluralism and, 46, 50, 53; provincial, 80
Curandera barriendo de susto/Faith healer sweeping away fright (Garza), *171*

Dachshund (Marzán), *55*
Dadd, Richard, 35
Dark Blue Roofscape (Buzio), *154*
Deadly Rain (Azaceta), *147*

Dear Rafe (Hinojosa), 55
Death Cart (Tapia), *66,* 67
death carts, *66,* 67, *169*
de la Rocha, Beto, 143, 204, 233
Día de los Muertos Ofrenda: Homage to Frida Kahlo (Garza), 64, *64, 65*
Días de los Muertos, 64
Dirube, Rolando López, 109, 157
Discussion at the Table (Briseño), *150*
Doña Sebastiana (Garza), *169*
¿Donde está la pelota? (Luján), *204*
Don't Play My Song (Roche), *117*
Dream, The (Roche), *231*

Eccentricities in Nature (Gonzalez), 68, 72, *115*
Echo Park Lake #1–4 (Almaraz), *38–40*
Enano White, El (Martínez), *209*
Entangled (Fernandez), *162*
Esmeralda, La (The Queen That Shoots Birds) (Perez), 67–68, *68, 219*
Espada, Ibsen, 68, 106, 109; *Aquarium I, 68, 71, 160;* bibliography on, 252; biography of, 157, 160; *El Yunque, 68, 158; Octopus I, 159; Orchestra II, 112; Salsa para ti, 6; Warriors in the Park, 156*
ethnic diversity: among Hispanics, 22, 24–25, 53; in United States, 21–22
ethnicity: American art and, 45–46; Hispanic art and, 46, 50, 53. *See also* identity, Hispanic
Europe and the Jaguar (Almaraz), *42,* 60

Faith healer sweeping away fright/Curandera barriendo de susto (Garza), *171*
Fall, The (Roche), *116*
Famba, La (Sierra), 68, *69*
family, 14, 25–26
fantastic, the, 68, 72
Fatima (Valadez), 58, *59*
Fernandez, Rudy, 75, 101; bibliography on, 252; biography of, 161, 164; *Entangled, 162; Mocking Me, 163; Sal si Puedes, 104; Waiting, 78, 164*
Fighting at the Table #4 (Briseño), *124*
First Opportunity of Pain, The (Frigerio), *166–67*
folk art, 93–94
Fountain Figure #1 (Graham), *183*
Fountain Figure #2 (Graham), *126*
Fountain Figure #3 (Graham), *183*
Fountain View (Gonzalez), *181*
Four, Los, 143, 204, 233
French Arrangement (Juarez), *197*
Frigerio, Ismael, 72, 118; bibliography on, 252; biography of, 165, 168; *The First Opportunity of Pain, 166–67; The Loss of Our Origin, 48–49, 72; The Lurking Place, 130; The Lust of Conquest, 72, 122–23*
Fritzmobile (Romero), *101*
Fruit Boat (Juarez), *78*

Gamboa, Harry, 174, 185, 188
Garza, Carmen Lomas, 57, 58, 67, 114, 208;
 Abuelitos Piscando Nopalitos, 44;
 bibliography on, 252; biography of, 169,
 172; *Curandera barriendo de susto/Faith
 healer sweeping away fright, 171; Día de
 los Muertos Ofrenda: Homage to Frida
 Kahlo, 64, 64, 65; Doña Sebastiana, 169;
 Nopalitos Frescos, 170; Sandía/
 Watermelon, 45; Self-Portrait, 15*
General sin Manos, El (Stand), 72, *76*
Georgia Stele (Moroles), *127*
Gil de Montes, Roberto, 118, 120, 125;
 bibliography on, 252; biography of, 173–
 74, 176; *El Auto Cinema, 177; Jaguar
 Man-Panther Man, 174; Nocturne, 61, 63;
 The Receptor, 61, 120; Salsa Man, 175;
 Self-Portrait, 173*
God (Perez), 106, *108*
Goldman, Shifra, 57, 58
Gonzalez, Patricia, 68, 72, 114, 118;
 Affection, 72, 72; bibliography on, 252;
 biography of, 179–80; *Eccentricities in
 Nature, 68, 72, 115; Fountain View, 181;
 Heart Forest, 114; Sleep, 178*
Graham, Robert, 57, 74, 80, 127, 131;
 bibliography on, 252; biography of, 182,
 184; *Fountain Figure #1, 183; Fountain
 Figure #2, 126; Fountain Figure #3, 183;
 Olympic Torso, Female, 52, 184; Olympic
 Torso, Male, 52, 184*
Greed (Almaraz), *141*
Green Roofscape with Church (Buzio), *155*
Gronk, 75, 100, 101, 174; bibliography on,
 252; biography of, 185, 188; *Broken
 Blossoms Beads, 186; Cabin Fever, 75, 77;
 La Tormenta, 101, 189; No Nose, 187*

Hanging Out (Luján), *100*
Heart Forest (Gonzalez), *114*
Hernández de Neikrug, Judithe, 57, 58, 174
Herron, Willie, 174, 185
Higham, John, 50
Hinojosa, Rolando, 55
Hispanic: defined, *13n*
Hispanic art: Chicano, 57–58, 60, 99–101,
 105 (*see also specific artists*); ethnicity
 and, 46, 50, 53; the fantastic and, 68, 72;
 myths and, 118, 120; politics and, 72;
 provincialism and, 80; religious, 64, 67–
 68, 94; social influences on, 35; stylistic
 influences on: *see* stylistic influences on
 Hispanic art. *See also* American art; *and
 specific artists*
Hombre que le Gustan las Mujeres
 (Martínez), *98,* 99–100
Homeless (Azaceta), *51,* 75
Honky Tonk (Jimenez), *105, 192*
Hot Dog meets La Fufú con su Poochie
 (Luján), *61*
Howl (Jimenez), *191,* 193; *Working Drawing
 for, 73*
Hunger of Memory (Rodríguez), 53

identity, Hispanic, 13–37; Chicano, 57–58,
 60; pluralism and, 46, 50, 53
Immigrant, The (Azaceta), *121*
immigration, 21–22
Indios Verdes No. 4 (Neri), *23*
International New Expressionism, 118, 120

Jaguar Man-Panther Man (Gil de Montes),
 174
Jetter's Jinx (Gamboa), *188*
Jimenez, Luis, 58, 60, 74, 75, 105, 118,
 213; bibliography on, 252–53; biography
 of, 190, 193; *El Chuco, 60; Honky Tonk,
 105, 192; Howl, 191, 193; Sod Buster, 193;
 Southwest Pieta, 193; Vaquero, 193;
 Working Drawing for Cruzando el Rio
 Bravo (Border Crossing), 58; Working
 Drawing for Howl, 73*
Juarez, Roberto, 75, 78, 80, 106, 109, 114,
 118, 131; bibliography on, 253; biography
 of, 194, 196; *Broken Cup, 87; French
 Arrangement, 197; Fruit Boat, 78; Sun
 Woman, 78, 81; Three Birds, 78, 79;
 Three Mushrooms, 195; Two Sister Dolls,
 78, 110*

Kahlo, Frida, 64, 90, 114, 180
Kind, Phyllis, 33, 226

Lam, Wifredo, 37, 90, 106, 114, 138
Large Blue Roofscape (Buzio), *109*
Latino/Hispanic Modernism, 106, 109, 114
Limón, Richard, 248
Lion (Archuleta), *145*
Living Like a Refugee (Perez), *88*
Lizard (Marzán), *210*
López, Félix A., 67, 94, 97; bibliography on,
 253; biography of, 199, 201; *Cristo, 198;
 St. Anthony of Padua, 201; San Augustín
 Obispo, 97; San Francisco, 67; San José,
 97; San Miguel, 97; San Ysidro, 200*
Loss of Our Origin, The (Frigerio), *48–49,*
 72
Love Makes the City Crumble (Almaraz), 60,
 62
Luján, Gilbert Sánchez ("Magu"), 57, 74, 75,
 100, 101, 143, 233, 248; *Beach Couple at
 Santa Monica, 205;* bibliography on, 253;
 biography of, 202, 204–5; *¿Donde está la
 pelota?, 204; Hanging Out, 100; Hot Dog
 meets La Fufú con su Poochie, 61;
 Magulandia, 205; Our Family Car, 102–3;
 Stepping Out, 203*
Lurking Place, The (Frigerio), *130*
Lust of Conquest, The (Frigerio), 72, *122–23*

Mad Dogs (Sierra), *119*
Madonna (Ramírez), *12,* 94
Magulandia (Luján), *205*
Marielitos, Los (Perez), *220*
Martínez, César Augusto, 57, 58, 60; *Bato
 con Sunglasses, 47, 58;* bibliography on,
 253; biography of, 206, 208; *El Bizco,
 207; El Enano White, 209; Hombre que le
 Gustan las Mujeres, 98,* 99–100
Marzán, Gregorio, 46, 93, 94; biography of,
 210–11; *Dachshund, 55; Lizard, 210; Red
 Goat, 93; Rooster, 211; Spotted Bird (with
 orange beak), 211; Striped Butterfly, 210;
 Striped Giraffe, 55*
Masson, André, 90, 106
Matta, Roberto, 37, 90, 106
¡Méjico, Mexico! (Romero), *250*
Mexican Americans: Chicanos distinguished
 from, 53

Mexican Neo-Surrealism, 114
Mexicans, 24–25
Minimalism, 74, 85
Mi querido Rafa (Hinojosa), 55
Mocking Me (Fernandez), *163*
Moroles, Jesús Bautista, 127; bibliography
 on, 253; biography of, 213–15; *Georgia
 Stele, 127; Spirit Inner Column #1, 53;
 Texas Facade, 214; Texas Shield, 212;
 Vanishing Edge, 215*
mother (maternal image), 26, 33
Movimiento, El, 56–57
Mujer Pegada Series No. 1 (Neri), *129*
Mujer Pegada Series No. 2 (Neri), *128*
murals, 57, 99–101, 247, 248
myths, 118, 120

Narrative Art, 89
nation, concept of, 14, 17, 19; United States
 and, 19–22. *See also* identity, Hispanic
Naturalezza Viva (Briseño), *125*
Neo-Surrealism, Mexican, 114
Neri, Manuel, 57, 74, 80, 127, 131;
 Annunciation No. 2, 74; bibliography on,
 253; biography of, 217–18; *Indios Verdes
 No. 4, 234; Mujer Pegada Series No. 1,
 129; Mujer Pegada Series No. 2, 128;
 Untitled V, 216*
New Expressionism, 89, 109; International,
 118, 120
New Image Painting, 89
"new regionalism," 89, 90
Nilsson, Gladys, 33, 226
Nocturne (Gil de Montes), 61, *63*
No Nose (Gronk), *187*
Nopalitos Frescos (Garza), *170*
Nutt, Jim, 33, 226

Octopus I (Espada), *159*
Olympic Torso, Female (Graham), *52, 184*
Olympic Torso, Male (Graham), *52, 184*
On Hold in the Blue Line (Alfonzo), *86*
Orchestra II (Espada), *112*
Orozco, José Clemente, 90, 106
Ortega, José Benito, 97
Our Family Car (Luján), *102–3*

participation, 14, 17, 19, 22, 35
Pasto, Tarmo, 33, 35, 223, 226
Peña, Arnado, 208
Perez, Pedro, 67, 106, 109; bibliography on,
 253; biography of, 219, 222; *Cubans are
 Funny as Shit, 221; God, 106, 108; La
 Esmeralda (The Queen That Shoots Birds),
 67–68, 68, 219; Living Like a Refugee,
 88; Los Marielitos, 220*
Petty Joy (Alfonzo), *70*
phantasma, 37. See also fantastic, the
Picassesque Surrealism, 106, 114
Piso de Sangre (Romero), *234*
Plan del Barrio, El, 56
pluralism: artistic, 85, 89; cultural, 46, 50,
 53
politics: Hispanic art and, 72
Porcupine (Archuleta), *93*
Preacher (Valadez), *246*
provincialism, 80
Puerto Ricans, 24, 25, 53, 55. *See also
 specific artists*

Queen That Shoots Birds, The (La Esmeralda) (Perez), 67–68, *68*, *219*
Quemados, Los, 208
Quirarte, Jacinto, 57

Rabbit (Archuleta), *93*
Ramírez, Martín, 46, 80, 90, 93, 94, 131; bibliography on, 253–54; biography of, 28, 33, 35, 223, 226; *Madonna*, *12*, 94; *Untitled* (Animal), *224*; *Untitled* (Animal), *225*; *Untitled* (Cities and Courtyards), *84*; *Untitled* (Family of Deer), *34*; *Untitled* (Horse and Rider), *92*; *Untitled* (Jesus), *29*; *Untitled* (Proscenium Image), *32*; *Untitled* (Scroll), *223*, *226*; *Untitled* (Tunnels and Trains) (c. 1950s), *36*; *Untitled* (Tunnels and Trains) (c. 1953), *30–31*
Receptor, The (Gil de Montes), 61, *120*
Red Goat (Marzán), *93*
religious art, 64, 67–68, 94. See also *santos*
Reredos (Tapia), *95*, *96*, 245
retablos, 67, 164
Reyes, Felipe, 57, 208
Rivera, Diego, 90, 106, 205
Roche, Arnaldo, 75, 118, 120; bibliography on, 254; biography of, 227, 230; *Burning the Spirit of the Flesh*, *3*; *Carving the Spirit of the Flesh*, *229*; *Don't Play My Song*, *117*; *The Dream*, *231*; *The Fall*, *116*; *The Source*, *27*; *The Spirit of the Flesh*, *228*
Rodríguez, Richard, 53
Romero, Frank, 57, 100, 118, 140, 143, 204, 248; bibliography on, 254; biography of, 232–33; *The Closing of Whittier Boulevard*, *56*; *Fritzmobile*, *101*; *¡Méjico, Mexico!*, *250*; *Piso de Sangre*, *234*; *Still Life with Red Car*, *235*; *Toto*, *232*
Rooster (Marzán), *211*
Round Blue Roofscape (Buzio), *82*

St. Anthony of Padua (López), *201*
Salsa Man (Gil de Montes), *175*
Salsa para ti (Espada), *6*
Sal si Puedes (Fernandez), *104*
San Augustín Obispo (López), *97*
Sandía/Watermelon (Garza), *45*
San Francisco (López), *67*
San José (López), *97*
San Miguel (López), *97*
santeros, 94, 97
santos, 26, 64, 67, *67*, 94, 97, *97*, *198*, *200*, *201*, 245
San Ysidro (López), *200*
sculpture, 26, 28, 74, 127. See also specific artists
Sea Bitch Born Deep (Alfonzo), 68, *139*
Self-Portrait (Garza), *15*
Self-Portrait (Gil de Montes), *173*
Self-Portrait as a She-Wolf (Azaceta), *17*, *75*
Self-Portrait #2 (Alfonzo), *18*
separation, *14*, *17*, *19*, *22*, 35
Sheep (Archuleta), *145*
Sierra, Paul, 68, 106, 114, 118, 120; bibliography on, 254; biography of, 236, 239; *Cuatro Santos*, 68, *237*; *La Famba*, 68, *69*; *Mad Dogs*, *119*; *Three Days and Three Nights*, 68, *238*

Sindicato, El, 240
Siqueiros, David Alfaro, 90, 106
Sleep (Gonzalez), *178*
Smith, David, 74
society, 17; Hispanic vs. North American, 25–26; influence on Hispanic art of, 35. See also identity, Hispanic
Sod Buster (Jimenez), *193*
Source, The (Roche), *27*
Southwest Pieta (Jimenez), *193*
Spirit Inner Column #1 (Moroles), *53*
Spirit of the Flesh, The (Roche), *228*
Spotted Bird (with orange beak) (Marzán), *211*
Stand, Luis, 72, 118, 120; bibliography on, 254; biography of, 240, 243; *El General sin Manos*, 72, *76*; *El Viejo Tigre*, *241*; *Untitled* (Figures with Machetes), *242*
Stepping Out (Luján), *203*
Still Life with Red Car (Romero), *235*
Striped Butterfly (Marzán), *210*
Striped Giraffe (Marzán), *55*
stylistic influences on Hispanic art, 37, 74–80, 85–131; folk art and, 93–94; Latino/Hispanic Modernism and, 106, 109, 114; New Expressionism and, 89, 109, 118, 120; new regionalism and, 89, 90; Picassesque Surrealism and, 106, 114; religious art and, 64, 67–68, 94. See also biographies of individual artists
Sun Woman (Juarez), 78, *81*
Surrealism, 37; Picassesque, 106, 114

Tall Green Roofscape (Buzio), *91*
Tamayo, Rufino, 37, 90, 106
Tapia, Luis Eligio, 67, 94, 97; bibliography on, 254; biography of, 244; *Death Cart*, *66*, 67; *Reredo*, *245*; *Reredos*, *95*, *96*
Texas Facade (Moroles), *214*
Texas Shield (Moroles), *212*
Three Birds (Juarez), 78, *79*
Three Days and Three Nights (Sierra), 68, *238*
Three Mushrooms (Juarez), *195*
Tormenta, La (Gronk), 101, *189*
Torres-García, Joaquín, 90, 106, 114, 118, 153
Toto (Romero), *232*
Trail (Alfonzo), *136*
Two Chairs, The (Almaraz), *142*
Two of a Kind (Almaraz), *111*
Two Sister Dolls (Juarez), 78, *110*

Untitled (Animal) (Ramírez), *224*
Untitled (Animal) (Ramírez), *225*
Untitled (Cities and Courtyards) (Ramírez), *84*
Untitled (Family of Deer) (Ramírez), *34*
Untitled (Figures with Machetes) (Stand), *242*
Untitled (Horse and Rider) (Ramírez), *92*
Untitled (Jesus) (Ramírez), *29*
Untitled (Proscenium Image) (Ramírez), *32*
Untitled (Scroll) (Ramírez), *223*, *226*
Untitled (Tunnels and Trains) (Ramírez; c. 1950s), *36*
Untitled (Tunnels and Trains) (Ramírez; c. 1953), *30–31*
Untitled V (Neri), *23*

Valadez, John, 57, 204; *Beto's Vacation (Water, Land, Fire)*, 58, *132–34*; bibliography on, 254; biography of, 247–48; *The Broadway Mural*, 248; *Fatima*, 58, *59*; *La Butterfly*, 58, 99–100, *99*; *Preacher*, 246
Valdéz, Horacio, 67, 244
Valdez, Patssi, 185
Vanishing Edge (Moroles), *215*
Vaquero (Jimenez), *193*
Varo, Remedios, 114
Viejo Tigre, El (Stand), *241*

Waiting (Fernandez), *78*, *164*
Warriors in the Park (Espada), *156*
Watermelon/Sandía (Garza), *45*
Where Tears Can't Stop (Alfonzo), *107*
Working Drawing for Cruzando el Rio Bravo (Border Crossing) (Jimenez), *58*

Yunque, El (Espada), 68, *158*

Zuñiga, Francisco, 90, 205

PHOTO CREDITS

The photographers and the sources of photographic material other than those indicated in the captions are as follows:

Adam Avila: pp. 59, 99, 132–34, 246; William Bengston: pp. 69, 119, 237, 238; Bruce Berman: pp. 58, 73, 105, 191, 192; John Betancourt: frontispiece, pp. 27, 116, 117, 228, 229, 231; David Cardenas: pp. 207, 209; Charles Cowles Gallery: pp. 15, 128, 129; Ivan Dalla Tana: pp. 23, 48–49, 51, 55, 76, 82, 91, top left 93, 109, 121, 122–23, 130, 147, 150, 151, 154, 155, 166–67, 210, 211, 241, 242; Wolfgang Dietze: pp. 18, 44, 45, 64, 65, 169, 170, 171; P. Richard Eells: p. 54; M. Lee Fatherree: p. 74; Patricia Fisher: pp. 16, 70, 86, 107, 136, 139; Rick Gardner: p. 221; Robert Graham Studio: pp. 52, 184; Paul Hester: p. 95; Hickey-Robertson: cover, pp. 6, 47, 53, 71, 72, right 93, 98, 112, 114, 115, 126, 127, top 145, 156, 158, 159, 160, 178, 181, 183, 212, 214, 215; Jennifer Kotter: pp. 12, 29, 30–31, 32, 34, 36, 60, 68, 84, 88, 92, 108, 219, 221, 223, 224, 225, 226; Robert Miller Gallery, New York: pp. 79, 87, 110; William Nettles: pp. 77, 186, 187, 189; William Nugent: pp. 66, 67, bottom left 93, 96, left 97, left and bottom 145, 198, 200, 201, 245; Blair Paltridge: p. 216; © Douglas M. Parker 1987: pp. 38–40, 42, 56, 62, 63, 101, 111, 113, 120, 141, 142, 173, 174, 175, 177, 232, 234, 235, 250; Robert Sherwood: pp. 78, 104, 162, 163; © Steven Sloman: pp. 81, 195; Steve Sparkman: pp. 26, center and right 97; George Tatge: pp. 124, 125; Tom Van Eynde: p. 197; Tom Vinetz: pp. 61, 100, 102–3, 203, 204, 205.